MICHAEL KÖCKRITZ

A PASSION FOR CARS

BEST OF RAMP

teNeues

IMMER IN BEWEGUNG

MICHAEL KÖCKRITZ
Chefredakteur

IMMER IN BEWEGUNG — Wovon lebt ein gutes Roadmovie? Auf jeden Fall braucht man einen Helden und eine Straße, dann wäre ein Auto nicht so verkehrt, der Horizont ist ohnehin gesetzt. Konkret oder auch gerne als Metapher, nur eng sollte er bitte nicht sein. Aufbruch, der Wunsch nach Veränderung, die Hoffnung auf eine bessere Welt oder wenigstens auf gute Begegnungen und feine Abenteuer. Das stilistische Leitmotiv des Genres verrät: Immer wenn Bewegung ins Spiel kommt, wird die Angelegenheit spannend.

Wer dann unterwegs ist, entwickelt und verändert sich. So etwas gilt für die Helden der Roadmovies – und es gilt für uns. Für ramp. Aus dem ursprünglichen Ansatz, mit kreativen Zugängen und frischen Inszenierungen etwas Bewegung in die Welt der Lifestyle- und Automedien zu bringen, hat sich eine moderne Medien-Luxusmarke mit einer ganzen Reihe von Line-Extensions entwickeln können. Eine Marke, die sich aus Prinzip immer wieder lebendig neu definiert – und dabei auch gerne mit einem ganz eigen-inspirierten Lebensgefühl verbunden wird. Na ja, und ganz nebenbei hat sich der ramp-Verlag Red Indians längst als gefragter Think-and-do-Tank für strategisches Content Marketing und innovative Medienentwicklungen etabliert. Bewegung bleibt also im Spiel.

Mit diesem Buch feiern wir jetzt also die ersten 25 Jahre ramp! 25 tolle, bewegte und sehr lebendige Jahre! Okay, es sind vielleicht klassisch gerechnet doch eher nur acht, aber wenn man die Fülle an Einfällen, Geschichten und Bildern einmal sortiert, meint man, die Ergebnisse aus 25 Jahren vor sich zu haben. Aus mindestens 25 Jahren. Nimmt man die Einfälle, Geschichten und Bilder dazu, die es nicht ins Heft geschafft haben, weil so ein Heft leider eben dann doch nicht mehr als etwa 250 Seiten haben sollte, dann kommt manch ein flotter Rechner sogar locker auf 50 Jahre. Unsere Controller sowieso.

Lob und Anerkennung gab es überraschend viel für ramp, dazu bislang weltweit über 60 Auszeichnungen. Das schönste Kompliment aber kommt von unseren Lesern. Für die ist ramp nämlich nicht nur eines der schönsten und besten Magazine, sondern vor allem auch eines der übermütigsten und bestgelaunten.

In genau diesem Sinn wünsche ich Ihnen viel Vergnügen mit diesem Buch zu den besten Bildern aus unseren ersten Jahren mit dem Autokulturmagazin ramp.

Ihr – Yours – Bien à vous

ALWAYS ON THE MOVE — What are the essentials of a good road movie? Well, inevitably, you need a protagonist and, obviously, one or more roads. Given that, you might as well throw in the car too. The other essential is this: Whatever you want it to be, factual or metaphorical, prior to thinking beyond the horizon, make sure your horizon isn't too narrow to begin with. As for leitmotif, such as the dawn of a new beginning, the desire for change, the hope for a better world, positive encounters, or fine adventures, it is essential to keep in mind the stylistic aspect of the genre as well: Anytime action enters into the picture, it never fails to capture the attention of an audience.

Indeed, being on the move has a way of shaping and changing people. It's true of the protagonists in the road movies—and it's true of us at ramp. What began with a concept involving new creative talents and new interpretations of familiar themes to breathe some new life into the world of lifestyle and automotive media has evolved into a sophisticated media luxury brand with a whole range of line extensions. A brand which thrives on redefining itself on principle—and which enjoys being associated with its own self-inspired lifestyle. Incidentally, ramp-Verlag Red Indians has long since established itself as a much sought-after think-and-do-tank for strategic content marketing and for innovative media development. Indeed, action is the name of the game.

By publishing this book, we are now celebrating the first 25 years of ramp! 25 awesome, emotional, and very intense years! OK, in classic calendar terms, maybe it's closer to 8 years, but going through our vast collection of ideas, stories, and pictures, it does seem like 25 years' worth of outcome. At least 25 years. Once you factor in all the ideas, stories, and pictures that never made it to publication, considering a magazine shouldn't really contain 250+ pages, doing some quick math could easily make it 50 years. Like our controllers could.

We're still surprised by all the praise and recognition of ramp, especially by the more than 60 awards we've received from all over the world. However, the most precious compliment comes from our readers. To them, ramp isn't just one of the nicest and best magazines, it's also one of the boldest and most cheerful ones.

It is exactly in this spirit that I hope you find this book featuring the best pictures from our early years with the car culture magazine ramp to be a most joyful experience.

TOUJOURS EN MOUVEMENT — Quels sont les ingrédients d'un bon road-movie ? Il faut impérativement un héros et une route. Ensuite, une voiture, ça ne serait pas mal. Quant à l'horizon, il est là, incontournable. Concret ou, si vous préférez, métaphorique. Mais en aucun cas étriqué. Départ, désir de changement, espoir d'un monde meilleur ou du moins de belles rencontres et d'aventures superbes. Le leitmotiv stylistique du genre veut cela : c'est toujours lorsqu'il y a du mouvement que l'action devient passionnante.

Dès lors, quiconque prend la route évolue et change. C'est vrai pour les héros des road-movies - c'est vrai aussi pour nous. Pour ramp. L'idée initiale visant à insuffler un peu de mouvement dans l'univers des médias consacrés au life-style et à l'automobile, par le biais d'approches créatives et de mises en scène audacieuses, a pu donner naissance à une marque de média moderne haut de gamme, avec toute une série de déclinaisons. Une marque reposant sur le principe d'une redéfinition perpétuelle, de manière vivante - et en cela volontiers associée à la joie de vivre qu'elle inspire elle-même. Au passage, l'éditeur Red Indians qui publie ramp s'est rapidement imposé comme un think-and-do-tank prisé proposant du marketing stratégique de contenus ainsi que le développement de nouveaux médias innovants. Là encore, du mouvement.

Avec ce livre, nous célébrons les 25 ans de ramp ! 25 années extraordinaires, mouvementées, pleines de vie ! Bon, d'accord : si on y regarde de plus près, cela ne fait que huit ans, en réalité. Mais au vu de la profusion d'idées, d'articles et de photographies, on aurait tôt fait de penser qu'il s'agit du fruit de 25 ans de travail. Au bas mot. Ajoutez à cela toutes les idées, les articles et les photos qui n'ont pas trouvé place dans le magazine, une publication de ce type ne pouvant décemment pas compter plus de 250 pages, quelqu'un qui compte vite arriverait facilement à 50 ans. Demandez un peu à nos contrôleurs de gestion, pour voir.

Les éloges et les récompenses ont été étonnamment nombreux pour ramp. À ce jour plus de 60 distinctions venues du monde entier. Mais le plus magnifique des compliments nous vient de nos lecteurs. Pour eux, ramp n'est pas seulement l'un des plus beaux magazines et l'un des meilleurs. C'est aussi, et surtout, l'un des plus audacieux, respirant le plus la joie de vivre.

Dans cet esprit, j'espère que vous prendrez beaucoup de plaisir à feuilleter ce livre qui réunit les meilleures photographies des premières années de ramp, le magazine de la culture automobile.

DIE KULTURALISIERUNG DER MOBILITÄT

Von Ulf Poschardt

Natürlich das Auto. Insbesondere in Deutschland. Wir haben es erfunden und wir lieben es, zumindest noch, wir putzen und pflegen es, wir sparen dafür, wir geben damit an, versauen die Umwelt: manchmal ökologisch, oft genug ästhetisch. Wir Deutschen haben ein denkbar enges, fast intimes Verhältnis zum Automobil, aber wenn es um die Überschreitung, den Irrsinn, den Hyperstyle, die gelebte Eleganz, das Verrückte geht, sind wir Deutschen ein wenig gehemmt. Als eine freiheitliche Leitwährung der Popkultur haben wir das Auto lange ignoriert, wohl auch, weil es hierzulande zu wichtig und zu ernst ist für das Gelingen des Ganzen: Die Arbeitsplätze, das BIP, die Zulieferer, die Autobahnen. Das ist auf den ersten Blick dann zu entscheidend, um wirklich lustig zu sein.

Auf der anderen Seite haben wir die Autobahn. Und, noch viel wichtiger, die freie Fahrt darauf. Wer in einem, sagen wir, luftgekühlten Elfer auf der Autobahn mit Tempo 250 nach Hause rutscht, hat es immer wieder mit heroischen Schnauzbärten in ihren Dienstwagenkombis aus Ingolstadt, Unter-türkheim oder München zu tun, die hinter einem herheizen, was der 530 d so hergibt. Sie fahren sicher und nur die Vollidioten unter ihnen drängeln, wo es nicht sein muss. Es gibt viele gute Autofahrer in diesem Land und zunehmend mehr schlechte. Junge Menschen, denen der Erwerb des Führerscheins egal ist, die ihn lustlos machen und am Ende mit Carsharing modern leben, aber eben auch ohne einen Hauch von Leidenschaft. Aggressive Umweltschützer nutzen die Autobahnen, aber auch die Tempo-30-Zonen, zu volkspädagogischen Riten. Sie fahren auf allen Spuren im Zweifel knapp unter der erlaubten Geschwindigkeit und auf der Autobahn gerne mit dem von ihnen politisch gewünschten Limit von 100 km/h. Aber diese Überzeugungstäter sind weniger problematisch, als die generelle, zum Teil breite Erschlaffung der Automanie. Die Emanzipations- und Freiheitserzählung des Autos lahmt. Seine kulturelle Bedeutung, seine soziale Relevanz findet nur zäh den Weg in die wichtigen Debatten um Mobilität Es dominiert das Bedenken.

Gleichzeitig wächst an den Graswurzeln unterschiedlichster Gesellschaftsplateaus herrlicher Wahnsinn mit Euphorie und Ekstase heran, der einen solchen Sog, eine solche Wucht erzeugt, dass die Sache mit dem Auto in Deutschland doch noch eine andere Wendung nehmen könnte. Das Wörtherseetreffen der VW- und Audi-Gemeinde hat dem sonst eher biederen Image dieser populären Marken einen rauen, wüsten, megakreativen Pusch verschafft. Da mögen es viele mit der Wahl der Felgen und der Farbe beim Autokauf bewenden lassen, eine neue, sehr junge, sehr unelitäre Autopopkultur erfindet sich hyperindividualistisch ihr Traumauto selbst. Anders als die Witzfiguren aus den Manta-Filmen ist die Lowrider- und Tunerszene, die zu ihrem Kirchentag nach Österreich pilgert, eher stilsicher und subtil, brachial mit kulturellen Referenzen, die von Computerspielen bis zu Jeff Koons' Art Car reichen. Die Autokonzerne haben die Bedeutung dieser freien Szenen nach anfänglichem Fremdeln erkannt. VW CEO Martin Winterkorn fühlt sich zwischen den Tätowierten und Basecaps sichtlich wohl. Sie sind ihm näher als so mancher Controller, der in den Autos vor allem Zahlen sieht.

Auf der Mille Miglia, eine Art automobilem Vorschein des Paradieses, sind die Deutschen nach den Italienern die treuesten und zahlreichsten Fans dieser Oldtimerrallye die im Leben eines jeden Petrolheads nach Hochzeit und Geburt der Kinder den absoluten Höhepunkt ausmacht. An diesen vier Tagen im Mai lässt sich erahnen, was alles an unglaublichen Preziosen in deutschen Garagen schlummert. Im sozialneidfreien Italien gibt es keine Aggression gegen millionenteure alte Ferrari, Jaguar, Healey, Bentley oder Bugatti. Im Gegenteil: Sie werden gefeiert. Und die Deutschen werden bewundert für ihre Autos und die Art, wie sie sie bewegen. Auf deutschen Oldtimerveranstaltungen regiert oft genug noch biedere Vereinsmeierei und jene verkrampfte Orginalitätsfixierung, deren Zwanghaftigkeit den Spaß am alten Blech zu überragen droht. Aber es entstehen auch neuere Formen der Zusammenkunft.

Wem es im Verein ein wenig zu bieder und spießig ist, der gründet selbst eine Gang. Der trifft sich mit Freunden zu Ausfahrten abseits aller Vereinsversuchungen.

Im Zentrum vieler Gangs stehen Werkstätten und Schrauber, die längst mehr geworden sind als Reparaturanstalten, sondern vielmehr Sinnzentren der Raserei. Das Mezgerwerk in der Nähe von Hamburg hat in Matthias Höing, einem punkrockig tätowierten Stilfetischisten so einen Megakommunikator, der einen porscheverrückten Proktologen mit Motoraver Helge Thomsen, benzinsüchtige Chefredakteure und Düsseldorf-R-Gruppen-Impressarios zusammenbringt. Im Küchenraum hinter der Werkstatt wird in den Pausen Tag für Tag ein lockerer Stammtisch eingerichtet, in dem die wichtigen Dinge des Lebens,aber vor allem Autogeschichten, verhandelt werden. Es sind Wissensbörsen der Extraklasse: Wer verkauft was, wer hat welchen Streckenrekord,

soll man alte Ferrari jetzt kaufen und was macht überhaupt Jeremy Clarkson?

Typen wie Höing, die mittlerweile eine dicke Pressemappe haben, glauben an das solide Handwerk als Basis, sein Meisterbrief hängt da irgendwo, aber er will, dass die von ihm restaurierten und getunten Elfer mehr sind als ansehnliche Wertanlage, er sieht in ihnen eine Verpflichtung zur artgerechten Haltung. Deswegen organisiert er mit Patrick Long die erste europäische „Luftgekühlt"-Veranstaltung. Einem Treffen von Porschesüchtigen, die ihr Auto als Glücksmaschine bewegen und pflegen. Wie unreligiös und erzliberal diese Begeisterung ist, verdeutlicht sein Companion Torsten Hanenkamp, der mit „il motore" eine Werkstatt betreibt, die sich vor allem auf ältere Lancia und Fiat konzentriert, allen voran auf den original Cinquecento, dessen Zweizylinder er locker 50 Pferdestärken herauskitzelt.

Es sind die Menschen, die aus Autos das machen, was daran so faszinierend sein kann. Die Fans, Freunde, Bastler, Schrauber und Macher sehen jeweils etwas ganz anderes in ihnen, als sich das die Konzerne einst gedacht haben. Die Selbstermächtigung des Konsumenten über die Gebrauchsanweisung ist ein bedeutender Schritt der Emanzipation im Kapitalismus.

Kommen wir zu den Medien. Auch da tut sich was. Eine Zeitschrift wie ramp hat dem Auto den Weg in eine Hochglanzverehrung beschert, wie sie so radikal und verschwenderisch bislang niemand vorgebracht hat. „Ein Heft wie ein Roadmovie", wie Michael Köckritz selbstbewusst schreibt, postuliert und sich selbst daran messen lassen will. Aber auch Blogs verändern das Antlitz des Motorjournalismus. Es gibt einen neuen Autorensound, der gänzlich ohne die Ernüchterungsfilter der Professionalisierung jene buntscheckige PS-WELT beschreibt, so wie dies der Wörtherseematador aus Berlin-Köpenick, André Weber, als Kopf der Sourkrauts tut. Wer wissen will, wie Lowrider ticken, wird bei ihm fündig, wer sich so anziehen will wie sie, auch. Die sozialen Netzwerke verdichten die Kulturalisierung der Mobilität wohl im selben Speed, mit dem die Möglichkeiten der freien Fahrt schwinden.

Und dennoch ist es eine gute Zeit für Autos und auch für radikal-subjektivistischen, quasi-literarischen Motorjournalismus. Wir stehen am Anfang. Sind gerade am Ford T vorbei zum ersten Bugatti evolutioniert. Gerade weil vielen zeitgenössischen Autos jede Aura fehlt, selbst da, wo sie mit Namen, Silhouette oder Werbung mit dem historischen Erbe spielen, kann die Emotionalisierung von vernünftigen wie unvernünftigen Fahrzeugen den Genuss von Beschleunigung und Bewegung verfeinern.

Autos sind auch Aktien geworden. Einige Marken und ihre edelsten Produkte hängen in der Wertentwicklung jede andere Anlageform ab. Das tut nicht nur gut, schärft aber den Blick für die Kostbarkeiten aus vergangenen Epochen. Als Gegenentwicklung zum ökologisch unverantwortlichen Ex-und-Hopp-Konsum ist die Pflege von Gebrauchtem eine Säule nachhaltigen Wirtschaftens und Konsumierens. Nie hat sich die Welt schneller und entschiedener verändert als im Augenblick. Das Neue rast. Die Digitalisierung löst alles auf. Autos, besonders die alten, sind wie Dinosaurier. Aber sie werden nicht aussterben, weil wir gelernt haben, das Besondere zu verehren, was nicht vergeht, sondern bleiben kann und weiter vererbt wird. Altes zu restaurieren und zu retten, verschwendet Arbeitszeit, aber weniger Ressourcen verglichen mit einem Neukauf. Und neue Autos müssen an der Re-Auratisierung ihrer Funktionalität arbeiten.

Ein Teil der Digitalisierung wird die Feier des Analogen sein. Weniger als Nostalgie, denn als Modernitätsordnung, um das Gefühl für das Große und Ganze nicht zu verlieren. Das Taktile, die Gerüche und Klänge eines Ferrari Achtzylinders, der einem in den Nacken faucht, oder eines luftgekühlten Elfers sind ein Sinnenspektakel, das jenen sterblichen, nicht digitalisierbaren Teil des Menschen lebendig und gesund hält.

Evolutionsbiologisch gehören wir möglicherweise schon zum alten Eisen, im richtigen Blech sind wir kräftig genug für den Kampf gegen Avatare und Cyborgs.

Und wer will schon in Autos sitzen, die ein Algorithmus lenkt?

Ulf Poschardt ist stellvertretender Chefredakteur der WELT-Gruppe und Autor von mehreren Büchern, unter anderem „Über Sportwagen" (Berlin, 2002) und „911" (Stuttgart, 2013).

THE CIVILIZATION OF TRANSPORTATION

By Ulf Poschardt

———— You bet it's about cars. Especially among us Germans. We invented 'em, still love 'em, and always will (or, till the day the chickens come home to roost, some might say.) We religiously clean and maintain 'em, we save money for 'em, we show off in 'em, and we do our humble part in messing up the environment in 'em. Like most people, we're all for going Green, just not at the expense of riding in style. It's remarkable the way we as Germans tend to feel almost intimately close to our cars, while any other kind of excess, irrationality, hyper style, unbridled elegance, or other eccentricity has a way of making us feel a tad uneasy. Even so, it took us Germans forever to acknowledge the growing significance of cars as pop culture icons of freedom and independence. Chalk it up to the already fundamental significance of cars to the German economy in terms of jobs, GDP, supply industry, and, of course, the country's autobahns. Given the significance of all of these factors, pop culture simply took a backseat.

Speaking of autobahns, here's a little insight into the world's only highway *sans* speed limit. If you ever find yourself on the autobahn on your way back from work, comfortably cruising along at 155 mph in, let's say, an air-cooled 911 and looking in the rearview mirror, don't be surprised to see some mustache-sporting delivery driver seemingly hell-bent on tailgating you, his 530 d cargo van begging for mercy. Overall, though, motorists on the autobahn drive safely, and it's only the morons who never run out of excuses for tailgating. Good drivers exist aplenty in Germany, along with an increasing number of bad ones. The latter primarily involves young people failing to grasp the responsibility that comes with a driver's license, having somehow passed without ever truly understanding or appreciating it, content with driving as part of the modern car sharing herd without developing any appreciation for the act itself. Also, don't be surprised to see aggressive environmentalists using our autobahns, along with our 30-km speed limit zones, in their attempts to draw public attention to their causes. These folks like to play it safe by doggedly driving just slightly below the posted speed limit; no matter what lane they're in, including any fast lane. Traveling on the autobahn, they abide by their own self-imposed speed limit of 62 mph, which they favor to become the law of the land, again, including the fast lane. However, any problem that may be posed by these folks pales in comparison to the prevailing slackness of auto mania, a slackness that remains widespread in some areas. Think of it as an automotive struggle for freedom from convention that lacks momentum. Any cultural significance or social relevance this freedom struggle may have is hard to connect with any of the major debates surrounding mobility. The cloud of doubt remains.

At the same time at the grass roots of every level of society, we're seeing the beginning of a magnificent mix of insanity, euphoria, and ecstasy creating its own sort of undertow powerful enough it might just shift the attitude towards cars in Germany in a new direction after all. For example, the Wörthersee Tour of the VW and Audi community in Austria has considerably revamped the otherwise square image of these two popular brands by adding a raw, wild, and mega creative edge to it. While many of us looking for a set of wheels will go the usual route of buying a car with a handful of rims and colors to choose from, there's a new, very young and anti-elitist automotive pop culture on the rise ready to build their own dream cars in their own hyper-individual way. Unlike the goofballs you see in the Opel Manta road flicks, the enthusiasts making the low rider and tuner pilgrimage to Austria are confident in style and subtle about it, and they're raw when it comes to cultural references, running the gamut from computer games to Jeff Koons' BMW Art Car. Although skeptical at first, automakers have come to understand the relevance of these independent enthusiast communities. Just look at how VW CEO Martin Winterkorn feels right at home amongst all those enthusiasts with their tattoos and baseball caps. In fact, he seems to bond more easily with them than with some of his controllers, whose interest in cars is best summed up in numbers and figures.

Venturing farther south to Italy, you have Mille Miglia, that automotive preview of paradise. Not counting countless scores of Italian fans, Germans constitute the highest and most loyal number of fans of this famous motorsport rally for classic and vintage cars, regarded by all classic petrol heads to be the zenith of their lives, preceded in significance only by their weddings and the birth of their kids. In the course of four days in May, this unique rally gives an idea of the amazing vintage treasures likely tucked away in garages throughout Germany. Untroubled by class envy, Italy is the kind of place where Ferraris, Jaguars, Austin-Healeys, Bentleys, or Bugattis worth millions are known to be safe from any acts of aggression. If anything, cars like that are the subjects of celebration in Italy. Meanwhile, Germans are primarily admired for their cars as well as for their approach to transportation in general. That said, the problem with classic car events in Germany is that many of them are subject to the same old club politics and high-strung fixation on originality that keep a stranglehold on the fun normally associated with vintage rides. The good news is the growing number of new and more flexible clubs in Germany.

Of course, if you feel you're stuck in a club that's too stodgy and rigid, you can always start your own club. That way, you're free to organize excursions on your own with your buddies.

Many car clubs revolve around repair and workshops that long ago went from being mere shops to becoming clubhouses. Case in point: Mezgerwerk, located near Hamburg in Germany. Its owner is a dude named Matthias Höing, punk rock ink aficionado and mega communicator, known for the impressive feat of gathering a Porsche-loving proctologist, a local moto raver going by the name of Helge Thomsen, a bunch of fuel burning chief editors, and some Düsseldorf R-Group impresarios under one roof. Right behind his shop, there's a kitchen area, where Matthias and his staff like to spend their lunch break everyday by casually sitting together at the same table specifically

designated for that purpose, talking about the important aspects of life, well, mainly, rides. It's a knowledge exchange in a class of its own: Who's looking to sell what, who has which track record, is this the right time to buy up old Ferraris, and, by the way, what's Jeremy Clarkson up to these days?

Guys like Matthias Höing, who has gained some impressive media exposure, believe in solid craftsmanship as the basis for success. Having his Master's Certificate 'around there somewhere,' Matthias specializes in the restoration and tuning of Porsche 911s. His work philosophy, however, goes beyond the mere process of producing highly visible value assets. To him, it's more of a personal commitment to the proper care and well-being of these cars. In the same spirit, he recently set out with a partner, Patrick Long, to organize the first official 'Air Cooled' gathering in Europe. It's a meeting for full-blown practicing Porsche-holics, who aren't shy about experiencing and maintaining their daily dose of Porsche. Evincing the same kind of unbridled and unabashedly free-spirited enthusiasm is a buddy of his, Torsten Hanenkamp, who runs his own shop called 'il motore,' where he mainly works on vintage Lancias and Fiats, especially original Fiat Cinquecentos. Taking their tiny old two-cylinder engines, he can easily boost their engine output to 50 horsepower.

These are the people among us, who transform cars into anything that makes them as truly fascinating as can be. Whether they're fans, enthusiasts, tinkerers, handymen, or professionals, they all form their own individual ideas about cars, each one being radically different from whatever the car manufacturers originally had in mind. This form of self-empowerment by consumers under the guidance of instruction manuals presents a decisive step towards autonomy within a capitalist framework.

Then there's the media, which, perhaps not surprisingly, plays an active part within the overall context. Take a publication such as ramp, which has elevated cars with the kind

of high gloss reverence so radical and lavish it continues to outshine every other publication currently out there. "A magazine akin to a road movie," writes Michael Köckritz, revealing no small measure of pride in positing its use as a litmus test for himself. Of course, blogs are doing their part in changing the face of motor journalism, including the latest trend amongst authors to fully dispense with all the usual chill factors applied by industry professionals to produce blog contents describing the multifarious domain of horsepower in much the same way as a certain Wörthersee matador from Berlin-Köpenick by the name of André Weber does as head of a Berlin-based reseller shop and social network called 'Sourkrauts.' If you want to know what makes a low rider tick, André has the answer; if you want to dress like a low rider, André has it all. It seems as if social networks are solidifying the civilization of transportation at the same rate at which the abundance of open speed limits is diminishing.

Yet, the immediate outlook appears bright for cars as well as for motor journalism of the radically subjective and quasi-literary kind. And we're still at the beginning stage. Looks like we just fast-forwarded evolution by skipping ahead from the Ford Model T to the first Bugatti. Many of today's cars are characterized by an utter lack of any kind of aura, to the point where some of them stand to lose historical legacies associated with them. Adding some personal emotional value to them, whether they're sensible or non-sensible, goes a long way in making these cars feel special in a way they never could have before.

Some cars have even taken the place of securities. Indeed, some brands and their finest products outpace any other form of investment in terms of value development. The positive value development of these cars notwithstanding, it still doesn't affect our appreciation of the treasures of past epochs. As a counter development to ecologically irresponsible throwaway consumerism, the act of saving used items for further use is a pillar of sustainable management and consumption.

Our world today is changing in unprecedented ways at an unprecedented rate. Anything new seems to happen in a flash. Everything is digitized these days. Cars, especially older rides, come to be regarded as dinosaurs faster than they ever did before. The reason why they're not going to go extinct anytime soon is because we've learned to appreciate anything that's strong enough, and therefore special enough, not to die away, but to survive and to further pass on its genes. While the act of saving and restoring old rides may seem like a waste of time and effort, but it also translates into wasting fewer resources compared to a new purchase. Besides, most of those new rides continue to suffer from aforesaid lack of aura.

The irony of it all is that the age of digitization will ultimately be remembered in part for the comeback of analog. It won't likely be driven by a sense of nostalgia as much as by the need to maintain some sort of balance within the overall picture of existing state-of-the-art technology. The tactile perceptions, smells, and sounds of a Ferrari eight-cylinder breathing down one's neck, like those of an air-cooled Porsche 911, all culminate in a feast of the senses that help keep the mortal, non-digitized part in all of us alive and well.

Whether we're outdated in both evolutionary and biological terms or not, given the proper ride, we'll always have enough fight left in us to take on any Avatars and cyborgs out there.

Besides, who wants to ride in car piloted by algorithms?

———

Ulf Poschardt is the Editor-in-Chief of WELT-Gruppe and the author of several books, including "Über Sportwagen" (Berlin, 2002) and "911" (Stuttgart, 2013), both of which are about sports cars.

ÉRIGER LA MOBILITÉ EN CULTURE

Ulf Poschardt

———— L'automobile, bien sûr. Particulièrement en Allemagne. Nous l'avons inventée et nous l'aimons - du moins jusqu'à nouvel ordre - nous la nettoyons et l'entretenons, nous économisons pour elle, nous frimons avec elle, nous polluons l'environnement : parfois sur le plan écologique, trop souvent sur le plan esthétique. Les Allemands entretiennent un rapport très étroit, voire intime à l'automobile. Mais lorsqu'il s'agit de transgression, de folie, d'hyper-style, d'élégance vécue, d'excentricité, il faut bien dire que nous sommes un peu coincés. Longtemps, nous avons ignoré l'automobile comme valeur synonyme de liberté dans la culture pop, sans doute aussi parce que chez nous, c'est un sujet trop important, trop sérieux pour la réussite collective, à savoir l'emploi, le PIB, les sous-traitants, les autoroutes. A priori, un domaine trop vital pour qu'on puisse vraiment s'en amuser.

D'un autre côté, nous avons les autoroutes. Et, plus important encore, des autoroutes sans limitations de vitesse. Quiconque rentre chez lui, le soir, disons en Porsche 911 à moteur refroidi par air, à 250 km/h sur l'autoroute, aura toujours affaire à des petits bourgeois moustachus qui tentent de le suivre. Se prenant pour des héros à bord de leurs breaks de fonction d'Ingolstadt, d'Untertürkheim ou de Munich, ils font cracher à votre poursuite tout ce qu'un moteur de 530 d peut donner. Ils roulent en bons pères de famille. Et seuls les abrutis complets parmi eux vous collent, alors que c'est inutile. Ce pays compte beaucoup de bons conducteurs. Et aussi de plus en plus de mauvais. Des jeunes qui n'ont que faire de leur permis et le passent avec indifférence. Au final, ils vivent dans la modernité, en pratiquant l'autopartage, mais aussi sans un brin de passion. Il y a les écologistes militants qui sur les autoroutes, mais aussi dans les zones limitées à 30 km/h célèbrent des rites visant à éduquer le tout-venant. Ils roulent sur toutes les voies, dans le doute juste en dessous de la vitesse limite autorisée et, sur autoroute, s'astreignent

volontiers au respect d'une limite de 100 km/h, qu'ils aimeraient voir imposer au niveau politique. Cependant, ces militants posent moins problème que le tiédissement généralisé, parfois profond, de la passion pour l'automobile. Le récit d'émancipation et de liberté que faisait l'automobile s'étiole. Sa signification culturelle et sa pertinence sociale ont du mal à s'imposer dans les débats sur la mobilité, pourtant d'une importance capitale, où les réserves règnent en maître.

Parallèlement, une réjouissante folie qui prend naissance dans l'euphorie et l'extase au sein des catégories sociales les plus diverses provoque de tels remous, de tels chambardements que les relations à l'automobile en Allemagne pourraient bien, au final, prendre un tour très différent. La rencontre des communautés VW et Audi à Wörthersee, en Autriche, a dopé l'image habituellement plutôt terne de ces marques populaires, qui se sont dotées d'une aura décalée, nouvelle, ultra-créative. Si nombre d'acheteurs se contentent de choisir les jantes et la couleur de leur voiture, une nouvelle culture pop très jeune, très antiélitiste invente elle-même l'automobile de ses rêves, de manière hyper-individualiste. Aux antipodes des personnages caricaturaux présents dans les films Manta, le milieu des autos basses de caisse ou préparées, qui pour son grand rassemblement part en pèlerinage en Autriche, est plutôt stylé et subtil, regorgeant de références culturelles allant des jeux sur ordinateur à l'Art Car de Jeff Koons. Initialement méfiants, les constructeurs automobiles ont désormais reconnu l'importance de ces milieux indépendants. Manifestement, Martin Winterkorn, CEO de VW, est parfaitement à l'aise parmi les tatoués et les porteurs de casquettes de baseball. Il se sent plus proche d'eux que d'un comptable pour qui une automobile, ce sont avant tout des chiffres.

À la Mille Miglia, un genre d'avant-goût du paradis en matière d'automobile, les Allemands comptent après les Italiens parmi les

aficionados les plus fidèles et les plus nombreux de ce rallye de véhicules anciens, qui constitue dans la vie d'un amoureux de l'automobile un temps fort exceptionnel, juste après son mariage et la naissance de ses enfants. Lors de ces quatre jours de mai, on imagine aisément tous les incroyables joyaux qui sommeillent dans les garages allemands. En Italie, où la jalousie sociale n'est pas de mise, il n'y a pas d'agressions contre les Ferrari, Jaguar, Healey, Bentley ou Bugatti anciennes, qui valent des millions. Au contraire : on les célèbre. Et on admire les Allemands pour leurs autos et la manière dont ils les mènent. Dans les rassemblements de voitures anciennes, en Allemagne, règne encore souvent une atmosphère bien terne d'association, avec une fixation obsessionnelle sur l'originalité, dont le caractère contraint pourrait bien nuire au plaisir qu'apportent ces merveilles d'hier. Cependant, de nouveaux types de rassemblement se font jour.

Quiconque trouve son association trop terne et étriquée fonde lui-même sa bande, qui permet de se retrouver entre amis pour des sorties, loin de tout esprit de « club ».

Au cœur de nombreuses bandes, on trouve des ateliers et des mécaniciens de génie, devenus bien plus que des lieux de réparation, des sites porteurs de sens voués à la grande vitesse. L'atelier Mezger, dans la banlieue de Hambourg, a trouvé en Matthias Höing, passionné ultra-stylé couvert de tatouages punk rock, un communiquant d'exception, qui parvient à réunir un proctologue fondu de Porsche, le fondateur du magazine Motoraver Helge Thomsen, des rédacteurs en chef qui carburent à l'essence et des impresarios de la R-Gruppe de Düsseldorf. Dans le coin cuisine, derrière l'atelier, on installe tous les jours, lors des pauses, une table autour de laquelle les habitués se réunissent à la bonne franquette pour débattre des choses importantes de la vie, mais surtout de voitures. Ces réunions sont des lieux d'échange

de savoir uniques : qui vend quoi, qui détient tel record sur piste, est-ce le moment d'acheter des Ferrari anciennes ou que devient l'animateur Jeremy Clarkson ?

Des gars comme Höing, qui possèdent un épais dossier de presse, considèrent que la base, c'est un solide savoir-faire. D'ailleurs, son diplôme de mécanicien est affiché quelque part. Il lui tient à cœur que les 911 qu'il restaure et prépare soient davantage qu'un beau placement, considérant qu'elles portent en elles l'obligation de les entretenir avec les égards dus à leur rang. Aussi organise-t-il avec Patrick Long la première rencontre européenne des « moteurs refroidis par air ». Une rencontre entre accros aux Porsche, qui font rouler et entretiennent leurs automobiles comme des machines du bonheur. Loin d'être religieuse, cette ferveur est très libérale, ce qu'illustre la présence de son complice Torsten Hanenkamp, qui gère avec « il motore » un atelier spécialisé essentiellement dans les Lancia et les Fiat anciennes, plus particulièrement dans la Cinquecento originelle, une bicylindre dont il tire allègrement 50 chevaux.

Ce sont les êtres humains qui rendent les automobiles aussi fascinantes. Fans, amis, bricoleurs, mécaniciens de génie et créateurs : tous voient en elles des choses très différentes de ce que les constructeurs automobiles avaient imaginé à l'origine. En se libérant des modes d'emploi, le consommateur accomplit un pas important vers l'émancipation dans le monde capitaliste.

Mais venons-en aux médias. Là aussi, les choses bougent. Un magazine tel que ramp a permis à l'automobile d'accéder à une adoration sur papier glacé, inédite sous une forme aussi radicale et dispendieuse. « Un magazine semblable à un road-movie », a écrit fièrement Michael Köckritz, érigeant ce constat en postulat à l'aune duquel il demande à être jugé. Les blogs, eux aussi, modifient la physionomie du journalisme

automobile. Parmi les auteurs, un ton nouveau s'est fait jour, qui décrit, libéré des filtres de la désillusion associée à la professionnalisation, ce monde bigarré des chevaux fiscaux, comme le fait André Weber, de Berlin-Köpenick et matador de Wörthersee, en sa qualité de directeur de Sourkrauts. Quiconque veut savoir ce qui se passe dans la tête des lowriders ou souhaite s'habiller comme eux trouve en lui l'interlocuteur idoine. Les réseaux sociaux contribuent à ériger la mobilité en culture, au même rythme forcené que disparaissent les possibilités de rouler librement.

Malgré tout, l'époque est favorable pour l'automobile – et aussi pour un journalisme auto-moto radicalement subjectiviste, quasi-littéraire. Nous n'en sommes qu'au début. Nous venons de passer la Ford T pour évoluer vers la première Bugatti. Précisément parce qu'une quelconque aura fait défaut à de nombreuses autos contemporaines, même lorsqu'elles jouent sur leur patrimoine historique avec leurs noms, leurs lignes ou leurs publicités, l'émotionnalisation de ces véhicules, qu'ils soient raisonnables ou non, peut renforcer le plaisir pris lors de l'accélération et du mouvement.

Les autos sont aussi devenues de véritables actions. Certaines marques et leurs produits les plus hauts de gamme surpassent de loin, en termes de plus-value, les marges réalisables avec tout autre investissement. Si cela n'a pas que des bons côtés, cela permet d'aiguiser le regard porté sur les joyaux d'époques révolues. Évolution aux antipodes du mode de consommation du tout-jetable, écologiquement irresponsable, l'entretien des produits d'occasion constitue le pilier d'une gestion et d'une consommation durables. Jamais le monde n'a évolué aussi rapidement et aussi fondamentalement qu'aujourd'hui. La nouveauté arrive à la vitesse de l'éclair. La numérisation efface tout. Les automobiles, notamment les anciennes, sont comme des dinosaures. Cependant, elles ne vont pas dis-

paraître, car nous avons appris à vénérer l'exceptionnel qui ne s'efface pas, mais qui au contraire perdure pour être transmis. Restaurer et sauver les biens anciens exige de la main-d'œuvre, mais moins de ressources qu'un nouvel achat. Et les automobiles récentes doivent s'efforcer de conférer une aura nouvelle à leur fonctionnalité.

Une partie du numérique servira à célébrer l'analogique, moins par nostalgie que pour mettre de l'ordre dans la modernité, afin de conserver la vision d'ensemble. Le plaisir tactile, les odeurs et les sonorités des huit cylindres d'une Ferrari qui feulent dans la nuque du conducteur, ou d'un moteur de 911 refroidi par air, sont un spectacle pour les sens, qui maintient en vie et forme la facette mortelle, non numérisable, de l'être humain.

En termes d'évolution des espèces, peut-être sommes-nous déjà dépassés. Mais au volant de l'automobile adéquate, nous sommes largement en mesure de lutter contre les avatars et autres cyborgs.

D'ailleurs, qui aurait envie de prendre place dans des voitures pilotées par un algorithme ?

━━━━━━━━━

Ulf Poschardt est rédacteur en chef adjoint du groupe WELT et auteur de plusieurs ouvrages, notamment « Über Sportwagen » (Berlin, 2002) et « 911 » (Stuttgart, 2013).

1

AUTO

AUTO.

Autos wollen wir berühren, einsteigen, starten, fahren, unsere Lust ausleben, erleben. So intensiv und so subjektiv wie möglich.

CAR.

Cars: Here's something you can touch, get into, rev up, ride, put your passion into, and feel as intensively and subjectively as you can.

AUTO.

Les automobiles. Nous voulons les toucher, les investir, les faire démarrer, les piloter, vivre à fond nos envies. Avec le plus d'intensité et de subjectivité possible.

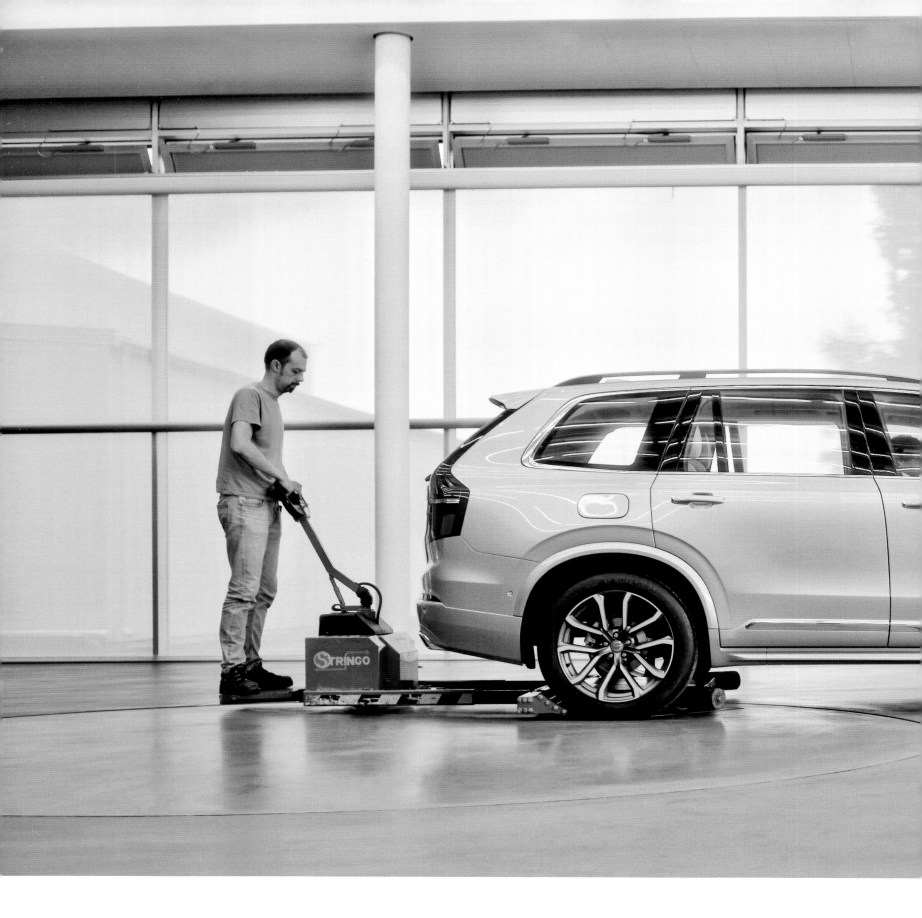

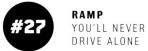

#27

RAMP
YOU'LL NEVER
DRIVE ALONE

STORY Made in Sweden / **PHOTOGRAPHER** Benjamin Pichelmann

CAR Volvo XC90

AH!-RANGIERT — Exklusiver Termin im Hochsicherheitstrakt von Volvo Design: Der neue XC90 mit seinem Designer Thomas Ingenlath. Und wir. Als weltweit erstes Medienteam. Für das Fotoshooting werden zwei Rolling Chassis gestellt. Ein Mitarbeiter rangiert die Autos für uns - und Fotograf Benjamin Pichelmann hält schon mal drauf.

AWE-RRANGED — We got exclusive access to Volvo Design's maximum safety wing. Specifically, the new XC90 with its designer Thomas Ingenlath. And us testing it—the first media team worldwide to do so. They even provided two rolling chassis for our photo shoots. One of their representatives arranged the vehicles for us—our photographer Benjamin Pichelmann couldn't wait.

L'OH ! TOMOBILE — Rendez-vous dans les locaux hautement sécurisés de Volvo Design avec la nouvelle XC90 et son concepteur Thomas Ingenlath. Et nous, la première équipe média présente sur place, en exclusivité mondiale. Pour le shooting : deux châssis roulants qu'un employé met en place - aussitôt, le photographe Benjamin Pichelmann immortalise la scène.

EINER FÜR ALLES — Die Möglichkeiten der modernen Fotografie und Bildbearbeitung sind ja mittlerweile beeindruckend. Da wird aus einem einzigen smart beim Shooting plötzlich eine ganz Flotte - Carsharing kreativ umgesetzt. Hunderte smart, überall. Und das Beste: Attraktive Frauen lassen sich genauso einfach multiplizieren.

ONE FOR ALL — It's amazing what you can do with modern photography and image processing nowadays. For example, using one Smart ForTwo to produce an entire fleet of 'em in a single photo shoot—now that's creative car sharing right there! We're talking hundreds of Smart cars, as far as the eye can see. And the best part: It's just as easy to produce hotties.

DUPLICATION À L'INFINI — La photographie moderne et les retouches numériques nous offrent désormais des possibilités étonnantes. Une unique smart présente lors du shooting donne soudain vie à toute une flotte - mise en œuvre artistique de l'auto-partage. Partout, des smart, par centaines. La meilleure, c'est que dupliquer des femmes sublimes est tout aussi simple.

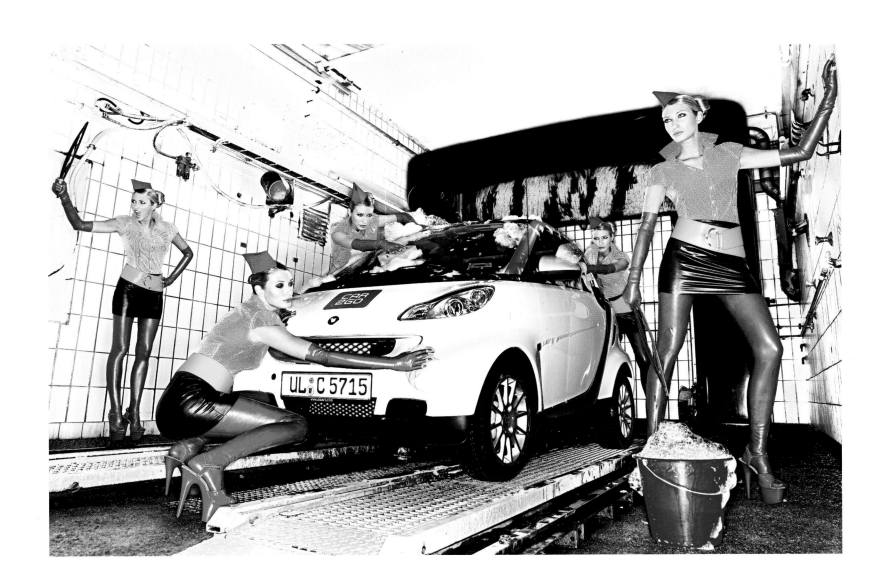

#05

RAMP
UPON THE
LADIES!

STORY smartsharing / **PHOTOGRAPHER** Bernd Kammerer

CAR smart fortwo

17

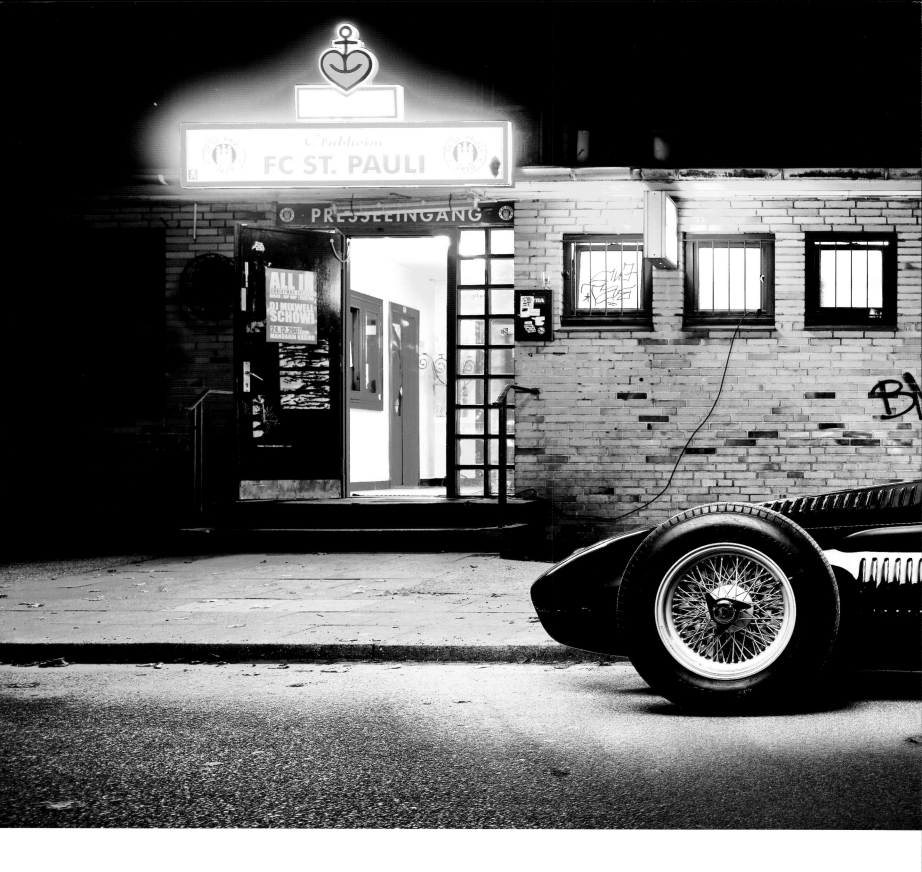

 RAMP
IN DER HITZE
DER NACHT

STORY *Prinz der Nacht* / **PHOTOGRAPHER** Bernd Kammerer

CAR Maserati 250F

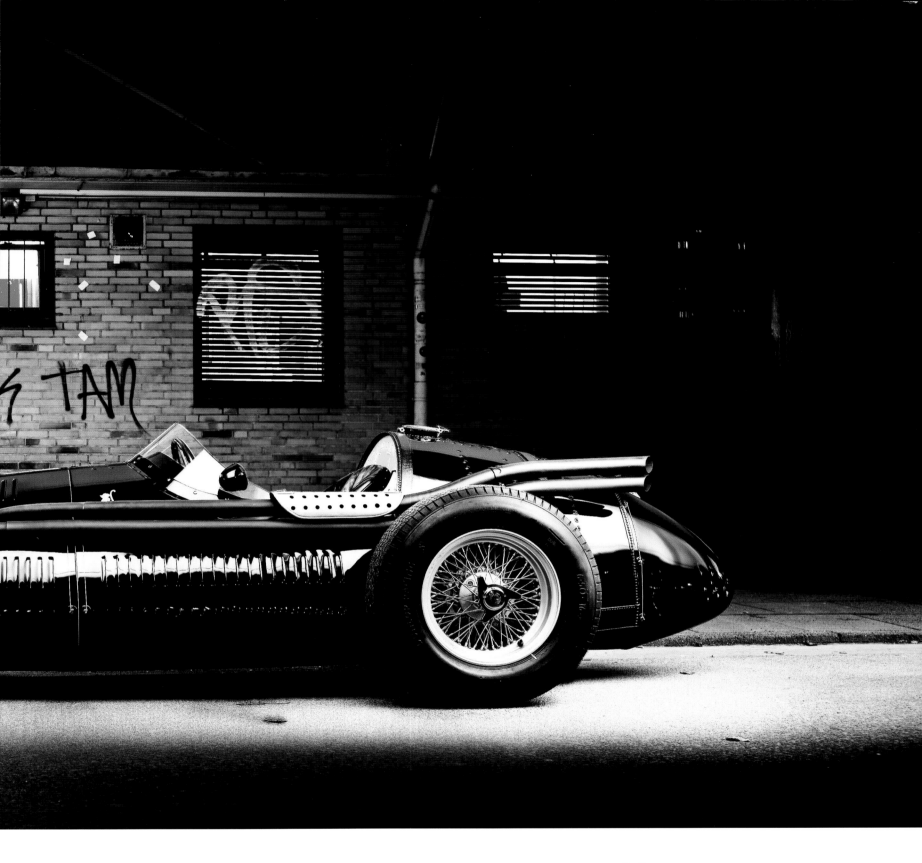

KONTRASTOBJEKTE — Zwei zeitgenössische Objekte, die unterschiedlicher nicht sein könnten. Hier das alte Klubhaus des FC St. Pauli kurz vor dem Abriss, davor ein Maserati 250F. Genauer gesagt, der Wagen von Birabongse Bhanutej Bhanubandh, kurz: Prinz Bira. Am Ende fotografiert Bernd Kammerer eines der bisher erfolgreichsten ramp-Cover.

OBJECTS OF CONTRAST — In Hamburg, Germany, we have two contemporary objects that couldn't possibly contrast more sharply. One of them is the old clubhouse of the local soccer team FC St. Pauli, now awaiting demolition. The other one is the Maserati 250F parked in front of it, owned by none other than Birabongse Bhanutej Bhanubandh, better known as Prince Bira of Siam (now Thailand). Captured by photographer Bernd Kammerer, this motif remains one of the most successful ramp covers to date.

ÉLÉMENTS CONTRAIRES — Deux sujets contemporains, aussi éloignés que possible l'un de l'autre : le clubhouse du FC St. Pauli, en passe d'être démoli, et une Maserati 250F ; plus précisément, la Maserati de Birabongse Bhanutej Bhanubandh, dit prince Bira. Bernd Kammerer a ainsi réalisé l'une des couvertures les plus célèbres de ramp.

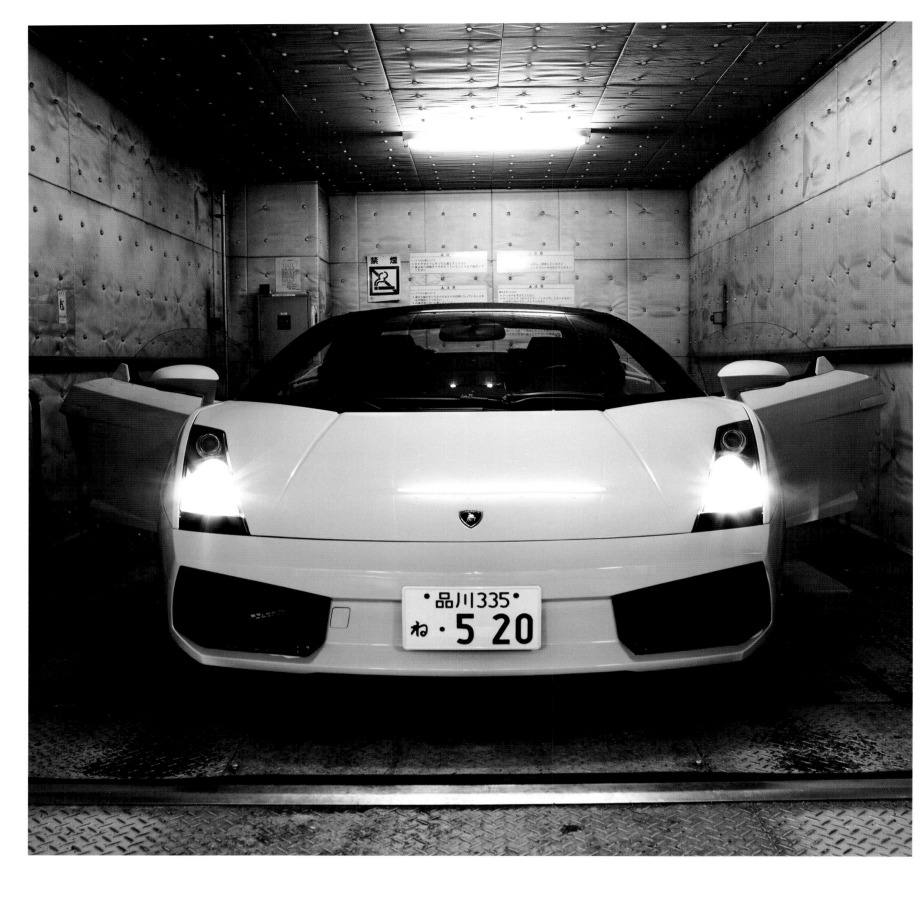

#02 **RAMP**
 IN DER HITZE
 DER NACHT

STORY Tokyo Night Show / **PHOTOGRAPHER** Frank Kayser

CAR Lamborghini Gallardo

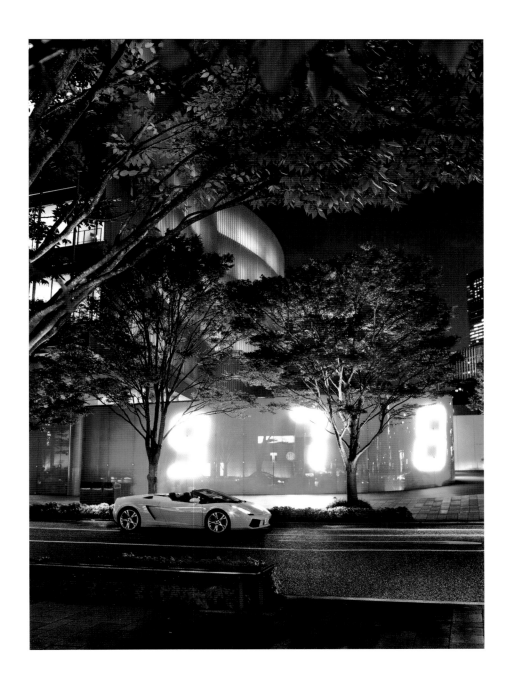

ONE NIGHT IN TOKYO — Wie verknüpft man die Agilität und das pulsierende Leben der Stadt Tokio mit der böse-intensiven Aura eines Lamborghini Gallardo? Das war die Herausforderung. Die Lösung lieferte Frank Kayser in beeindruckender HDR-Fotografie.

ONE NIGHT IN TOKYO — How do you reconcile the agility and pulsating life of metropolitan Tokyo with the raw, unadulterated badness of the Lamborghini Gallardo? That was the challenge for photographer Frank Kayser. Taking it head-on, he used HDR photography with some truly impressive results.

ONE NIGHT IN TOKYO — Comment concilier la vitalité et l'animation trépidante de Tokyo avec l'aura intense et sombre d'une Lamborghini Gallardo ? Frank Kayser a relevé le défi, avec d'impressionnantes photographies en HDR.

IST DAS KUNST ODER FÄHRT DER WEG? — Ein so reduziertes und kompromissloses Auto wie ein Porsche 911 GT3 mit 415 PS bei gerade mal rund 1 400 Kilogramm lässt viel Raum für kreative Ansätze. Es geht um die Kunst der Reduktion. Weniger ist leichter. Und so haben wir jegliche Vorgaben für den Fotografen einfach weggelassen.

JUST A WORK OF ART OR DOES IT ACTUALLY RUN? — A ride as uncompromising and vastly reduced to the minimal as the Porsche 911 GT3, boasting 415 hp while weighing in at barely 1,400 kilograms or just a little over 3,000 pounds, leaves plenty of room for creativity. We're talking about the art of minimizing, as in 'less is lighter.' Our way of practicing it was to throw out any instructions for our photographers to give them free reign instead.

C'EST DE L'ART OU ELLE EST EN TRAIN DE PARTIR ? — Une voiture aussi épurée que la Porsche 911 GT3 et ses 415 chevaux pour tout juste 1 400 kilos invite à la créativité. Tout réside dans l'art de réduire. Réduire pour alléger. Nous nous sommes donc abstenus de toute consigne au photographe.

RAMP
LET'S GET OUT
OF HERE!

STORY Abfalltütenplastikhimmelblau 7.0

PHOTOGRAPHERS outtofocus – David Breun & Martin Grega

CAR Porsche GT3 (997)

A PASSION FOR CARS ——— **AUTO**

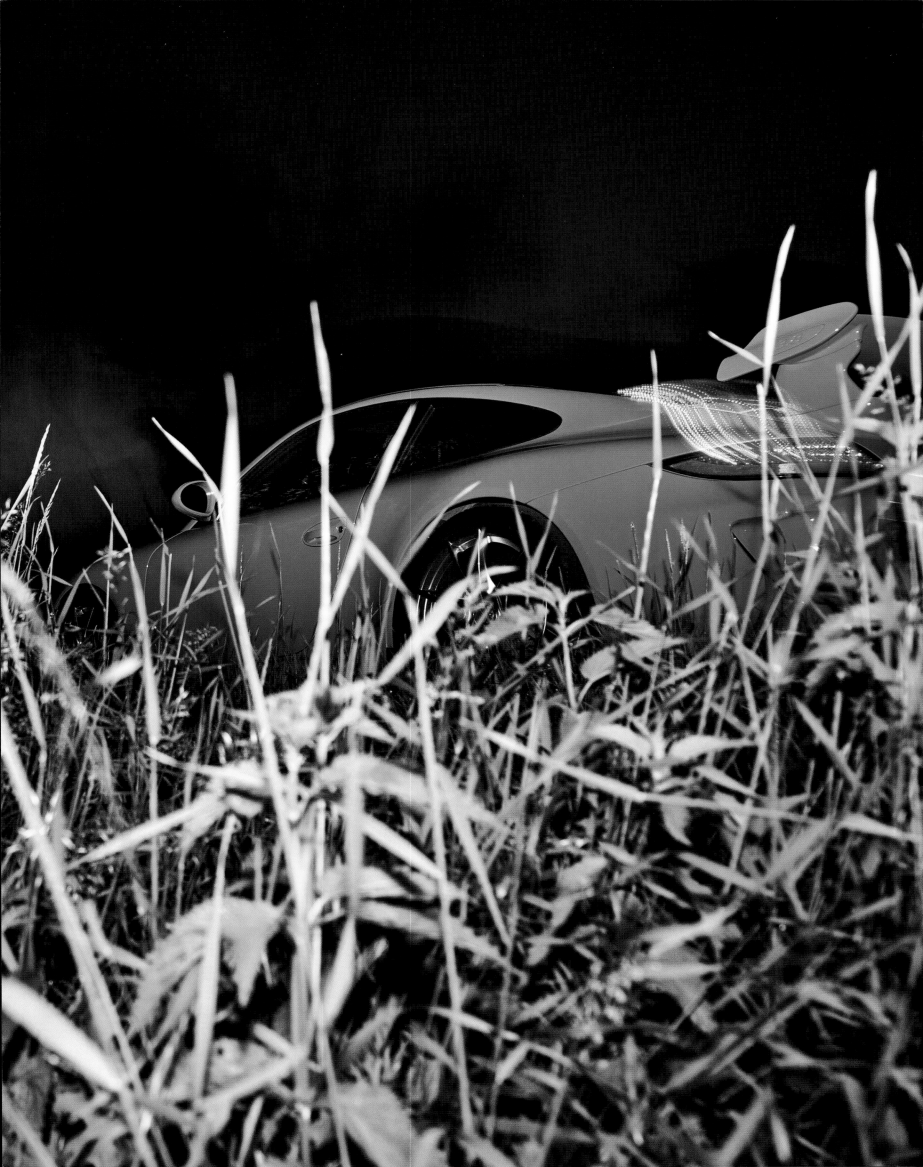

 RAMP
JETZT NEHMEN
WIR DIE SACHE
MAL SELBST IN DIE
HAND (LET'S GO!)

STORY Kurt im Gurt / **PHOTOGRAPHER** Frank Kayser

CAR Ferrari F599 GTB Fiorano

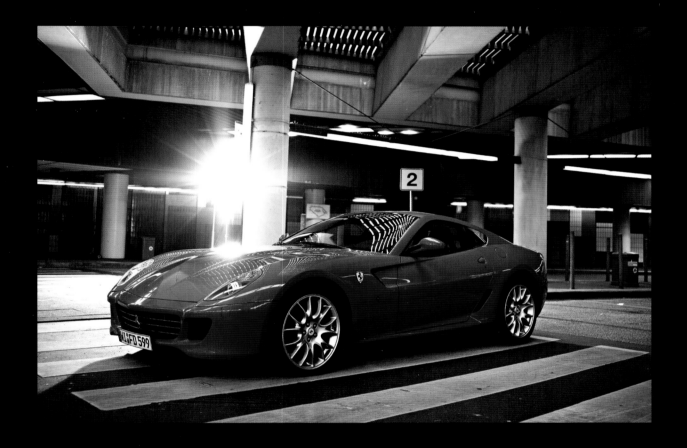

SCHEINFREI — Bleifuß, Frauenheld, Lebemann und ramp-Kolumnist der ersten Stunde: Kurt Molzer - ohne Führerschein. Ideale Vorrausetzungen, um ihm einen Ferrari vor die Tür zu stellen. Er fand's nicht lustig. Aber wir.

NO ID — Meet Kurt Molzer—ramp columnist, lead foot, lady-killer, playboy par excellence— and currently short of a driver's license. What better time to park that Ferrari in front of his door. He didn't think it was funny. We sure did.

SANS PERMIS — Fou du volant, tombeur, noceur et chroniqueur de la première heure chez ramp, Kurt Molzer n'a plus de permis de conduire. Le contexte idéal pour garer une Ferrari devant sa porte. Il n'a pas apprécié la plaisanterie. Nous si.

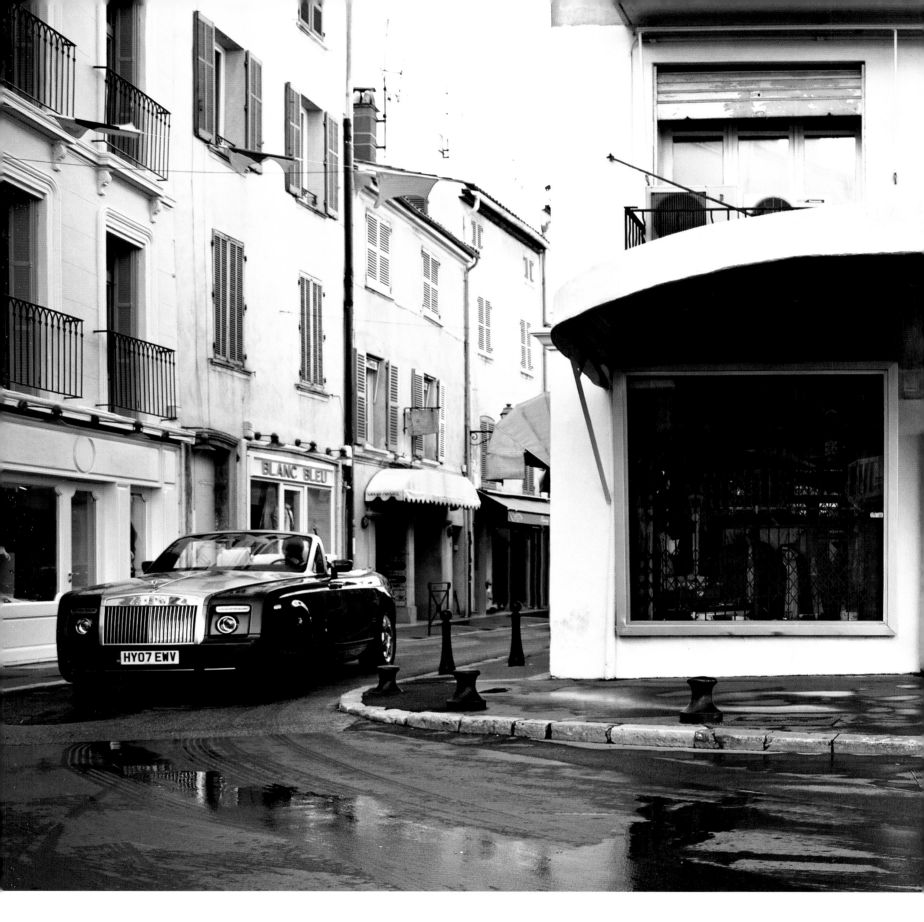

 RAMP
UPON THE
LADIES!

STORY The Story of Ecstasy / **PHOTOGRAPHERS** outtofocus – David Breun & Martin Grega

CAR Rolls-Royce Phantom Drophead

AUS DEM MORGENLAND — Ein Rolls-Royce gleitet in den Morgenstunden durch die leeren Straßen von Saint-Tropez. Die Kombination aus dem richtigen Zeitpunkt, dem richtigen Ort und natürlich dem richtigen Auto schaffte so eines der ausdrucksstärksten ramp-Bilder.

STRAIGHT OUTTA THE ORIENT — Picture a Rolls-Royce gliding through the empty streets of Saint-Tropez in the wee hours of the morning. It's the kind of combination of perfect timing, perfect location, and, of course, the perfect ride that made for the most vividly expressive pictures ever featured in ramp.

L'ESPRIT DE L'ORIENT — Au petit matin, une Rolls-Royce glisse dans les rues désertes de Saint-Tropez. Coïncidence du lieu, de l'instant et de l'automobile idoines, pour l'une des images les plus saisissantes du magazine.

ANSICHTSSACHE — Atemberaubendes Design trifft auf atemberaubendes Fahrerlebnis: Sofort entstehen Bilder vor dem geistigen Auge, die auf reale Bilder treffen. Wie stellt man das dar? Logisch: ein Blick von innen nach außen, raus auf das wartende Auto. Dabei war Eile geboten. Denn allzu lange blieb das Auto nicht stehen.

MATTER OF OPINION — Breathtaking design meets breathtaking driving experience. It's a concept that promptly evokes mental images inevitably being pitted against actual pictures. How do you present something like that? Exactly. You do it from the inside out, before you finally get out and into that sweet ride awaiting you. Take it from us: don't hesitate, cause that sweet ride ain't gonna be around forever.

QUESTION DE PERSPECTIVE — À design époustouflant, sensation de conduite époustouflante : les images qui se forment aussitôt dans l'imaginaire se confrontent aux images réelles. Comment traduire cela ? C'est simple : en regardant de l'intérieur vers l'extérieur, sur l'automobile à l'arrêt. Cependant, il fallait faire vite. Car elle n'est pas restée longtemps immobile.

#01

RAMP
JETZT NEHMEN
WIR DIE SACHE
MAL SELBST IN DIE
HAND (LET'S GO!)

STORY Der Entschleunigungs-Beschleunigungs-

GT-Kompressor-Racer / **PHOTOGRAPHER** Marcus Sauer

CAR Mercedes-Benz SLR McLaren

SMILE — Daniel Brühl mit dem Audi TTS Roadster in Berlin. Leider schaut der Schauspieler auf jedem Bild so ernst. Macht nichts, dachten wir uns, und wählten für unser Buch einfach dieses Bild. Da gibt es eine lustige Wandbemalung am Haus im Hintergrund. Und der Typ lächelt ganz bestimmt. (Kann man nur nicht sehen!)

SMILE — Daniel Brühl driving an Audi TTS Roadster through Berlin. Too bad that every photo shoot taken of the German actor showed him frowning into the camera. Ultimately, we felt it didn't matter, and simply chose this image of him for our book. Seeing him pictured in front of some funky graffiti on the building that served as background, we're positive the dude is smiling! (You just can't see it.)

SMILE — Daniel Brühl et le roadster Audi TTS à Berlin. Dommage, l'acteur a l'air tellement sérieux sur les photos. Nous nous sommes dit que ce n'était pas grave et avons retenu cette photo pour cette édition. On voit une peinture murale amusante à l'arrière-plan. Et le gars sourit, à coup sûr (en fait, on ne le voit pas !).

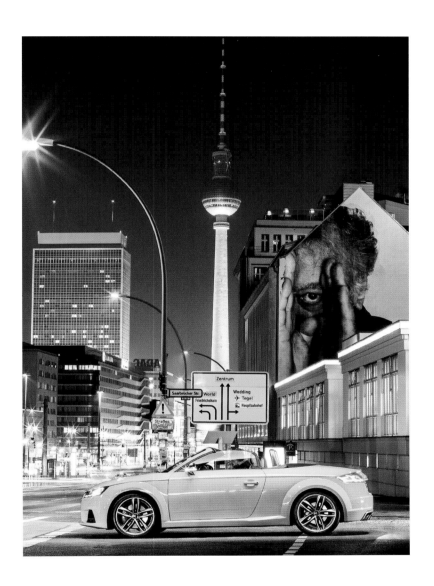

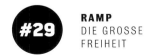

#29

RAMP
DIE GROSSE
FREIHEIT

STORY Daniel und sein Düsentrieb / **PHOTOGRAPHER** David Breun

CAR Audi TTS Roadster

UND DAZU POMMES ROT-WEISS —
Ohne Zulassung, ohne Kennzeichen, ohne Licht. Dafür mit dem Lancia Stratos HF Prototypen in einem Keildesign, das in einem matten Rot in etwa so unauffällig durch die Straßen zieht wie eine feiernde Horde Fußballfans. Da war es dann auch schon egal und so konnten wir fröhlich bei einer Currywurstbude einkehren.

HOW 'BOUT SOME FRIES, RED-WHITE STYLE? — No registration, no tags, no lights. Instead, here we were, driving around in a Lancia Stratos HF Prototype, its matte red wedge design about as discrete in the streets as a bunch of drunk and loud soccer fans. What difference did it make if we pulled over for some curry sausage takeout, anyhow?

ET UNE PORTION DE FRITES KETCHUP MAYO — Sans carte grise, sans plaque, sans lumières. Mais à bord du prototype de la Lancia Stratos HF. Avec son design cunéiforme et sa livrée rouge mat, elle passe aussi inaperçue qu'une horde de supporters de foot en liesse. À ce stade, ça n'avait plus d'importance ; aussi, nous nous sommes arrêtés pour savourer gaiement des saucisses au curry.

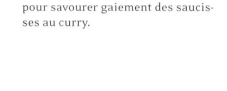

#08 **RAMP**
LET'S GET OUT
OF HERE 2

STORY Unterwegs / **PHOTOGRAPHERS** outtofocus –

David Breun & Martin Grega / **CAR** Lancia Stratos HF

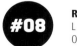 **AUTO** ——— A PASSION FOR CARS

TRANSFORMATION — G-Man Jerry Cotton auf der Jagd nach den bösen Jungs. Wie? Schnell – in seinem 3,8 Liter starken Jaguar E-Type. Oder noch schneller im Jaguar C-X16 Concept Car. Ähnlichkeiten zwischen den beiden Autos sind nicht zufällig. Auch nicht die mit dem neuen F-Type – der aus dem Concept Car zwischenzeitlich entstanden ist.

TRANSFORMATION — In German-speaking countries and Finland, "G-Man Jerry Cotton" is this popular pulp hero hunting down bad guys. In that sense, he's not unlike the secret-service guys in "The Man from U.N.C.L.E," except for the speed factor: "G-Man Jerry Cotton" gets to kick butt in his very own 3.8-liter Jaguar E-Type. So, if you ever find yourself on the run from "G-Man Jerry Cotton" like we are, you'll need something faster like the Jaguar C-X16 concept car. By the way, similarities between the two rides aren't just happenstance. Nor are any similarities to the new F-Type— which just so happens to be an offshoot of the concept car.

TRANSFORMATION — Le G-Man spécial Jerry Cotton à la poursuite des méchants. Comment ? À toute vitesse – dans sa Jaguar type E 3,8 l. Ou bien encore plus vite, dans son concept-car Jaguar C-X16. Ce n'est pas un hasard si ces deux autos se ressemblent. Comme elles ressemblent à la nouvelle type F – le modèle qui, depuis, a été dérivé du concept-car.

 RAMP
DLDUUDGR*
*DAS LEBEN, DAS UNIVERSUM
UND DER GANZE REST

STORY Cotton's Cars / **PHOTOGRAPHER** Steffen Jahn

CARS Jaguar E-Type & Jaguar C-X16

NA GROSSARTIG! — Wie lässt es sich in einem smart großartig fühlen? Also im wahrsten Sinne des Wortes. Ganz einfach, dachten wir uns: indem man die Umgebung schrumpft. Schon war sie geboren, die Idee, mit dem smart zu einem der kleinsten Häuser der Welt zu fahren.

GREAT! — What's a good way to feel great in a Smart ForTwo? Seriously, in the truest sense of the word. Actually, we found a perfectly simple way to do it: by shrinking the surroundings. So we came up with the idea of taking the ForTwo out to one of the world's smallest houses for its photo shoot.

TOUT SIMPLEMENT IMPOSANT ! — Comment faire pour en imposer au volant d'une smart, au sens littéral du terme. C'est tout simple, avons-nous pensé : il suffit de rapetisser le décor. C'est ainsi qu'est née l'idée de rejoindre en smart l'une des plus petites maisons du monde.

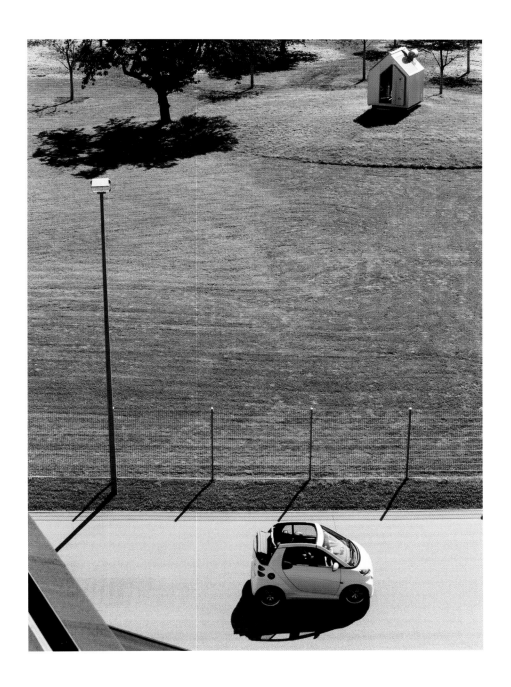

 #23 **RAMP**
ENDSTATION
SEHNSUCHT

STORY Gedanken aus der (kleinen) Tonne / **PHOTOGRAPHER** Anna-Lisa Lange

CAR smart fortwo

ELFERSCHIESSEN — Der Porsche 911 GTS steht im Grunde dafür, Bewährtes und Gutes noch besser zu machen. Wo man dann fotografiert, ist eigentlich fast schon egal - vor allem dann, wenn Perspektive und Look stimmen. Und das taten sie im Fall von Bernd Kammerer.

SCORING A PERFECT 11 — The Porsche 911 GTS basically stands for taking tried and proven concepts and improving on them. In that sense, the location for a photo shoot is almost insignificant—especially when the perspective and overall composition of a photo shoot are both in sync. They certainly are in Bernd Kammerer's pictures.

TIRS AU BUT — La Porsche 911 GTS est l'incarnation parfaite de l'idée qu'à partir de l'excellence, on peut faire encore mieux. Le lieu où on la photographie n'a en réalité aucune importance – surtout lorsque la perspective et le look sont au rendez-vous. Ce qui est le cas avec Bernd Kammerer.

#28 **RAMP**
ALL YOU
CAN WISH

STORY Vollendete Gegenwart

PHOTOGRAPHER Bernd Kammerer / **CAR** Porsche 911 GTS (991)

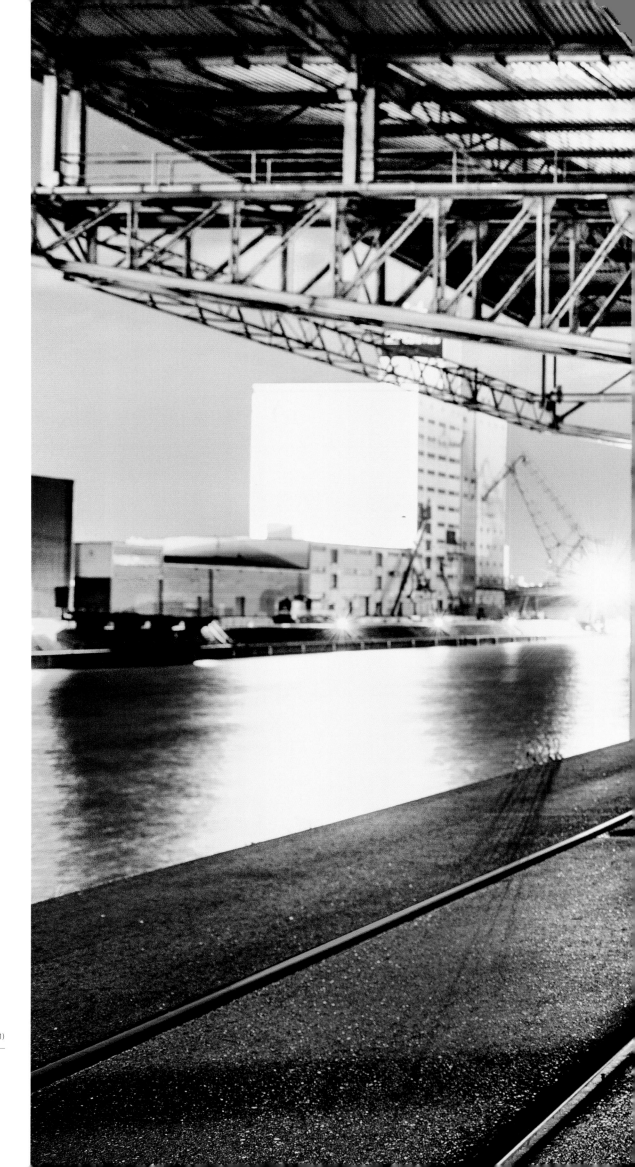

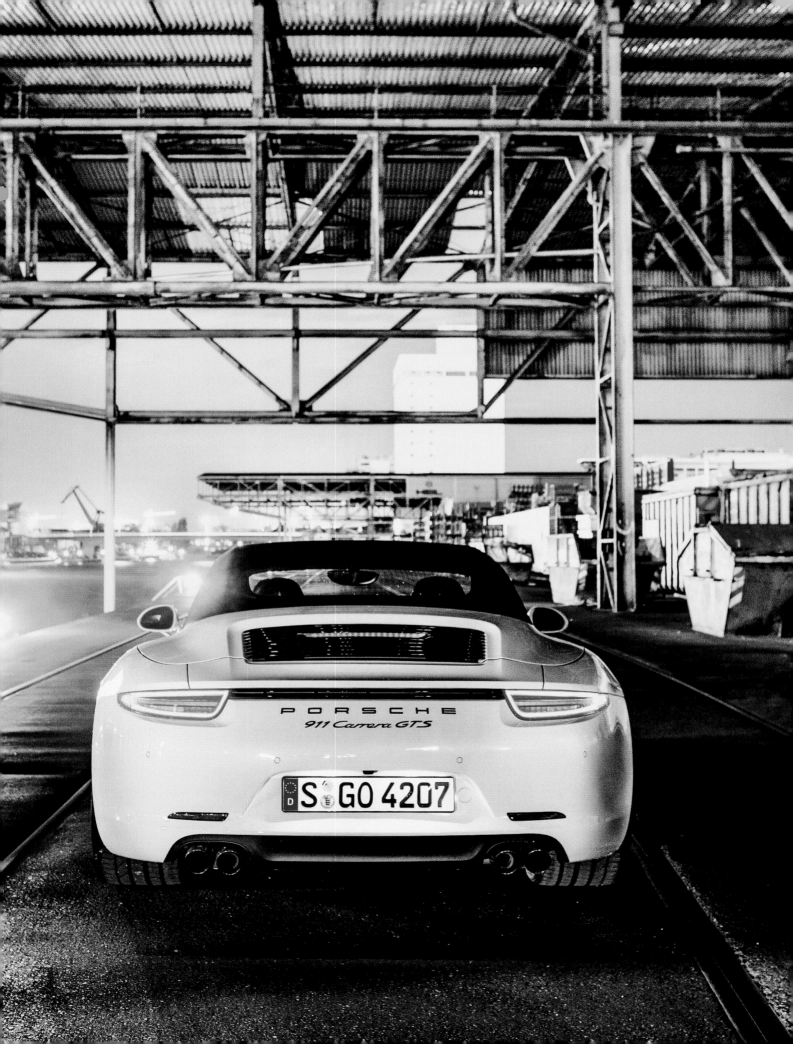

MONDFAHRZEUG — Opel greift nach dem Mond. Für's erste jedenfalls. Mit dem Ampera stellen sie das erste permanent elektrisch angetriebene Serienfahrzeug Europas. Für die Bilder musste allerdings nicht wirklich auf den Mond geflogen werden. Anders als noch 1969 reicht die Rechenleistung moderner PCs mittlerweile für ansehnliche Bildbearbeitung.

MOON BUGGY — Opel—yes, that's GM's German subsidiary—is reaching for the moon. Well, for the time being, anyway. With the Opel Ampera, the automaker presents Europe's first fully electric production vehicle. OK, we didn't really fly to the moon for the photo shoot. Unlike the lunar mission back in '69, we can rely on state-of-art computer technology to produce some decent pictures right here in the studio.

ROVER LUNAIRE — Opel vise la lune. Dans un premier temps, du moins. Avec l'Ampera, le constructeur présente la première voiture de série tout-électrique d'Europe. Pour les photos, il n'a pas été nécessaire d'aller sur la lune. Depuis 1969, la puissance des PC modernes permet des prouesses impressionnantes en terme de traitement d'image.

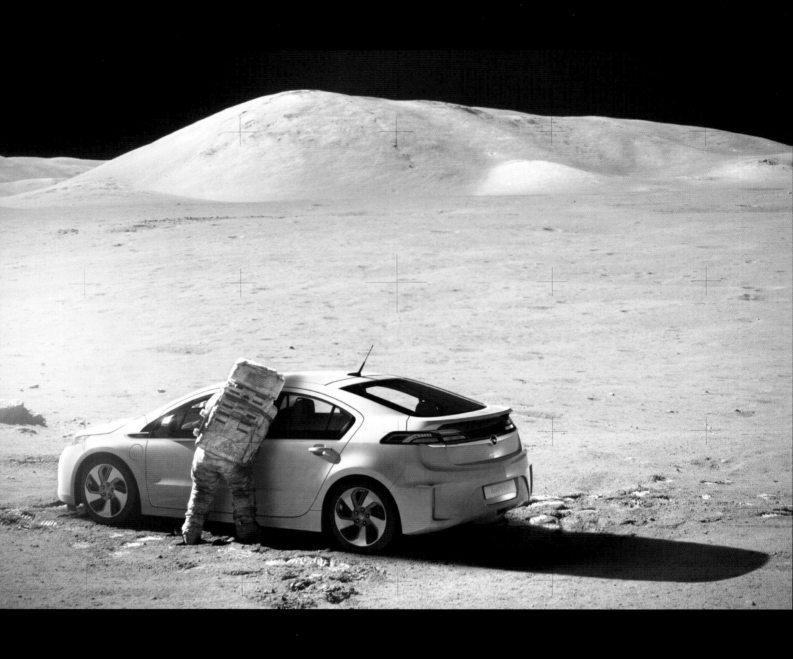

#14

RAMP
NIGHT ON EARTH

STORY Moonraker 2.0 / **PHOTOGRAPHER** Robert Roither

CAR Opel Ampera

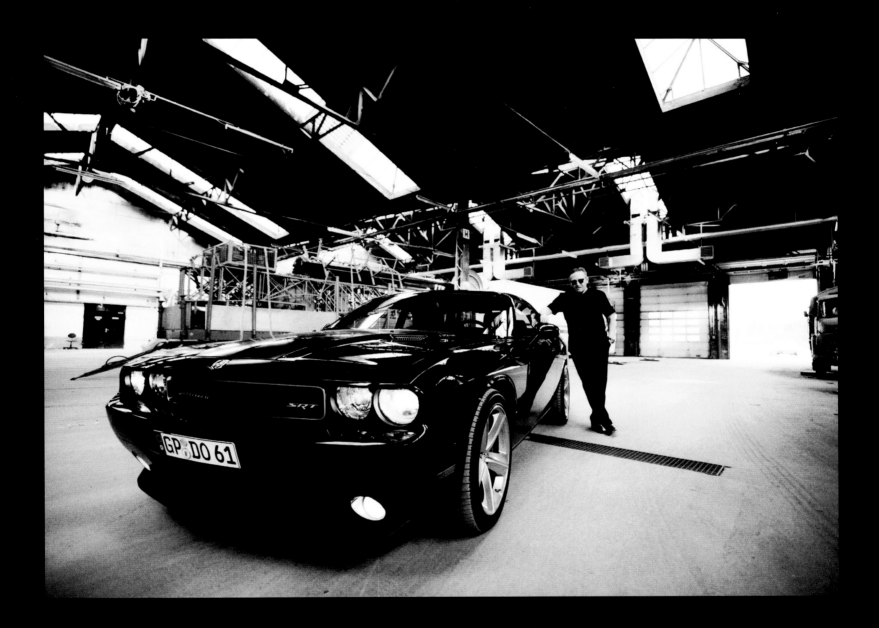

ZWEI TYPEN — Er ist Musiker, Moderator, Stadionsprecher und Kultfigur: Matthias Holtmann. Es ist amerikanisches Muscle-Car, Männertraum, Rock 'n' Roll auf Rädern und natürlich Kultauto: Dodge Challenger. Zusammen sind sie zwei echte Typen und eine ramp-Geschichte.

TWO ICONS — One is a musician, TV host, stadium announcer, and a cult figure in his native Germany: Matthias Holtmann. The other is an American muscle car, dream car, rock 'n' roll on wheels, and, of course, a cult car: Dodge Challenger. Together, they present two real icons and a story in ramp.

DEUX FORTS CARACTÈRES — Musicien, animateur, speaker de stade et personnalité culte, c'est Matthias Holtmann. Muscle car américain, rêve masculin, rock'n'roll sur quatre roues et bien sûr une auto culte : c'est le Dodge Challenger. Deux fortes personnalités, réunies dans un article pour ramp.

L'ALLEMAND FOU! — Mit Fotograf Andy Fox unterwegs im Mini an der Côte d'Azur. Und ganz nebenbei erwähnt der, dass er drei Jahre lang Porsche Carrera Cup gefahren ist. Natürlich musste er ans Steuer. Ergebnis: Wenn heute in Südfrankreich jemand von „l'allemand fou" spricht, spricht er vermutlich von ihm.

L'ALLEMAND FOU! THE GERMAN NUTJOB — Riding along with photographer Andy Fox in a Mini Cooper as he cruises down the French Riviera. At some point, he casually mentions the three years he spent participating in the Porsche Carrera Cup— as a driver, you know. Ever since, he concludes, anytime you hear talk of 'l'allemand fou' in this part of France, chances are, folks are talking about him.

L'ALLEMAND FOU ! — Nous longeons la côte d'Azur en Mini avec le photographe Andy Fox. En passant, il me confie qu'il dispute la Porsche Carrera Cup depuis trois ans, alors il souhaite prendre le volant. Résultat : si vous entendez parler de « l'Allemand fou » dans le sud de la France, c'est lui, à tous les coups.

#23

RAMP
ENDSTATION
SEHNSUCHT

STORY Vent Cuisine! / **PHOTOGRAPHER** Andy Fox

CAR Mini Cooper S Paceman

STORY Fight or Flee / **PHOTOGRAPHERS** Helmut Werb & Daniel Reinhard

CAR BMW Z4 GT3

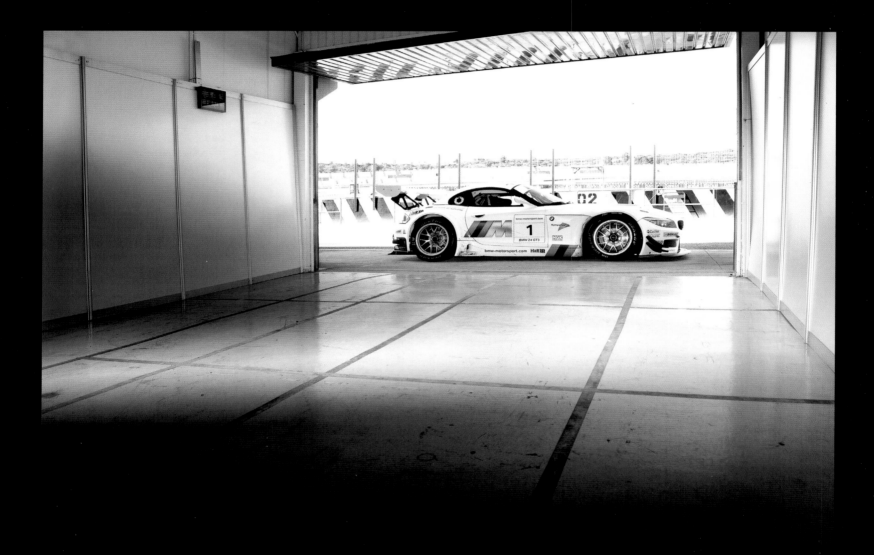

RITTERSCHLAG — Wenn du dich mit einem BMW M3 GT4 erst einmal warmfährst, bleibt die Frage, was denn da noch kommen mag auf der Rennstrecke? Ein BMW Z4 GT3 mit über 500 PS vielleicht? Rennwagen eben. Da kann einem schon mal das Herz stehen bleiben. Nur vom Hinschauen.

ACCOLADE — Once you reach the point where you feel perfectly at home driving a BMW M3 GT4, you begin to wonder what else might be lurking out there on the racetrack on any given day? How about a BMW Z4 GT3 packing more than 500 hp? Sure enough, it's the racecar version. Kinda makes your heart skip a beat, doesn't it? You know, the mere glimpse of it.

COUP DE MAÎTRE — Après un tour de chauffe dans une BMW M3 GT4, on se demande ce qu'on peut trouver de mieux sur le circuit. Peut-être une BMW Z4 GT3, avec plus de 500 chevaux ? Car on a affaire à des voitures de course. On en aurait le souffle coupé, rien qu'à les regarder.

ERFOLGSFORMEL — Mag man kaum glauben: Aber das war eines der preisgünstigsten Shootings in der ramp-Geschichte. Ausreichend waren ein Parkplatz und ein Fotograf. Okay, und das Auto natürlich. In diesem Fall einer der erfolgreichsten Formel-1-Renner überhaupt.

FORMULA TO SUCCESS — Believe it or not, but this was actually one of the most inexpensive shootings in the history of ramp. All we needed was a parking lot and a photographer. Well, yeah, the car too (duh!). This particular one happens to be one of the most successful Formula 1 racecars ever.

LA FORMULE QUI GAGNE — Incroyable mais vrai, c'est l'un des shootings les moins chers de l'histoire de ramp. Il a suffi d'un parking et d'un photographe. Et de l'automobile, bien sûr. En l'occurrence, l'une des F1 les plus victorieuses.

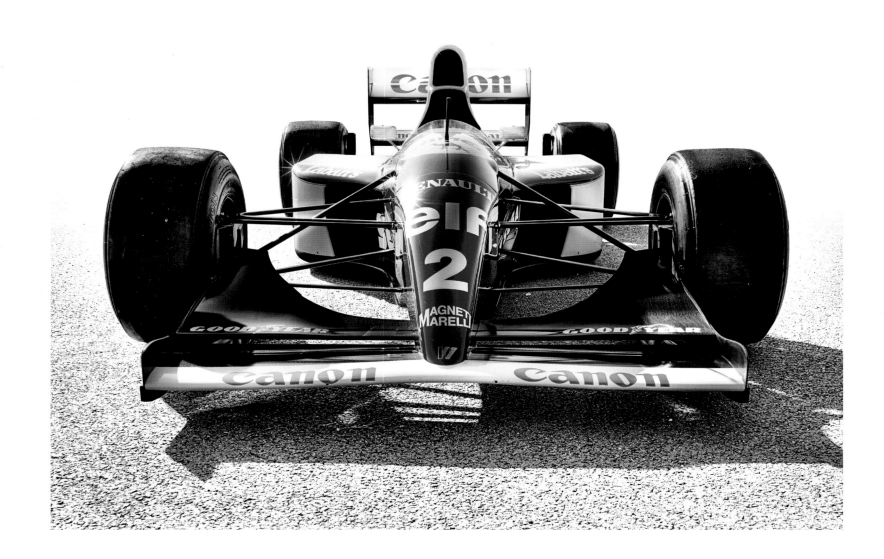

 #06

RAMP
ES LEBE DER SPORT!

STORY Win by Wire / **PHOTOGRAPHER** Igor Panitz

CAR Williams-Renault FW15C

OH, LÀ, LÀ! — Die entspannte französische Lebensart des Laissez-faire trifft auf die gemütliche Lebensart der Bayern. Da sollten dann die 35 PS eines Wellblechwohnwagens auch genügen. Zumal in der Münchner Innenstadt.

OH, LÀ LÀ! — The laidback French combination of savoir-vivre and laissez-faire meets the easygoing lifestyle of the Bavarians. We figured the 35 hp of this French corrugated sheet metal camper should suffice for a cultural encounter such as this. Especially in the crowded streets of downtown Munich.

CHARME FRANCO-BAVAROIS — Quand la décontraction à la française rencontre la convivialité des Bavarois. Les 35 chevaux d'un fourgon en tôle ondulée sont alors amplement suffisants, surtout si c'est pour s'en servir de camping-car en plein centre de Munich.

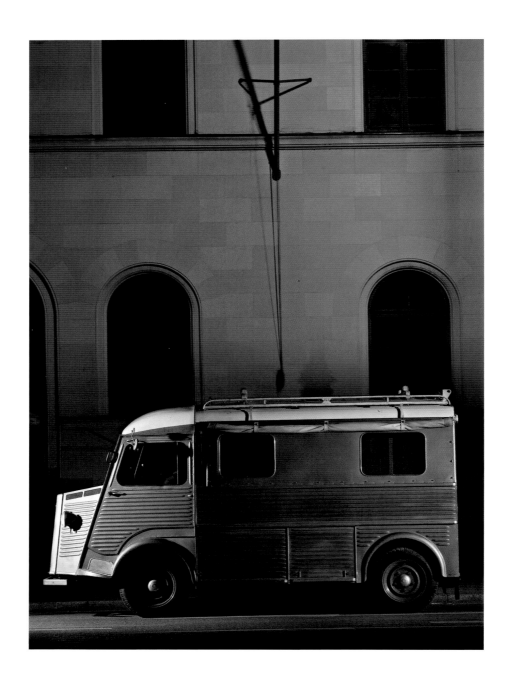

 RAMP
HELDEN

STORY Pflasterstrand und Wellblech / **PHOTOGRAPHERS** outtofocus –

David Breun & Martin Grega / **CAR** Citroën HZ

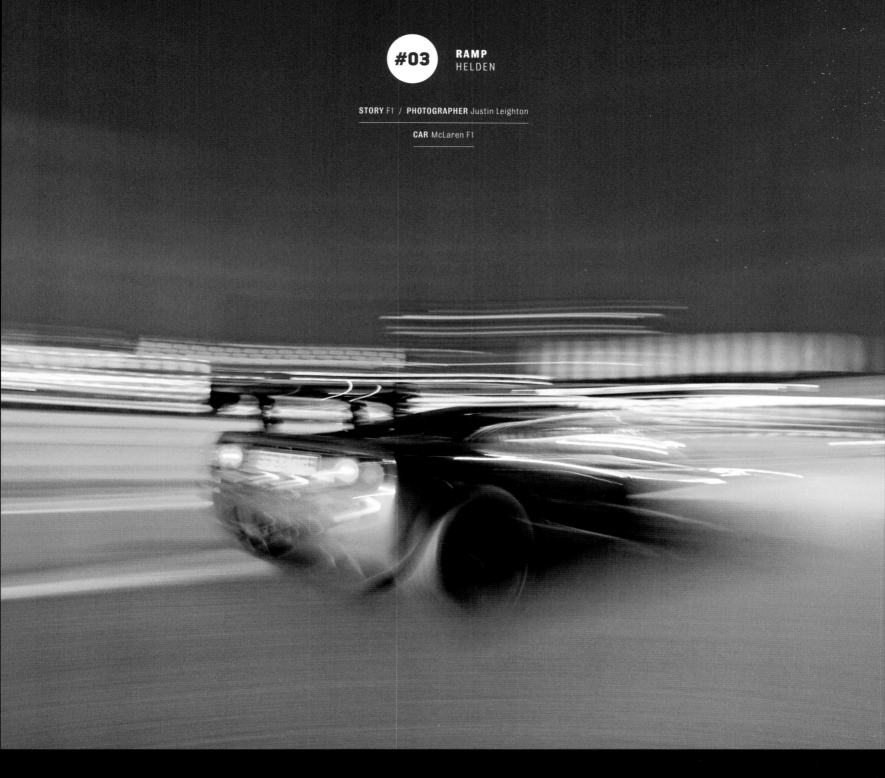

BILDGESCHWINDIGKEIT — Er ist einer der exklusivsten Supersportwagen der Welt. Und darüber hinaus nur eines von drei GT-Fahrzeugen, das bei seinem Debüt in Le Mans gewinnen konnte. Die Dynamik des McLaren F1 ist beeindruckend. Genau diese Geschwindigkeit musste die Geschichte ausdrücken.

IMAGE SPEED — It's one of the most highly exclusive super sports cars on the planet. Moreover, it's one of only three GT models to make its debut by winning in Le Mans. The McLaren F1 delivers jaw-dropping performance, to say the least. Picturing it is exactly what this story is all about.

CADENCE DE PRISE DE VUES — C'est l'une des supercars les plus luxueuses au monde. Et aussi l'un des trois seuls véhicules GT ayant réussi à gagner au Mans à ses débuts. Ses capacités dynamiques sont impressionnantes. C'est précisément cette vitesse que cet article devait souligner.

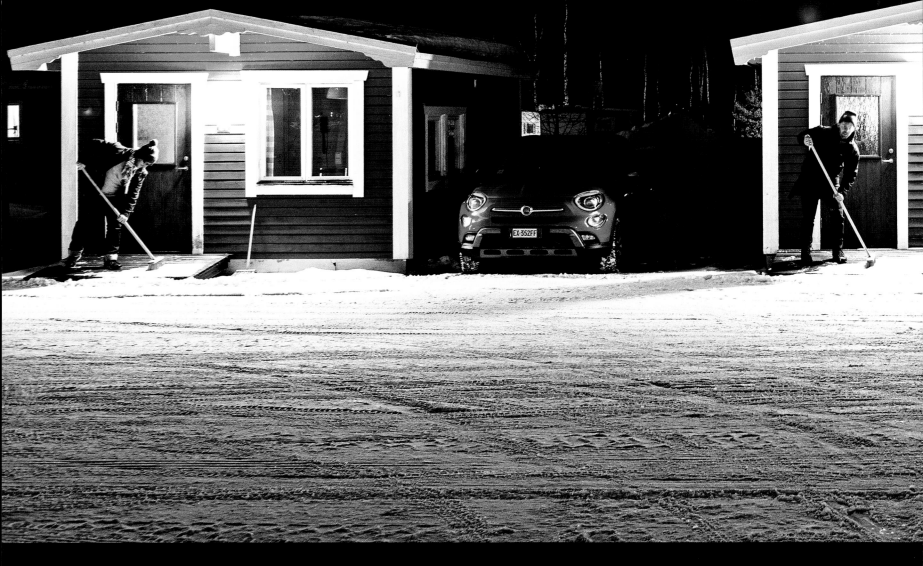

RAMP
{FAR-FAIR-
GNU-GHEN}

STORY Von Ausbrüchen und Wirbelstürmen / **PHOTOGRAPHER** Tim Adler

CARS Fiat 500X & Jeep Renegade

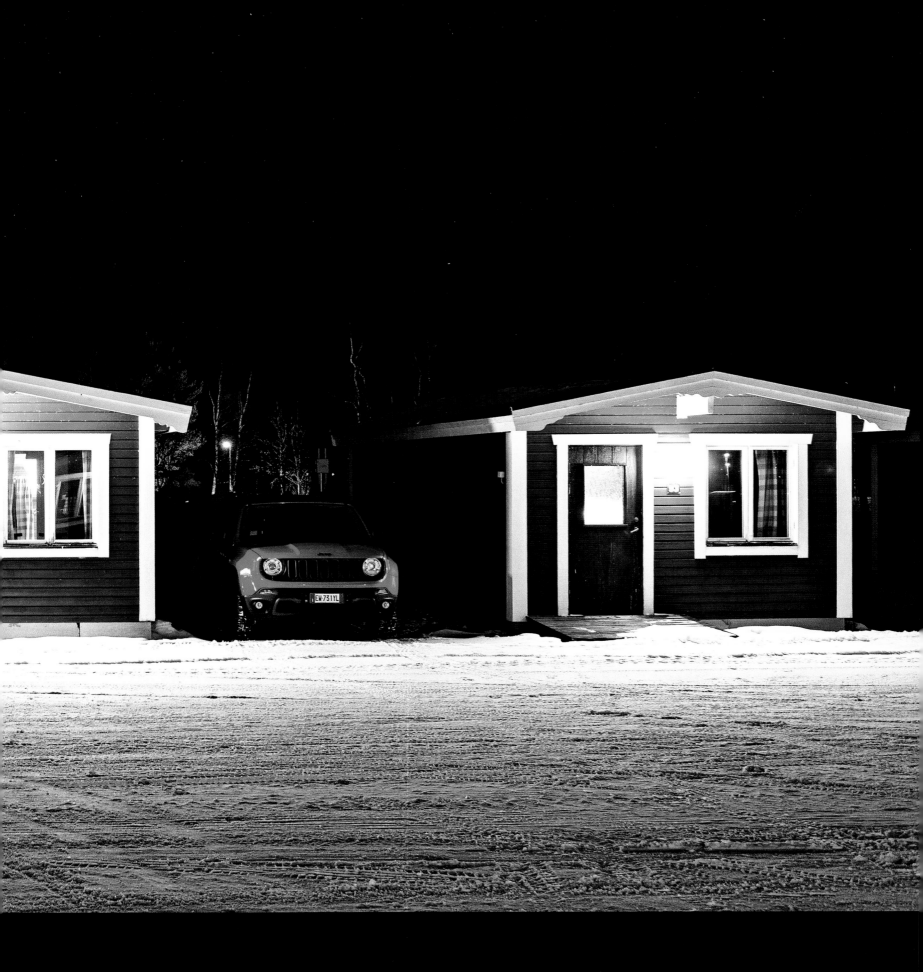

SCHNEEBLIND — Arjeplog, Schweden. Mitten im Winter. Hier testet die Automobilindustrie die frostigen Bedingungen. Ein echt cooler Job. Und verdammt coole Bilder für ein Heft, das im Sommer erscheint.

SNOW BLIND — Arjeplog, Sweden, dead of winter. Here the automotive industry does testing under frosty conditions. This can be a really cool job. And worth some pretty damn cool pix in our mag due out this summer.

NEIGE AVEUGLANTE — Arjeplog, Suède. En plein hiver. C'est là que l'industrie automobile vient tester la conduite sur glace. Un job vraiment cool. Qui donne des images ultra-cool - pour un numéro qui paraît en été !

MEHR LICHT!? — Fahrspaß u
nachhaltige Mobilität. Als Ror
Kuhn den neuen Hybrid-Sportl
BMW i8 in Amerika fotografier
ist die Verwunderung groß. „Ha
Sie denn kein Licht dabei?", so
besorgten Produzenten. Die läs
Antwort von Roman: „Das Tage
licht in Miami reicht." Und die E
beweisen: Recht hatte er.

A FLASH!? — Think sustaina
mobility that's a blast to drive
Hired to do a photo shoot promo
BMW's new hybrid driving mac
the i8, in the U.S., Roman Kuh
arrival initially leads to confu
among anxious producers of t
shoot. "Don't you have a flash?"
ask him. To which Roman casu
replies, "Miami offers plenty o
daylight." The pictures he tool
certainly prove he was right.

PLUS DE LUMIÈRE !? — Plais
la conduite et mobilité durabl
Lorsque Roman Kuhn vient ph
graphier la nouvelle sportive hy
BMW i8 en Amérique, l'étonner
est grand. « Vous n'avez pas app
d'éclairages ? », lui demanden
producteurs inquiets. Très coc
il répond : « La lumière du jou
Miami suffit. » Les photos lui o
donné raison.

#18 **RAMP**
ENDLICH 18!

STORY Who's Gonna Drive You Home?

PHOTOGRAPHER Roman Kuhn / **CAR** BMW i8

MUTPROBE — Wenn du deinen Führerschein ganz frisch gemacht hast, bist du meist 18 und freust dich, wenn man dir einen smart für die erste Fahrt bereitstellt. Unser Autor Wladimir Kaminer war bei seiner Jungfernfahrt, sagen wir mal höflich, Ü40. Da er uns sehr am Herzen liegt, haben wir ihm viel Knautschzone mit einem Defender und einem Cayenne gegeben.

ON A DARE — The day we're issued our first driver's license, most of us are 18 years old and deeply appreciative of every opportunity to put our newly acquired driving privileges into practice, even if it involves starting out in a Smart ForTwo. Then there are those who are in no particular rush when it comes to acquiring their driving privileges, including one of our authors, Wladimir Kaminer, who didn't acquire his until he was in his forties. Since we're all very fond of him, we gave him a lot of extra crumple zone in the form of a Land Rover Defender and a Porsche Cayenne.

BIZUTAGE — Lorsqu'on vient de passer son permis, généralement à 18 ans, on est content de se voir proposer une Smart pour son premier trajet. Notre journaliste Wladimir Kaminer, lui, en avait un peu plus de 40, dirons-nous pour rester polis, quand il a pris le volant pour la première fois. Tenant beaucoup à lui, nous avons mis à disposition un Defender et une Cayenne, avec de belles zones déformables pour absorber les chocs.

 RAMP
ENDLICH 18!

STORY Die Weltforscher: Defender vs. Cayenne / **PHOTOGRAPHER** Benjamin Tafel

CAR Land Rover Defender

HELL BOY! — Ein De Tomaso Pantera mit einem 580 PS-starken Nascar-Motor ist ein ziemlich böses Auto. Die perfekte Location hierfür wäre wohl die Hölle. Doch da haben wir keine Genehmigung bekommen. Wir wären zu gut, hieß es. Unser Fotograf entschied sich dann für eine verlassene Tankstelle. Die Quelle des Zündstoffs als Metapher für den höllischen Antrieb. Fanden wir gut, pardon: böse.

HELLBOY! — A De Tomaso Pantera powered by a 580-hp Nascar engine is definitely our idea of 'one bad ride.' The kinda ride that looks like it's right at home in hell. Too bad, we didn't get permission to shoot down there. We just weren't bad enough, we were told. Our photographer settled for an abandoned gas station instead. The source of flammable fuel as metaphor for a ride straight out of hell. We thought it was good— sorry, make that bad.

HELL BOY! — Avec son moteur Nascar de 580 chevaux, la De Tomaso Pantera est plutôt diabolique. L'enfer aurait été le cadre idéal pour le shooting. Mais nous n'avons pas obtenu d'autorisation. Motif : nous sommes trop bons, nous a-t-on répondu. Notre photographe a donc opté pour une station service abandonnée. La source du carburant comme métaphore de la propulsion diabolique. Cela nous a paru bien. Pardon, d'enfer.

#03 **RAMPCLASSICS**
GO LIKE HELL

STORY Wie man etwas Böses noch böser macht

PHOTOGRAPHER Jan Steinhilber

CAR De Tomaso Pantera GTS

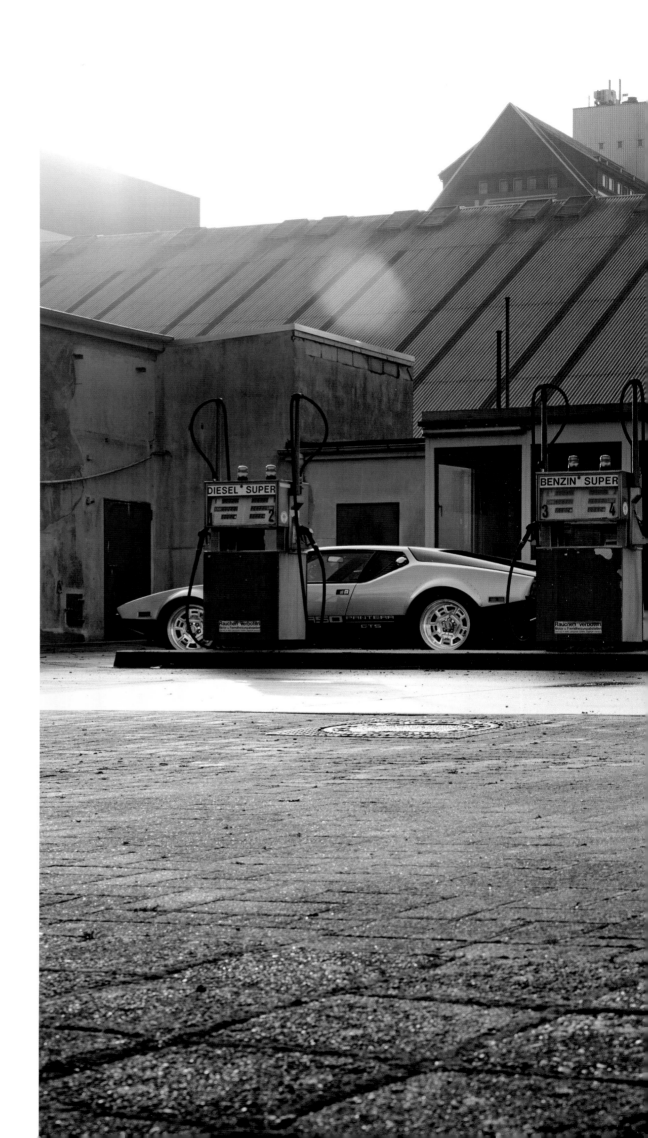

2

KULTUR

—

KULTUR.

Kultur ist für uns gleichbedeutend mit der Freude am Leben. Nichts wie mitten rein – am besten mit dem Auto. Unterwegs zu Menschen, Ideen, Orten, Dingen und Ereignissen. Das Auto im Kontext von Musik und Mode, Kultur und Lebensart, Design und Kunst. Aber auch Autokultur pur: die Mythen, die Geschichten und Geschichtchen rund um unsere Helden, Autos und Marken.

CULTURE.

To us, culture is all about joie de vivre. That's because the best way to experience the joy of living is by car. Think of all the places you ever drove to meet different people to explore different ideas, things, and events. In the same vein, take any musical, fashion, art/design, lifestyle or other cultural trend, and think about all the rides involved in discovering and promoting them in the first place. Then there's the car as a cultural object in and of itself, including any myths, legends, and fairytales about cars, their brands and any heroes who ever drove them.

CULTURE.

La vie culturelle est pour nous indissociable de la joie de vivre. Foncer au cœur de l'action – en auto de préférence. Pour rencontrer êtres humains, idées, lieux, objets et événements. L'automobile dans un univers de musique et de mode, de culture et d'art de vivre, d'art et de design. Mais aussi de la culture automobile à l'état pur : les mythes, les histoires et les anecdotes ayant trait à nos héros, aux voitures, aux marques.

RAMP

JETZT NEHMEN
WIR DIE SACHE
MAL SELBST IN DIE
HAND (LET'S GO!)

STORY Happy Taxi to You! / PHOTOGRAPHER Frank Kayser

CAR New York City Cab

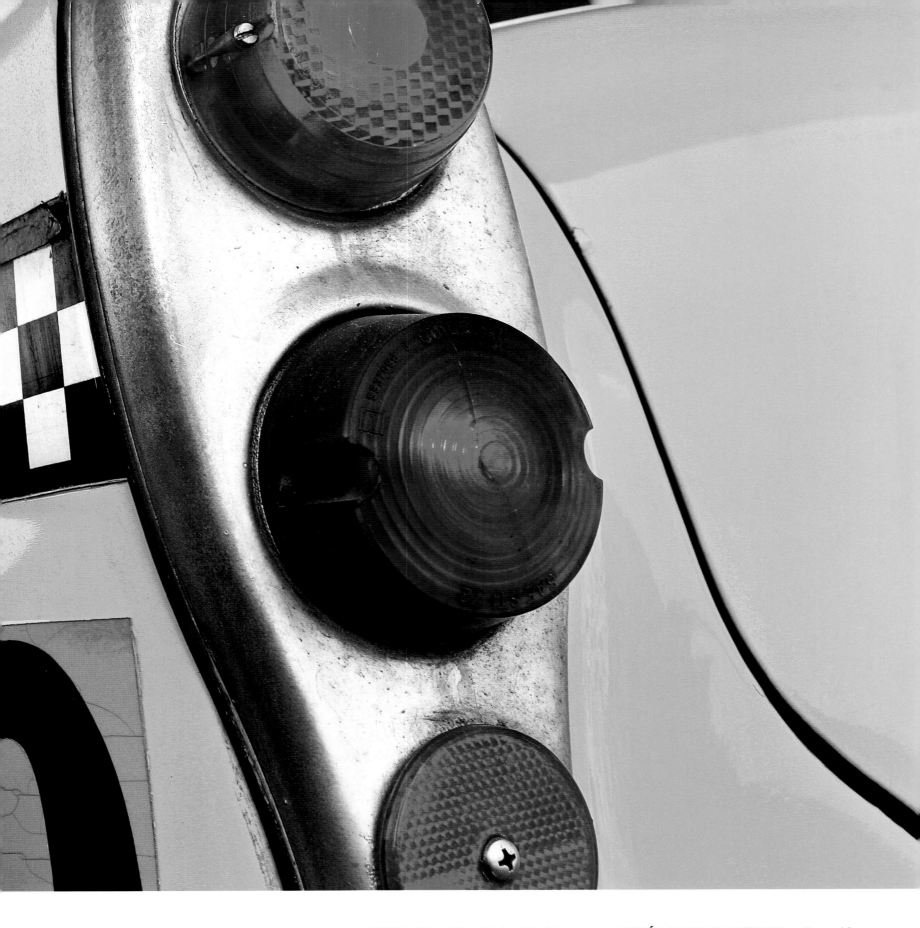

ALLES GELBE — Ein Taxi in New York ist nicht einfach nur ein Taxi in einer hektischen Stadt. Ein Taxi in New York ist im besten Fall ein mobiler Tempel der Erkenntnis und Weisheit während man reist. Zum 100-jährigen Geburtstag mussten wir gratulieren. Mit Bildern und den richtigen Sprüchen.

ALL IN YELLOW — A New York cab isn't just another taxi in another bustling city. If you're lucky, you may find a New York cab to be a mobile temple of knowledge and wisdom while you're on the go. Naturally, we had to congratulate NYC Yellow on their 100th anniversary. Including pix and appropriate postings.

LIVRÉE JAUNE DE RIGUEUR — Un taxi à New York, ce n'est pas un simple véhicule dans une ville en effervescence. À New York, un taxi devient parfois, au mieux, le temps d'un trajet, un temple mobile de la connaissance et de la sagesse. Félicitons les yellow cabs pour leur 100e anniversaire. Avec des images et des compliments appropriés.

LEGENDÄR — Daytona im Januar 1971. Der Ferrari 512 trifft auf den Porsche 917. Eine Heldenreise über 24 Stunden, 688 Runden und 4218,5 Kilometer mit einem Schnitt von 175,75 km/h. Es wird eines der legendärsten Rennen der Geschichte des Sports werden. Grund genug, zurückzukehren. Mit den Helden von damals. Und dem Blick von heute.

LEGENDARY — Daytona, January 1971: Ferrari 512 meets Porsche 917. It was a heroes' journey, which lasted more than 24 hours, covering 688 laps over a total distance of 4,218.5 kilometers (2,621 miles) at an average speed of 175.75 kph (109.21 mph). It would go on to become one of the most legendary races in the history of racing. In other words, plenty of reason to revisit it. Joining us were the heroes from back in the day, watching it all from a present-day view.

LÉGENDAIRE — Daytona, janvier 1971. La Ferrari 512 affronte la Porsche 917. Une odyssée héroïque de 24 heures, 688 tours et 4218,5 kilomètres à une moyenne de 175,75 km/h, qui deviendra l'une des courses les plus légendaires de l'histoire du sport automobile. Une raison suffisante pour revenir sur les lieux. Avec les héros d'hier. Et le regard d'aujourd'hui.

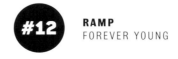

#12 **RAMP**
FOREVER YOUNG

STORY The Race of the Century / **PHOTOGRAPHER** Steffen Jahn

CARS Ferrari 512 #1006 & Porsche 917-013

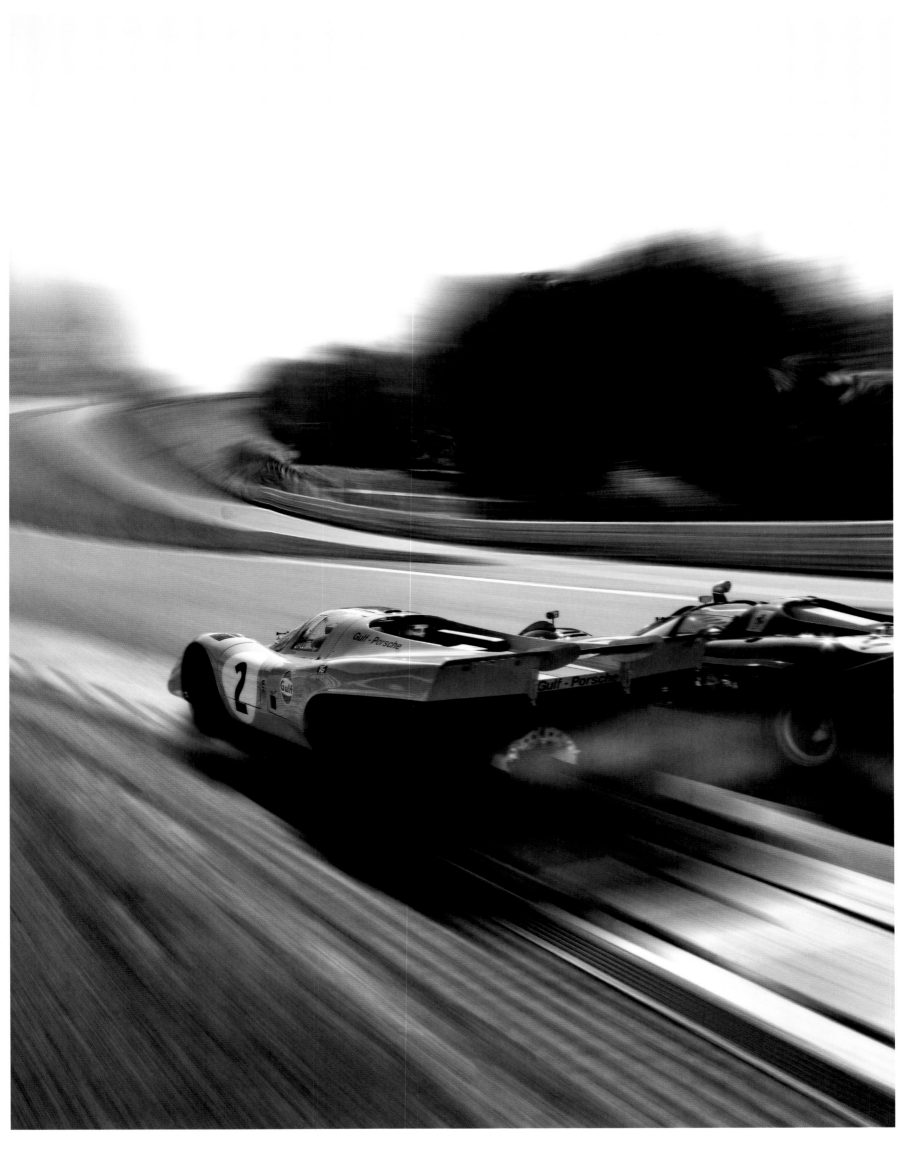

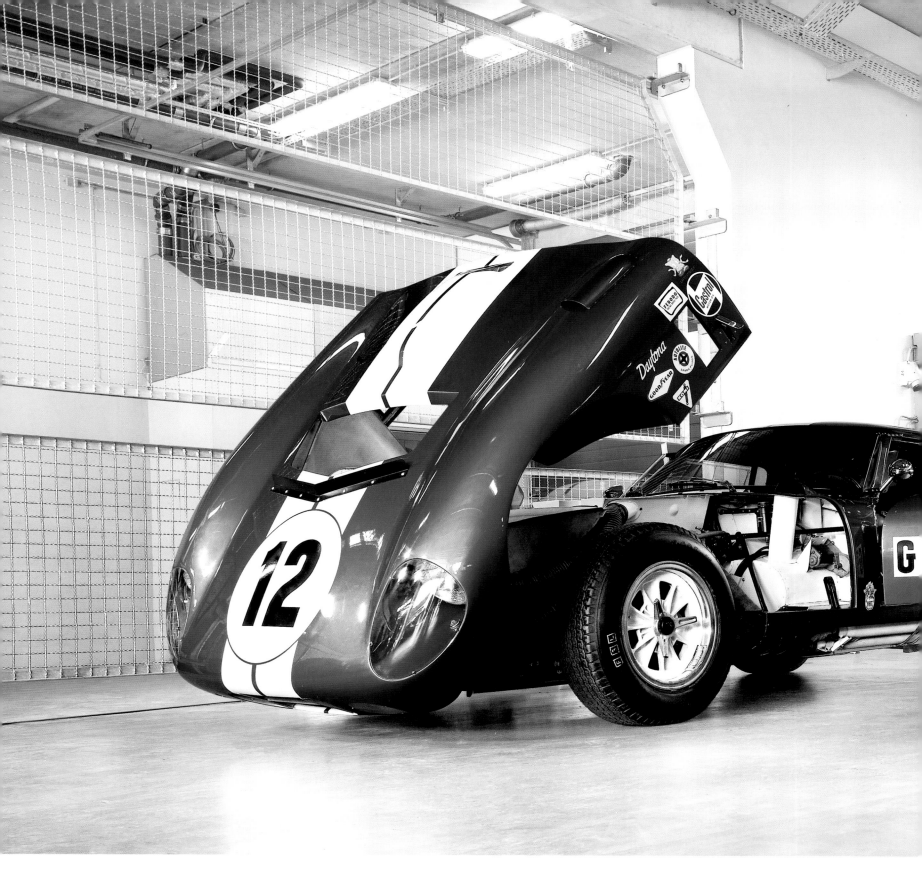

RAMP
JETZT NEHMEN
WIR DIE SACHE
MAL SELBST IN DIE
HAND (LET'S GO!)

#01

STORY Der Ferrari-Cobra-Krieg / PHOTOGRAPHER Marcus Philipp Sauer

CARS Ferrari 250 GTO vs. Shelby Cobra Daytona Coupe

A PASSION FOR CARS ——— KULTUR 56

WENN SPANNUNG BILDLICH WIRD —
Es gab in der Geschichte des Rennsports
wenige Duelle, die so spannungsgeladen
und emotional ausgetragen wurden wie
der Krieg zwischen Carroll Shelby und Enzo
Ferrari. Zwei Egomanen, zwei Typen, pure
Leidenschaft und ihre Autos. Wir haben die
beiden Autos zusammengebracht und noch
ehe der erste Motor gestartet war, fing es
schon an zu knistern.

TENSION MADE VISIBLE — Few rivalries in
the history of racing have proven as fraught
with tension and emotionally charged as the
one between Carroll Shelby and Enzo Ferrari.
Two egomaniacs, two guys, pure passion, and
their cars. We put both of these cars side by
side, and what do you know: even before the
first engine was started, the crackling began.

**LORSQUE LE SUSPENSE SE TRADUIT EN
IMAGES —** Dans l'histoire du sport automo-
bile, rares sont les duels autant empreints de
tension et d'émotion que celui qui a opposé
Carroll Shelby et Enzo Ferrari. Deux égocen-
triques forcenés, deux fortes personnalités,
de la passion à l'état pur et leurs automobi-
les. Nous avons réuni les deux voitures. Et
avant même qu'elles ne démarrent, il y avait
déjà de l'électricité dans l'air.

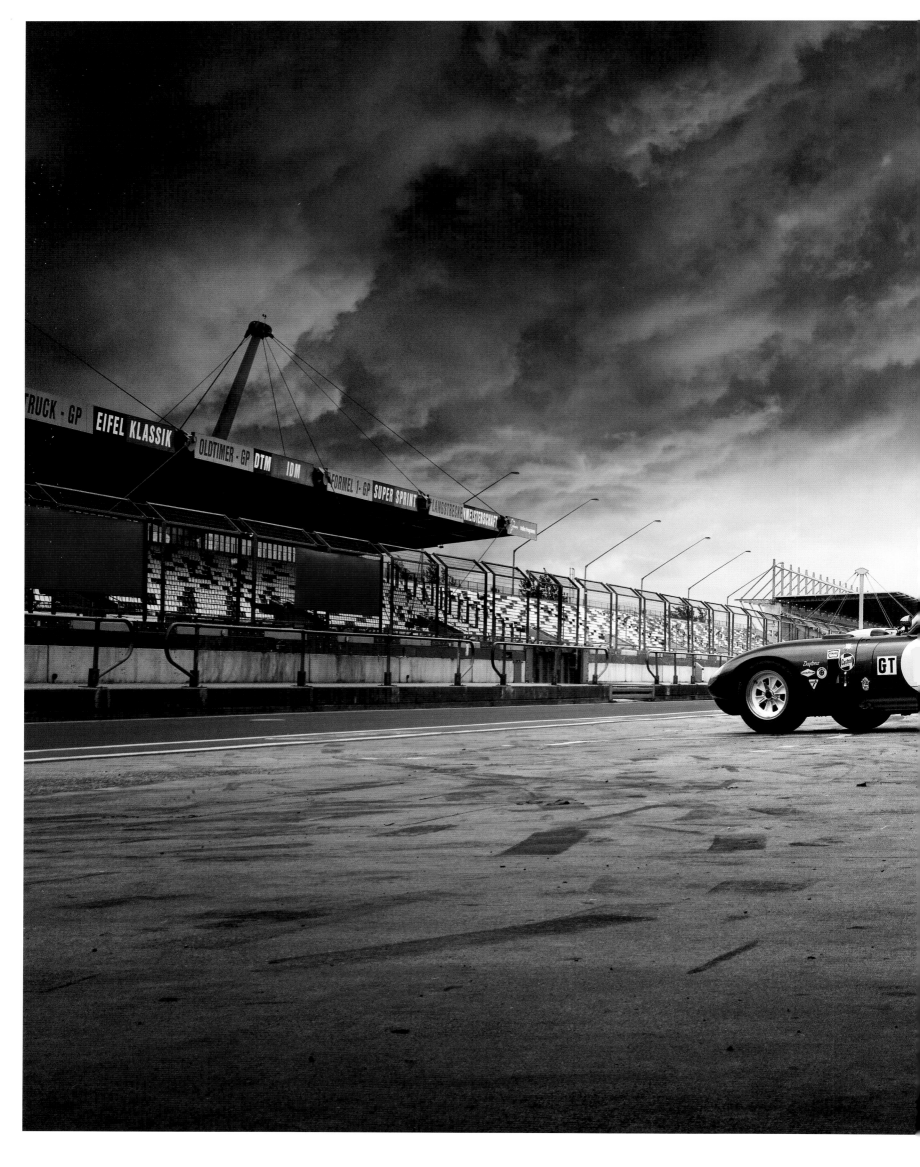

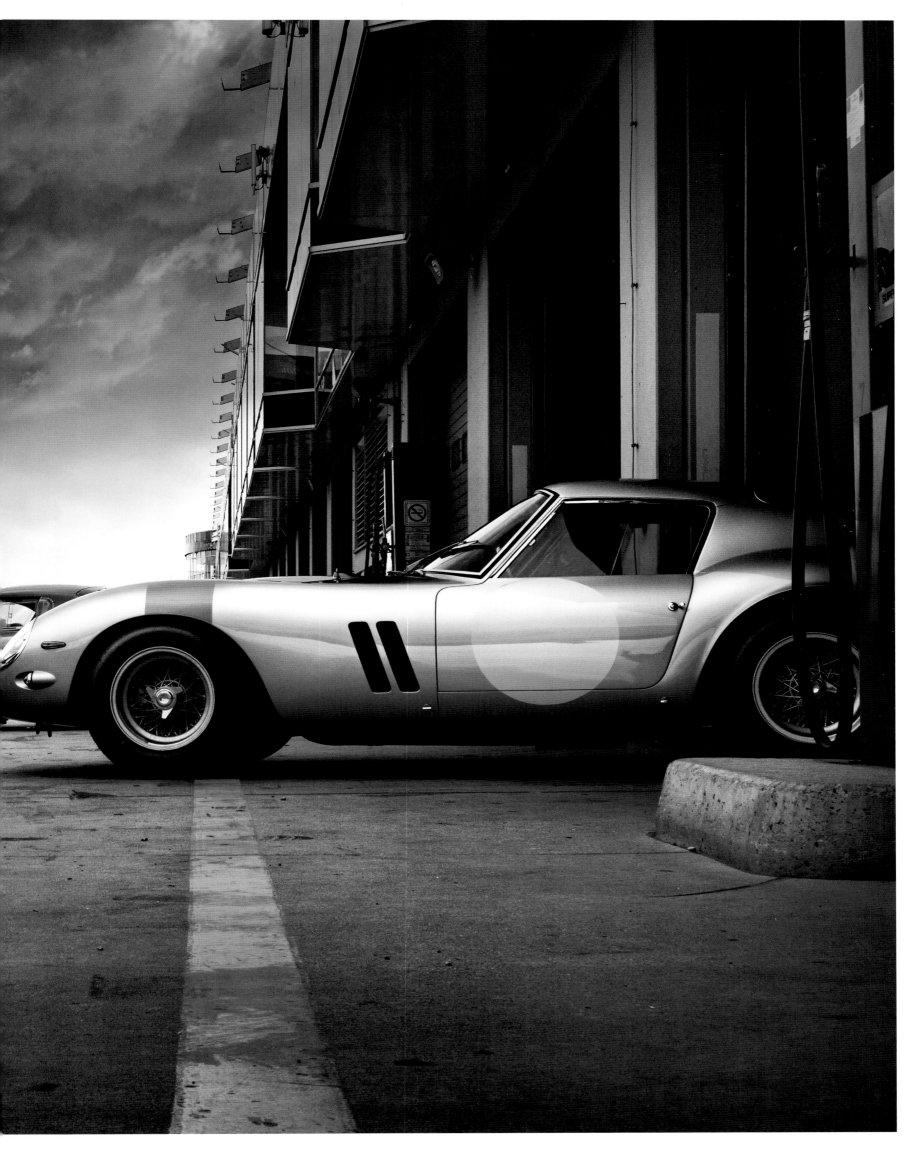

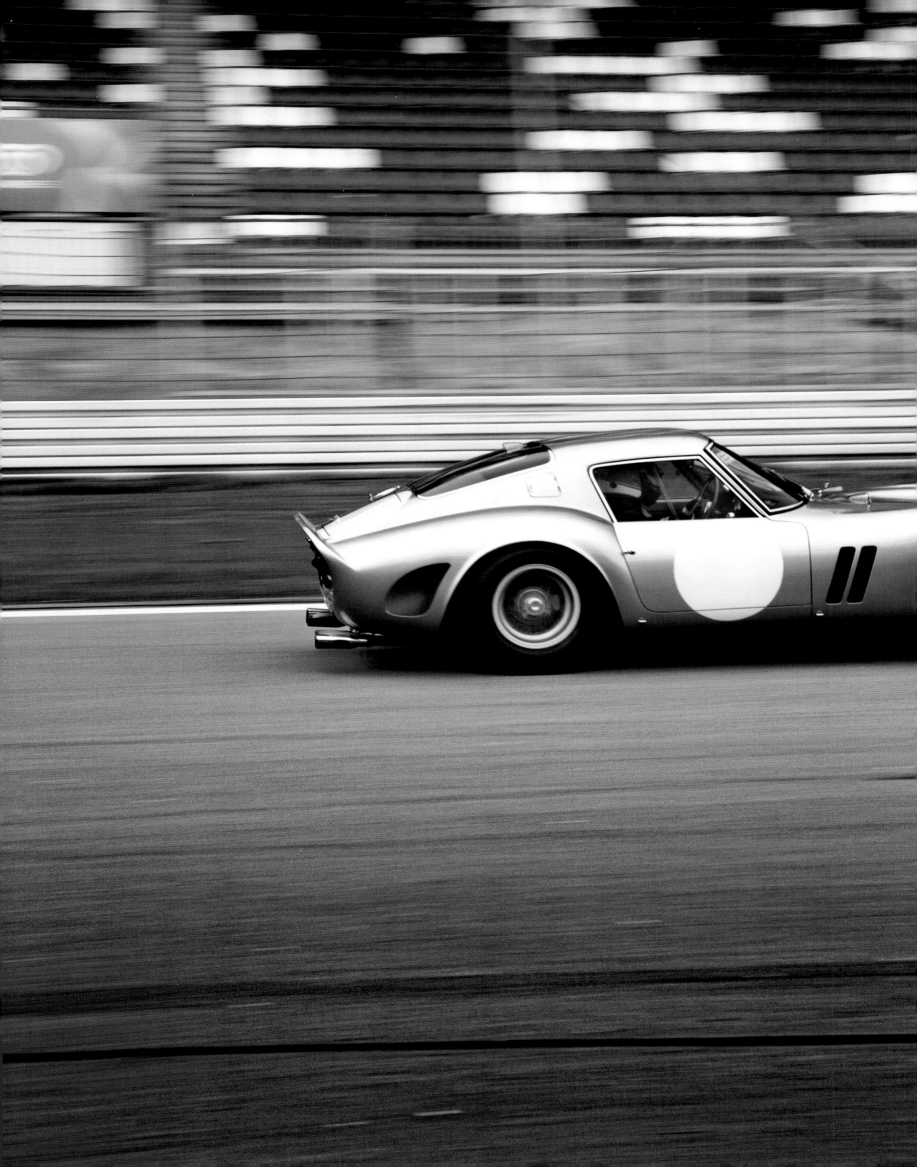

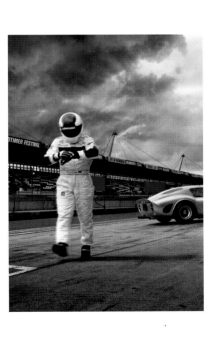

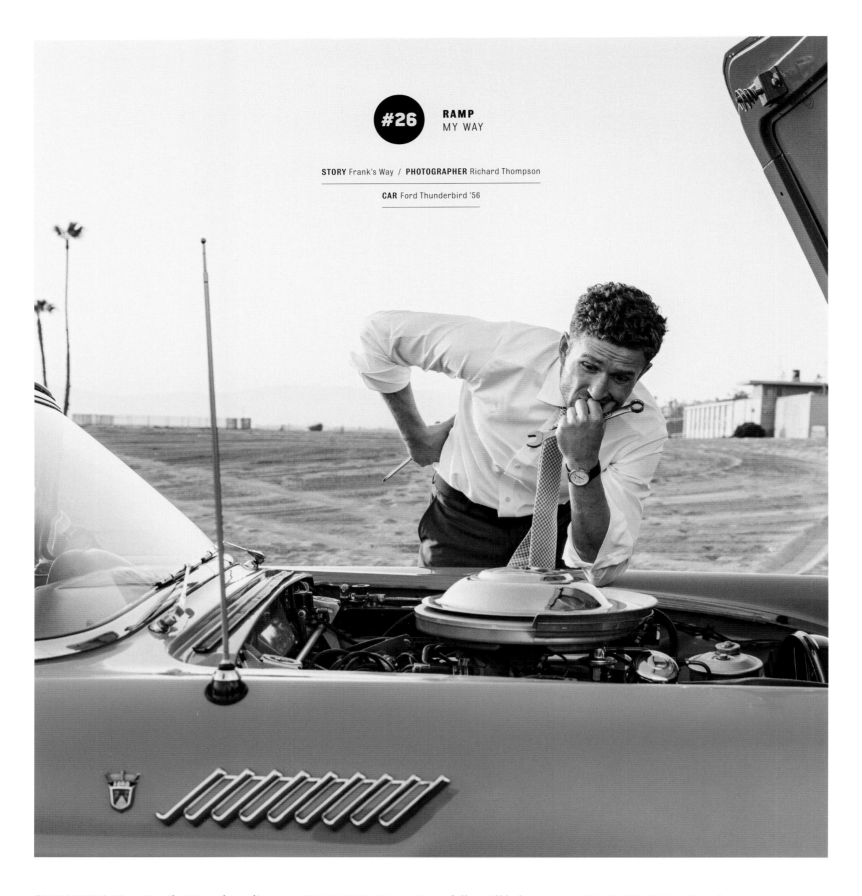

OL' BLUES CAR — Es gibt Menschen, die glauben, dass Elvis nach wie vor lebt. Sollen sie. Wir wissen, dass „The Voice" nie verstummt ist. Aber wie macht man die Stimme von Frank Sinatra sichtbar? Mit einem himmelblauen 56er Ford Thunderbird, mit dem auch Ol' Blue Eyes L.A. zu seiner Lady gemacht hätte.

OL' BLUES CAR — Some folks still believe that Elvis is alive. We say, let 'em. All we can say for sure is that "The Voice" never went silent. That said, is there any way to visualize the voice of Frank Sinatra? Well, how about a sky blue '56 Thunderbird? When it comes to Ol' Blue Eyes, L.A. would've been his lady in that one.

OL' BLUES CAR — Il y a des gens qui croient qu'Elvis est encore vivant. Eh bien, qu'ils continuent ! De notre côté, nous savons que « The Voice » ne s'est jamais tue. Mais comment matérialiser la voix de Frank Sinatra ? Avec une Ford Thunderbird bleu clair de 1956, dans laquelle Ol' Blue Eyes, le crooner aux yeux bleus, aurait sans doute subjugué sa lady, L.A.

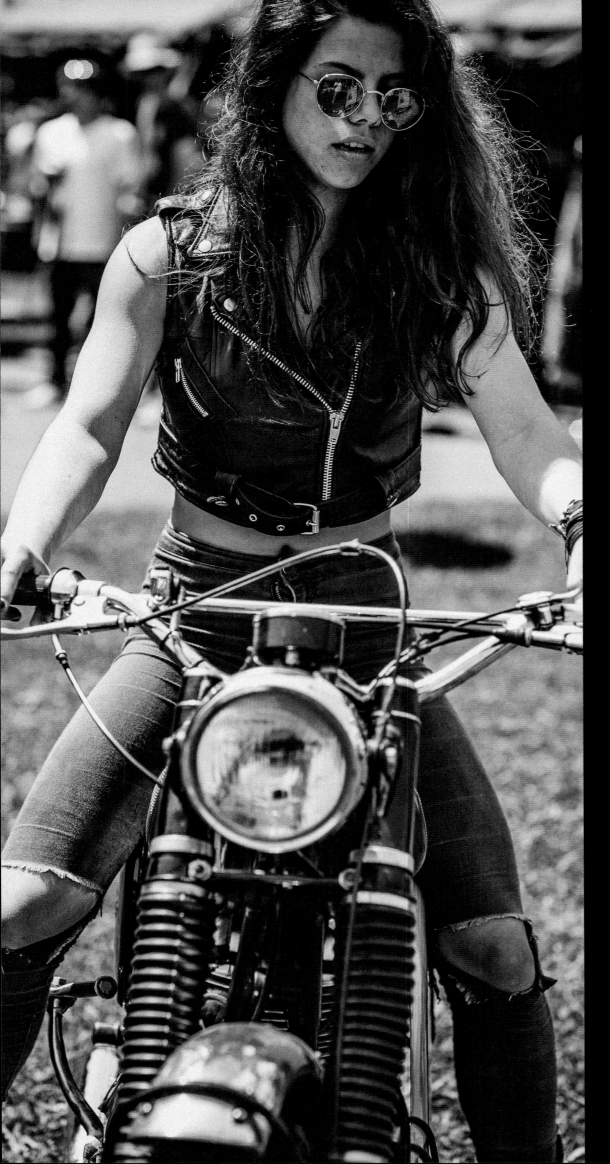

EINE PORTION ABENTEUER — Das Glück der 6oer im Heute. Autos. Motorräder. Musik. Surfen. Das ist Wheels & Waves. Bei diesem Festival geht es um die Portion Freiheit und Abenteuer, die wir zum Leben brauchen. Eine nostalgische Sehnsucht. Festgehalten in Fotografien, die Geschichten erzählen.

————

DOSE OF ADVENTURE — It's the Spirit of the Sixties today. Cars. Bikes. Music. Surfing. It's Wheels & Waves. This festival is all about catching a healthy dose of freedom and adventure, the kind we could all use to enrich our lives. It's a nostalgic trip unlike any other—captured in images with stories all their own.

————

UN ZESTE D'AVENTURE — Le bonheur des sixties transposé au présent : autos, motos, musique et surf au festival Wheels & Waves, qui incarne la part de liberté et d'aventure dont nous avons tous besoin pour vivre. Photos nostalgiques d'une époque épique.

RAMP
ALL YOU
CAN WISH

STORY Wheels and Waves / **PHOTOGRAPHER** Laurent

Nivalle / **CAR** Diverse Customized Bikes & Cars

DIE STADT DER TAUSEND BILDER —
Mit einem Infiniti quer durch New
York, von der Bronx nach Brooklyn.
Tausend Eindrücke, tausend kleine
Abenteuer. Im Layout haben wir es
nicht ganz geschafft, tausend Motive
zu zeigen, aber 65 waren es trotzdem.
Und damit mehr als in jeder anderen
ramp-Geschichte.

CITY OF A THOUSAND PICTURES —
Driving an Infiniti straight thru
NYC, from the Bronx to Brooklyn.
That translates into a thousand
impressions and a thousand little
adventures. We may have ended
up short of presenting a thousand
images in our layout, but we did
manage to squeeze in 65 of them.
That's more than we've ever pre-
sented in any other ramp story.

LA CITÉ AUX MILLE IMAGES —
Traverser New York en Infiniti, du
Bronx à Brooklyn. Mille impressions,
mille petites aventures. Sur la ma-
quette, nous n'avons pas tout à fait
réussi à réunir mille images. Il y en
a 65, quand même. Ce qui est déjà
plus que dans tout autre article de
ramp.

RAMP
HELDEN

STORY Catch Me If You Can / **PHOTOGRAPHER** Justin Leighton

CAR Infiniti G37 Coupé Sport

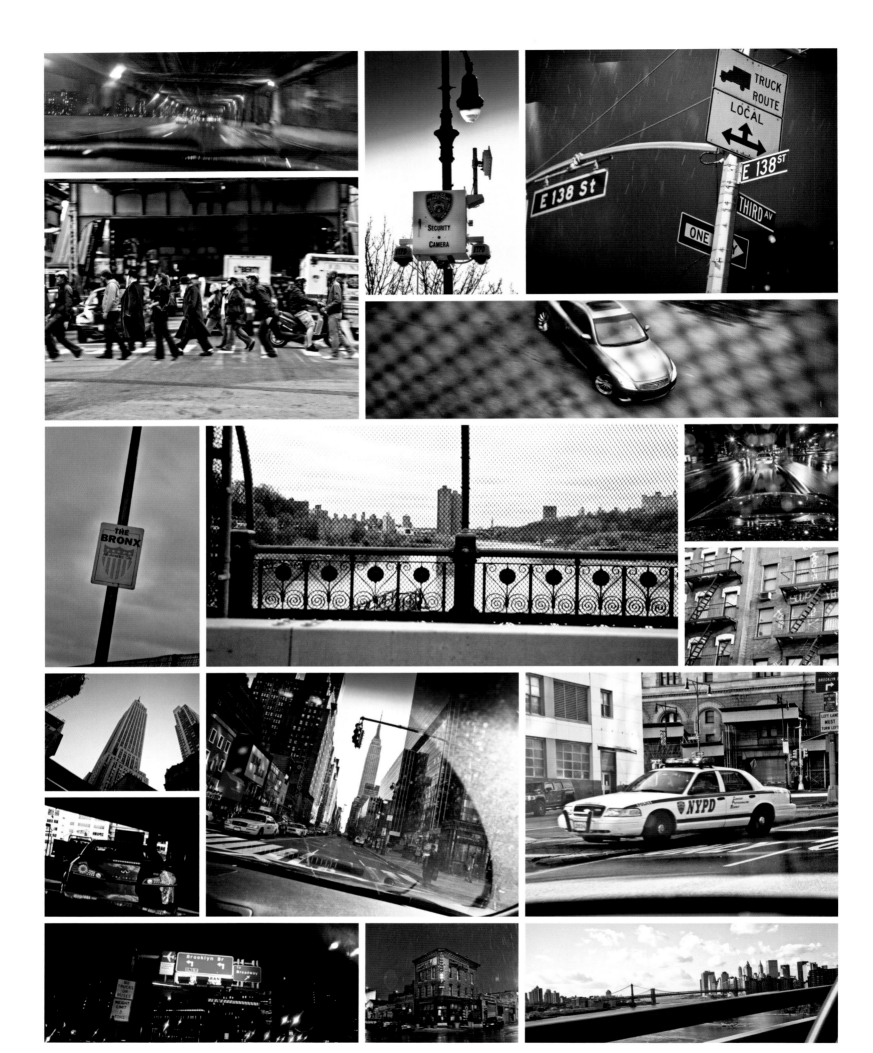

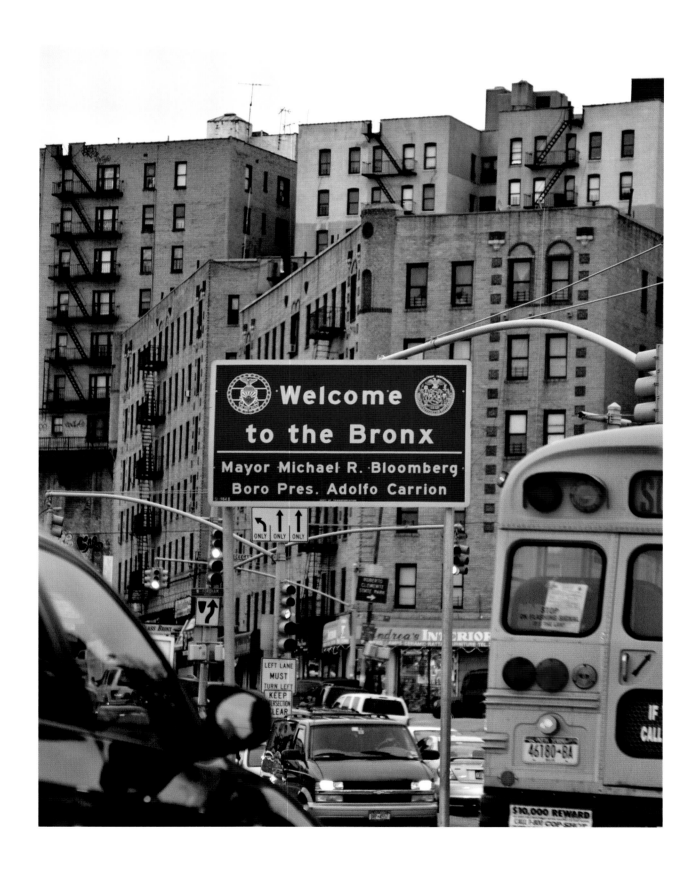

RAMP
SOME LIKE IT HOT

STORY Ausfahrt mit El Cam / PHOTOGRAPHER Laurent Nivalle

CARS El Camino and Others

POOLPARTY — Fotograf Laurent Nivalle fährt mit Kamera, ein paar coolen Autos und seinen Freunden einen Roadtrip durch Kalifornien. Ziel: eine Geburtstagfeier mit der Freundin in einem Pool mitten in der Wüste. Sensationelle Bilder! Nur die Freundin im Pool gab es nicht als Motiv.

POOL PARTY — Photographer Laurent Nivalle takes his camera and his entourage in a couple of cool cars on a road trip through California. Their destination: a birthday party with his girlfriend in a pool out in the middle of the desert. Talk about some sensational pix! Girlfriend in pool not included.

FÊTE AQUATIQUE — Le photographe Laurent Nivalle entame un road-trip à travers la Californie avec son appareil photo, quelques voitures sympas et des amis. L'objectif : une fête d'anniversaire avec sa petite amie dans une piscine, en plein désert. Des photos extraordinaires ! Mais malheureusement, aucune de la petite amie dans la piscine.

KULTUR? GUT! — Dieser Porsche zählt zu unserem Kulturgut. Leichtbau, Entenbürzel, luftgekühlter Boxermotor. Genau wie das Roadmovie. Und deshalb ist die Verbindung aus Porsche samt Anhängerkupplung und Wohnwagen wohl die unabhängige Ausdrucksmöglichkeit für den modernen Freiheitsgedanken.

CULTURE ROCKS! — This Porsche is part of our cultural heritage, owing to its lightweight construction, 'duck-tail' rear spoiler, and air-cooled boxer engine. Just like a certain road movie. If combining a Porsche, trailer hitch, and trailer isn't the ultimate independent expression of the modern ideal of freedom, what is?

BIEN CULTUREL ! — Légèreté, aileron « queue de canard », moteur boxer refroidi par air : cette Porsche fait partie de notre patrimoine culturel, au même titre que le « road movie ». Aussi l'association d'une Porsche équipée d'une boule d'attelage et d'une caravane forme-t-elle la traduction branchée de l'idée de liberté, revisitée avec modernité.

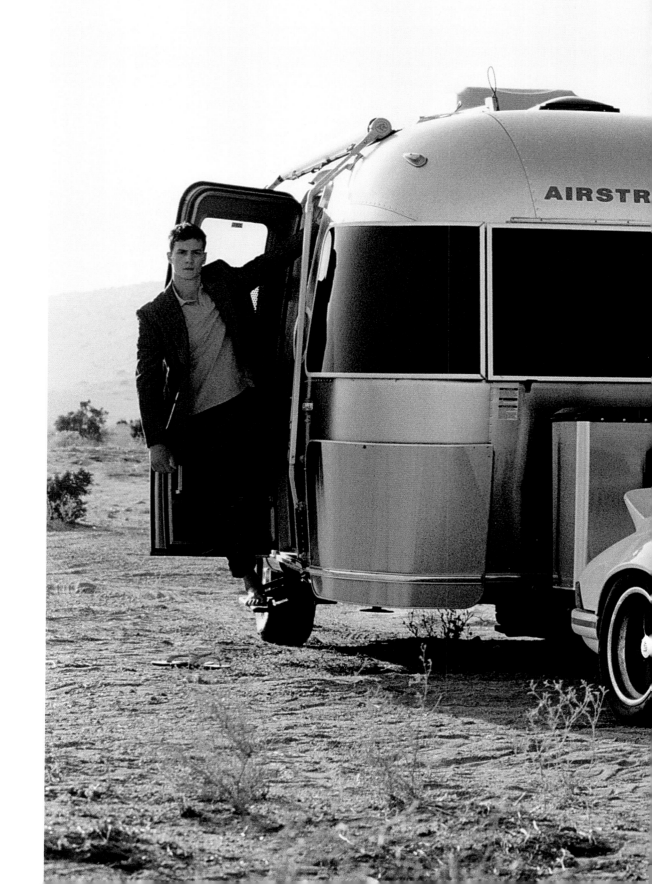

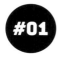

RAMP
JETZT NEHMEN
WIR DIE SACHE
MAL SELBST IN DIE
HAND (LET'S GO!)

#01

STORY Go Your Own Way / **PHOTOGRAPHER** Todd Cole

CAR Porsche Carrera RS 2.7

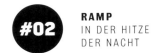
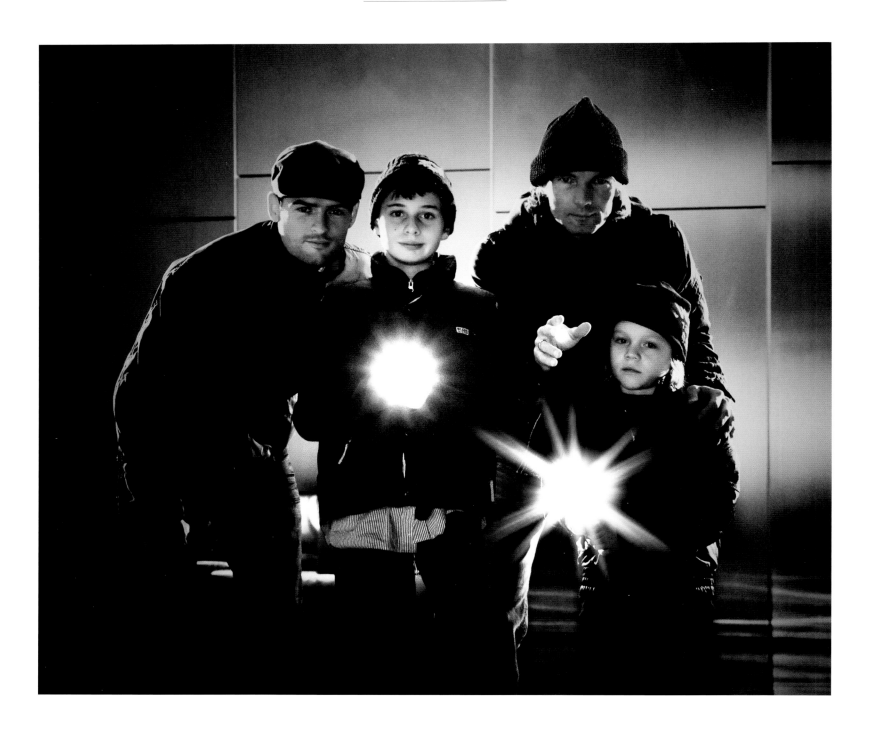

MUSEUMSREIF — Neues Museum und immer die gleichen, hell ausgeleuchteten Bilder. Langweilig, dachten wir uns. Und haben eben nachts vorbeigeschaut. Da das Museum da aber geschlossen war, mussten wir einbrechen. War nicht so einfach, aber die Bilder waren es wert.

HITTING THE MUSEUM — There it was, a new museum featuring more of the same: a brightly lit collection of pictures. Thinking how lame it was, we decided to pay a visit there during the night. Finding the place locked, we had no choice but break in. It wasn't easy, but the pix made it all worthwhile.

DIGNES D'UN MUSÉE — Un nouveau musée et toujours les mêmes images, bien éclairées. Ennuyeux, à nos yeux. Nous sommes donc allés y faire un tour la nuit. Le musée était fermé et nous avons dû y pénétrer par effraction. Ce qui n'était pas une mince affaire. Mais les photos en valaient définitivement la peine.

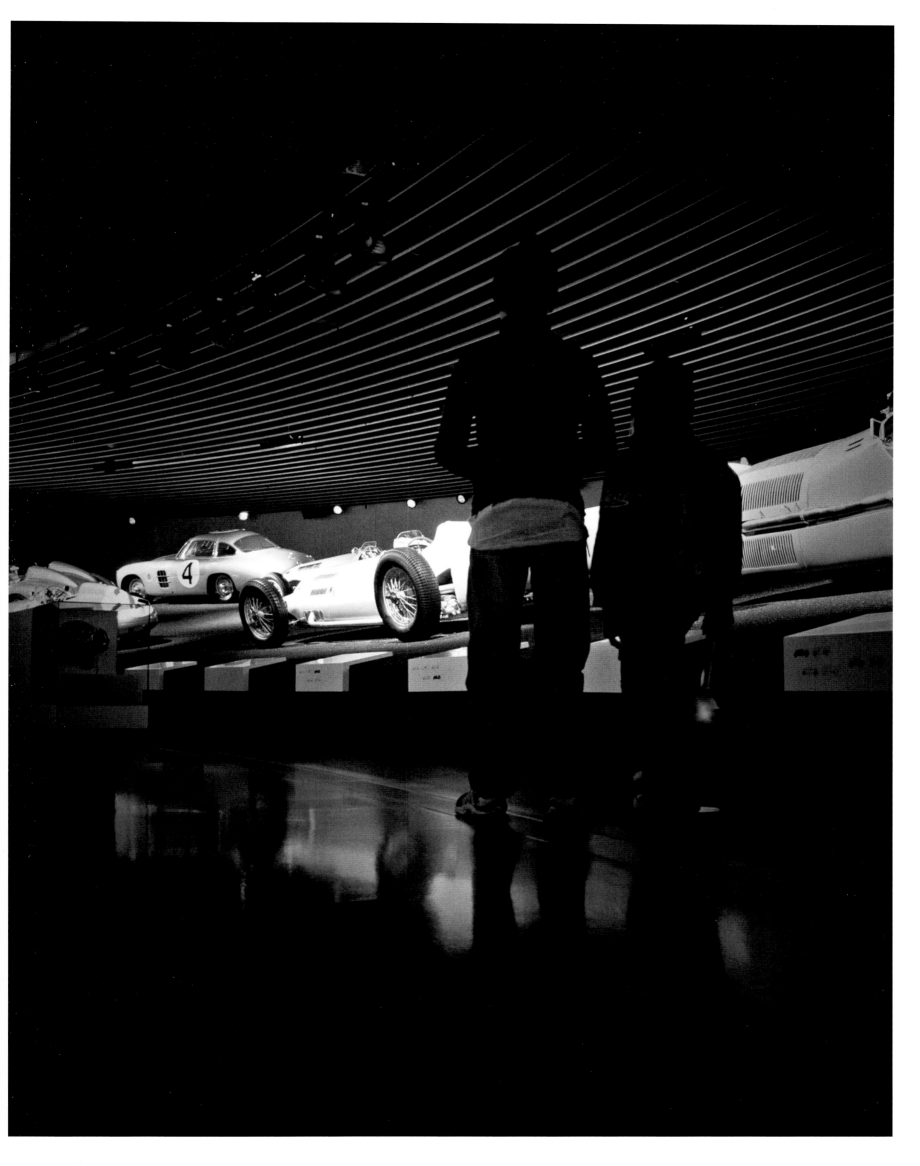

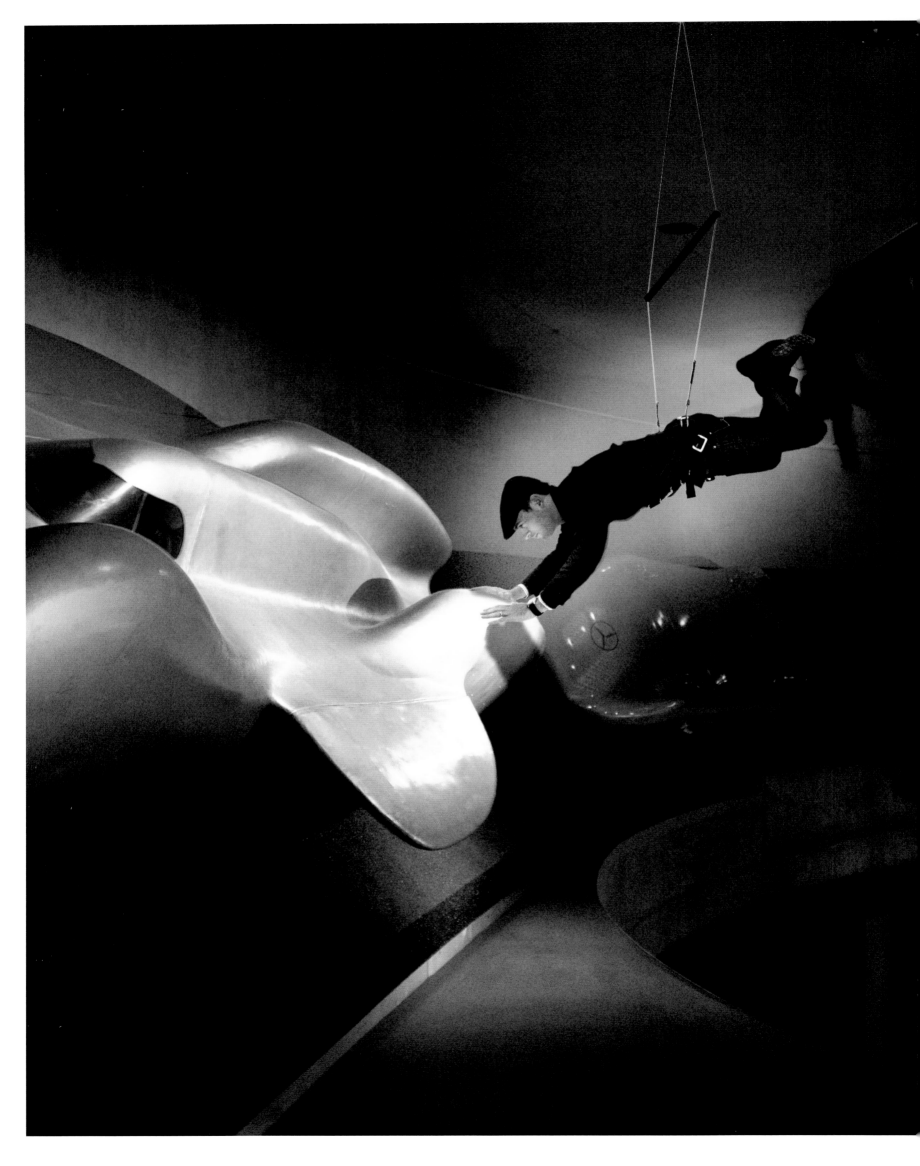

IN WÜRDE ALTERN — Halten wir es in Sachen Facelifting doch einfach mit Clint Eastwood. „Dann würde ich ja alle diese großartigen Falten zerstören." Wollen wir nicht. Erst recht nicht, wenn es sich um einen aquamarinfarbenen Porsche 356 A im Originalzustand handelt. Damit schauen wir bei dem „Willi seinen Kultkiosk" in Essen vorbei. Denn der Willi hat auch Falten. Und weiß in Würde zu altern.

AGEING GRACEFULLY — Regarding the issue of face lifting, Clint Eastwood said it best, "I'd hate to lose all those beautiful wrinkles." That's right. If it ain't broke, don't fix it. Especially when you're dealing with a teal-colored Porsche 356 A in original mint condition, which we had the privilege of driving. We decided to take it out to 'Willi's Kultkiosk,' a well-known and popular newsstand in the city of Essen. See, Willi has wrinkles too. And he knows how to age gracefully.

VIEILLIR DIGNEMENT — En matière de chirurgie esthétique, adhérons aux mots de Clint Eastwood : « Ça serait dommage de détruire ces superbes rides. » En effet, ce n'est pas l'objectif. Surtout pas quand il s'agit d'une Porsche 356 A aigue-marine dans son état d'origine. Avec elle, nous partons voir le « kiosque culte de Willi » à Essen. Car Willi, lui aussi, a des rides. Et il sait vieillir dignement.

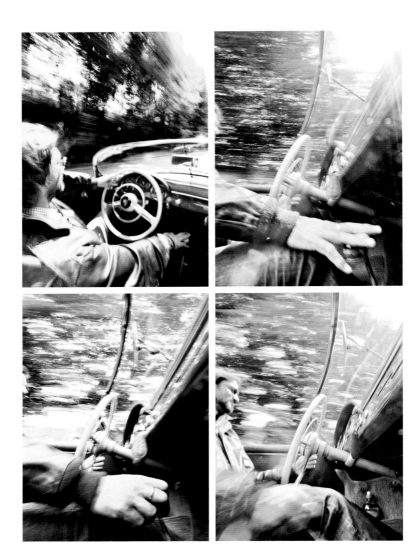

RAMP
FAMILY AFFAIRS

STORY Sternenreise / **PHOTOGRAPHER** Steffen Jahn

CAR Porsche 356A Speedster

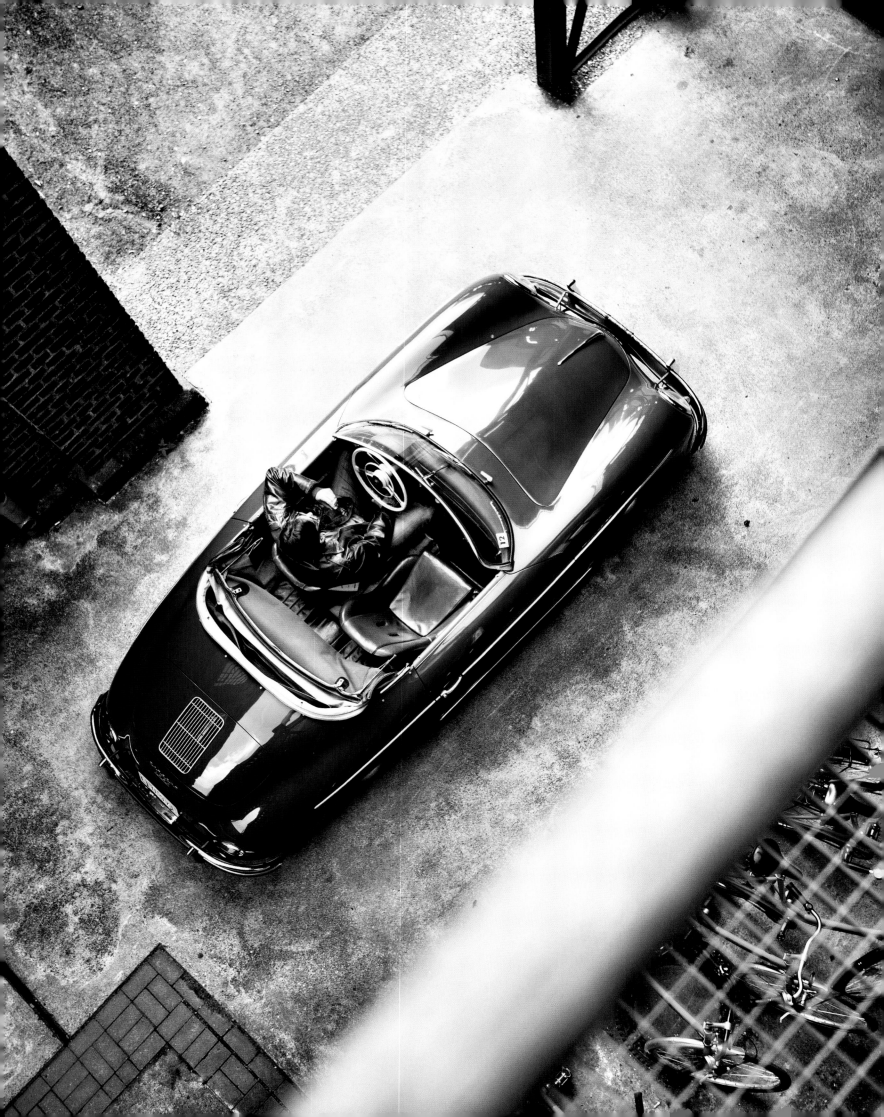

DER DEN WEG EBNET — Ein Traceur ist ein Mensch, der sich im urbanen Umfeld durch einen Parkour fortbewegt und Hindernisse zu kleinen Unebenheiten in der Stadtlandschaft degradiert. Wörtlich übersetzt bedeutet Traceur: „Der den Weg ebnet". Wenn sich dann noch die „Seele der Bewegung" in Gestalt der Mazda-Formensprache KODO hinzugesellt, wird Bewegung in der Betrachtung von ramp zum Fest der Sinne.

ONE WHO TRACES — Whenever we talk about a traceur, we refer to an urban parkour expert with the tendency to overcome obstacles by reducing them to small bumps in the urban landscape. The literal meaning of traceur is "One who traces." Add to that "Soul of Motion" in the form of KODO—Mazda's design language— motion, from a ramp perspective, indeed becomes a feast for the senses.

CELUI QUI OUVRE LA VOIE — Le traceur pratique l'art du déplacement en milieu urbain sur le Parkour, pour transformer les éléments de la ville en obstacles à franchir. Littéralement, traceur signifie « celui qui ouvre la voie », en se déplaçant à grande vitesse. Lorsque s'ajoute à cela « l'âme du mouvement » du KODO, le langage stylistique de Mazda, le mouvement observé par ramp devient un enchantement pour les sens.

RAMP
ZURÜCK IN DIE
ZUKUNFT

STORY Vorstadthelden

PHOTOGRAPHER Steffen Jagenburg / **CAR** Mazda 6

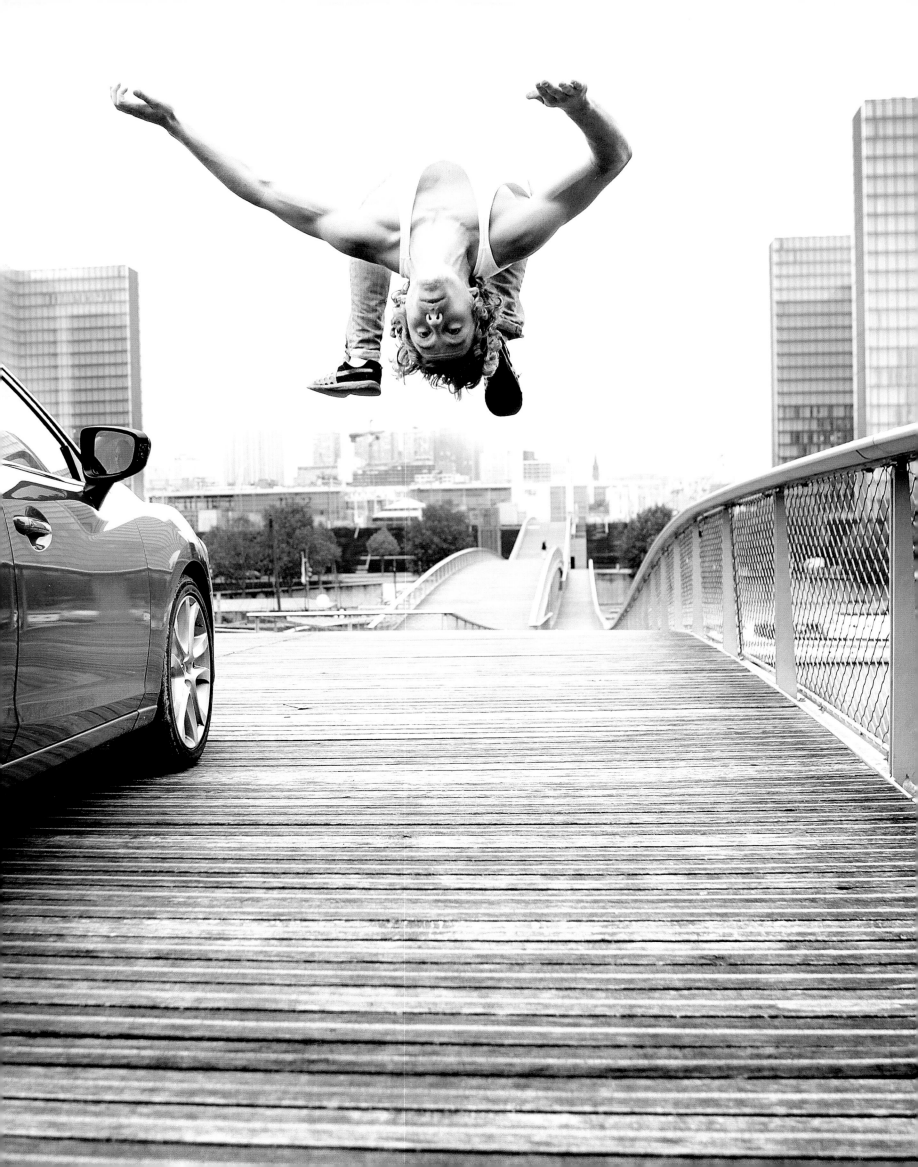

BORN TO RUN — Das Bike ist das Ziel. Oder eben die Straße. Mehr braucht es nicht für eine gute Story. Eine Harley wäre natürlich nicht schlecht. Oder eine Triumph. Oder beides. Dazu die der Haltung angemessene lässige Kleidung. Und über allem schwebt dieser prickelnde Duft von Kettenfett. Weil, hey, Baby, we were born to run.

BORN TO RUN — The bike is the place to be. Or is it the open road? Truth is, you don't necessarily need either one for a good story. Of course, it couldn't hurt having a Harley. Or a Triumph. Or both. Add to that the devil-may-care outfits reflecting the overall attitude, dominated only by the raw smell of chain grease hanging in the air like a lazy cloud. Well, hey, baby, we were born to run, remember?

BORN TO RUN — Le thème, c'est la moto. Ou bien la route. Il n'en faut pas plus pour faire un bon article. Une Harley, ça ne serait pas mal, bien sûr. Ou une Triumph. Ou même les deux. Avec la tenue décontractée adaptée à la posture. Le tout dans l'odeur âcre de la graisse pour chaînes. Parce que baby, we are born to run.

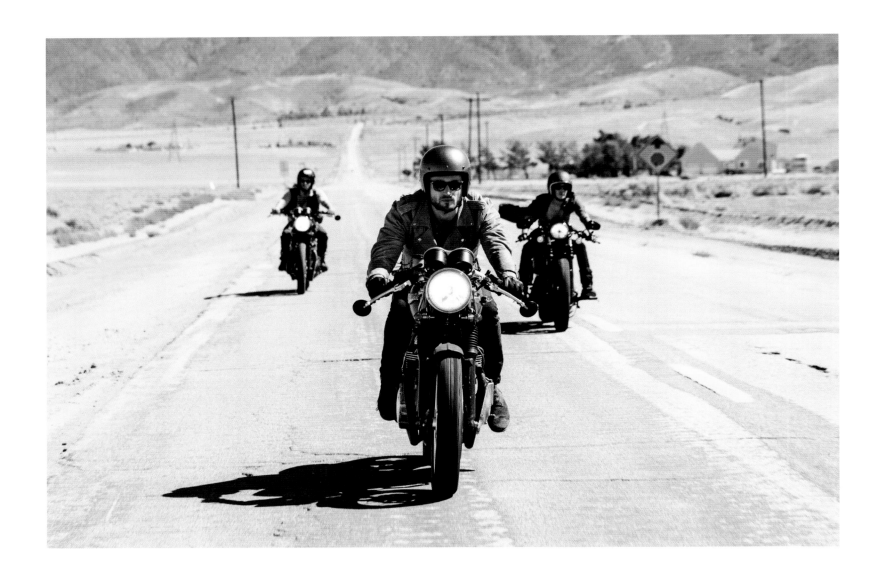

#23 **RAMP** ENDSTATION SEHNSUCHT

STORY Highway to Well / **PHOTOGRAPHER** Scott G. Toepfer

BIKES Triumph & Harley-Davidson, diverse motorbikes

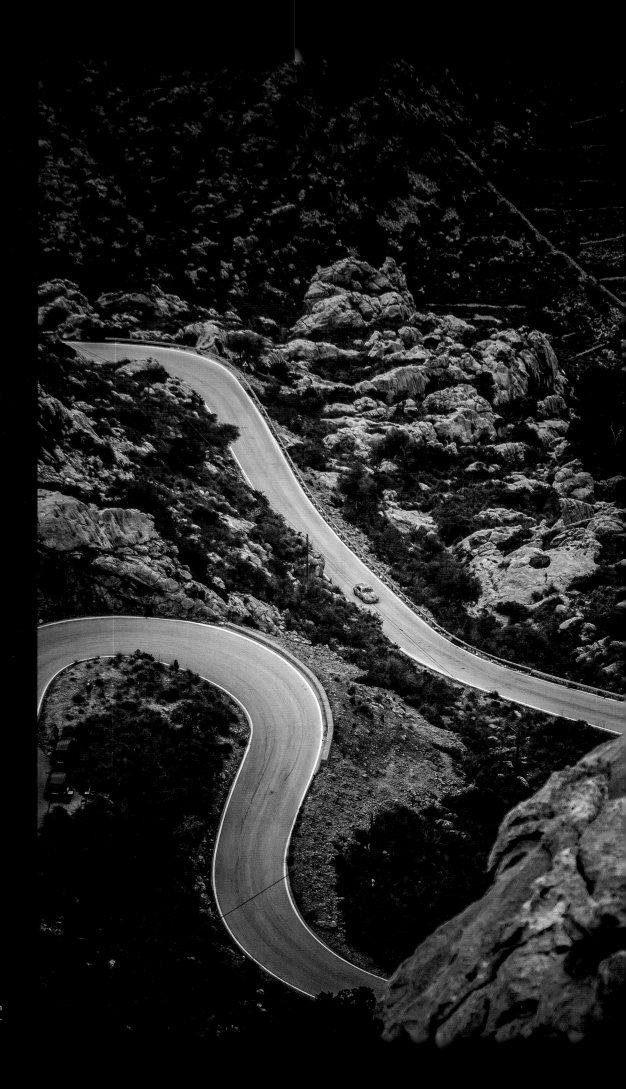

KLASSISCHE KNOTENLEHRE —
Es wird gleich sehr schnell sehr
steil zugehen. Die Krawattenkurve
trägt ihren Namen nicht umsonst.
Mit 270 Grad knotet sie sich in Mal-
orcas Berge. Eine Herausforderung
für die E-Types, die AC Cobra, die
Ferrari oder die unzähligen Porsche
der Oris Rally Clásico Isla Mallorca.
Und ein Fest für den Fotografen
Roman Kuhn.

THE CLASSIC KNOT TYING LESSON —
Any second now, they should see
a very steep incline looming ahead.
After all, it wasn't by accident that
the notorious 'Nus de sa Corbata'
got its name 'tie knot.' With its 270-
degree, it snakes its way through the
mountainous landscape of Mallorca/
Spain. It presents a challenge unlike
any other to all the E-Types, AC Cobra,
Ferraris, and countless Porsches
participating in Oris Rally Clásico
Isla Mallorca. At the same time,
it proved a feast for photographer
Roman Kuhn.

**APPRENTISSAGE CLASSIQUE DES
NŒUDS —** Brusquement, la montée
se fait très abrupte. Le « nœud de
cravate » porte bien son nom. Il trace
une boucle à 270 degrés dans les
montagnes de Majorque. Un défi pour
les types E, la AC Cobra, la Ferrari et
les innombrables Porsche de la Oris
Rally Clásico Isla Mallorca. Et un
vrai régal pour le photographe Roman
Kuhn.

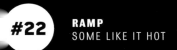
STORY 270 Grad und weiter / **PHOTOGRAPHER** Roman Kuhn

CARS Diverse makes & models

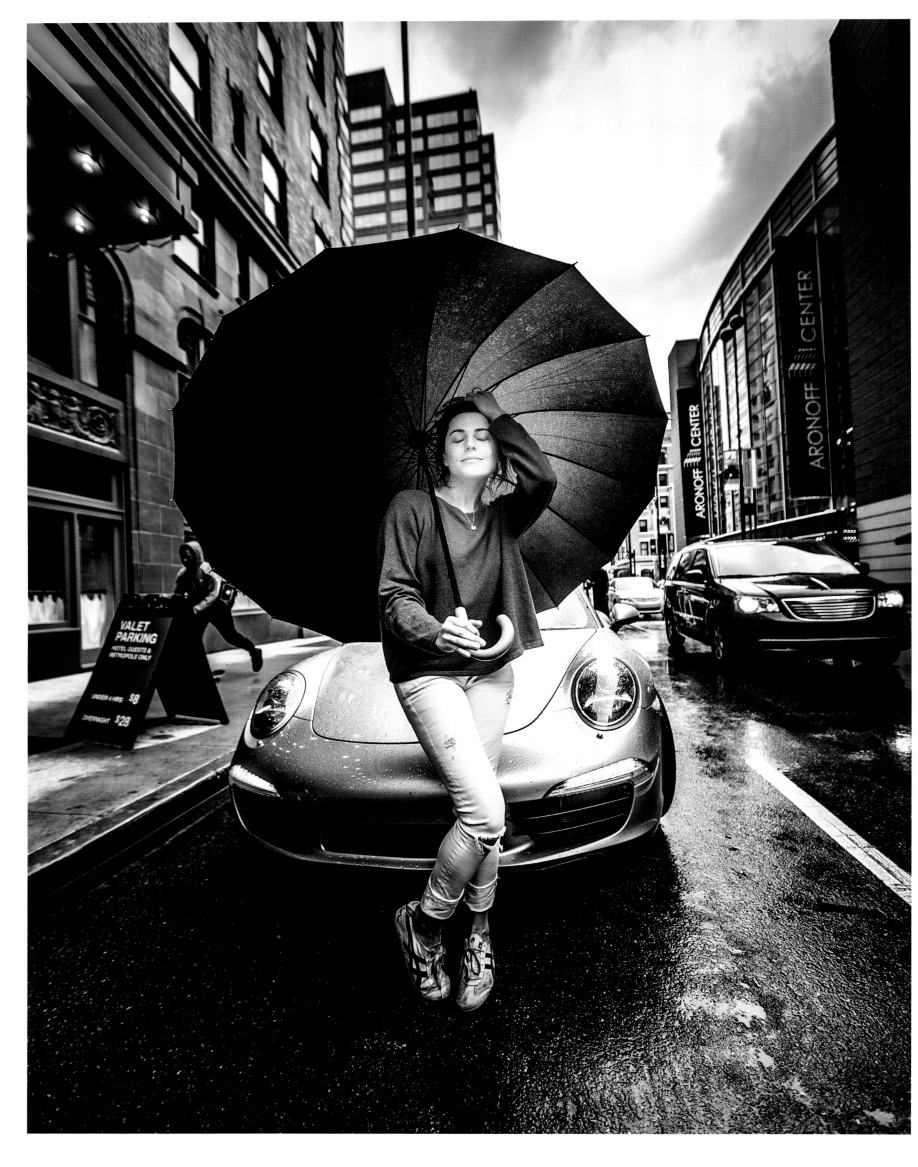

SUPER PLUS — Antje Traue machte als Faora Superman in „Man of Steel" das Leben schwer. Unserem Fotografen Roman Kuhn hingegen machte sie es leicht und nahm ihn einfach mit auf ihren Roadtrip quer durch Amerika im Porsche 911 Cabrio. Wohin die Reise ging? Hollywood natürlich!

SUPER PLUS — Assuming the role of Faora in "Man of Steel," German actress Antje Traue makes life difficult for Superman. On the other hand, she sure made it easy for our photographer Roman Kuhn by simply taking him along on her road trip straight through the United States in a Porsche 911 Cabriolet. Destination? Hollywood, of course!

SUPER PLUS — Dans l'Homme d'Acier, Antje Traue, alias Faora, rend la vie dure à Superman. Pour notre photographe Roman Kuhn, au contraire, elle a facilité les choses, l'emmenant dans une virée à travers les États-Unis en Porsche 911 Cabriolet. Destination finale ? Hollywood bien sûr !

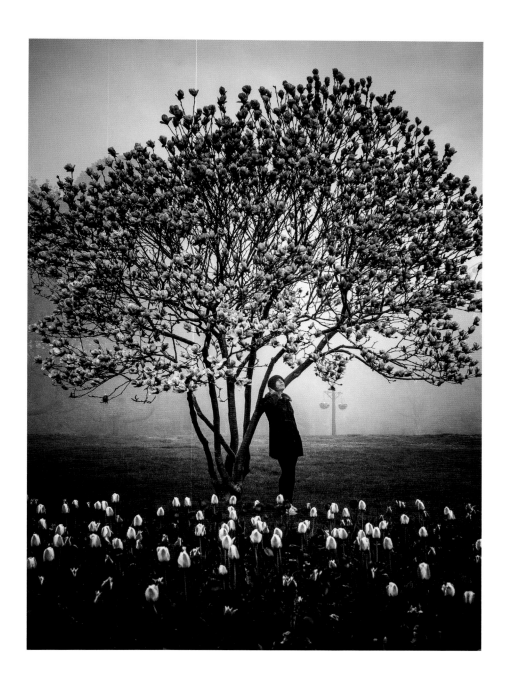

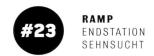

#23 **RAMP**
ENDSTATION
SEHNSUCHT

STORY This Is Not America / **PHOTOGRAPHER** Roman Kuhn

CAR Porsche 911 Cabrio (991)

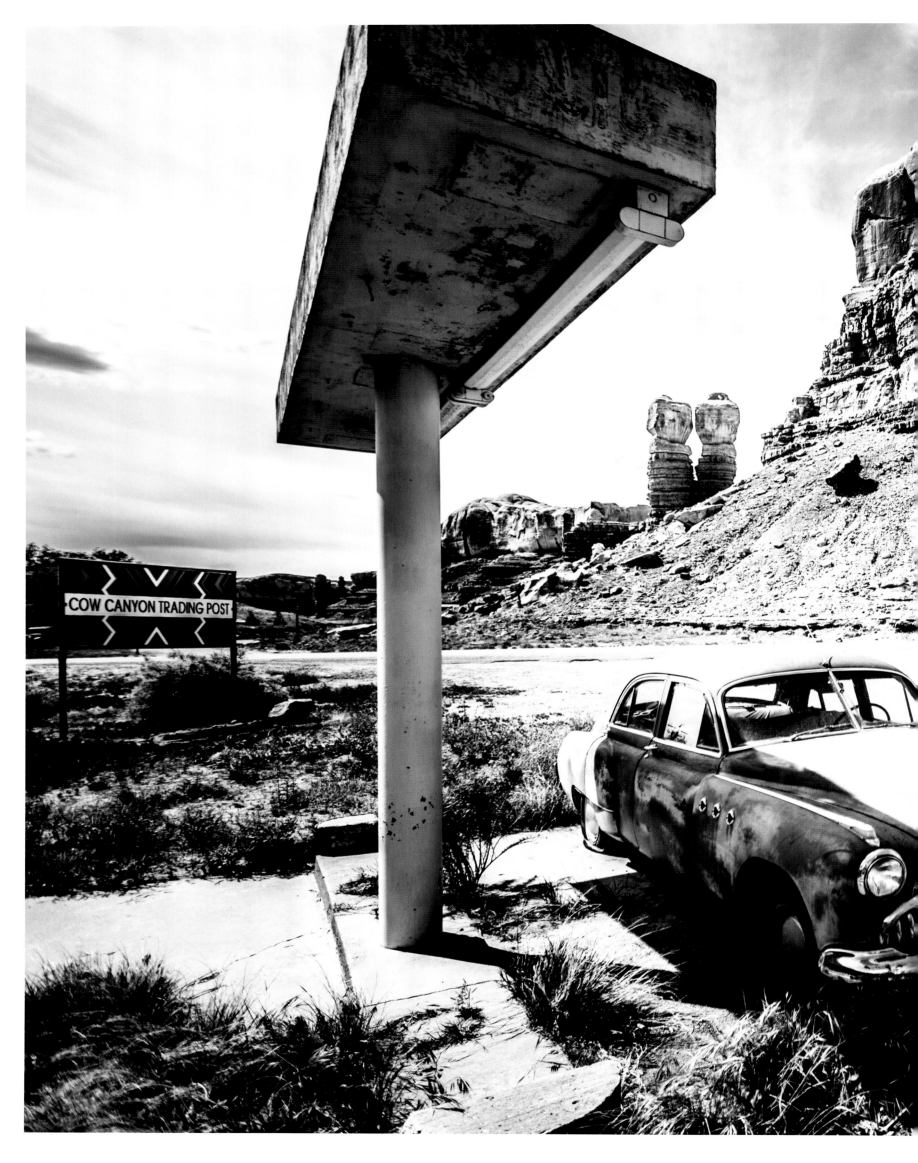

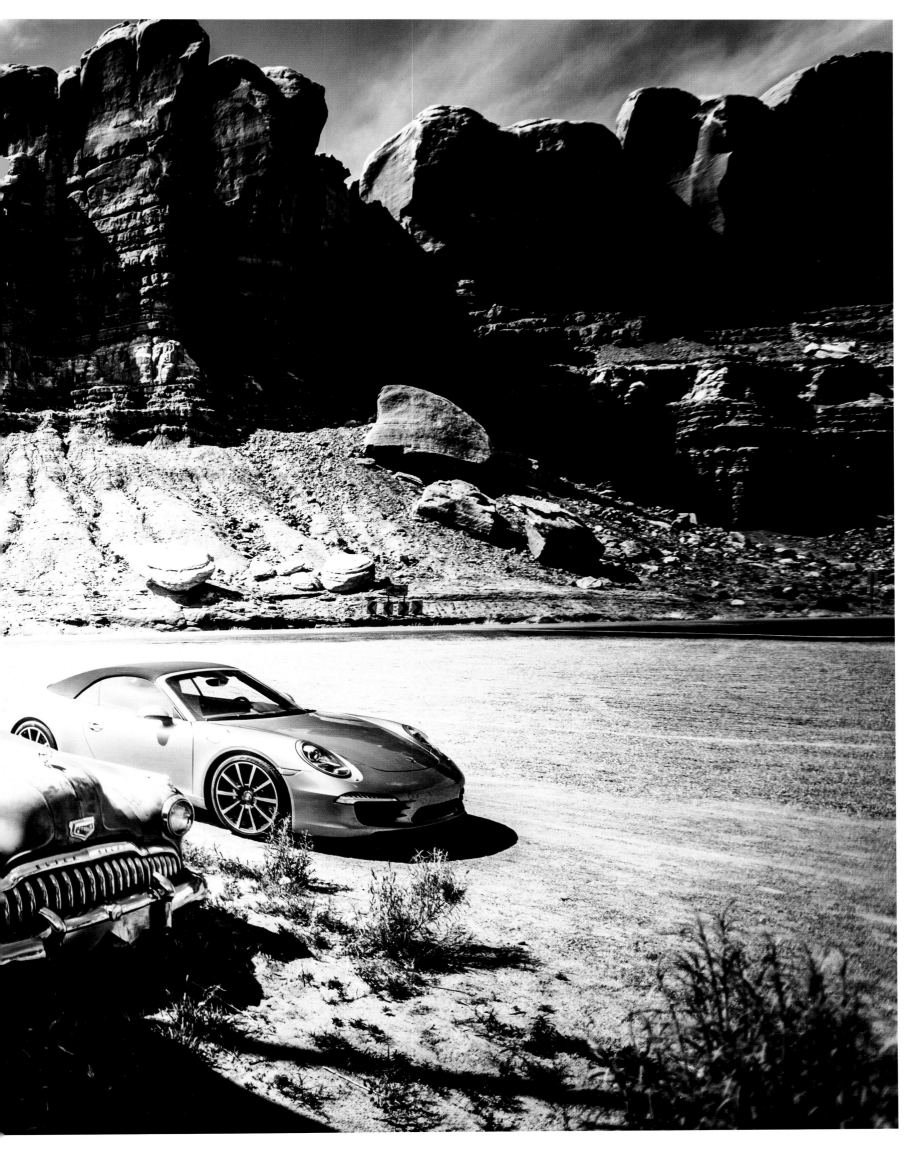

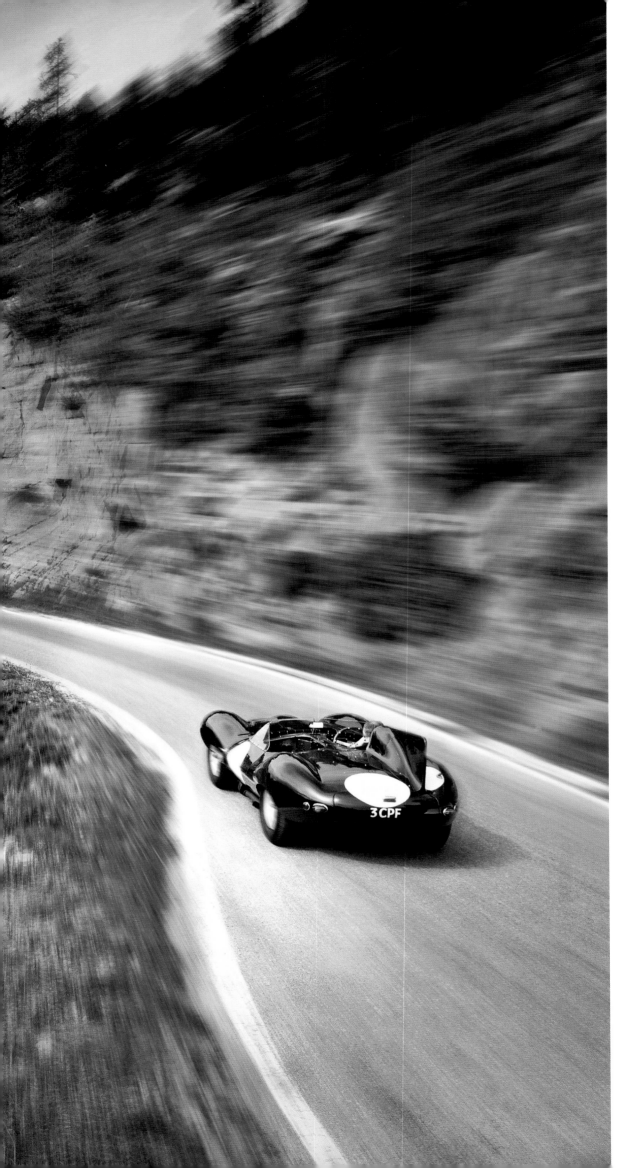

BRITISCH FÜR SCHÖN — Die Endlichkeit des Autos ist in seltenen Fällen eine Tragödie. In manchen Fällen aber geht sie gepflegt in eine gefühlte Unendlichkeit über. Wie bei diesen zwei britischen Exemplaren zum Beispiel. Verortet in der Schönheit der Berge fanden wir so das perfekte Setting für dieses Zusammentreffen.

BRITISH FOR BEAUTEOUS — Seldom does the finite nature of cars present a tragedy. At other times, however, that same finite nature presents itself—very well maintained—on its way into infinity, the kind that you feel more than anything else. Take these two British specimens, for example. Located within the serenity of the mountains, we also found the perfect setting for this little get-together.

LA BEAUTÉ STYLE « BRITISH » — La finitude d'une automobile est rarement une tragédie. Dans certains cas cependant, elle accède, bien entretenue, à une heureuse éternité. Comme ces deux spécimens britanniques, par exemple. Dans la splendeur des montagnes, nous avons trouvé le cadre parfait pour cette rencontre.

#04 **RAMP**
NACH DEM AUTO?

STORY Six Appeal / **PHOTOGRAPHERS** outtofocus –

David Breun & Martin Grega / **CARS** Jaguar D-Type

XKD406 vs. Aston Martin DB3 S/9

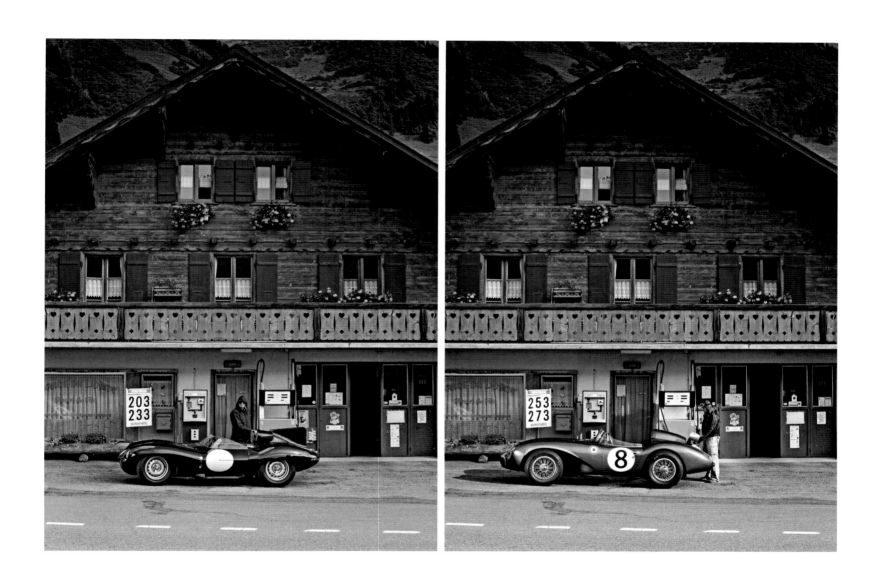

Drei Minuten lagen zwischen diesen beiden Aufnahmen –
und in dieser Zeit stieg der Benzinpreis um 25 Prozent.

All but a three-minute interval between these two photos—
and in that time the price of gasoline went up by 25 percent.

Trois minutes séparent ces deux prises de vue – et dans
l'intervalle, le prix de l'essence a augmenté de 25 %.

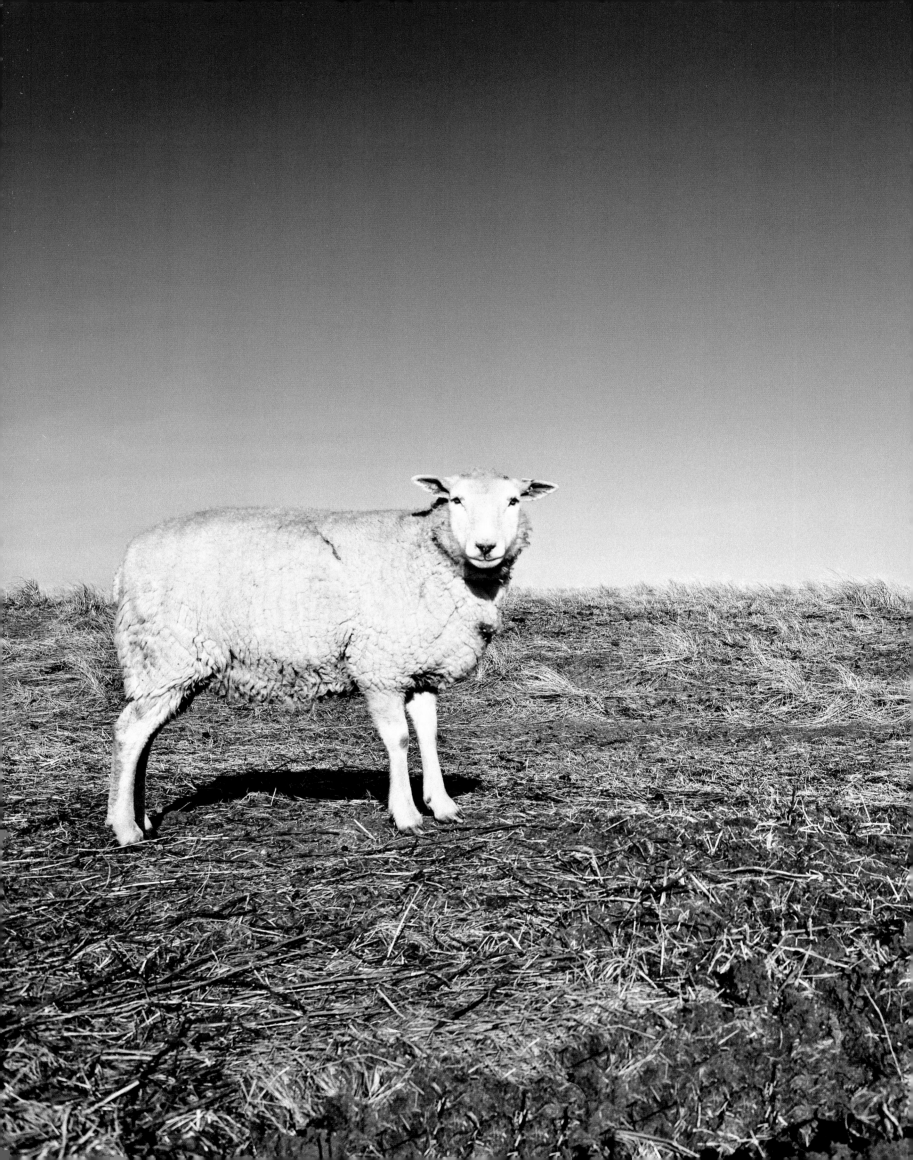

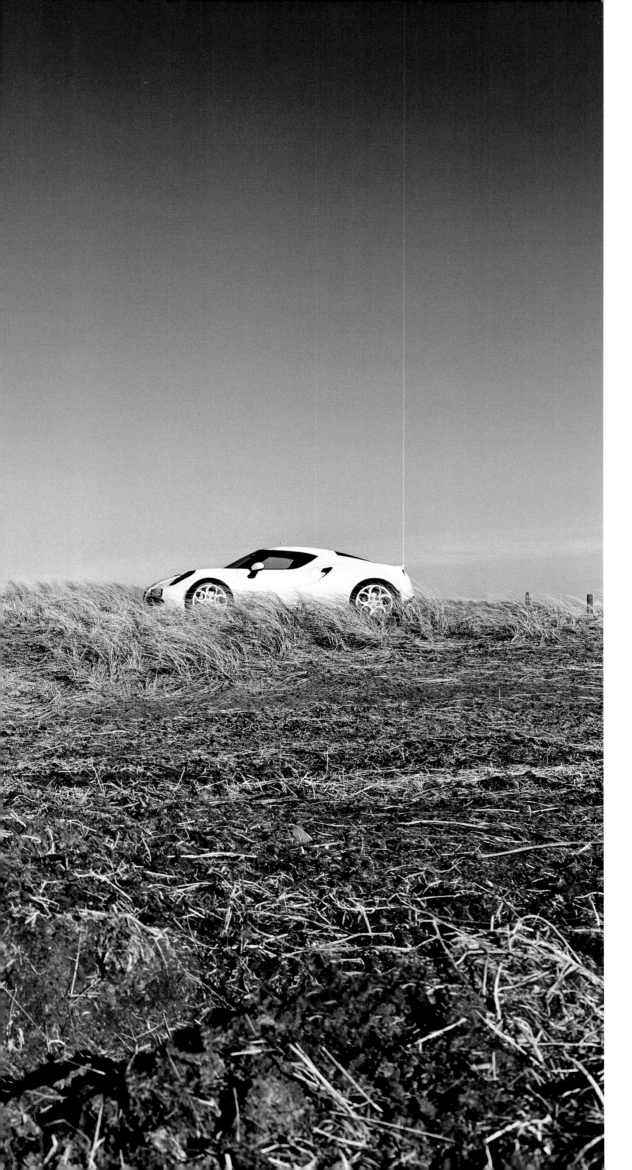

ENTSCHLACKUNGSKUR — Wenn Alfa Romeo sich mit seinem Supersportwagen 4C einer Superentschlackungskur unterzieht und nebenbei eine geballte Verdichtung an Design, Technik, Aerodynamik und Fahrwerkskunst auf die Straße bringt, dann kann man schon mal die Strandfigur in Strandnähe testen. Wo? Sylt bietet sich wunderbar an.

TOTAL MAKEOVER — Given the total makeover Alfa Romeo has planned for its super sports car 4C in combination with numerous updates to design, technology, aerodynamic properties, and chassis prior to its launch, we already had the chance to test the new 4C in its new beach bod at a nearby beach. Which one? Well, the German island of Sylt appeared to be perfectly suited for the purpose.

CURE D'AMINCISSEMENT — Lorsque Alfa Romeo se soumet à une super-cure d'amincissement, avec sa super-4C tout en lançant sur les routes un concentré de design, de technologie, d'aérodynamique et d'art automobile, il peut se permettre d'exhiber son physique d'été sur une plage. Où ça ? À Sylt, bien sûr.

RAMP
MODERN TIMES

STORY Beauty Building / **PHOTOGRAPHER** Benjamin Pichelmann / **CAR** Alfa Romeo 4C

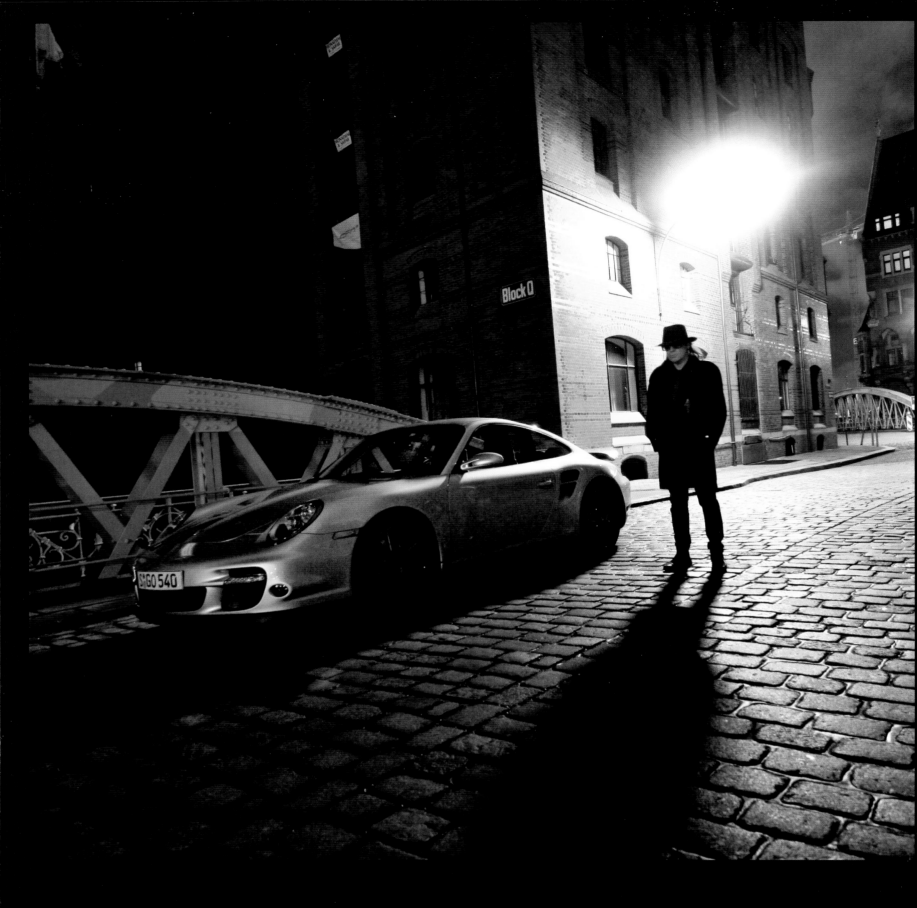

#06 **RAMP**
ES LEBE DER
SPORT!

STORY „Ich hab ne' Kondition wie ein Automatikgetriebe"

PHOTOGRAPHER Tine Acke / CAR Porsche 911 Turbo (997)

GUT DRAUF — Wie kommt Udo Lindenberg gut drauf? Mit dem Porsche natürlich. Schon seit jeher. Wenn es dann noch durch das geliebte Hamburg geht, bei Nacht, dann wird so ein Zusammentreffen schnell mal zur kreativen Jamsession und ramp-Freund Udo zeichnet noch rasch seinen Lindenberg-schen Käfig zur Rettung der Welt.

IN GOOD SPIRITS — What puts a German rock star like Udo Lindenberg in good spirits? His Porsche, of course. It's been that way pretty much since time immemorial. Whenever he cruises through his favorite place to be—his native Hamburg—at night, it's not uncommon for a get-together to turn into a creative jam session at the spur of the moment. Moreover, ramp supporter Udo will also render a quick drawing of his famous "Lindenberg's Cage for Saving the World."

DE BONNE HUMEUR — Comment Udo Lindenberg trouve-t-il l'inspiration dans la bonne humeur ? Avec une Porsche, bien sûr. Depuis toujours. Quand en plus, il traverse Hambourg, ville chère à son cœur, de nuit, la rencontre donne rapidement lieu à une jam-session créative. Udo, l'ami de ramp, dessine à toute vitesse la cage de sa chanson, pour sauver le monde.

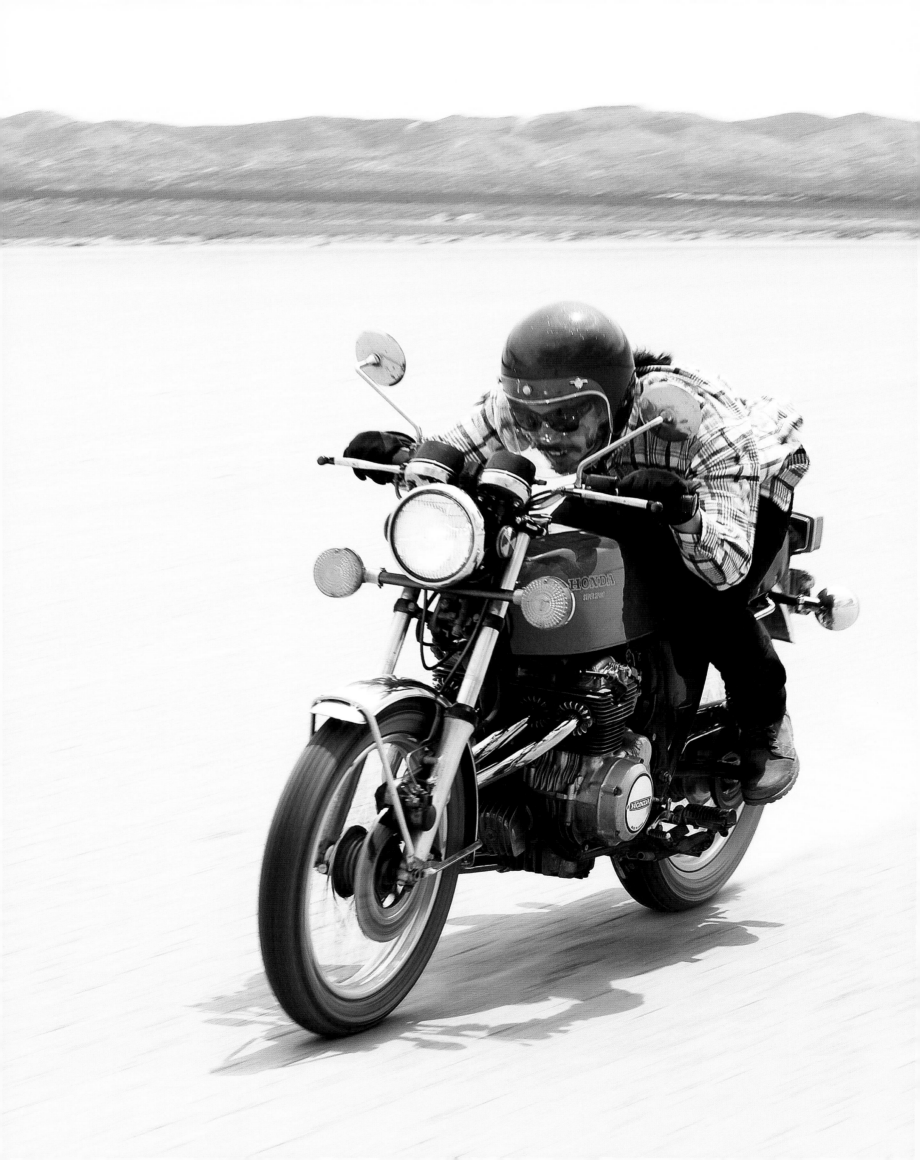

ALLES ANDERE ALS LANGWEILIG — Ob Salzwüste oder Schlammgrube – echten Bikern verdirbt nichts so schnell den Spaß. Sonnenbrille auf, Visier runter, Gas geben. Aber bitte nicht zurücklehnen auf der Honda. Wir wollen doch alles andere als langweilig sein. Fotograf Scott G Toepfer ist übrigens auch alles, aber sicher nicht langweilig. Check it out!

ANYTHING BUT HO-HUM — Be it out in the salt flats or in a mud hole somewhere—real bikers can have a rockin' good time just about anywhere. Just put the shades on, drop the visor down, and hit the gas. Just don't lean back on your Honda. Remember our mission—anything but ho-hum. On that score, photographer Scott G Toepfer is anything but ho-hum too. Check it out!

TOUT SAUF ENNUYEUX — Désert de sel ou fosse de boue – les vrais bikers ne se laissent pas facilement gâcher leur plaisir. Lunettes de soleil sur le nez, visière rabattue, accélération. Tout est permis sur cette Honda, sauf de se reposer. Ennuyer nos lecteurs, voilà une perspective qui nous ferait horreur ! D'ailleurs, Scott G Toepfer est tout sauf ennuyeux. Voyez par vous-même !

RAMP
24

STORY Chapter Opener

PHOTOGRAPHER Scott G Toepfer/ **BIKE** Honda

„D"-TIME — Ein Rennwagen für die Straße. Davon wird ja gerne geredet. Wirklich zutreffend ist das aber wohl nur für eine Handvoll ausgewählter Fahrzeuge: wie diesem Jaguar D-Type zum Beispiel. Einer der seltenen fünf Longnosemodelle und der D-Type mit den meisten Renneinsätzen. Wir testeten die „Alltagstauglichkeit" rund um Silverstone.

"D"-TIME — A racecar for the streets—who doesn't like the sound of that? But let's not kid ourselves, there are only a handful of cars out there worthy of that distinction, and the Jaguar D-Type is one of 'em. One of the five rare Longnose models, the D-Type is also the one with the longest history of racing. We took it out to Silverstone to test its abilities as a 'daily driver.' Look, just trust us on this one.

« D » TIME — On parle volontiers de voiture de course pour la route. Mais cela ne vaut que pour une poignée de véhicules triés sur le volet, comme cette Jaguar Type D. Il n'existe que cinq exemplaires de ce modèle à museau long et c'est la Type D qui totalise un nombre record de compétitions. Nous avons testé ses capacités à servir de « véhicule de tous les jours » autour de Silverstone.

#28

RAMP
ALL YOU
CAN WISH

STORY „D"-Day / **PHOTOGRAPHER** Amy Shore

CAR 1955 Jaguar D-Type XKD 504 Longnose (Factory Car)

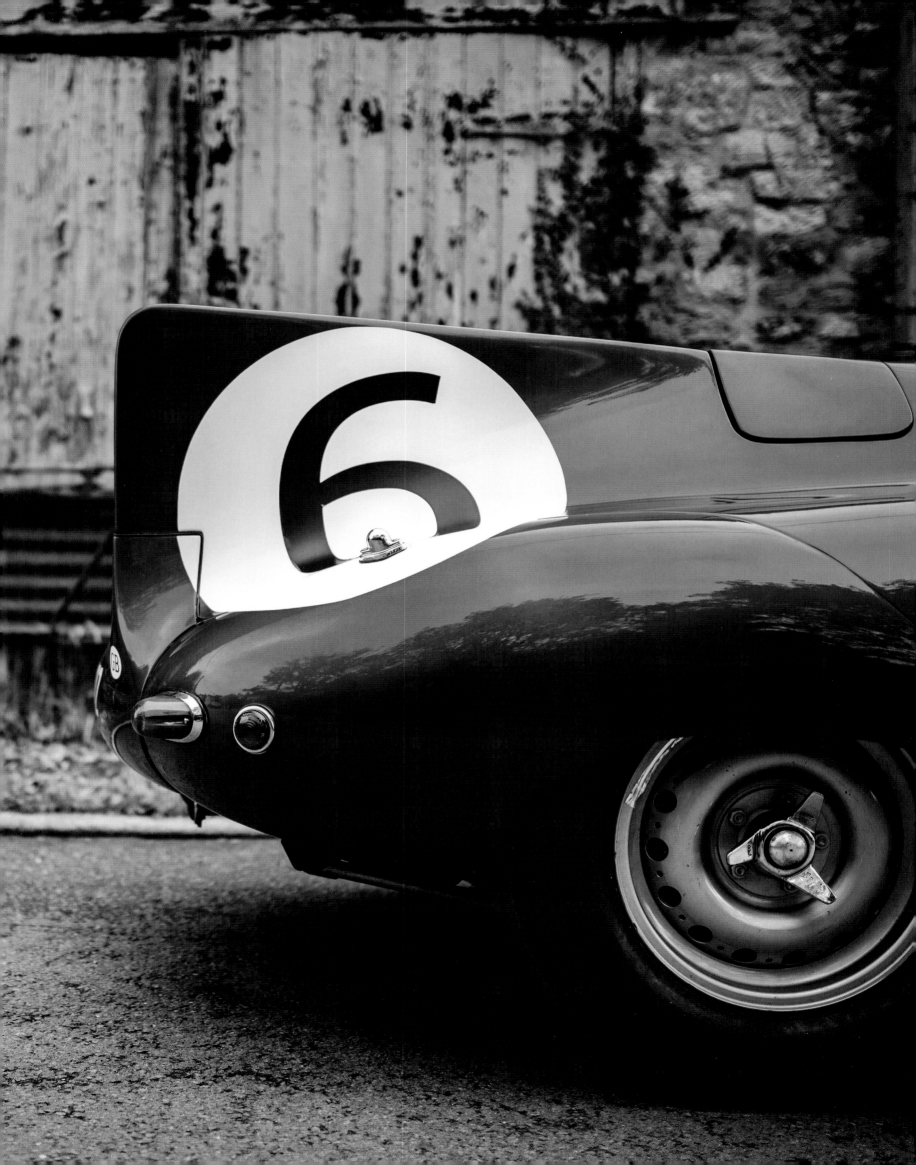

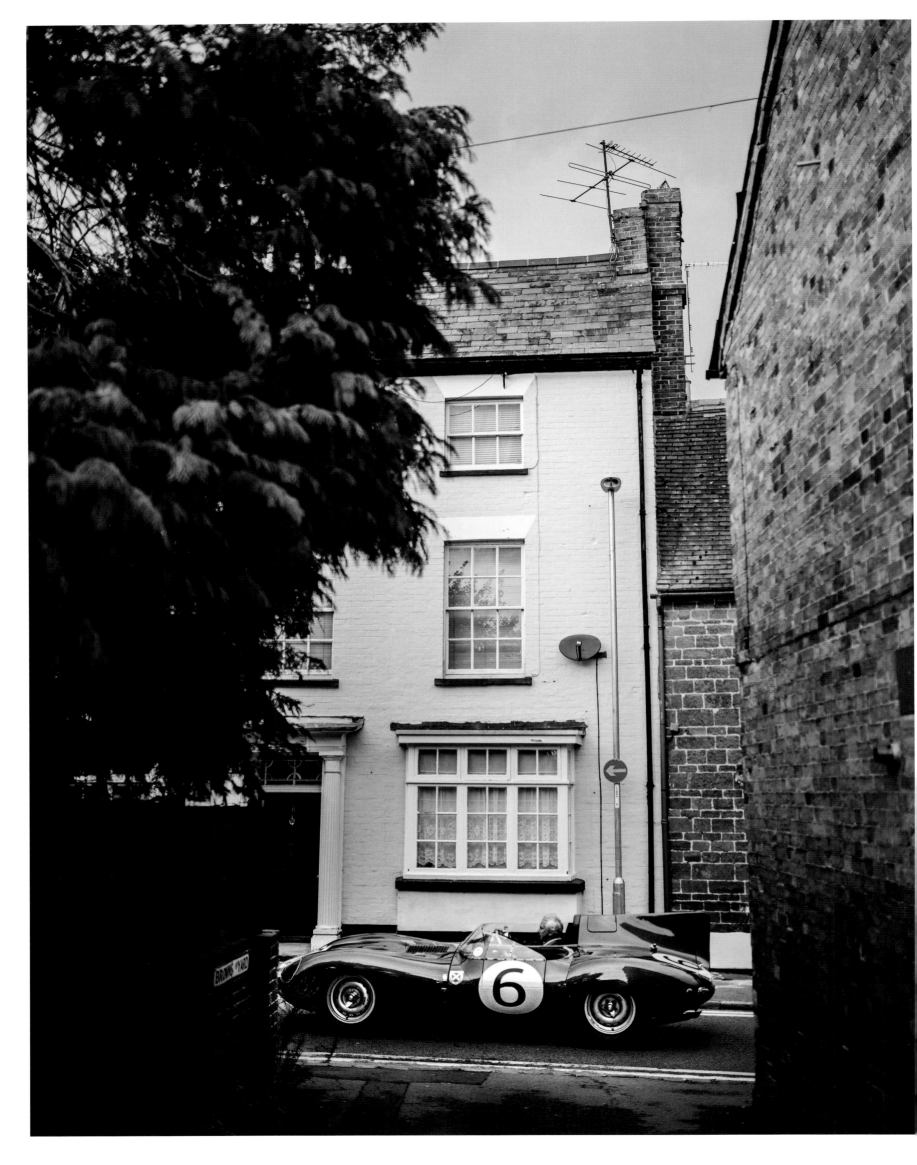

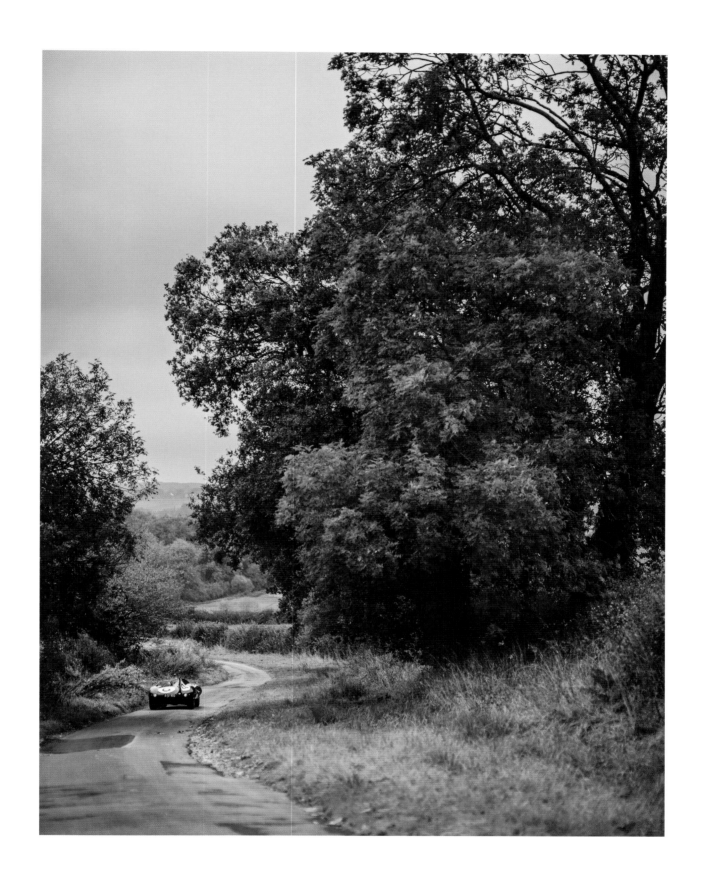

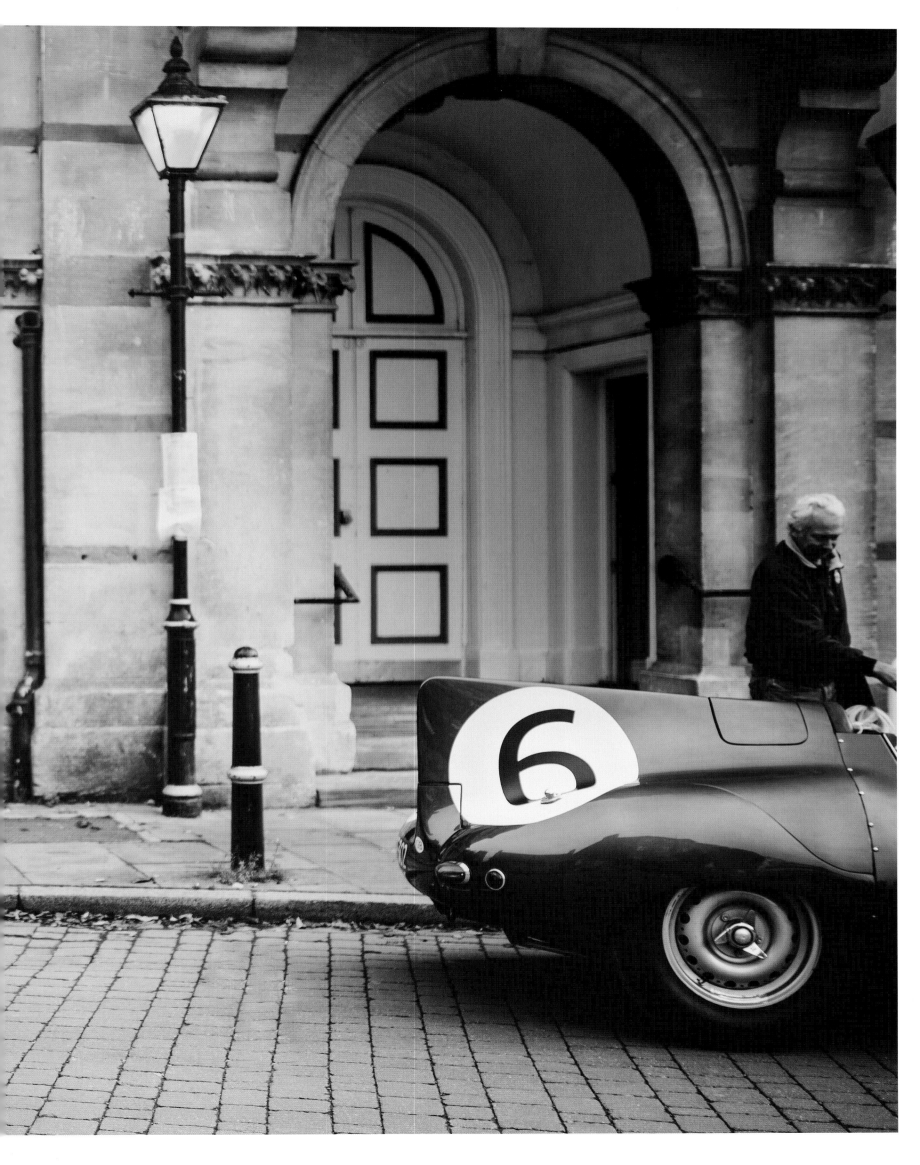

ANTRIEBSPROBLEME — Ein exklusives Auto. Seltener als ein Ferrari 250 GTO, sollte das Millionen teure Schmuckstück für eine Auktion in Los Angeles fotografiert werden. Damit nichts passiert, durfte nur der Sohnemann des Besitzers ans Steuer. Und dann schrottet er das Getriebe.

TRANSMISSION PROBLEMS — Here was this exclusive car that's even more rare than a Ferrari 250 GTO. Worth millions, this gem of a car was on its way to a photo shoot for some kind of auction in Los Angeles. Expecting his exclusive ride to be in safe hands, the owner trusted no one but his son to drive it there. Well, guess who ruined the transmission on his way out there...

PROBLÈMES DE TRANSMISSION — Une automobile d'exception. Ce bijou plus rare qu'une Ferrari 250 GTO, d'une valeur de plusieurs millions d'euros, devait être photographié pour des enchères à Los Angeles. Afin d'éviter tout pépin, seul le fiston du propriétaire était autorisé à s'installer au volant. Ça n'a pas loupé : il a flingué la boîte de vitesses !

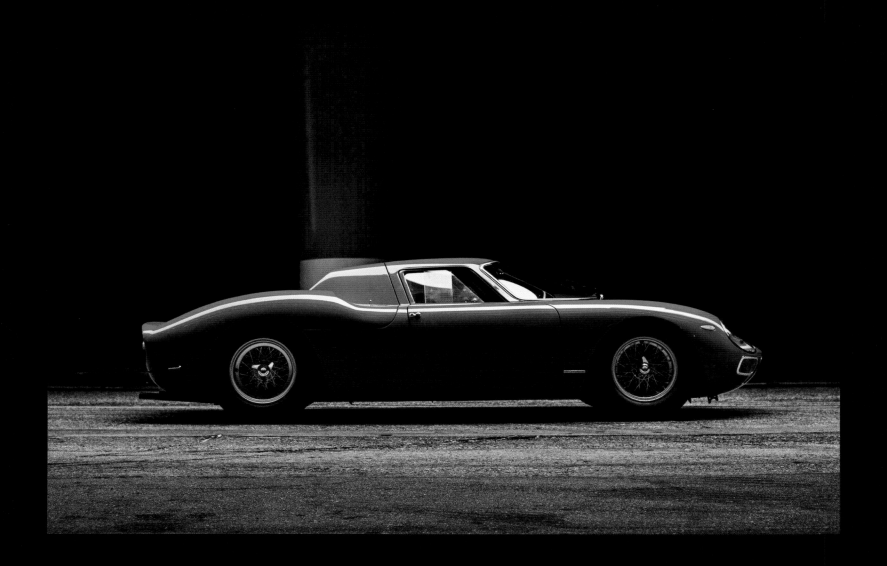

#28 **RAMP**
ALL YOU
CAN WISH

STORY Den Teufel im Nacken / **PHOTOGRAPHER** Richard Thompson

CAR Ferrari 250 LM

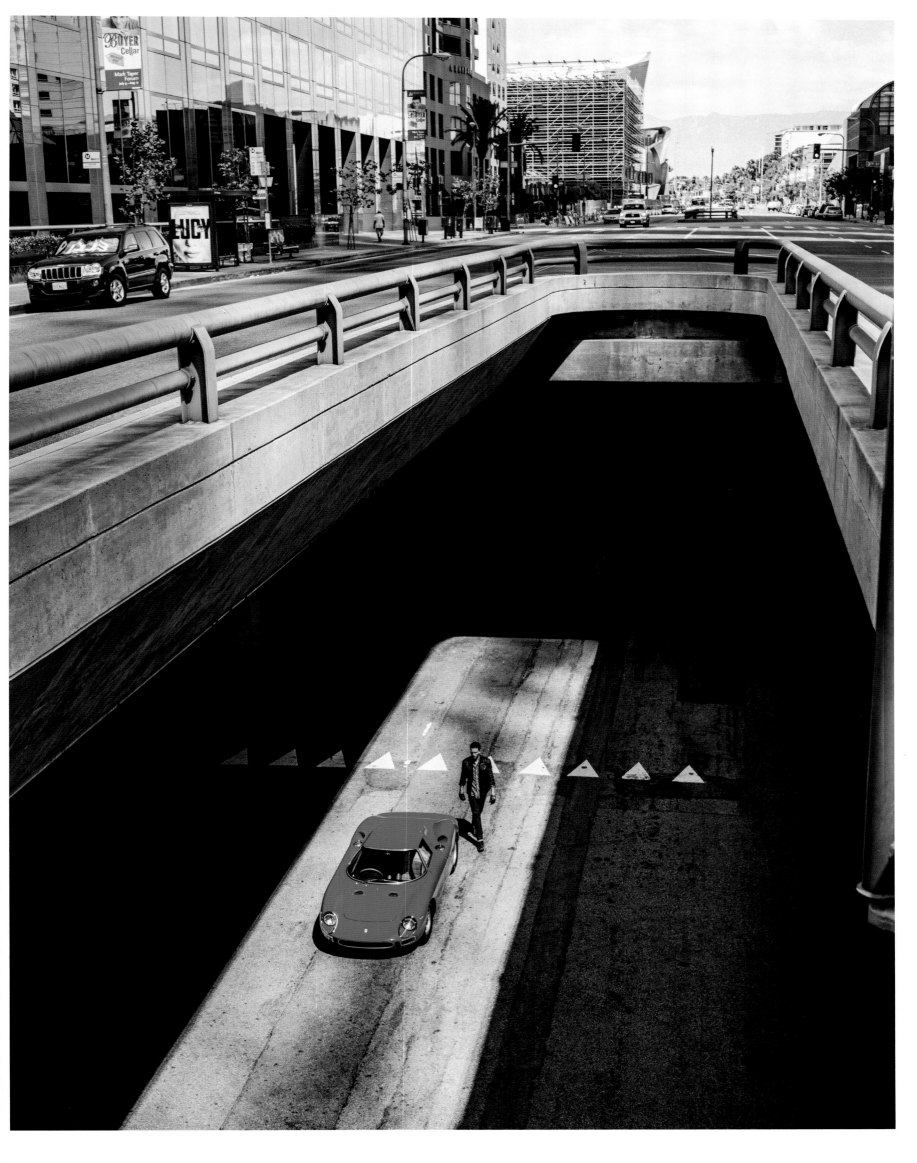

HEIMATGEFÜHLE — Weissach, das Zuhause des Porsche-Motorsports. Höchste Zeit, die legendären Le-Mans-Fahrzeuge in ihrer Heimat zu verorten. Also ab damit ins Grüne und auf die Straßen in und um Weissach.

HOMETOWN FEELIN' — The German town of Weissach is the home of Porsche Motorsport. We felt it was high time to take the legendary Le-Mans cars on a tour through their hometown. So we took them to the country roads and streets in and around Weissach.

NOSTALGIE DES ORIGINES — Weissach : berceau de la course automobile Porsche. Il était grand temps pour les lauréates du Mans de revenir aux origines. Aussi : cap sur la campagne et les routes de Weissach et de ses environs.

RAMP
DIE GROSSE
FREIHEIT

STORY Heimspiel / **PHOTOGRAPHER** Steffen Jahn

CARS Porsche

#16

RAMP
DLDUUDGR*
*DAS LEBEN, DAS UNIVERSUM
UND DER GANZE REST

STORY Staying Alive / **PHOTOGRAPHERS** outtofocus –

David Breun & Martin Grega / **CAR** Nissan Juke & Nissan GTR

OPEN-MINDED — Besser als Büroschlaf: der Blick in die Freiheit. Noch viel besser: ein Abenteuer. Mit einem Nissan Juke darf das auch gerne in einem Parkhaus starten. City-Offroader fühlen sich bisweilen auch dort wohl. Selbst die mit turboaufgeladenen 190 PS. Alles eine Frage der Dimension.

OPEN-MINDED — What's better than an office nap? How about a taste of freedom. What's a lot better? How about adventure. With a Nissan Juke, adventure can easily start right in the parking garage. For the city offroaders among us, it's as good a place to start as any. Even as some of them ride on turbo-charged 190-hp engines. It's all just a matter of finding the right size.

OUVERTURE D'ESPRIT — Mieux qu'une sieste au bureau : une fenêtre ouverte sur la liberté, ou mieux encore, l'appel de l'aventure. Avec un Nissan Juke, cela peut commencer dès le parking. Il est des citadines tout-terrain qui y sont parfaitement à l'aise, même celles de 190 chevaux suralimentées par turbo. Le tout, c'est d'être compact.

RAMP LEIHT SICH FLÜGEL —
Daniel Ricciardo im offenen Renn-
boliden aus den 1970ern auf den
legendären Straßen der einstigen
targa florio in Sizilien. Die Bilder
mussten wir haben, obwohl sie Jim
Krantz eigentlich für Red Bull foto-
grafiert hat. Dort zeigte man sich
großzügig und packte noch ein paar
Dosen Brause oben drauf. Nochmals:
Vergelt's Gott dafür!

RAMP IS GIVEN WIIINGS —
Here was Daniel Ricciardo at a photo
shoot behind the wheel of an open
race car from the 1970s, flying down
the legendary streets of the former
targa florio in Sicily. Taken by photo-
grapher Jim Krantz, the photo shoot
was originally intended for Red Bull.
If only we could get some copies of
that shoot! To our surprise, Red Bull
proved to be more than generous
when we approached them, even add-
ing some free cans of their soda as
a gift to us. Thank you kindly,
Red Bull, and God bless you guys!

RAMP SE LOUE DES AILES —
Daniel Ricciardo dans ce bolide ouvert
des années 1970 sillonnant les routes
de la mythique Targa Florio, en Sicile.
Nous avons fait des pieds et des mains
pour obtenir les images, alors qu'au
départ, Jim Krantz les avait réalisées
pour Red Bull. Ces derniers se sont
montrés généreux et nous ont même
offert des canettes de leur boisson.
Merci les gars, Dieu vous le rendra !

#30

RAMP
{FAR-FAIR-
GNU-GHEN}

STORY La Follia Siciliana / **PHOTOGRAPHER** Jim Krantz

for Red Bull Media House / **CAR** Alfa Romeo T33/TT/3

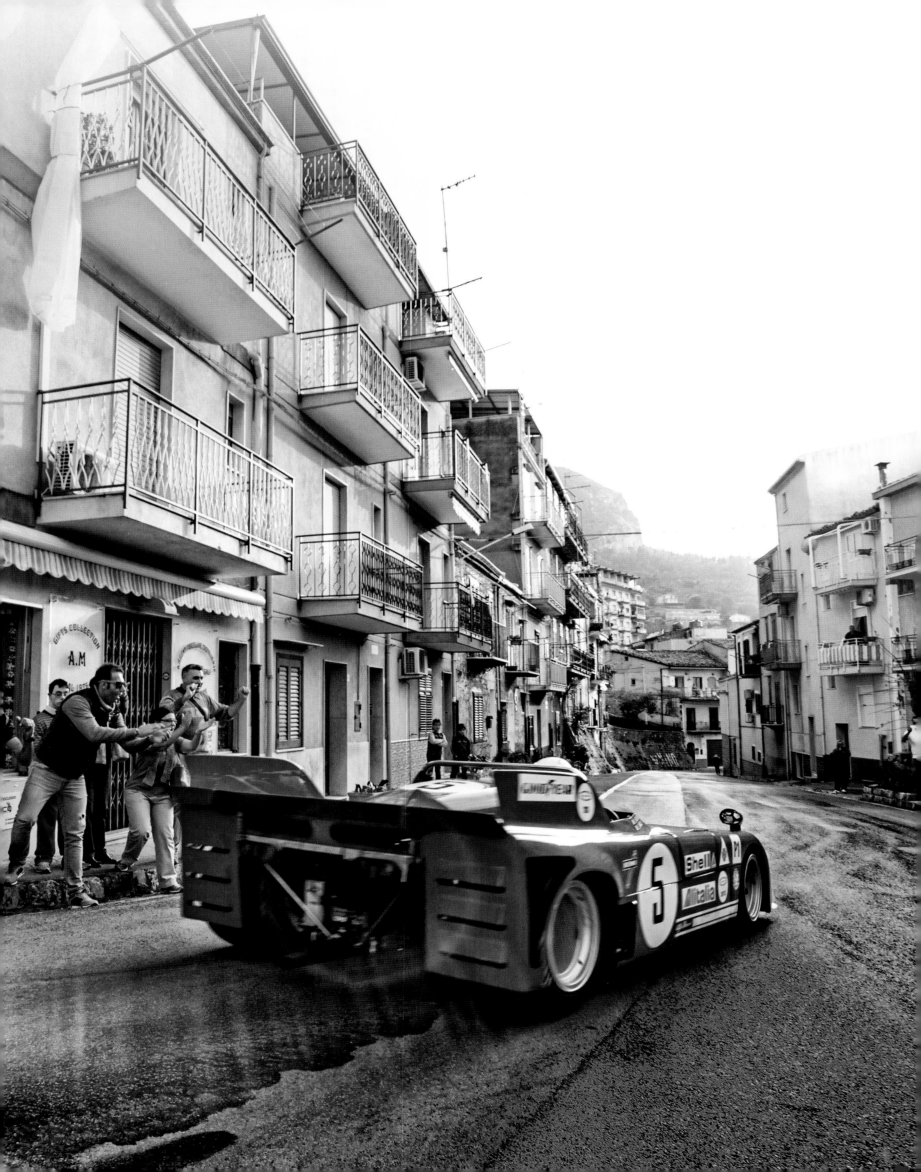

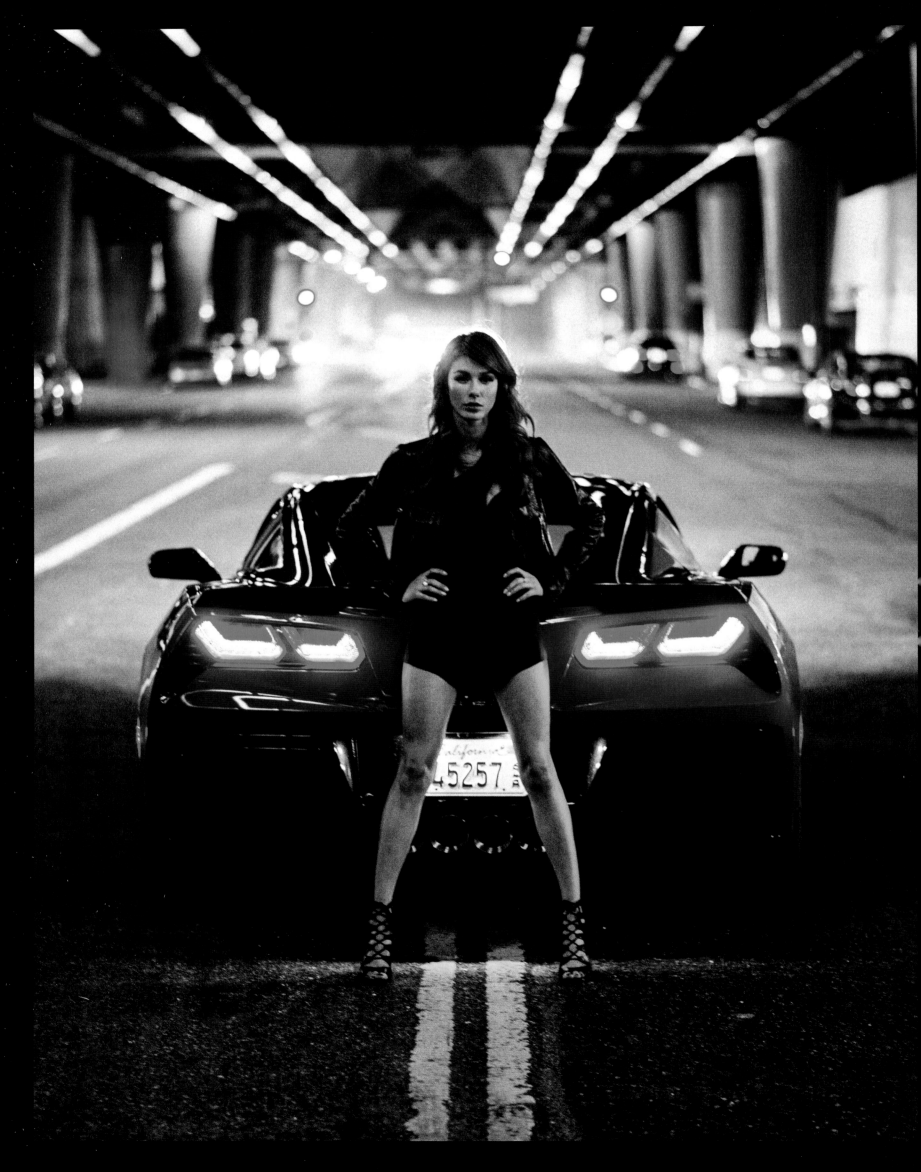

LICHTMOMENT — Richard Thompson einen Sportwagen zu geben und auf gute Bilder zu hoffen, ist in etwa so ein sicheres Ding wie einen Bausparvertrag abzuschließen. Also legten wir noch einen drauf: Ein Coverfoto für die #29 hätten wir gern. Hat er dann gemacht. Einfach so. Ort: das historische Palace Theater in Downtown LA auf dem South Broadway.

MOMENT OF LIGHT — Giving Richard Thompson the keys to a sports car and trusting he'll come back with some good pictures is pretty much akin to buying gold for financial security. So we followed up by asking him to do a cover photo for our upcoming Iss. #29. And he did a great one too. Easy as pie. Location: the historical Palace Theater on South Broadway in downtown L.A.

MOMENT DE GRÂCE — Confier une voiture de sport à Richard Thompson en espérant de bonnes photos, c'est aussi fiable que d'ouvrir d'un PEL. Nous sommes donc passés à la vitesse supérieure : nous lui avons demandé une photo pour la couverture du n° 29. Ce qu'il a fait, tout simplement. Le décor : le Palace Theater, théâtre historique de South Broadway, au centre de L.A.

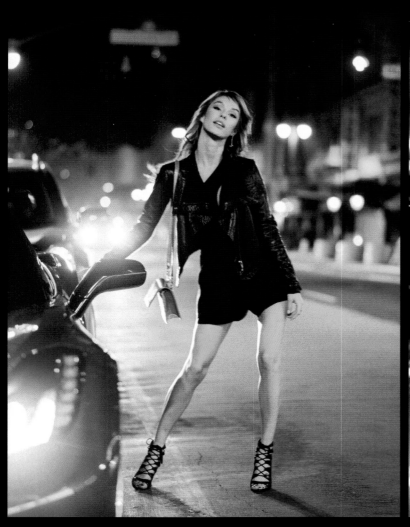 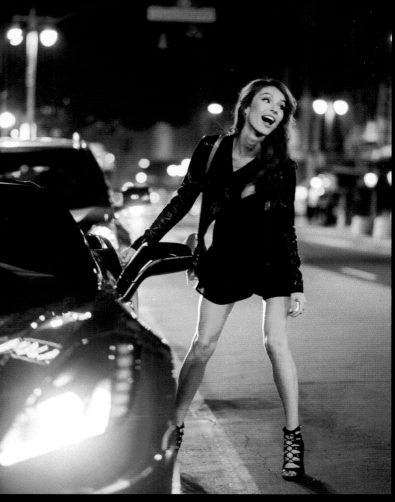

#29　**RAMP**
DIE GROSSE
FREIHEIT

STORY Der Letzte seiner Art / **PHOTOGRAPHER** Richard Thompson

CAR Corvette Stingray C7

W PRESENT
H BILL NYE
UGENE MIRMAN

JEWELRY & REPAIR

Castillo

VENDEMOS ORO 14K, PLATA,
ANILLOS DE MATRIMONIO, QUINCEAÑOS
MEDALLAS DE BAUTIZO, PRIMERA COMUNION.
NOS ESPECIALIZAMOS EN ANILLOS DE GRADUACION
TODO TIPO DE REPARACION DE JOYAS PRECIOSAS

213 955 8083 • 323 313 6343

Anillos de Diamantes
y Piedras Preciosas

Castillo
Jewelry & Repair

SE HACEN REPARACIONES

PARA RELOJES, CAMBIO DE PILAS • SE HACE TODO TIPO DE
CAMBIO DE EXTENSIBLES ANILLOS DE GRADUACION
DE PIEL O DE METAL • REPARACIONES DE JOYAS

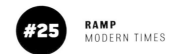

STORY Neues aus dem Quattrozoikum / **PHOTOGRAPHER** Sjoerd ten Kate

CAR 1931 Bugatti T53 4WD

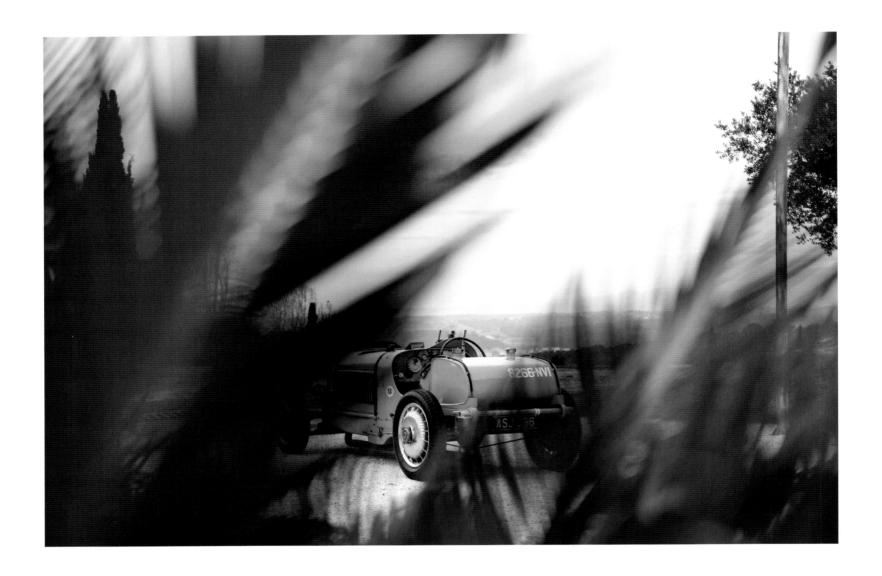

PIONIER HOCH VIER — Mythos. Legende. Bugatti. Ein geübter Superlativ für Kenner. Der Typ 53 entstammt einer Zeit, als Autobau noch eine Pioniertat mit ungewissem Ausgang war. Wie sein Allrad: blankes Risiko. Sauschnell am Berg, bockig in den Kurven. Aber immerhin hatte Jean Bugatti noch Zeit, einem Mädchen zuzuwinken, bevor er eines der drei je gebauten Exemplare beim Bergrennen zerstörte.

4WD PIONEER — Myth. Legend. Bugatti. It's the automotive superlative exclusively tried, tested, and driven by expert enthusiasts for even more expert enthusiasts. The Type 53 harkens back to a time when automotive engineering just began to evolve beyond mere pioneering achievements, whose outcome was often far from certain. Bugatti's own all-wheel drive at the time was an accident waiting to happen. It made some Bugattis notoriously fast on Alpine roads and just as obstinate in cornering them. At least, M. Jean Bugatti found the time to wave at a girl at an Alpine race before he personally totaled one of only three of these Bugattis ever built.

PIONNIER PUISSANCE QUATRE — Un mythe. Une légende. Bugatti, un superlatif connu des collectionneurs. La type 53 date d'une époque où la construction automobile était encore une activité pionnière à l'issue incertaine. À l'image de ses quatre roues motrices : le risque à l'état pur. Hyper-rapide en montagne, récalcitrante dans les virages. Il n'empêche que Jean Bugatti a pris le temps d'adresser un signe de la main à une jeune fille, avant d'anéantir lors d'une course en montagne l'un des trois seuls exemplaires jamais construits.

RAMP
ALL YOU
CAN WISH

STORY Von Anfang an / PHOTOGRAPHER Götz Göppert

CAR Hyundai Genesis

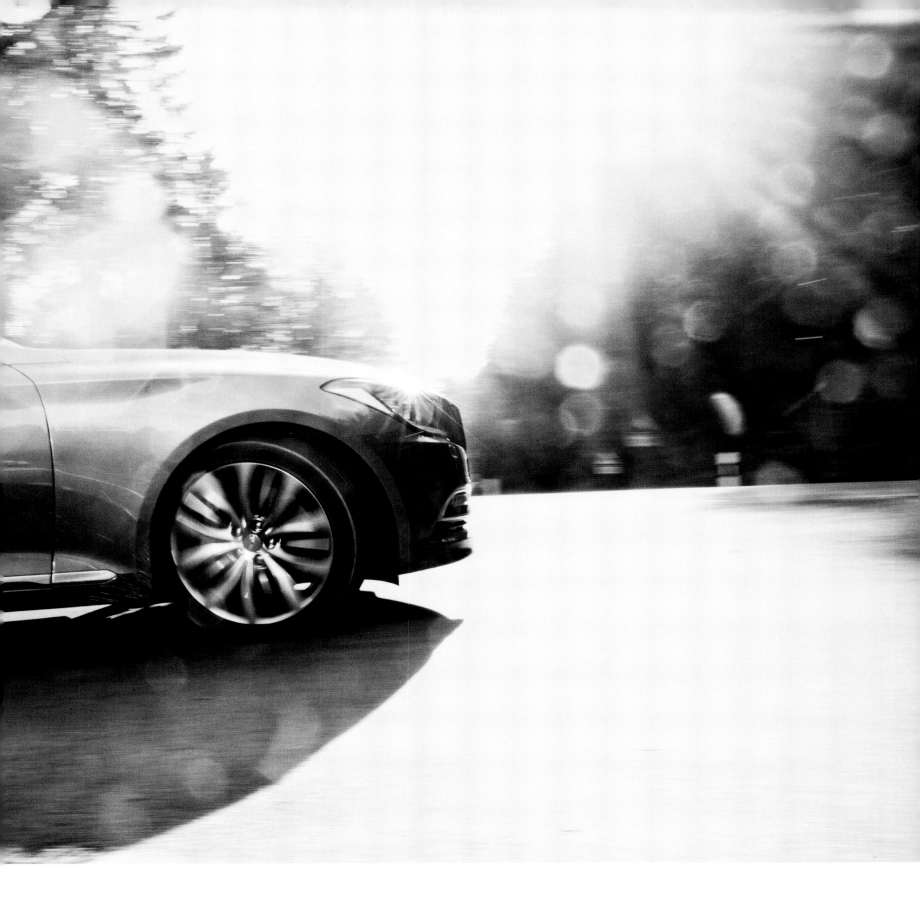

GÖTZ-DÄMMERUNG — Hyundai strebt mit seiner neuen Luxuslimousine wahrlich Großes an - wie schon der Name verdeutlicht: Genesis. Da klingelte es freilich sofort: Bibel, Schöpfungsgeschichte und so. Der Plan: eine Magazingeschichte in sieben Tagen produzieren. Kann ja nicht so schwer sein. Am Ende reichten uns zwei Tage. Götz Göppert war einfach so schnell.

IN GÖTZ WE TRUST — Hyundai is aiming higher than ever with its new luxury ride—the name says it all: Genesis. Right away, it made us think along the lines of the Bible, creation story, and so on. So our plan was to produce a story for our magazine in exactly seven days. How hard could it be? In fact, it took us no more than two days. It was just the amazingly fast pace at which Götz Göppert worked.

LE CRÉPUSCULE DE GÖTZ — Genesis : comme son nom l'indique, Hyundai vise vraiment très haut avec sa nouvelle berline haut de gamme. Chez nous, ça a tout de suite fait tilt : Bible, Genèse, etc. Le projet : créer un magazine en sept jours. Cela ne devait pas être si difficile. Finalement, deux jours ont suffi. Götz Göppert a tout simplement été très rapide.

VROOAAAM! — Auch Sexsymbole werden älter. Ein Blick auf, sagen wir, Pamela Anderson genügt. Wie gut, dass auch das Auto als Synonym von Kraft und Beweglichkeit als prima Sexsymbol durchgeht. Besonders dann, wenn die Haube nicht nur lang, sondern auch genügend Dampf drunter ist. Und so frisch interpretiert wie in Markus Meuthens Comicwelten werden sie dann auch gewiss nie alt.

VROOOOOM! — Age inevitably catches up with sex symbols too. Just look at, say, Pamela Anderson. Isn't it nice to know that cars, being synonymous with power and mobility, have become excellent sex symbols in their own right, especially if they come with big powerful engines complementing their long hoods. Given their fresh interpretations in the comic-like dream worlds of photographer Markus Meuthen, and his use of comic-like imagery, any age factor is bound to be permanently left in the dust.

VROUM ! — Même les sex-symbols vieillissent. Regardez Pamela Anderson, par exemple. Heureusement que l'automobile, synonyme de vitesse et de mobilité, est un super sex-symbol qui résiste aux outrages du temps. En particulier lorsque le capot n'est pas seulement long, mais qu'il abrite aussi de la puissance. Revisitées avec autant de fraîcheur que dans les BD de Markus Meuthen, ces voitures ne vieilliront jamais.

 RAMP
SEX, DRUGS & ROCK'N'ROLL

STORY Man's Last Stand / **ILLUSTRATOR** Markus Meuthen

CAR Ferrari 250 GT Berlinetta

STORY Here Comes The Sun / PHOTOGRAPHER Henrik Purienne

CAR Porsche 911 Carrera RS 2.7

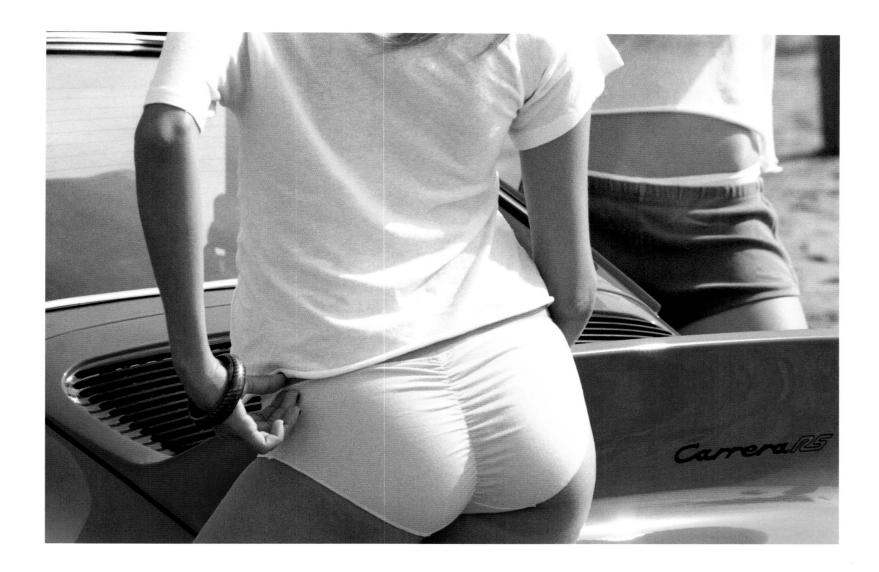

TRENDSETTER — Der eine setzt heute Trends in der Modefotografie. Der andere hat in den 1970ern mit seinem puristischen Konzept einen Trend im Motorsport zur Referenz verdichtet. Man müsste die beiden mal zusammenbringen. Haben wir uns gedacht. Und Henrik Purienne hat aus seinem Rendezvous mit dem 911 Carrera RS 2.7 einen „Summer in Paradise" gemacht.

TRENDSETTER — All right, take a certain trendsetter in today's fashion photography. Now take another trendsetter, one whose purist concept went from a mere trend to the new standard-bearer in the motor sports world of the Seventies. We figured there had to be a way to unite the two. Enter Henrik Purienne, who turned his rendezvous with the 911 Carrera RS 2.7 into a 'Summer in Paradise.'

CRÉATEURS DE TENDANCES — L'un lance de nouvelles tendances dans la photographie de mode. L'autre a érigé une tendance en référence dans le sport automobile des années 1970, avec son concept épuré. Il faudrait réunir les deux, avons-nous pensé. De la rencontre entre Henrik Purienne et la 911 Carrera RS 2.7 est né un enchantement du type « Summer in Paradise ».

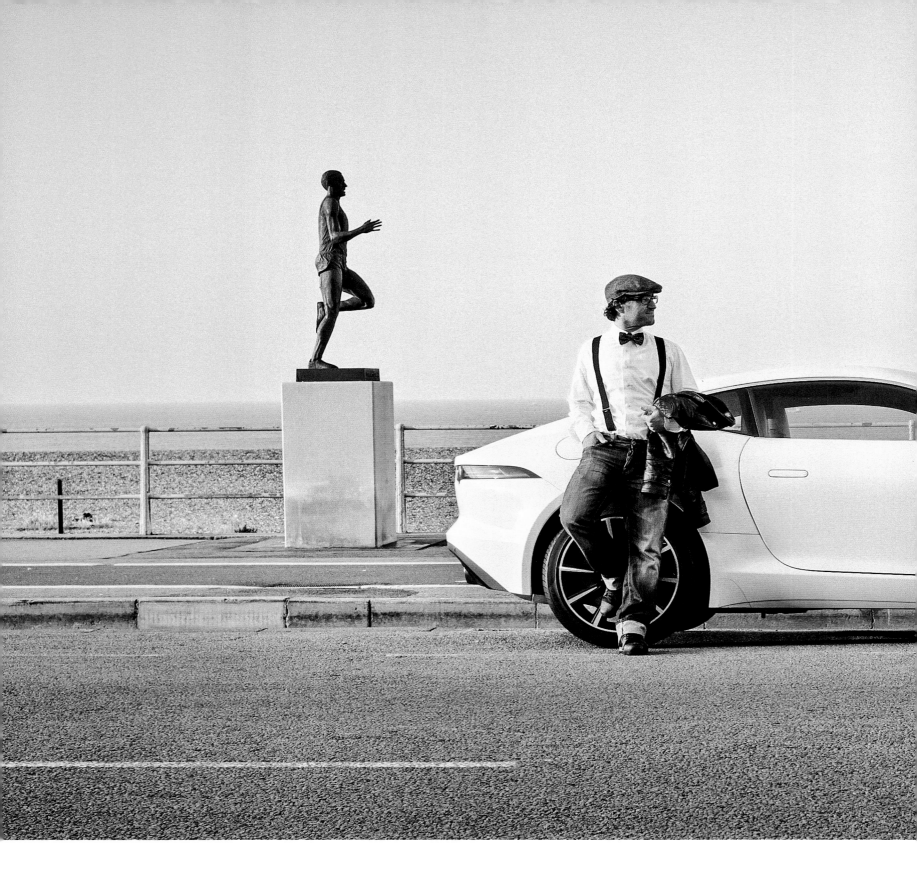

RAMP
ALL YOU
CAN WISH

STORY Was man eben so (b)raucht / PHOTOGRAPHER Benjamin Pichelmann

CAR Jaguar F-Type

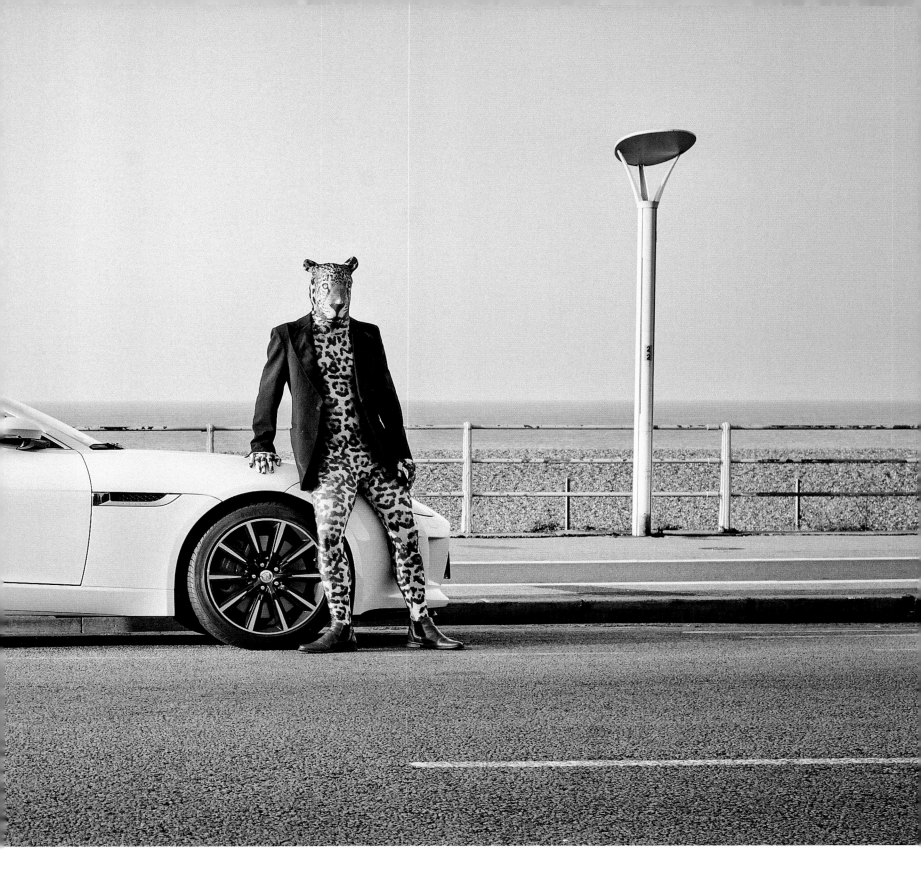

TRIFFT EIN JAGUAR EINEN JAGUAR ... —
Mit dem Jaguar F-Type von Deutschland nach Goodwood zum Festival of Speed, über Nacht. Ein Roadtrip im ramp-Stil. Und Fotograf Benjamin Pichelmann packt morgens um halb sechs Uhr in Brighton ein Jaguarkostüm aus. Warum? „In jeder meiner ramp-Geschichten taucht irgendwo ein Tier auf." Und ein Hund war gerade nicht zur Verfügung.

JAGUAR MEETS JAGUAR ... — Imagine driving a Jaguar F-Type from Germany to England overnight, specifically, the Goodwood Festival of Speed. We're talkin' road trip, ramp style. Meanwhile, at 5:30 a.m. in the English seaside resort of Brighton, our photographer Benjamin Pichelmann is busy unpacking a jaguar costume. What gives? "No ramp story of mine is complete without an animal in it somewhere," he explains. Guess, he didn't have his dog costume handy.

QUAND UN JAGUAR RENCONTRE UNE JAGUAR... — Virée nocturne en Jaguar Type F, depuis l'Allemagne jusqu'à Goodwood, pour le festival de vitesse. Un road-trip tout à fait dans l'esprit ramp. À Brighton, au petit matin, le photographe Benjamin Pichelmann sort de ses bagages un déguisement de jaguar. Pourquoi ? « Dans chacun de mes articles pour ramp, il y a toujours un animal. » Et cette fois, je n'avais pas de chien sous la main.

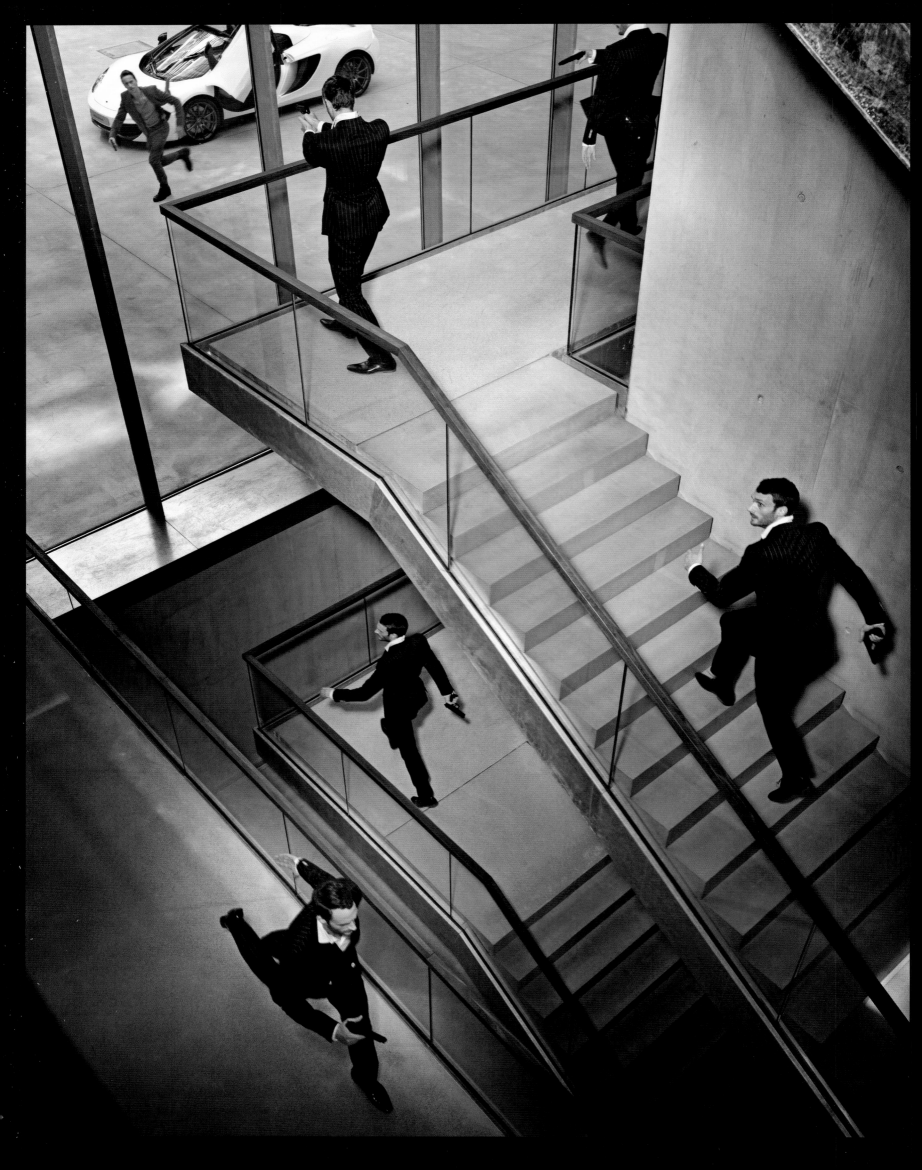

SUPERSPEZIALAGENTENSTORY — Super-gefährlich, supercool, supersuper. Wir haben uns da mal eine Geschichte mit zwei Hauptrollen überlegt – Mister 007 und Mister MP4-12C-Spider. Plus: Eine schöne Brünette und ein paar Superschurken. Bestens in Szene gesetzt in einem Park-haus; der Traum vom Männerspielzeug und einer heißen Puppe.

SUPERSPECIALAGENTSTORY — Super dangerous, super cool, super super. We came up with a plot featuring two main casts– Mister 007 and Mister MP4-12C-Spider. Plus, a beautiful brunette and a couple of super villains. The entire photo shoot was perfectly set up in a parking garage, illustrating every guy's dream of a boy toy along with a hot babe.

HISTOIRE D'AGENTS TRÈS SPÉCIAUX — Super dangereux, super cool, super tout. Pour vous, nous avons imaginé une histoire avec deux personnages principaux – un agent 007 et un MP4-12C-Spider. Et aussi : une belle brune et quelques super-méchants. Mise en scène dans un parking couvert comme il se doit ; le rêve du joujou masculin et de la belle incendiaire.

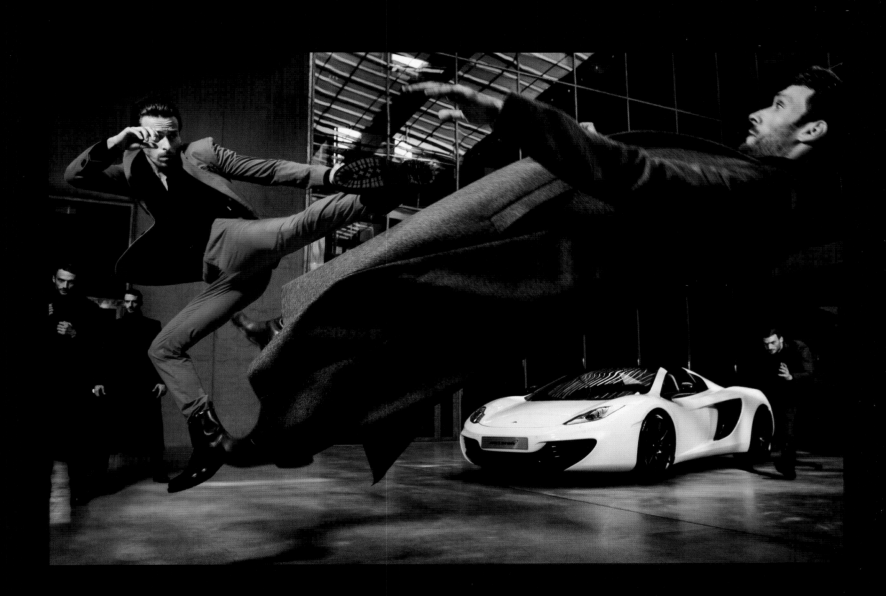

#20 **RAMP**
HUNGRY HEARTS

STORY Tougher Than The Rest / **PHOTOGRAPHER** Bernd Kammerer

CAR McLaren MP4-12C-Spider

KEINE AUSLAUFZONE. NIRGENDS. —
Mit 305 km/h auf einer Straße, die
so eng ist, dass du den Straßenrand
mit der offenen Tür mähen könntest.
Keine Auslaufzone. Nirgends. Und
das auf 60 langen Kilometern. Das
ist die Isle of Men Tourist Trophy.
Prima. Die perfekte Teststrecke für
einen blassgrünen Gallardo Super-
leggera. Müssen wir nur noch die
magische Marke von 18 Minuten
knacken.

NO RUN-OFF AREA. NONE AT ALL. —
Doing 305 kph (190 mph) on a road
so narrow you could mow the grass
growing on the side of it by opening
the door. And not a single run-off
area. Anywhere. For 60 long kilome-
ters (37 miles). Welcome to the Isle
of Men Tourist Trophy. Sweet! This
is the perfect test track for a pale
green Gallardo Superleggera. All we
need to do now is beat the magic
mark of 18 minutes.

**AUCUNE ZONE DE DÉGAGEMENT,
NULLE PART. —** À 305 km/h, sur
une route si étroite que l'on pourrait
tondre ses accotements en ouvrant
la portière. Aucune zone de dégage-
ment, nulle part. Et ce, sur 60 longs
kilomètres. C'est le Tourist Trophy
de l'île de Man. Super. C'est la piste
d'essais parfaite pour une Gallardo
Superleggera vert pâle. Il ne reste
plus qu'à battre le chrono magique
de 18 minutes.

#13 **RAMP**
EASY RIDERS

STORY Zielgenau auf die Straßenmitte

PHOTOGRAPHER Steffen Jahn

CAR Lamborghini Gallardo Superleggera

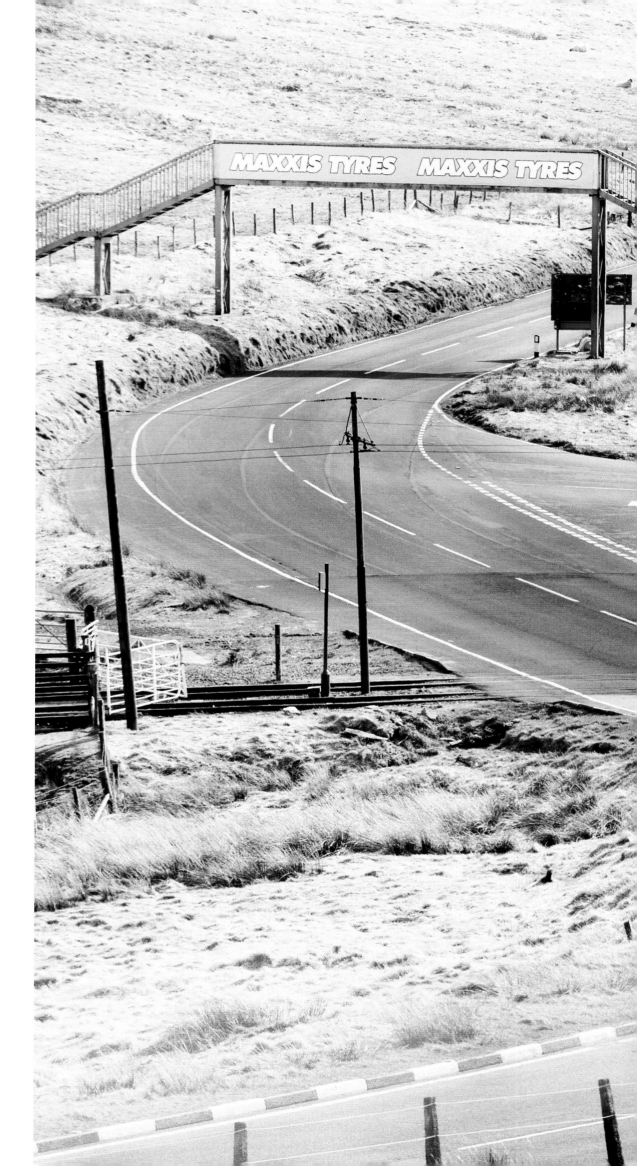

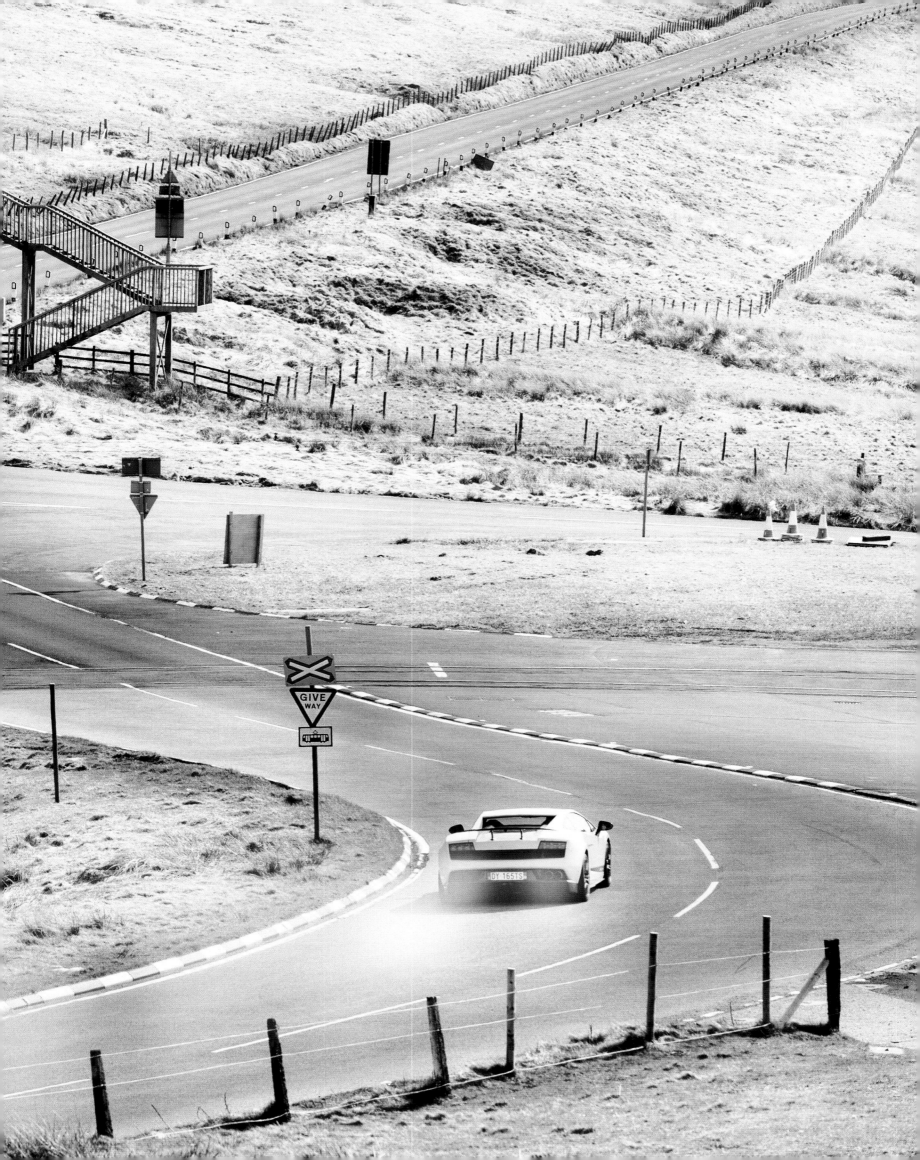

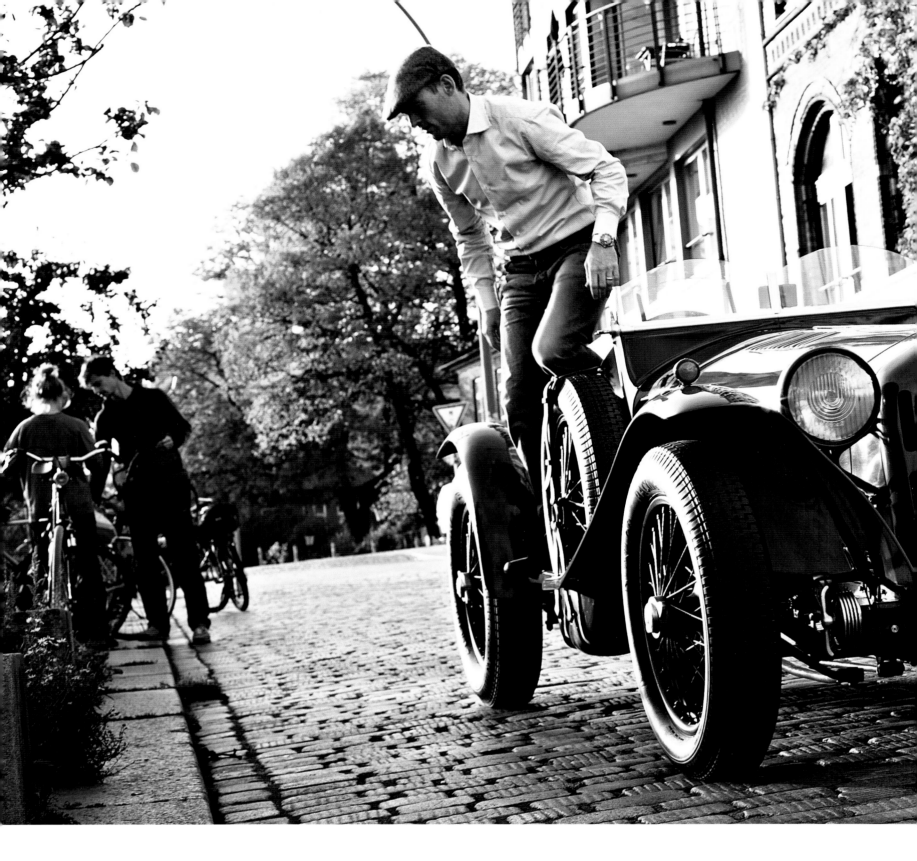

RAMP
ZURÜCK IN DIE
ZUKUNFT

STORY Stadtlust / **PHOTOGRAPHERS** Benjamin Pichelmann & Fabian Sommer

CAR Alfa Romeo 8C Monza 2.6

BESCHLEUNIGTES ENTSCHLEUNIGEN — Einer will nach Hamburg. Der andere nimmt ihn mit. Im Alfa Romeo Monza 8C. Das ist so etwas wie der Ritt auf dem Rücken eines Tigers. Mit dem Unterschied, dass hier keine Wildkatze faucht, sondern acht Zylinder mit einem gewaltigen Kompressor ohne Dämpfung. Schön, wenn man dabei noch über die Entschleunigung des Lebens meditieren kann.

ACCELERATED DECELERATION — One guy is going to Hamburg. The other one gives him a ride. In an antique Alfa Romeo Monza 8C, that is. It's a little bit like riding on the back of a tiger. Except it wasn't a large feline they depended on to take them to Hamburg, but rather the same antique eight cylinders and huge compressor *sans* sound dampening that doggedly kept this old baby going. At least, there was plenty of time to meditate on the pros and cons of slowing down a hectic lifestyle.

DÉCÉLÉRATION ACCÉLÉRÉE — Le premier veut se rendre à Hambourg. Le second le prend avec lui. En Alfa Romeo Monza 8C. Un genre de promenade à dos de tigre, sauf qu'ici, ce n'est pas un félin qui feule, mais un huit cylindres doté d'un énorme compresseur sans silencieux. Et tant mieux si l'on arrive encore à méditer sur la décélération de la vie.

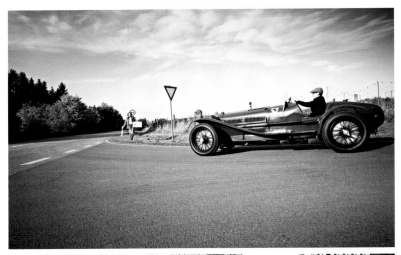

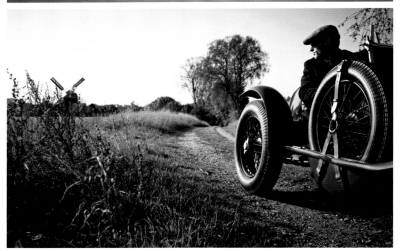

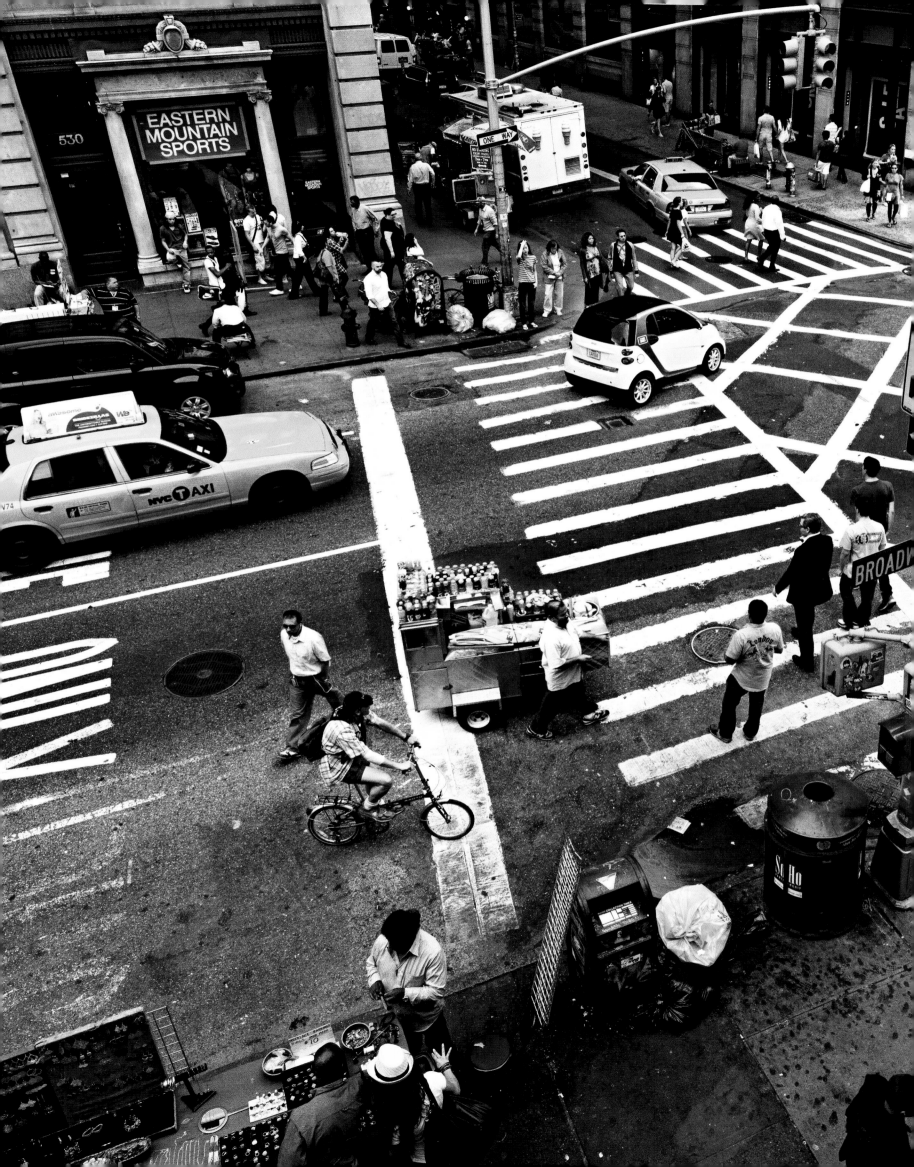

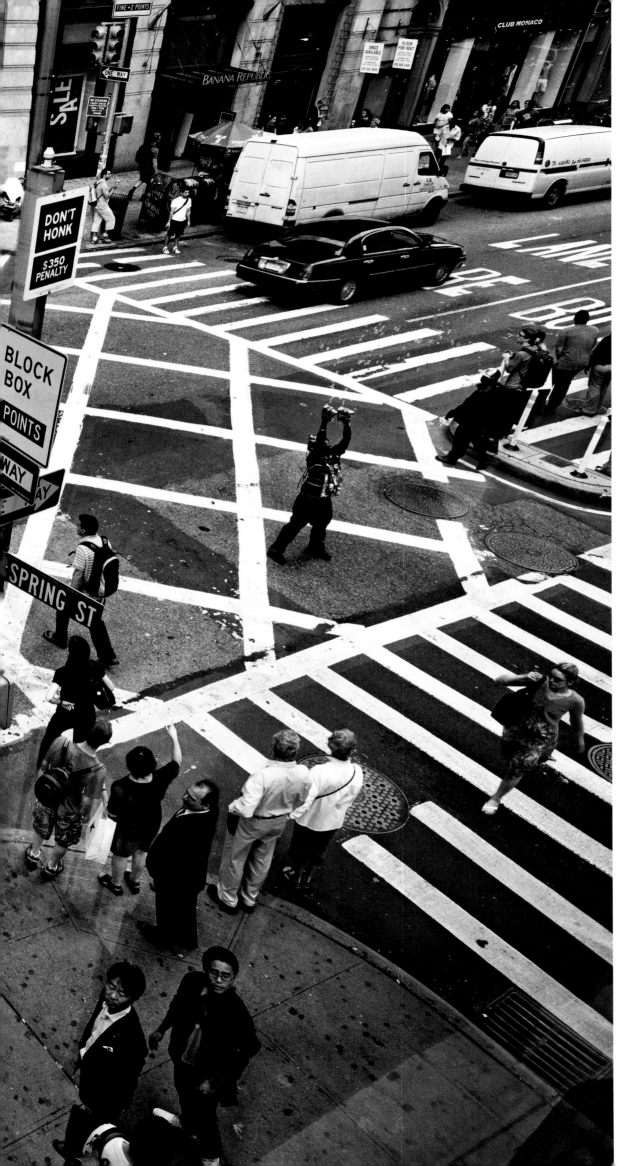

VOM KLEINEN IM GROSSEN —
Wer es in New York schafft, schafft
es überall. Heißt es. Wir haben es
erst einmal nach New York geschafft.
Mit einem smart2go. Um dort das
Kleine im Großen zu finden. Um ganz
smart Manhattan zu entdecken.
Und wir müssen sagen: weißes Auto
mit schwarzem Dach auf schwarzem
Asphalt mit weißen Streifen - passt.

**THE LITTLE THINGS IN THE BIG
PICTURE —** If you can make it in
New York, you can make it anywhere.
You know what they say. Heck, we
just barely made it into New York.
In a Smart2go. We set out to discover
all the little things that help us see
the big picture. And to discover
Manhattan the Smart way. All right,
here's our take: Driving a white car
with a black roof on black pavement
with white stripes—we blended right
in, man.

**LA PETITE AUTO DANS LA GRANDE
VILLE —** Qui se débrouille à New
York peut se débrouiller partout,
paraît-il. Nous y sommes allés avec
une smart2go. Pour que le tout petit
côtoie l'infiniment grand. Et pour
une découverte très smart de
Manhattan. Il n'y a pas à dire : une
voiture blanche à toit noir sur
l'asphalte noire à bandes blanches -
ça en jette.

 RAMP
LET'S GET OUT
OF HERE 2

STORY smartsharing Vol. II

PHOTOGRAPHER Kai-Uwe Gundlach for car2go

CAR smart fortwo

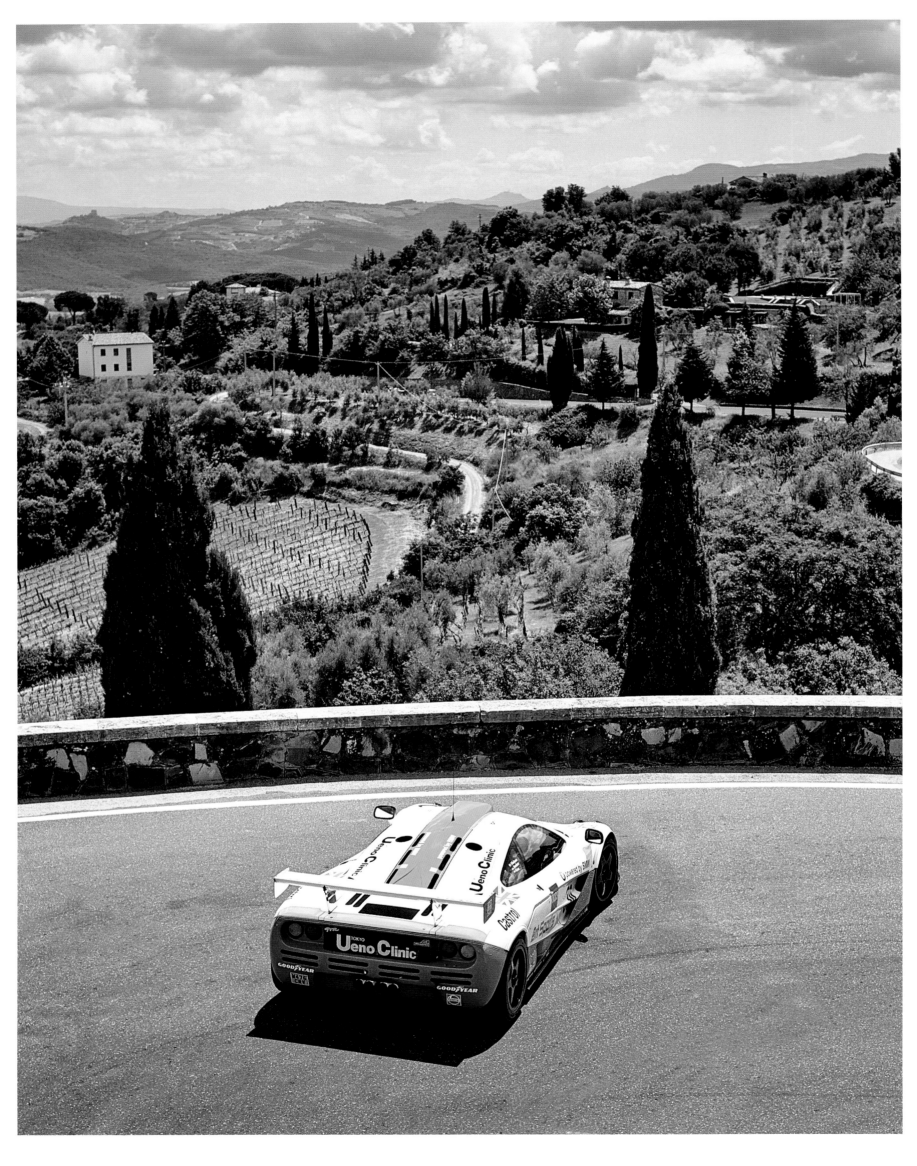

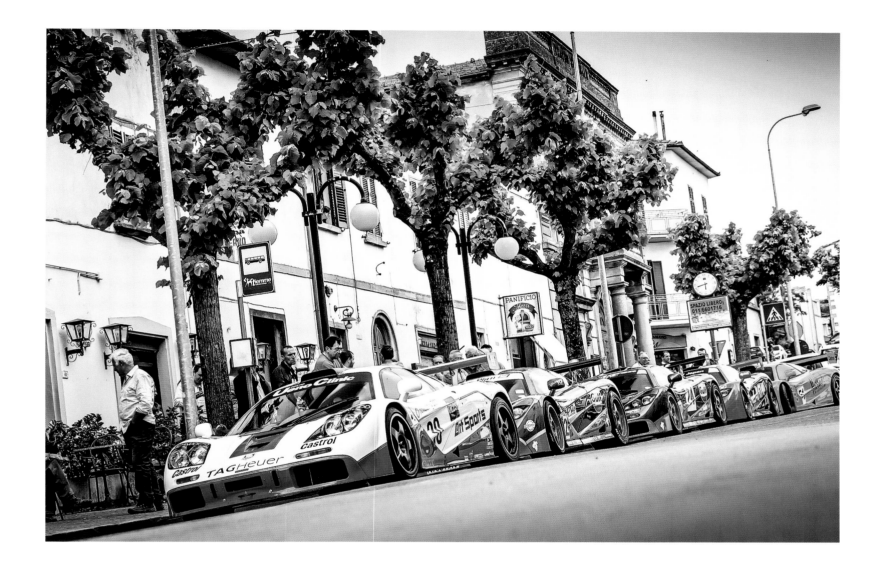

EINE ITALIENREISE — Rund ein Dutzend McLaren F1 jagen auf einer der exklusivsten Touren durch Italien. Doch was, wenn der kleine Hunger kommt? Kein Problem, kurzer Zwischenstopp in einem Straßencafé. Das Bild zeigt wohl einen der exklusivsten Rastplätze in der ramp-Geschichte.

EXPLORING ITALY — Picture about a dozen McLaren F1's going down the fast lane to explore Italy as part of a highly exclusive tour. So what do their drivers do if they want to grab a bite to eat? Well, why not just pull over for a snack at one of those nice Italian street cafes? The image shows what has got to be one of the most exclusive rest breaks in the annals of ramp.

LE VOYAGE EN ITALIE — Une douzaine de McLaren F1 avalent les routes d'Italie pour une tournée d'exception. Mais comment faire en cas de petite faim ? Pas de problème : il suffit d'une courte pause à la terrasse d'un café. Voici sans doute l'une des aires de repos les plus chics de l'histoire de ramp.

WILLKOMMEN ZU HAUSE —
Traumlocations? Kann jeder. Wenn
aber die „erfolgreichste Oberklas-
senlimousine der Welt" zu Hause
willkommen geheißen wird, gibt es
keinen besseren Ort, als den Vorgar-
ten des Mercedes-Benz-Werks. Haus-
herr Dr. Dieter Zetsche kam dann
auch gerne zum E-Klasse-Interview
an der Imbissbude.

WELCOME HOME — Dream locations?
Anybody can do that. Try this one
on for size: A welcome home party for
"the world's most successful luxury
sedan," namely right on the front yard
of the local Mercedes-Benz produc-
tion plant. Add to that the man of the
house, Dr. Dieter Zetsche, who was
happy to join us at a nearby snack
stand for an E-Class interview.

BIENVENUE À LA MAISON —
Des sites de rêve ? C'est à la portée
de tous ! Mais lorsque « la berline
haut de gamme la plus primée » est
accueillie à domicile, il n'y a pas
de meilleur endroit pour cela que le
jardin à l'entrée de l'usine Mercedes.
Le maître des lieux, Dieter Zetsche,
est venu sans hésiter à la baraque
à frites, pour un entretien sur la
classe E.

#01 **RAMPSPECIAL**
WELCOME HOME!

STORY On the Road / **PHOTOGRAPHER** Deniz Saylan

CAR Mercedes-Benz E-Class

#07

RAMP
LET'S GET OUT
OF HERE

STORY Fly Away / **PHOTOGRAPHER** Bernd Kammerer

CAR Cobra 289 1964 Chassis No. 2480

A PASSION FOR CARS ——— **KULTUR**

138

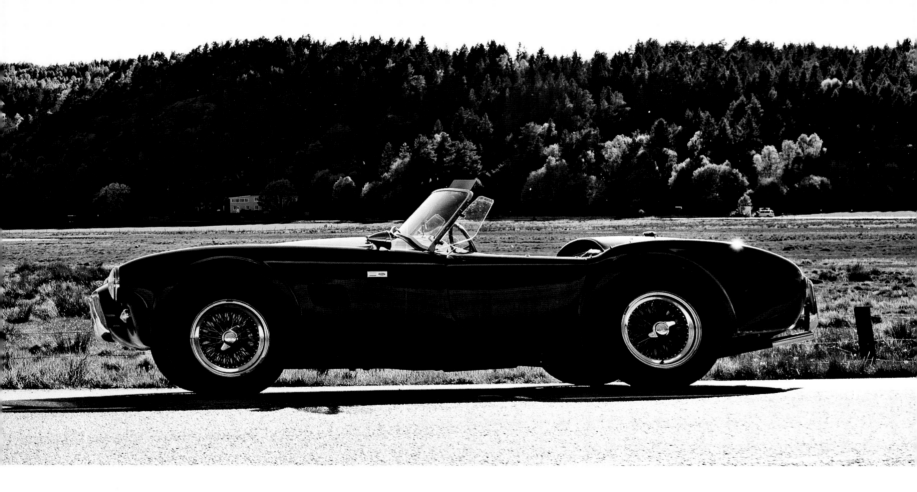

ER FÄHRT UND FÄHRT UND FÄHRT — Was macht ein Korse, wenn er mit einer 64er Cobra 289 in Südschweden landet? Er fährt und fährt und fährt. Eine spontane Reisereportage. Mit Weitblick. Dynamik. Gegenschnitten. Und Lenny Kravitz singt uns einen.

GOING AND GOING AND GOING — Picture a guy from Corsica arriving in southern Sweden in a '64 Cobra 289? He just keeps going and going and going. The end result is a spontaneous travel report. Insightful and energetic, it explores some interesting contrasts observed along the way. All while listening to the tunes of Lenny Kravitz.

IL ROULE, ROULE ET ROULE — Que fait un Corse lorsqu'il arrive dans le sud de la Suède en 64 Cobra 289 ? Il roule, roule et roule. Pour un reportage de voyage spontané. Avec vues panoramiques, vitesse et contre-champs. Et Lenny Kravitz en musique de fond.

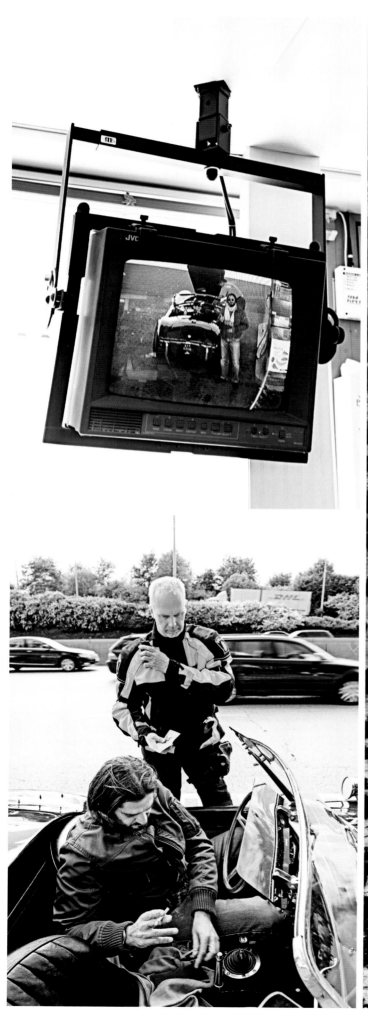

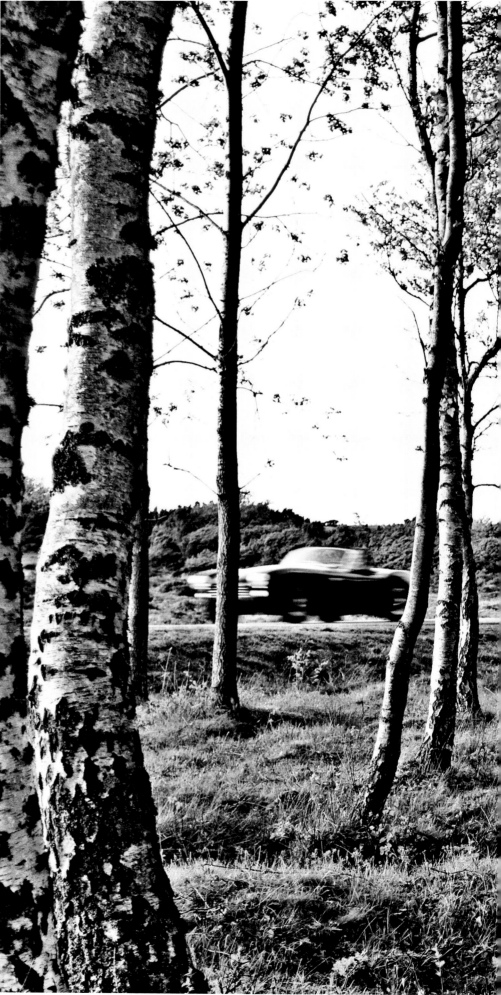

GEDICHTSTRÄCHTIG — Jason Lee Perry mag Gedichte, unternimmt weite Autofahrten mit wenig Geld und braut sein eigenes Bier. Nebenbei fotografiert er. Mode. Motorräder. Und Mädchen. Wie Hailey Clauson. Die ist nicht nur ein Model wie ein Gedicht. Sondern bringt auch Storys zum Laufen. Und anschließend? Gehen die beiden zusammen einen trinken. Oder zwei.

GOT POETRY? — Jason Lee Perry digs poetry, likes to go on extended car trips with little cash, and brews his own beer. He also does photo shoots on the side. His motifs include fashion, motorbikes, and women. Like Hailey Clauson. Not only is she a model as divine as fine poetry. She's also known for doing story animations. What about after that? They like to get together for a drink. Or two.

POÉTIQUE — Amateur de poésie, Jason Lee Perry fait de longs voyages en auto, avec peu d'argent. Et il brasse sa propre bière. En passant, il prend des photos. De mode. De motos. Et de femmes. Comme Hailey Clauson. Un mannequin qui n'est pas seulement d'une poétique beauté. Mais qui donne aussi vie aux articles. Et ensuite ? Ils sont allés boire un verre ensemble. Ou deux.

#13

RAMP
EASY RIDERS

STORY Wild Thing / **PHOTOGRAPHER** Jason Lee Perry

BIKES Diverse Bikes

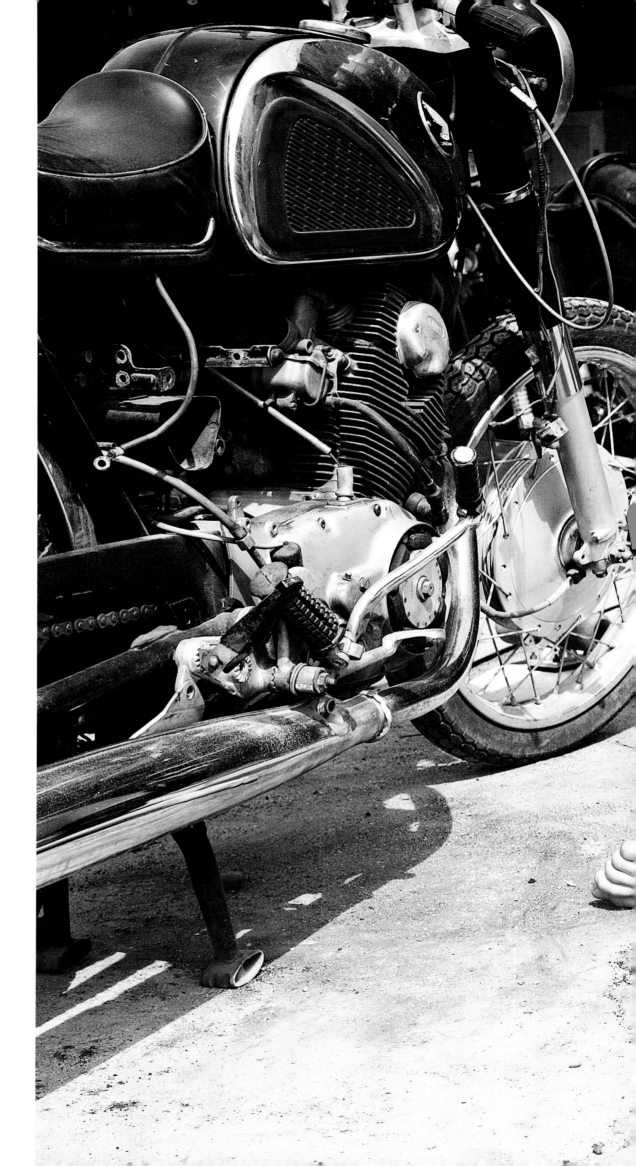

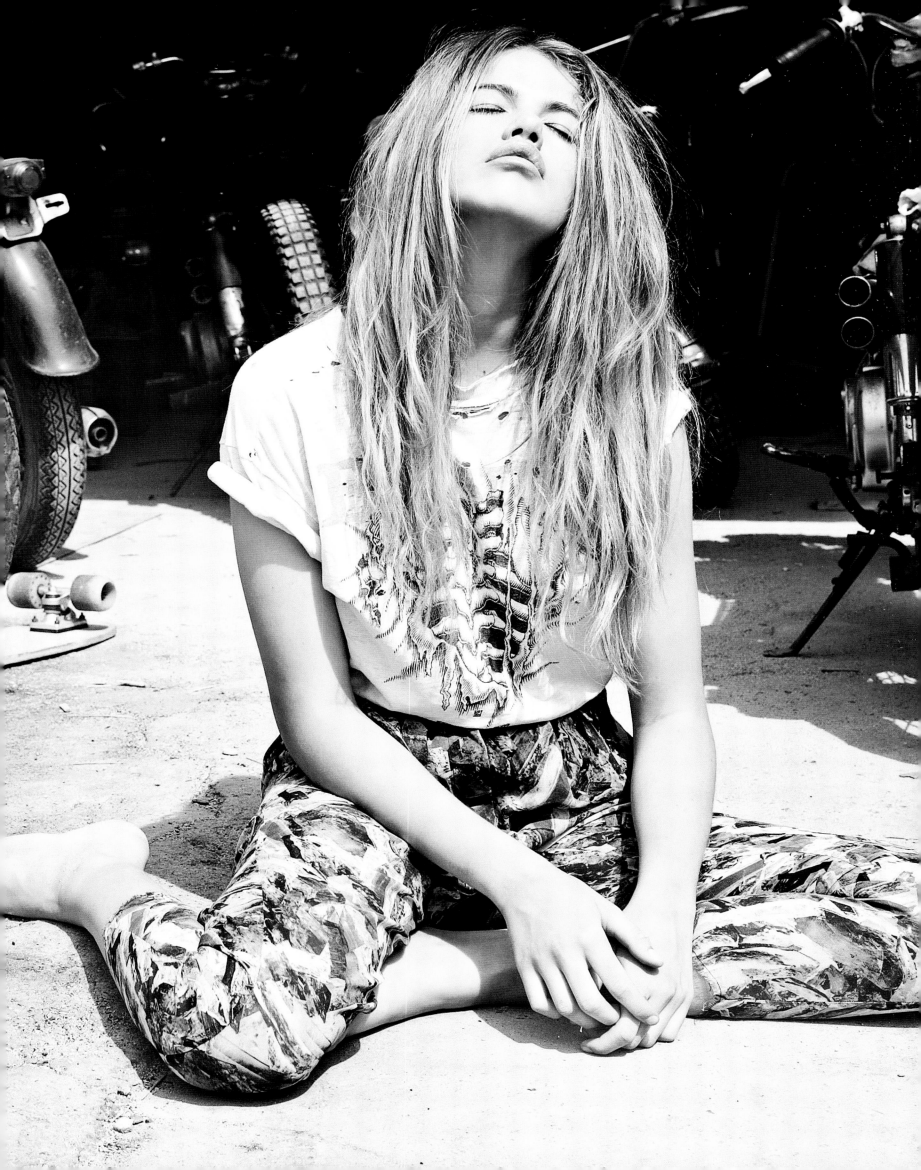

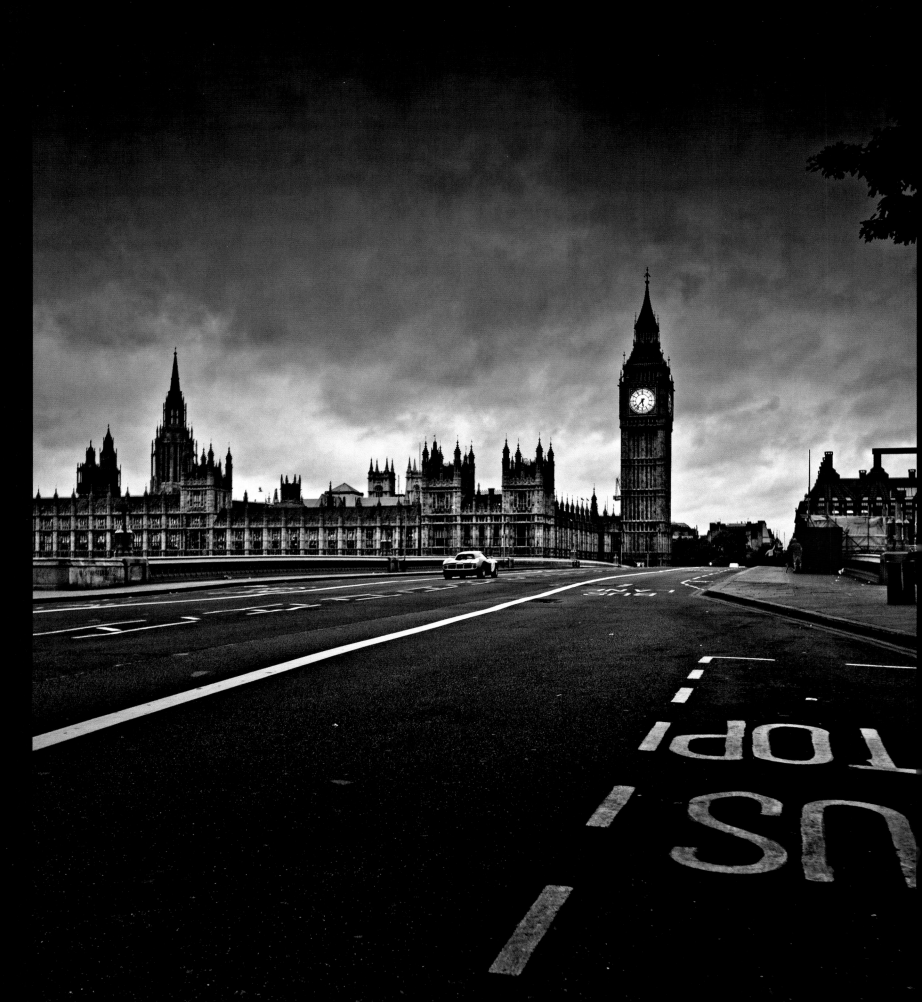

RAMP
UPON THE
LADIES!

STORY All Through The Night / **PHOTOGRAPHER** Roman Kuhn

CAR Ferrari 250 LM

C'ÉTAIT UN RENDEZ-VOUS — Die Zutaten: Da ist ein Ferrari 250 LM, ein Auto mit dem unter anderem Graham Hill und Jo Bonnier 1964 die zwölf Stunden von Reims gewannen; und da ist eine junge Frau. Gemeinsam ziehen sie früh morgens durch die verlassenen Straßen von London. Keine Hetzjagd im Stil von Lelouch, eher die entspannte Tour.

C'ÉTAIT UN RENDEZ-VOUS — First-off, the ingredients: You have a Ferrari 250 LM, the kind of car used by, among others, Graham Hill and Jo Bonnier back in 1964 to win the Twelve Hours of Reims, and you have a young woman. Together, you see them cruising the deserted streets of London. Don't worry, it's not a major chase Lelouch-style, just a casual stroll.

C'ÉTAIT UN RENDEZ-VOUS — Les acteurs : d'un côté, une Ferrari 250 LM, une voiture qui a notamment permis à Graham Hill et Jo Bonnier de remporter en 1964 les 12 heures de Reims ; de l'autre, une jeune femme. Ensemble, ils sillonnent au petit matin les rues désertes de Londres. Pas de course folle dans le style de Lelouch. Plutôt une virée décontractée.

SCHAU AN! — Amerikanische Speed-racer fliegen mit über 600 km/h über eine Salzwüste. Geschwindigkeit im Bild darzustellen, ist eigentlich absurd. (Wir haben es trotzdem geschafft.) Die Lösung hatte Fotograf Markus Altmann: mit stehendem Auto. Und einem Typen, der einer Staubwolke hinterherblickt.

LOOKIT THAT! — American speed racers fly across salt flats at speeds over 600 kph (373 mph). Trying to capture speed on camera is really kind of absurd. (We did it anyway.) It was photographer Markus Altmann, who came up with the solution, which was to capture a parked car. And some guy staring at a dust cloud moving away.

REGARDE-MOI ÇA ! — Des Speed-racer américains filent à plus de 600 km/h dans le désert salé. A priori, représenter la vitesse sur une photo est absurde (il n'empêche que nous avons relevé le défi). Le photographe Markus Altmann a trouvé la solution : avec une auto à l'arrêt. Et un gars qui suit du regard un nuage de poussière.

#06

RAMP
ES LEBE DER
SPORT!

STORY Das Tempodrom am Ende der Welt

PHOTOGRAPHER Markus Altmann

CAR American Land Speed Racer

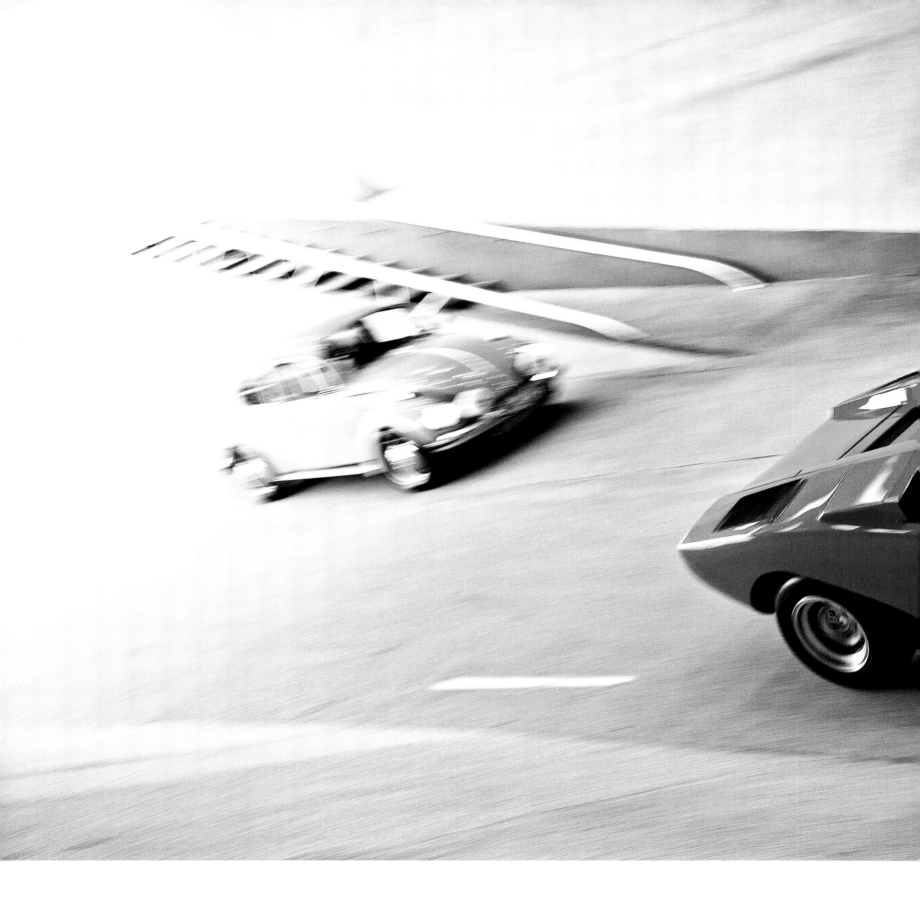

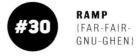

RAMP
{FAR-FAIR-
GNU-GHEN}

STORY Brüder im Geiste / **PHOTOGRAPHER** Nils Hendrik Müller

CARS Lamborghini Countach LP400 & Volkswagen Beetle

WETTERFÜHLIG — Lamborghini Countach und VW Käfer, mitten in der Stadt. So war der Plan. Doch dann: Wolkenbruch in Wolfsburg am Shootingtag. Fotograf Nils Hendrik Müller reagiert spontan: Ab ins phaneo, ab ins Trockene. Gut gemacht, Nils. Beim nächsten Mal schicken wir ihn nach Alaska.

WEATHER SUCKS — The plan was to take both a Lamborghini Countach and a Volkswagen Beetle out for a downtown spin. Had it not been for the steady downpour visiting downtown Wolfsburg on the very day we were scheduled to shoot. Photographer Nils Hendrik Müller spontaneously came up with Plan B: Go find someplace dry, anyplace. Good call, Nils! In fact, next time, we might just send him to Alaska.

CAPRICES MÉTÉO — Lamborghini Countach et coccinelle VW, au cœur de la ville, comme prévu. Malheureusement : pluie d'orage à Wolfsburg le jour du shooting. Réaction spontanée du photographe Nils Hendrik Müller : partir au musée du Phaneo. Au sec. Bien joué, Nils. La prochaine fois, on l'enverra en Alaska.

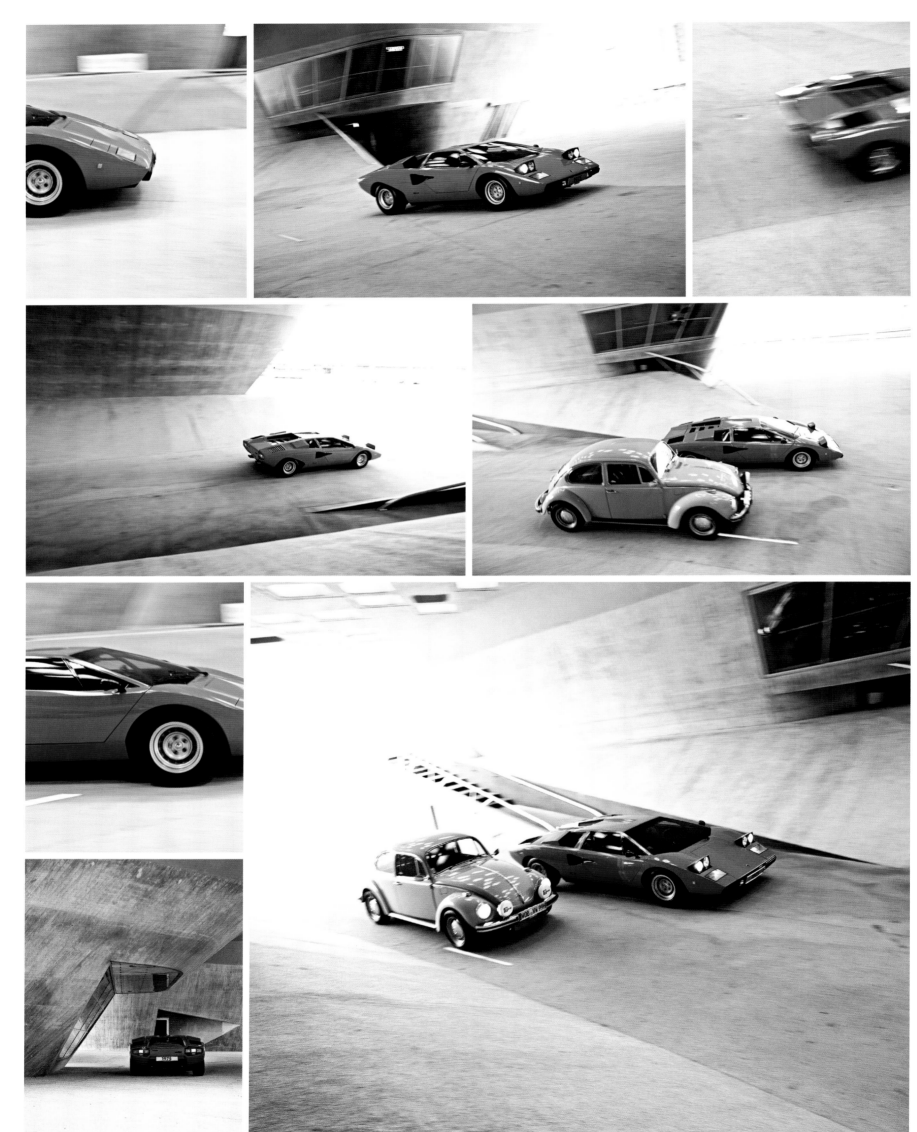

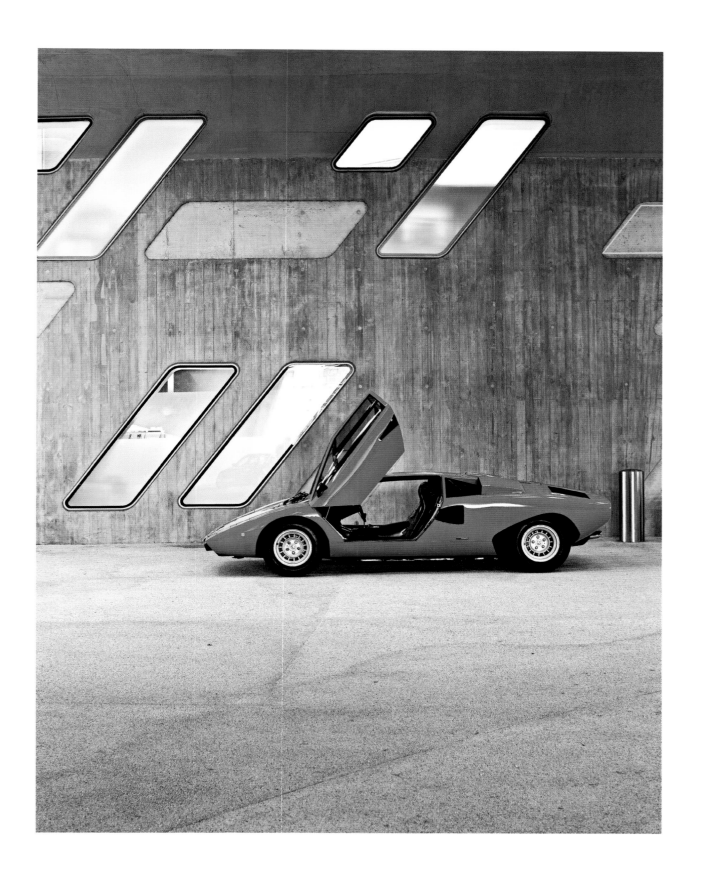

AUFGEMALT — Die Frage, ob das Kunst ist, darf hier gar nicht erst gestellt werden. Der wohl berühmteste BMW, ein M1 von Andy Warhol 1979 bemalt, steht normalerweise im Museum. Normalerweise. Logisch, dass dieses Auto, fahrend auf den Straßen von New York, ebenfalls Kunst ist. Egal aus welcher Perspektive.

CAR PAINTING — Please, don't even bother asking whether it's art. What might quite possibly be the most famous BMW around—an M1 that Andy Warhol painted on back in 1979—is usually kept in the museum. Usually. Of course, it's a no-brainer for this car to equally be a work of art when driven on the streets of New York. No matter how you look at it.

PEINTURE — Ici, la question de savoir si c'est de l'art n'est pas pertinente. La plus célèbre des BMW, une M1 peinte par Andy Warhol en 1979, est exposée dans un musée. Normalement. Quand elle roule dans les rues de New York, cela reste de l'art. Logique. Quelle que soit la perspective qu'on adopte.

#07

RAMP
LET'S GET OUT
OF HERE!

STORY „Ich liebe das Auto"

PHOTOGRAPHER Yona Heckl / **CAR** BMW M1

MISTER SHELBYS' STOLZ — Wer Mustang sagt, muss auch Shelby sagen. Wer Shelby sagt, muss auch Cobra sagen. Und wer sich den Boliden von Carroll Shelby anschaut, muss die Luft anhalten. Wir haben gleich vier Mustangs in einer Industriehalle in Aachen fotografiert, unter anderem einen Mustang TransAm von 1968 und eine 64er Cobra 289 TT Racer.

MISTER SHELBY'S PRIDE — In for a Mustang, in for a Shelby. In for a Shelby, in for a Cobra. Make no mistake about it: the sight of Carroll Shelby's muscle car is quite simply breathtaking. We went to an industrial warehouse in the city of Aachen, where we did a photo shoot of no fewer than four Mustangs, including a '68 Mustang Trans-Am and a '64 Cobra 289 TT Racer.

LA FIERTÉ DE MONSIEUR SHELBY — Qui dit Mustang, dit Shelby. Et qui dit Shelby, dit forcément aussi Cobra. Quiconque admire le bolide conçu par Carroll Shelby en a le souffle coupé. Nous avons photographié quatre Mustang dans un bâtiment industriel d'Aix-la-Chapelle, notamment une Mustang Trans-Am de 1968 et une Cobra 289 TT de course de 1964.

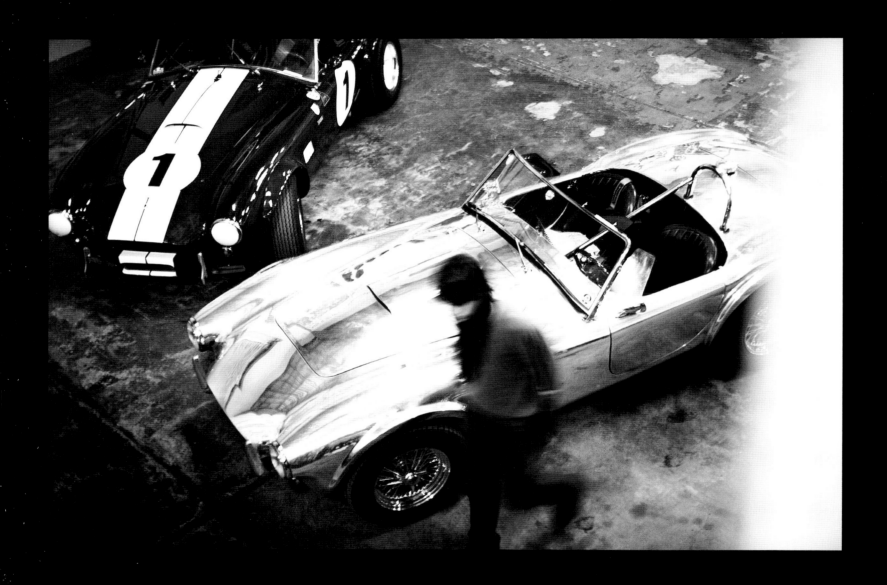

#17　　**RAMP**
24

STORY Carroll's Wild Things / PHOTOGRAPHER Byron Mollinedo & Greve

CARS Mustang TransAm & Shelby Cobra 289 TT Racer

DIE PERFEKTION DES PERFEKTEN —
Ferrari 250 - schon im Stand klingt
das perfekt. Das Kürzel GTO dreht
die Schraube aus Perfektion noch
ein Stück weiter in Richtung Exklu-
sivität. Die Bluse bei einem Stopp
lässig über dem Fenster trocknen zu
lassen - warum sollte sich ein GTO
dafür zu schade sein? Eben!

PERFECTION PERFECTED —
Ferrari 250—to hear it is to hear the
sound of perfection, even when its
engine is silent. The GTO moniker
further enhances that perfection
by underpinning its exclusiveness.
Seeing that same GTO parked with
a blouse casually left to dry on the
windshield—why would that be in-
appropriate on a GTO? Right?!

**LA PERFECTION DE LA
PERFECTION —** Ferrari 250 - même
à l'arrêt, c'est la perfection. Et le sigle
GTO fait monter le curseur encore
un peu plus haut, vers l'exceptionnel.
Laisser négligemment sécher son
chemisier par la fenêtre lors d'une
pause - pourquoi cela serait-il déva-
lorisant pour une GTO ? La preuve
en images !

#19 **RAMP**
WILD WILD WEST

STORY Nissssscht beschonderes

PHOTOGRAPHER Daniela Ellerbrock

CAR Ferrari 250 GTO (Chassis #4153)

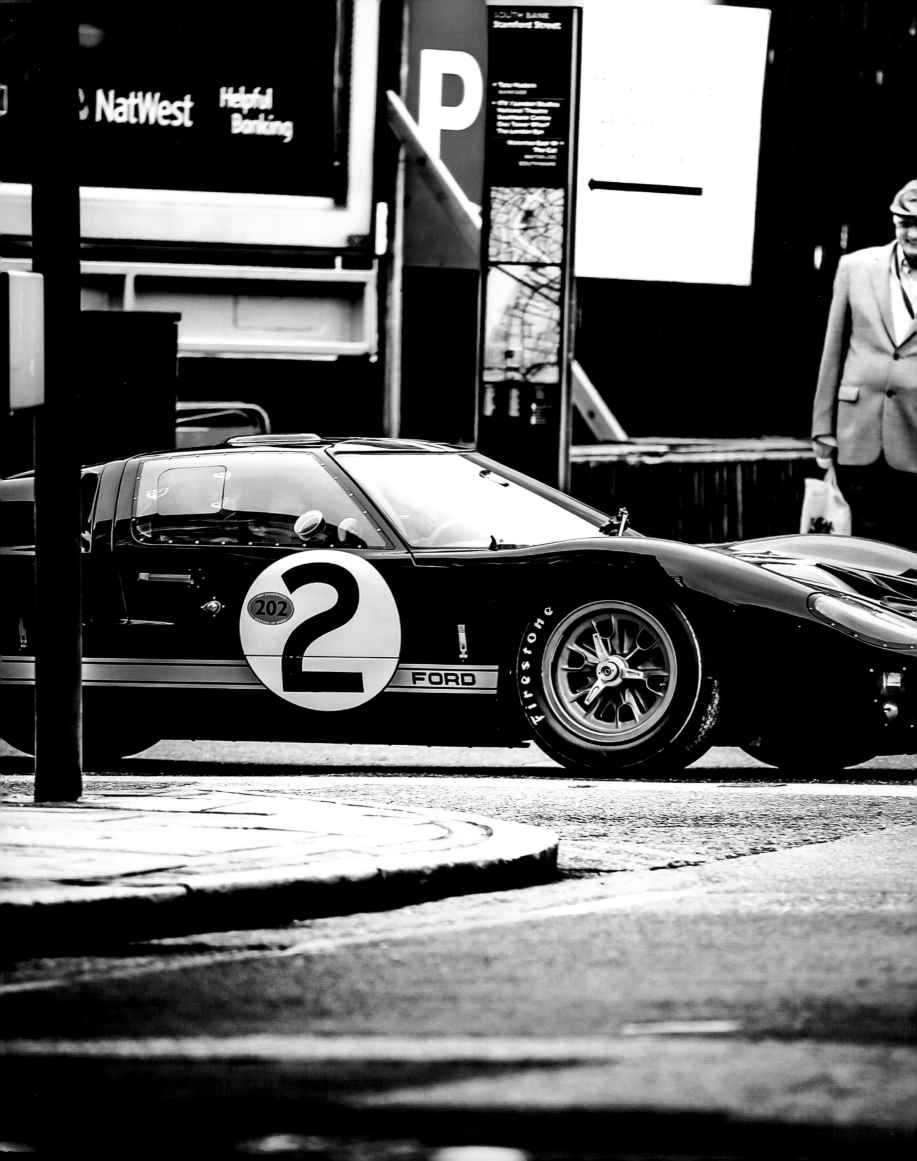

„MACHT KEINEN SCHEISS!" — Zwei Ford GT40 von London auf ihrem Weg nach Goodwood zu fotografieren, fanden wir eine tolle Idee. Gut, eine Genehmigung hatten wir nicht. Brauchten wir auch nicht. Waren eh alle Straßen frei, denn es war gerade G8-Gipfel. Der freundliche Polizist ließ uns dann auch mit den Worten passieren: „Freunde, tolle Autos. Fahrt weiter, aber macht keinen Scheiß!"

—————————

"DON'T DO ANYTHING BOLLOCKS!" — Doing a photo shoot of two Ford GT40s en route from London to Goodwood was a great idea as far as we were concerned. OK, so we didn't have the necessary permit. Heck, we didn't need it. Given the ongoing G8 Summit at the time, we didn't think there'd be any cops around to pull us over, anyhow. Well, the one that did was kind enough to let us go with a warning, "Fancy rides you got there, mates. All right, go on, then. Just don't do anything bollocks!"

—————————

« NE FAITES PAS DE BÊTISES ! » — Photographier deux Ford GT40 en route de Londres à Goodwood nous semblait une très bonne idée. Certes, nous n'avions pas d'autorisation. Mais nous n'en avions pas vraiment besoin. Car les routes étaient dégagées en raison de la tenue du sommet du G8. Un sympathique policier nous a laissé passer avec ces mots : « Superbes bagnoles, les gars. Allez-y, mais ne faites pas de bêtises ! ».

#03 **RAMPCLASSICS**
GO LIKE HELL

STORY Der Feldzug

—————————

PHOTOGRAPHER Roman Kuhn / **CAR** Ford GT40

—————————

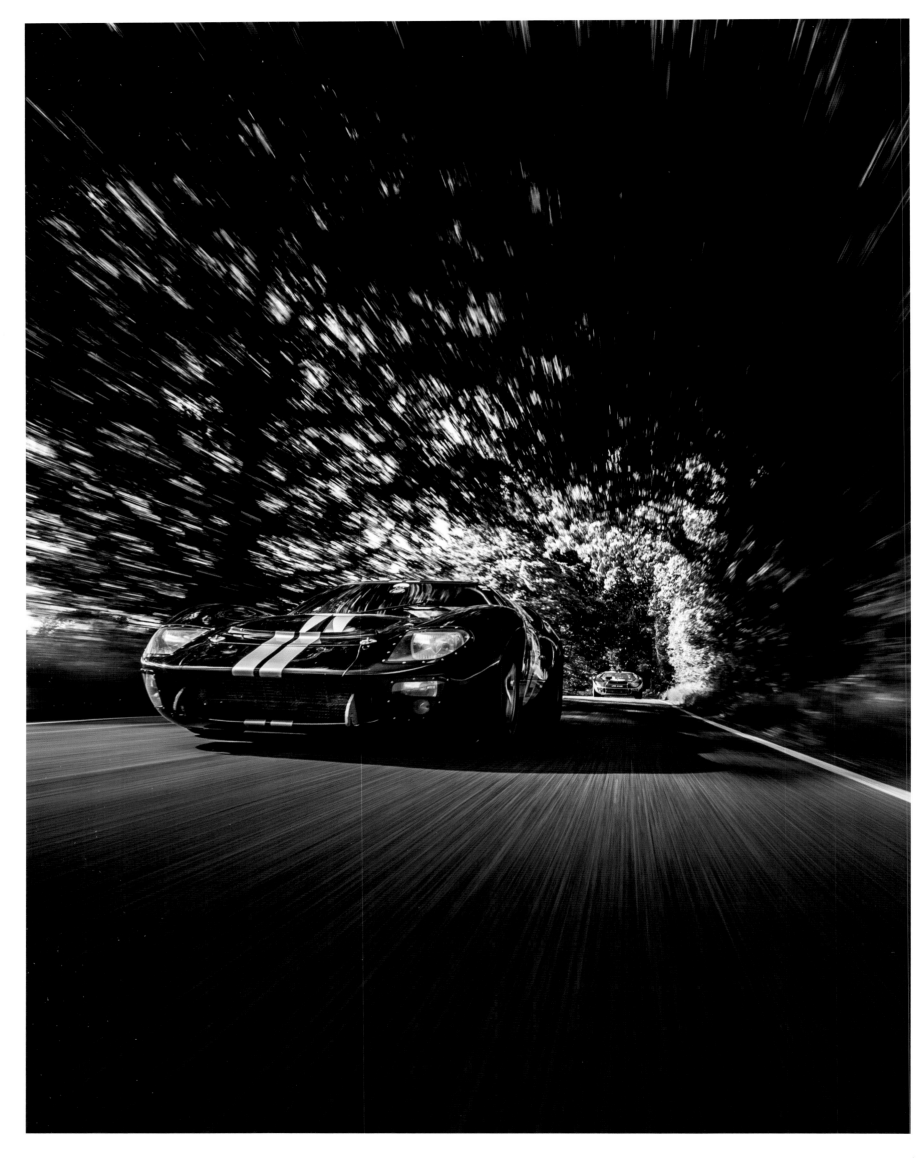

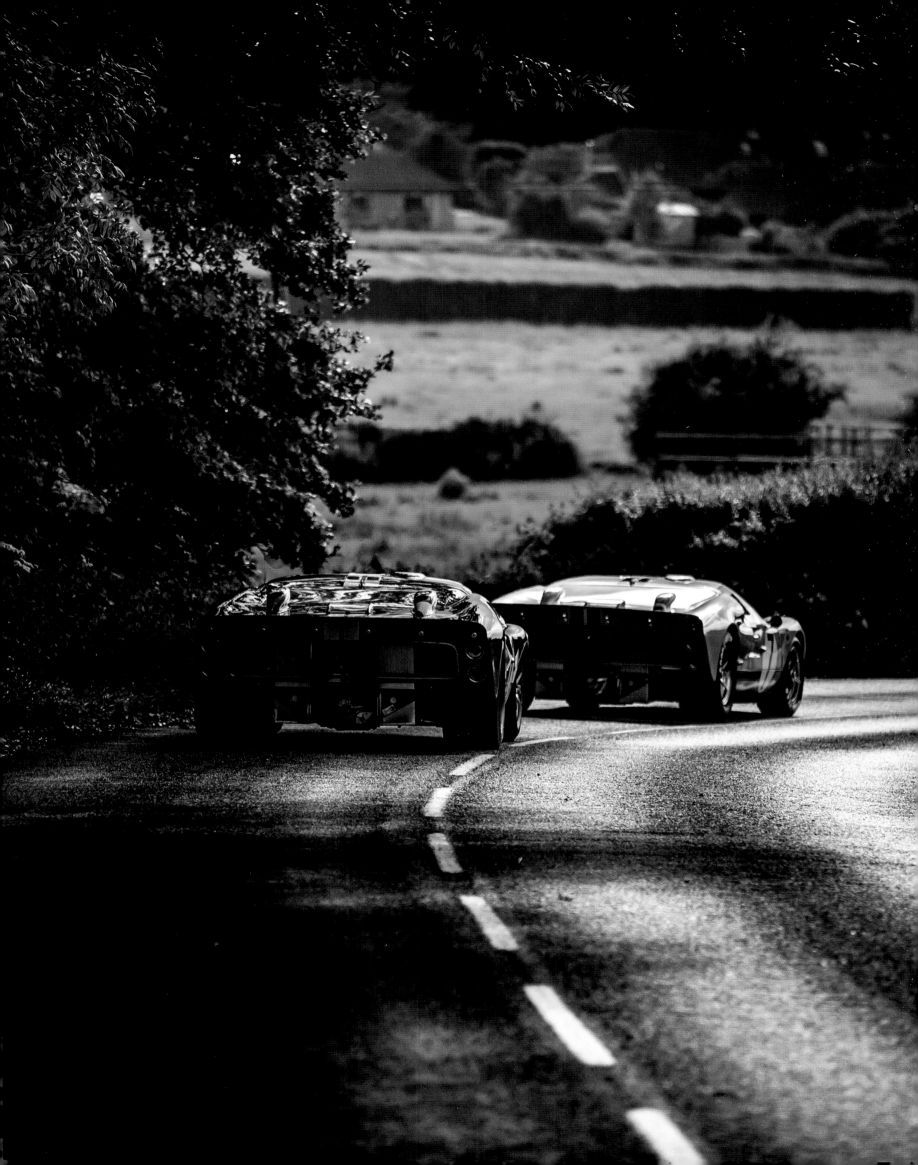

Von Michael Köckritz

———— Der Zeitgeist begegnete dem Automobil zunächst eher etwas sperrig.

„Wenn ich die Menschen gefragt hätte, was sie wollen, hätten sie gesagt: Schnellere Pferde", fasste Henry Ford die Angelegenheit einmal im Nachhinein trocken zusammen. Interviewt wurde von Ford am Anfang des letzten Jahrhunderts offensichtlich niemand, stattdessen antizipierte er mit einem unbestechlichen Möglichkeitssinn, was die Menschen haben wollten, aber es selbst noch nicht wussten: Ein Fahrzeug, das von einem Verbrennungsmotor angetrieben wird. Also perfektionierte Ford das Fließband, um das Auto fortan zum Massenartikel werden zu lassen.

Wir halten fest: Der Zeitgeist hatte keine Ahnung.

Ist aber in diesem Zusammenhang auch nicht weiter dramatisch.

Steve Jobs, einer der Henry Fords des 21. Jahrhunderts, erklärte auch weshalb: „It's not the customer's job to know what they want."

Wir werden in diesem Beitrag also zunächst vorsichtig mit dem umgehen, was sich so ein Zeitgeist zu wünschen scheint. Ganz im Sinn von Hans Magnus Enzensberger, der einmal festhielt: „Etwas Borniertertes als den Zeitgeist gibt es nicht. Wer nur die Gegenwart kennt, muss verblöden."

Da haben wir es! Es kommt nämlich nicht nur darauf an, sich in seiner Epoche auszukennen, man sollte vielmehr erst einmal wissen, was den Menschen tief in seinem Innern antreibt.

Mobilität war immer elementar für unser Überleben. Wer sich im Vergleich mit anderen leichter und schneller fortbewegen konnte, hatte sofort einen deutlichen Vorteil. Und das gilt seit der menschlichen Urgeschichte. Die umherschweifenden Jäger und Sammler profitierten früh, auch wenn sie von einer relativen Langsamkeit und begrenzten Transportfähigkeit physiologisch eingebremst wurden. Technische Hilfsmittel der Fortbewegung waren dann für eine Spezies, die sich über die ganze Erde verbreitete, ein wichtiger Entwicklungsturbo. Schon in den Mythen der meisten Völker waren selbstbestimmte, unbegrenzte und räumliche Fortbewegung und Geschwindigkeit ein zentrales Thema. Gerne als Attribut von Gottheiten oder Auszeichnung für den Men-

schen. Aber auch schon damals mit entsprechenden Risiken und Nebenwirkungen: Phaethon, der Sohn des Gottes Helios, überredete den Papa, ihm seinen Sonnenwagen zu überlassen und baute damit – wie sollte es anders sein – prompt einen Unfall.

Was immer diese Mobilitätsfähigkeiten beflügelt – und sei es „nur" in der Fantasie –, wird stark mit positiven Gefühlen besetzt. Immer wenn es in Umfragen um die größten Erfindungen der Menschheit geht, rangieren Rad, Fahrrad, Auto, Flugzeug und Eisenbahn sehr weit oder auch ganz vorne. Im unmittelbaren Umfeld begegnen uns Zündkerze, Dampfmaschine, Motor und Düsentriebwerk. Von den mythologischen Fantasien der Fortbewegung, den Götterwagen und Flugträumen der Antike, ergibt sich eine libidinöse Besetzung, die heute zuverlässig alle Stadien vom Laufrad über den Roller bis zum Auto durchläuft. Die Lust an der effizienten Fortbewegung ist zu einem archaisch verankerten Trieb geworden, der zugleich unsere hohe emotionale Affinität zum Auto schlüssig werden lässt. Letztlich bewerten wir eine potenzielle Verbesserung unserer Überlebensfähigkeit, wenn unser Herz beim Anblick eines Autos höherschlagen sollte. So gesehen punktet das Auto also schon einmal unter evolutionspsychologischen Aspekten eher zeitlos, weil es unsere Fähigkeit, in der Welt zu sein, technisch so wirkungsvoll verstärkt. Eine gute Basis für eine Beziehung.

Apropos Anblick: Unser zentrales Nervensystem belohnt den Blick auf Autos mit der Biochemie der Lustgefühle auch aus zwei weiteren Gründen. Einmal besitzen wir ausgeprägte sinnesphysiologische Präferenzen, die auf Körperanalogien wie ein Gesicht, eine Augenpartie, einen Hüftschwung oder einen Po aufmerksam bis ausgesprochen gerne reagieren. Wir können gar nicht anders. Gute Automobildesigner wissen so etwas selbstverständlich zumindest intuitiv.

Und dann machen wir uns mit dem Auto gerne hübsch. Es bietet sich ideal an, funktioniert wie ein Ornament. Und hier gilt: je aufwendiger so ein Ornament (z. B. ein Auto, mit dem ich mich schmücke), desto eindrucksvoller beweise ich überlegene Ressourcen und desto höher ist die Wahrscheinlichkeit sozialer Vorteile. Die Werbung für Sport- oder Luxusautos setzt hier schlau an. „Die ganze Natur ist übervoll von Phänomenen, die nur als Resultat kompetitiven Investierens in scheinbar überflüssige, tatsächlich aber höchst wertvolle Ornamente verstehbar sind", erklärt Professor Winfried Menninghaus. Bekannt wurde der Wissenschaftler für seine Arbeit im Feld der Ästhetik, außerdem ist er Gründungsdirektor des neuen Max-Planck-Instituts für empirische Ästhetik in Frankfurt am Main. „Alle Kulturen haben den ihnen möglichen Aufwand für Techniken der Selbstornamentierung getrieben. Diese hören nicht

an den Grenzen des Körpers auf. Der Besitz begehrter Objekte hat ebenfalls den Wert eines Ornaments. Er ist deshalb Teil und Medium einer hochkompetitiven sexuellen und sozialen Konkurrenz mit ästhetischen Mitteln." Das Auto bietet sich als ein externer Teil unseres Körpers an, und zwar als einer, der unmittelbar im Schaufenster sonstiger sexueller Körpervorzüge plakativ dekoriert werden kann. Das Auto als unsere schillernde Pfauenfeder.

So viel zur evolutionspsychologischen und -biologischen Affektbasis und zu den markanten Spuren in der Natur- und Kulturgeschichte.

Na ja, und dann kam das Auto eben tatsächlich in unser Leben. Womit wir die Kurve zum Zeitgeist bekommen hätten. Zunächst zum damaligen. Der wachte nämlich rasch auf. Das Auto und seine Optionen wurden zu einem Objekt der Begierde und zu einem Massenprodukt. Vor allem aber hatte das Auto einen gewaltigen kulturellen Einfluss. Das Auto war nicht nur etwas, es meinte etwas. Es meinte Freiheit und Autonomie. „Automobilität bedeutet die Möglichkeit zur Wahl von Fortbewegungsart, Strecke sowie Zeitpunkt und impliziert damit Individualität und Selbstbestimmung", formuliert der Philosoph Peter Sloterdijk.

Das Auto kam als eine Idee.

Die heutige westliche Kultur wurde vom automobilen Gedanken irreversibel geprägt. Und den Amerikanern lieferte es dann das geeignete Transportmittel zur Unabhängigkeitserklärung nach. Hier fuhren die unveräußerlichen Rechte eines jeden Menschen auf „Leben, Freiheit und das Streben nach Glückseligkeit" auf vier Rädern vor. „The Pursuit of Happyness" war untrennbar mit dem Auto verbunden. Das Auto transportierte Sehnsucht. Roadmoviefeeling. Alles kam in Bewegung. Hin und wieder auch die Gefühle im Auto: „Man müsste mal eine Abhandlung über den sittlichen, physischen und ästhetischen Einfluss des Ford-T-Modells auf das amerikanische Volk herausgeben", schrieb John Steinbeck. „Die meisten Babys jener dahingegangenen Epoche wurden im Ford-T-Modell gezeugt und nicht wenige in ihm geboren."

Das Auto als Liebesnest, generell als Nest, als Lebensraum. Viel später sollten dann auch einmal Verkehrspsychologen herausfinden, dass selbst eine richtige Rushhour nicht immer jene Qual ist, für die sie meist gehalten wird. Die Ergebnisse offenbaren nämlich, dass sich viele Verkehrsteilnehmer regelrecht auf den Stau im Berufsverkehr freuen würden. Dabei geht es nicht um Geselligkeit, sondern um das Gegenteil. Der Stau als die einzige Stunde am Tag, in der man mal in Ruhe seinen Gedanken nachhängen kann. Danach warten der Chef, die Beziehung oder die Kinder. „Der Platz hinter dem

Steuer bietet viel Raum für das Tagträumen", schrieb John Steinbeck, „ich habe auf langen Strecken Häuser geplant, Gärten angelegt und ganze Stücke geschrieben."

Smartphone und iPad und supervernetzte Autos waren da allerdings noch nicht erfunden.

Der amerikanische Historiker James J. Flick hat das 20. Jahrhundert einmal als „automobile age" bezeichnet. Damit ist es jetzt erst einmal vorbei. Beschränkte Ressourcen, Umweltbelastungen und überfüllte Straßen sind das eine, prägen den zeitgemäßen Blick einer zunehmend ökologisch geprägten Gesellschaft. Der Zeitgeist fordert hier das Weltretten ostentativ ein. Das Auto als unantastbares und unbekümmert genutztes Fortbewegungs- und Freiheitstool gibt es nicht mehr.

Das Auto hat seine Unschuld verloren.

Und außerdem gibt es ernst zu nehmende Konkurrenz.

Bis vor wenigen Jahren war das Auto Beziehungskiste und Beziehungsverstärker zugleich. Mit dem Auto fuhr man zu Freunden und zur Freundin, mit dem Auto lernte man Menschen und neue Kulturen kennen, pflegte Kontakte und Beziehungen. Mit dem Auto fuhr man mitten ins Leben.

Mittlerweile kann man einfacher ständig mittendrin und überall dabei sein.

Man muss dafür nicht einmal das Haus verlassen.

Alle sind im Netz vereint.

Allen voran der Nachwuchs.

Als die amerikanischen Marktforscher von J.D. Power, bekannt für ihre in vielen Ländern erhobenen Untersuchungen zur Kundenzufriedenheit, vor etwa vier Jahren mit einer Studie mehr über die Autovorlieben der Jahrgänge ab 1980 erfahren wollten, wurde es offensichtlich: „Mit der zunehmenden Wichtigkeit der ‚social media' und anderer elektronischer Kommunikationsformen", so lautete das Ergebnis, „empfinden ‚teens' und ‚early careerists' weniger die Notwendigkeit, sich real zu treffen, und haben deshalb weniger Bedarf an einem individuellen Transportmittel." Die sogenannte Generation Y (y für young) interessierte sich plötzlich nicht mehr für Autos, und so erkannt: Eine ganze Reihe von Studien und Beobachtungen lieferten ähnliche Analysen. Das Auto stand auf einmal deutlich entemotionalisiert in der Gegend herum und war nur noch eine Mobilitätsoption unter vielen, verankert in einem ganzen Portfolio von Möglichkeiten, zu dem auch Konzepte wie Carsharing oder

Pooling gehören. In den Chefetagen der Automobilmarken herrschte natürlich Alarmstufe Rot. Nicht zuletzt deshalb, weil ausgerechnet diese Generation Y über mehr Einkommen als jede andere Generation vor ihr verfügt. So eine zunehmend pragmatisch-nüchterne Einstellung zu Automobilbesitz und -gebrauch passte da in keinen Business- oder Strategieplan. Entsprechend kam etwas Bewegung ins Spiel. Mitunter auch etwas Aktionismus. Immerhin ging es darum, das Auto möglichst rasch neu zu erfinden. Irgendwie. Aber hatte nicht schon Henry Ford gewarnt: „Wer immer tut, was er schon kann, bleibt immer das, was er schon ist."

Also bietet sich das Auto so vielfältig an wie nie, immer neue Nischen und Varianten entstehen. Das Aktualisieren und Aufbrechen sozialer Differenzen in der postindustriellen Gesellschaft scheint also auch zu einer sozialen Differenzierung der Automobile, von der Kultur- zur Konsumwende. Auch denkt das Auto jetzt mit. Es reagiert auf die Umwelt, auf die Insassen und auf andere Fahrzeuge. Ob es uns auch selbstständig chauffieren könnte? Klar! „Autonomes Fahren" lautet hier das revolutionäre Zauberwort. Alleine und im Schwarm. Einen der ersten nachhaltigen Impulse setzte in diesem Fall aber keiner der etablierten Autobauer, sondern ausgerechnet das Internetunternehmen Google. Aber warum sollte ein Unternehmen, das gerne erfolgreich sucht, nicht auch ein Robo-Taxi selbstständig nach dem richtigen Weg suchen lassen? Nach den Enthüllungen des Google-Projekts vor fünf Jahren intensivierten auch die Autohersteller ihre Entwicklungen. Zur IAA 2013 nutzte Mercedes-Chef Dieter Zetsche die große Bühne, um sich von einer selbstfahrenden S-Klasse dorthin pilotieren zu lassen.

Begriffe wie „Big Data", „Semantic Web" und „Internet of Things" müssen jetzt in Verbindung mit Autos verstanden werden. Statt Raum und Mobilität sollen jetzt Zeit und Kommunikation kaufentscheidende Reize liefern. „Wer sich der virtuellen Welt nicht anschließt, wird ausgeschlossen", konstatiert der Trendforscher Peter Wippermann.

Oder er bekommt womöglich bald gar kein Auto mehr.

„Händler werden auch in Zukunft eine zentrale Rolle spielen", prophezeite etwa Jens Monsees von Google anlässlich eines Kongresses des Instituts für Automobilwirtschaft in Nürtingen. „Die Frage ist aber, wie kommt der Kunde zum Händler?" 200 Suchanzeigen gibt es bei Google derzeit pro Sekunde in Deutschland zum Thema Auto. „Kunden sind heute zunächst digital unterwegs, auf allen möglichen Kanälen, und sie kommen nicht mehr vier-, sondern nur einmal ins Autohaus", erklärt Malte Krüger von mobile.de. „Das Internet ist eindeutig die erste Informationsquelle beim Kauf eines Autos",

sagt auch Reinhard Zillessen von Ford. Ford investiere in die enge Verzahnung von Off- und Online auf allen Kanälen. „Im Jahr 2020 wird es nicht mehrere Massenmedien geben, sondern nur noch eines, das Internet", zeigt sich Zillessen überzeugt.

Audi hat bereits eine Art Testlabor für den zukünftigen Autokauf am Start – in den Innenstädten von London und Peking, Berlin kommt bald. „Audi City" nennt sich das Projekt und soll den Autokauf so einfach wie nie machen. Die neuen virtuellen Showräume zeigen über Bildschirme, die sich interaktiv über Gesten steuern lassen, alle Konfigurationsmöglichkeiten der Audi-Produktwelt. Bleibt noch festzuhalten, dass hier die schöne neue Verkaufswelt in bester Lage ganz real duftet – nach Kaffee. Statt aufdringlichen Beratern begegnet man nämlich freundlichen Relationshipmanagern, die möglichst entspannt Espresso servieren. Kein Wunder, dass sich Audi über Laufkundschaft und Spontankäufe freuen kann. „Es geht nicht mehr um das Ziel unserer Reise oder um Sehnsucht, es geht um unsere konkreten Wünsche", sagt Wippermann. „Für die Automobil-Unternehmen ergeben sich daraus die nächsten Evolutionsschritte: Nicht den Markt verstehen, sondern den Menschen. Ihre Ziele nicht für Business, sondern für die Welt zu formulieren." Mal sehen, ob's klappt.

Kurz: Das Auto kämpft. Mit allem was es hat, haben könnte oder gerne hätte. Aber bei aller Begeisterung für die reizvollen Versprechen, die unsere Zeit dem Automobil gerne anbietet, sollten wir die Angelegenheit locker angehen. Rolf Dobelli weist in seinem Buch „Die Kunst des klugen Handelns" auf die gefährliche Manie für das Neue hin. „Jede Gesellschaft, die sich ihre Zukunft vorstellt, legt zu viel Gewicht auf die momentan heißesten Erfindungen, die aktuellen ‚Killer-Apps'. Und jede Gesellschaft unterschätzt die Rolle althergebrachter Technologien. Die 60er-Jahre gehörten der Raumfahrt, also malten wir uns Schulklassenfahrten auf den Mars aus. In den 70er-Jahren war Plastik angesagt. Also dachten wir, würden wir in Zukunft in Plastikhäusern leben. Wir überschätzen systematisch die Rolle des Neuen." Für Dobelli ist diese „Neomanie" einer der typischen Irrwege, die man besser den anderen überlassen sollte. Und die „Schwarzen Schwäne" des Mathematikers und Philosophen Nassim Nicholas Taleb, diese ausgesprochen unwahrscheinlichen Ereignisse, die niemand vorsehen kann und die eine Delle im Universum hinterlassen und dem Lauf der Geschichte eine neue Wendung geben, werden uns (und das Auto) sowieso weiterhin überraschen.

Ansonsten darf das Auto tapfer auf den zotteligen Alien-Fernsehserien-Helden Alf vertrauen: „Was man nicht reparieren kann, das ist auch nicht kaputt."

By Michael Köckritz

As so often at first encounters that lead to great love affairs, the initial meeting between the automobile and the zeitgeist was somewhat awkward.

Henry Ford dryly summarized the situation: "If I had asked people what they wanted, they would have said faster horses." Although Ford obviously hadn't interviewed anyone in the early years of the 20th century, his sixth sense for unrealized potential enabled him to anticipate what people would soon want but didn't yet know they would want: a vehicle powered by an internal combustion engine. Ford perfected the assembly line... and the rest is history. The auto became a mass-produced article.

We explicitly note: the zeitgeist hadn't the faintest clue.

There's no further drama here, at least not in this context.

Steve Jobs, one of the 21st century's Henry Fords, explained why: "It's not the customer's job to know what they want."

We'll therefore begin this article by cautiously exploring what the zeitgeist seems to want. This is in accord with Hans Magnus Enzensberger's view: "Nothing is more narrow-minded than the zeitgeist. Anyone who's familiar only with the present day necessarily becomes dim-witted."

There we have it! Merely knowing one's way around one's own era isn't enough. One must first find out what it is that motivates human beings from deep inside them.

Mobility has always been crucial for survival. Ever since prehistoric times, anybody who could move with greater ease and at a faster pace instantly gained a major advantage. Roaming hunters and gatherers benefitted from mobility in the remote past, but physiological constraints imposed natural limits on their speed and transport capabilities. Technical aids to enhance mobility were an important turbocharger for the evolution of a species that gradually spread across the entire planet. Self-determined, speedy, unlimited mobility through space is a central theme in the myths of most cultures too, where mobility was often seen as an attribute of the gods or a boon to mortals, although its risks and side effects were well known. For example, Phaeton, son of the sun god Helios, persuaded Helios to let him borrow the solar chariot, which Phaeton—how could it be otherwise?—promptly crashed.

Whatever lends wings to mobility's abilities—even if those wings are only imaginary—becomes associated with strongly positive feelings. Whenever people are asked to name humankind's greatest inventions, the most frequent responses are always the wheel, the bicycle, the automobile, the airplane, and the railway, closely followed by the sparkplug, the steam engine, the internal combustion engine, and the jet engine. With its fantasies of locomotion, chariots of the gods and dreams of flight, classical mythology spun a libidinous thread that continues to run reliably through all stages of mobility from a child's kick roller to a teen's motor scooter to an adult's automobile. The pleasure derived from efficient locomotion is an archaically anchored drive that explains our potent emotional affinity with the automobile. Our hearts beat faster when we see a desirable roadster because our inner caveman senses a potential improvement in his chances for survival. A car timelessly scores points from the viewpoint of evolutionary psychology because its technology powerfully enhances our ability to exist in the world—a good basis for a relationship.

Apropos seeing: Two additional reasons explain why our central nervous system rewards us with the biochemistry of pleasurable sensations when we see an auto. First, because we have innate and well-developed preferences associated with sensory physiology that eagerly respond to bodily analogies such as a face, the eye area, the swing of a hip or the curves of a posterior. We simply cannot react otherwise. Explicitly or intuitively, good car designers know this so well that it goes without saying.

Second, we like to use cars to prettify ourselves. They're ideally suited for this because they function as ornaments. The rule of thumb here: The more elaborate an ornament is (e.g. the car with which I adorn myself), the more impressively I demonstrate my possession of superior resources and thus the greater likelihood of social advantages. Ads for sport cars and luxury automobiles adeptly trigger this mechanism. "All of nature is filled beyond the brim with phenomena that can only be understood as the results of competitive investments in seemingly superfluous but in fact highly valuable ornaments," writes Professor Winfried Menninghaus, who earned fame for his work in the field of aesthetics and became the founding director of the new Max Planck Institute for Empirical Aesthetics in Frankfurt am Main. "All cultures have always invested an enormous amount of time and effort in techniques of self-ornamentation that don't end at the body's boundaries. Ownership of desirable objects likewise has ornamental value. That's why it's a component and a medium of a highly competitive sexual and social rivalry by aesthetic means." A car offers itself as an external part of our body that can be strikingly decorated in the showcase of other sexual bodily assets. An auto is our iridescent peacock feather.

So much for the evolutionary, psychobiological, emotional basis and the distinctive traces it has left in natural and cultural history.

So far, so good. Then came the moment when the auto physically entered our lives. This brings us back to our earlier remarks about the zeitgeist. First, to the zeitgeist of the early 20th century, which awakened abruptly. The car, along with its options, became an object of desire and a mass-produced product. Above all, the auto exerted a tremendous cultural influence. Rather than merely being something, it also meant something, namely: freedom and independence. The philosopher Peter Sloterdijk writes: "Automotive mobility means the ability to choose one's preferred mode of locomotion, route, and departure time, and thus implies individuality and self-determination."

The auto arrived as an idea.

Contemporary Western culture has been irreversibly influenced by automotive thinking, which belatedly gave Americans the suitable means of transport for their declaration of independence. The inalienable human rights to "life, liberty, and the pursuit of happiness" came rolling toward us on four wheels. The 'pursuit of happiness' was indivisibly linked to the automobile. A car carried more than passengers: it also conveyed yearning and the feeling of a road movie. Everything came into motion in an auto, including, from time to time, the emotions. "Someone should write an erudite essay on the moral, physical, and esthetic effect of the Model T Ford on the American nation," wrote John Steinbeck. "Most of the babies of the period were conceived in Model T Fords and not a few were born in them."

The auto as love nest, nest, and habitat. Many years later, traffic psychologists discovered that even rush hour isn't always the torture it's commonly thought to be. Many drivers actually look forward to commuter traffic, not for community, but for its opposite: solitude. A traffic tie-up is the only hour of the day when most people can be alone to pursue their thoughts. The boss, the relationship or the children await them at the other end of the commute. "The seat behind the wheel provides ample space for daydreaming," John Steinbeck wrote. "On long drives, I've planned houses, laid out gardens, and written complete pieces."

All this occurred long before the invention of the smartphone, the iPad, and the hyper-

networked online Wi-Fi GPS car. The American historian James Flick described the 20th century as the 'Automobile Age.' But this era has passed, at least for the time being. Limited resources, environmental impacts, and over-crowded highways are part of the story, occupying the gaze of an increasingly eco-aware society. The zeitgeist pointedly calls upon us to save the world. The auto no longer exists as an inalienable tool for mobility and freedom, used with carefree disregard for its consequences.

The car has lost its innocence.

And it faces serious competition.

Until a few years ago, an auto was simultaneous-ly a crate and an amplifier for relationships. We hopped into our car to visit friends and girl-friends. With our cars, we got to know people, cultivated contacts and relationships, and drove ourselves into the midst of life.

But now simpler ways exist for us to be con-stantly and simultaneously in the midst of things and everywhere else.

We needn't even leave home.

Everyone is united in the global web.

And the younger generation leads the way.

This became clear about four years ago, when J.D. Power, an American market research company famed for its international studies of customer satisfaction, investigated the automotive preferences of the post-1979 gen-eration. The study found that "as social media and other electronic forms of communication become progressively more important, teens and early careerists feel that it's less necessary to meet one another face to face and according-ly have less need for individual modes of trans-port." J.D. Power wasn't alone in realizing that the so-called 'Generation Y' (Y stands for 'young') was suddenly no longer interested in cars. A large number of studies and observations yield-ed similar findings. The de-emotionalized auto was parked motionlessly, occupied space use-lessly and had become merely one mobility option among many, anchored in a portfolio of possibilities, which also includes ideas such as car sharing or carpooling. A red alert shrilled through the executive floors of the automobile brands, in part because none other than this Generation Y has greater disposable income than any past generation. An increasingly prag-matic and objective attitude toward owner-ship and usage of autos didn't fit in any busi-ness or strategy plan. Strong motivation brought movement and sometimes haste into the situation. The challenge at hand was nothing less than to reinvent the auto as quickly as possible. Years before, Henry Ford had warned:

"Who always does what he is already able to do, always remains what he already is."

Automobiles were accordingly offered with un-precedented diversity. New niches and novel variants arose. Postindustrial society's revision and rescission of social differences seem to conjure up social differentiation of the auto, mo-ving from a change in culture to a change in consumption. Today's cars think along with us: they respond to their environment, to their passengers, and to other vehicles. Will autos soon be able to chauffeur us autonomously? Without a doubt, alone and in flocks! The revo-lutionary magic words are 'autonomous driv-ing.' One of the first sustainable impulses in this context was provided not by an established automaker, but by none other than Google, the internet company. Why shouldn't a business that likes to search successfully also allow a robotic taxi to automatically search for the best route? After Google's project was unveiled five years ago, carmakers likewise intensified their developmental efforts. Mercedes' headman Dieter Zetsche, for example, let a self-driving S class Mercedes chauffeur him onto the big stage at the IAA 2013.

Ideas such as 'big data,' 'semantic web,' and 'the internet of things' must now be understood in relationship to automobiles. Time and commu-nication rather than space and mobility provide the decisive stimuli leading to a car's purchase. Trend researcher Peter Wippermann concludes: "Anyone who doesn't include himself in the vir-tual world will be excluded." Or perhaps he'll no longer be able to buy a car at all.

For example, at a Congress of the Institute for the Automobile Business in Nürtingen, Jens Monsees from Google prophesied: "Dealers will continue to play a central role in the future, but how will the customer come to the dealer?" Google currently handles 200 searches per sec-ond in Germany related to the theme of auto-mobiles. "Today's customers begin by searching digitally on all possible channels. They no longer come to a car dealership four times, but only once," explains Malte Krüger from Mobile.de. Reinhard Zillessen from Ford agrees: "The Internet is unambiguously the first source of information when a person prepares to buy a car." Ford invests in the close intermeshing of offline and online on all channels, says Zilles-sen, who's convinced that "there'll no longer be several mass media in 2020. There'll only be one. And that medium will be the Internet."

Audi has already opened a sort of testing labo-ratory for future automobile purchases in the inner cities of London and Peking, soon to be followed by a third lab in Berlin. 'Audi City' is the name of the project, which aims to make buying a car simpler than ever. These virtual showrooms rely on large screens that can be operated interactively to show all potential configurations in Audi's product world. These brave new worlds of car buying not only occupy optimal locations, but also emit a very real fra-grance: the aroma of coffee. Instead of pushy salespeople, one encounters friendly 'relation-ship managers' who serve cups of espresso with maximal leisureliness. No wonder Audi can be pleased that it now attracts passersby and con-verts them into spontaneous purchasers. "It's no longer about yearning or our journey's desti-nation. Now it has to do with specific wishes," Wippermann says. "This leads to the next evo-lutionary steps for automobile companies: don't understand the market, understand the person; and don't formulate the companies' goals for business, but for the world." Will it work? Only time will tell.

In a nutshell: the automobile is fighting back: with everything it has, could have, or would like to have. Notwithstanding all the enthusiasm for the tempting promises that our era likes to offer the car, we ought to approach this situa-tion casually. In his book "The Art of Thinking Clearly," Rolf Dobelli calls attention to the treacherous mania for newness. "Every society that imagines its future places too much im-portance on the hottest momentary inventions and the current 'killer apps.' Every society underestimates the role of time-honored tech-nologies. Space exploration inspired the 1960s, so we imagined class trips to Mars. Plastic was en vogue in the '70s, so we thought we would live in plastic houses someday. We systematical-ly overestimate the role of the new." Dobelli views this 'neomania' as one of the typical wrong tracks that we'd be better off shunning and letting others pursue. The mathematician and philosopher Nassim Nicholas Taleb coined the phrase 'black swan' to describe highly unlikely events that no one can predict, that make a dent in the universe, and that bring a new turn to the course of history. We can be sure that future black swans will continue to surprise us—and our cars.

The automobile can courageously trust Alf, the shaggy hero of a TV series about a friendly alien, who concludes, "If I can't fix it, it ain't broken."

Texte de Michael Köckritz

————Tout d'abord, l'esprit du temps s'est montré quelque peu rétif avec l'automobile.

« Si j'avais demandé aux gens ce qu'ils voulaient, ils auraient répondu : des chevaux plus rapides » : c'est en ces termes abrupts qu'Henry Ford a résumé les choses, rétrospectivement. De toute évidence, au début du siècle dernier, il n'a interrogé personne. Henry Ford a anticipé, plutôt, avec une incroyable clairvoyance, ce que les gens désiraient sans même le savoir : un véhicule doté d'un moteur à combustion. Aussi Ford a-t-il perfectionné la production à la chaîne pour permettre à l'automobile de devenir un produit de grande consommation.

On peut en conclure que l'esprit du temps n'y entendait pas grand chose.

Ce qui ici n'a d'ailleurs pas vraiment porté à conséquence.

Steve Jobs, l'un des Henry Ford du XXIe siècle, a décrété : « Ce n'est pas le boulot des clients de savoir ce qu'ils veulent. »

Nous allons donc, tout d'abord, envisager avec circonspection ce que l'esprit du temps semble désirer. Tout à fait dans l'idée de Hans Magnus Enzensberger, qui a dit : « Rien n'est plus borné que l'esprit du temps. Quiconque ne connaît que le présent est promis à l'abrutissement. »

Exactement ! L'important n'est pas seulement de bien connaître son époque, mais aussi et surtout de savoir ce qui anime l'être humain au plus profond de lui-même.

La mobilité a toujours été essentielle à la survie des Hommes. Ceux qui étaient en mesure de se déplacer plus facilement et plus rapidement que les autres bénéficiaient de suite d'un net avantage. Cela vaut depuis les temps préhistoriques. Les chasseurs-cueilleurs nomades sillonnant leur environnement ont rapidement prospéré, et ce bien qu'ils aient été freinés par une relative lenteur et une capacité de transport limitée, d'origine physiologique. Divers moyens techniques facilitant la locomotion ont joué un rôle d'accélérateur de développement digne d'un turbo pour une espèce qui a colonisé la Terre entière. L'aptitude à se déplacer rapidement dans l'espace, de manière autonome et sans limites, occupait déjà une place centrale dans les mythes de la plupart des peuples. Elle était souvent l'apanage de divinités ou une récompense offerte aux humains. Cependant, elle était déjà associée alors à des risques et à des effets secondaires : Phaéton, fils du roi Hélios, réussit à convaincre son papa de lui confier son char solaire avec lequel il n'a pas manqué d'avoir un accident, sur-le-champ – comment aurait-il pu en être autrement?

Les moyens qui favorisent ces capacités de déplacement – même lorsqu'ils ne sont qu'imaginaires –, quels qu'ils soient, sont étroitement associés à des sentiments positifs. À chaque enquête sur les grandes inventions de l'humanité, la roue, le vélo, l'auto, l'avion et le train arrivent en bonne position, voire carrément en tête de classement. Dans notre environnement immédiat, nous côtoyons bougies d'allumage, machines à vapeur, moteurs et réacteurs. Les fantasmes de mobilité de la mythologie, les chars divins et autres rêves d'envol de l'Antiquité ont donné naissance à une empreinte libidineuse, qui traverse aujourd'hui tous les stades de la locomotion, du vélo sans pédale à l'automobile en passant par le scooter. L'aspiration à un déplacement efficace est devenue une pulsion archaïque, ancrée dans la nuit des temps, qui explique notre lien émotionnel à l'automobile. En réalité, lorsque notre rythme cardiaque s'accélère à la vue d'un véhicule, nous ne faisons qu'évaluer une amélioration potentielle de notre capacité de survie. Envisagée sous cet angle, l'automobile s'affirme à un niveau intemporel en termes de psychologie de l'évolution, car elle renforce efficacement notre aptitude à évoluer dans le monde à l'aide de la technologie. Une bonne base pour les relations qui nous unissent à elle.

À propos de vision : si notre système nerveux central réagit à la vue d'une automobile par la biochimie du plaisir, c'est aussi pour deux autres raisons. D'une part, nous possédons des préférences neurophysiologiques sensorielles marquées, qui suscitent des réactions à des analogies avec le corps, comme le visage, une partie des yeux, la courbe des hanches ou des fesses, allant de l'attention à un plaisir marqué. C'est plus fort que nous. Bien évidemment, les bons designers automobiles le savent, du moins intuitivement.

D'autre part, nous aimons nous mettre en valeur avec notre automobile. Fonctionnant comme un ornement, elle s'y prête parfaitement. La règle est la suivante : plus mes atours (l'auto dont je me pare, par exemple) sont coûteux, plus j'affiche de manière ostentatoire que je dispose de ressources élevées et plus la probabilité est forte que je bénéficie de privilèges sociaux. La publicité pour les voitures de sport ou de luxe mise habilement là-dessus. « La nature toute entière regorge de phénomènes pouvant être décryptés uniquement comme le résultat d'une course compétitive à des investissements destinés à acquérir des ornements, en apparence superflus mais en réalité très précieux », explique le professeur Winfried Menninghaus. Connu pour ses travaux dans le domaine de l'esthétique, ce scientifique est le directeur-fondateur du nouvel institut Max-Planck d'esthétique empirique à Francfort-sur-le-Main. « Toutes les cultures ont fait leur possible pour mettre en œuvre des techniques d'ornementation de la personne. Celles-ci ne s'arrêtent pas aux limites du corps. Posséder des objets convoités a également valeur d'ornement. Cela participe donc à une concurrence sexuelle et sociale

extrêmement compétitive, dont elle est aussi le vecteur, par le biais de moyens esthétiques. » L'automobile apparaît donc comme une extension du corps pouvant facilement être décorée de manière ostentatoire, dans la vitrine des autres atouts physiques sexuels. L'automobile faisant office de plumes de paon chatoyantes de l'être humain.

Voilà ce qu'on pouvait dire sur la base émotionnelle de l'automobile liée à notre évolution psychologique et biologique, et sur les jalons importants qui ont marqué notre histoire naturelle et culturelle.

Et puis un beau jour, l'automobile est bel et bien entrée dans nos vies. Ce qui nous aurait permis de prendre le virage de l'esprit du temps. Du moins, de celui de l'époque. Qui s'est éveillé très vite. L'automobile et ses options sont devenues un objet de convoitise et un produit de grande consommation. Mais avant tout, l'automobile a eu une énorme influence culturelle. Elle n'*était* plus seulement quelque chose, elle *signifiait* quelque chose. Elle signifiait la liberté et l'autonomie, comme l'explique le philosophe Peter Sloterdijk : « La mobilité offerte par l'automobile implique la possibilité de choisir son mode de déplacement, son trajet ainsi que son heure ; elle suppose de ce fait individualité et autodétermination ».

L'automobile s'est faite idée.

La culture occidentale actuelle a été marquée par l'idée de l'automobile, de manière irréversible. Aux Américains, l'automobile a fourni rétrospectivement le moyen de transport adapté à la déclaration de l'indépendance. Dans ce pays, les droits inaliénables de tout être humain à « la vie, la liberté et la poursuite du bonheur » sont arrivés sur quatre roues. « The Pursuit of Happyness » était indissociable de l'automobile, qui transportait une aspiration. Ambiance de road-movie. Tout s'est mis en mouvement. Parfois même les sentiments : « On devrait publier un traité relatif à l'influence morale, physique et esthétique de la Ford modèle T sur le peuple américain », a écrit John Steinbeck. « La plupart des bébés de cette époque révolue ont été conçus dans une Ford modèle T et certains y sont même nés. »

L'automobile synonyme de nid d'amour, de refuge en général, d'espace de vie. Bien plus tard, des psychologues s'intéressant à la circulation ont découvert que les embouteillages ne sont pas toujours aussi mal vécus qu'on le croit souvent. Leurs études ont notamment montré que de nombreux conducteurs se réjouissent même des embouteillages aux heures de pointe. Il n'est pas question ici de convivialité, mais précisément du contraire. L'embouteillage comme seule heure de la journée où l'on peut tranquillement laisser vagabonder ses pensées, avant d'être soumis aux attentes du patron, du conjoint ou des enfants. « Au volant, on a tout le temps pour rêver ; pendant de longs trajets, j'ai imaginé des maisons, aménagé des jardins, écrit des ouvrages entiers. », a écrit John Steinbeck.

Il faut dire que le Smartphone, l'iPad et les automobiles super-connectées n'avaient pas encore été inventés.

L'historien américain James J. Flick a qualifié le XXe siècle d'« âge de l'automobile ». Une époque bel et bien révolue. Cela tient d'une part à la finitude des ressources, à la pollution et à la congestion du trafic, qui marquent la vision moderne d'une société de plus en plus soucieuse de la protection de l'environnement. Ici, l'esprit du temps invite de manière ostentatoire à la sauvegarde de la planète. Révolu le temps de l'automobile considérée comme un vecteur de locomotion et de liberté inaliénable, utilisé avec insouciance. L'automobile a perdu son innocence.

De plus, une concurrence s'est fait jour qu'il convient de prendre au sérieux.

Jusqu'à récemment, l'automobile servait à faire naître les relations humaines et à les entretenir. On prenait sa voiture pour aller voir des amis ou sa petite amie. L'automobile permettait de rencontrer des gens et de découvrir d'autres cultures (autrement dit : en auto, on explorait le monde), d'entretenir des contacts et des relations. L'automobile nous conduisait au cœur de la vie.

Désormais, on peut à tout instant être au cœur des choses, beaucoup plus facilement. Être présent partout. Sans même avoir besoin de sortir de chez soi.

Nous sommes tous unis par le réseau.

Principalement les jeunes.

Lorsque les analystes de la société d'études de marché J.D. Power, connue pour ses enquêtes sur la satisfaction client dans de nombreux pays, ont mené il y a environ quatre ans une étude pour mieux cerner les préférences des personnes nées après 1980 dans le domaine de l'automobile, le résultat est apparu clairement : « Avec l'importance grandissante des réseaux sociaux et d'autres formes de communication électronique », ont-ils constaté, « les ados et les jeunes adultes qui travaillent éprouvent moins le désir de se retrouver dans le monde réel, ils ont donc moins besoin de moyens de transport individuels. » Soudain, la « génération Y » (y pour *young*) ne s'intéressait plus aux automobiles, un constat que J.D. Power n'a pas été le seul à faire : une série d'études et d'observations ont abouti à des analyses semblables. D'un coup, l'automobile se retrouvait délestée en grande partie de sa charge émotionnelle, reléguée au rang de moyen de transport parmi tant d'autres, une possibilité au même titre que l'autopartage ou le covoiturage. Bien évidemment, les équipes de direction des constructeurs se sont mobilisées – notamment parce que cette fameuse génération Y disposait de revenus supérieurs à toutes les autres générations avant elles. Elle affichait une position de plus en plus pragmatique et dépassionnée face à la possession et à l'utilisation d'une automobile,

qui ne cadrait avec aucun business-plan ni aucun plan stratégique. Par conséquent, les lignes ont un peu bougé. Avec parfois même un peu d'activisme. Car il s'agissait de réinventer l'automobile, et vite. Rien que cela. D'une manière ou d'une autre. Mais Henry Ford n'avait-il pas déjà prévenu : « Celui qui se contente de faire ce qu'il sait faire, restera toujours ce qu'il est déjà. »

Désormais, l'automobile est donc plus multiple que jamais, de nouvelles niches et de nouvelles variantes ne cessant d'apparaître. La redéfinition et la disparition des différences sociales dans la société postindustrielle semblent avoir aussi conduit à une différenciation sociale de l'automobile, objet culturel devenu objet de consommation. Désormais, l'automobile est intelligente. Elle réagit à son environnement, à ses passagers, aux autres véhicules. Serait-elle capable de nous transporter sans conducteur ? Bien sûr ! « Conduite autonome », telle est la formule magique révolutionnaire. Seule et dans le flot de la circulation. Dans ce domaine toutefois, l'une des premières impulsions durables n'a pas été donnée par un constructeur automobile établi, mais précisément par Google, le géant d'Internet. Pourquoi une entreprise spécialisée dans la recherche de l'information ne laisserait-elle pas un taxi robotisé chercher lui-même le bon chemin ? Suite à l'annonce du projet par Google il y a cinq ans, les constructeurs automobiles ont eux aussi intensifié leurs travaux de développement. Lors du dernier salon automobile IAA 2013, Dieter Zetsche, directeur de Mercedes, a profité de la tribune qui lui était offerte pour se rendre au salon à bord d'une classe S équipée d'un système de conduite autonome.

Il convient désormais d'aborder les concepts du type « Big Data », « Semantic Web » et « Internet of Things » en relation avec les automobiles. Dorénavant, les stimuli incitant à l'achat ne doivent plus venir de l'espace ni de la mobilité, mais du temps et de la communication. « Quiconque n'entre pas dans le monde virtuel s'exclut de fait », constate Peter Wippermann, spécialiste de l'analyse des tendances.

Ou risque de bientôt ne plus pouvoir se procurer de voiture.

« Les vendeurs vont continuer à jouer un rôle clé à l'avenir », a prédit Jens Monsees, de Google, lors d'un congrès de l'Institut d'économie automobile à Nürtingen. « La véritable question est de savoir comment le client va trouver le vendeur ». Actuellement, 200 recherches ayant trait à l'automobile sont effectuées chaque seconde sur Google Allemagne. « Les clients commencent par entamer leurs recherches avec des outils numériques, en explorant tous les canaux possibles. Ils ne viennent plus quatre fois, mais une seule chez le concessionnaire », explique Malte Krüger, de mobile.de. « Internet est clairement la principale source d'information pour l'achat d'une automobile », confirme Reinhard Zillessen, de Ford, qui explique que l'entreprise investit dans

l'étroite imbrication du offline et du online, dans tous les canaux de distribution. Reinhard Zillessen en est convaincu : « En 2020, il n'y aura plus une diversité de médias, mais un seul : Internet ».

Audi a déjà lancé une sorte de laboratoire d'essais pour l'achat automobile du futur – dans les centres-villes de Londres et de Pékin. Un troisième suivra bientôt à Berlin. Baptisé « Audi City », ce projet est destiné à rendre l'achat d'une automobile plus simple que jamais. Les nouveaux showrooms virtuels présentent sur des écrans interactifs commandés par des mouvements toutes les configurations possibles dans l'univers des produits Audi. Soulignons que ces beaux espaces de vente d'un genre nouveau, idéalement situés, exhalent un arôme bien réel – celui du café. Le client n'a plus affaire à des vendeurs envahissants, mais à d'aimables conseillers de clientèle, qui lui servent des expressos dans une atmosphère volontairement détendue. Rien d'étonnant donc à ce que Audi profite avec bonheur de la clientèle de passage et des achats d'impulsion. « Il n'est plus question du but d'un voyage ni d'aspirations, il en va de nos souhaits concrets », explique Peter Wippermann. « Les constructeurs automobiles peuvent en déduire les prochaines étapes à franchir pour évoluer : il ne s'agit plus de comprendre le marché, mais l'être humain. Ne plus formuler des objectifs en termes de résultats chiffrés, mais pour le monde. » Nous verrons bien s'ils y parviendront.

En résumé : l'automobile se bat. Avec ce qu'elle a, ce qu'elle pourrait avoir ou ce qu'elle aimerait avoir. Cependant, malgré tout l'enthousiasme que suscitent les alléchantes promesses offertes par notre époque à l'automobile, il nous faut prendre du recul. Dans son livre « L'art de bien agir », Rolf Dobelli attire l'attention sur la dangereuse manie de la nouveauté. « Toute société qui imagine son avenir accorde trop d'importance aux découvertes les plus attrayantes du moment, les 'killer-apps' actuelles. Et chaque société sous-estime le rôle des technologies héritées du passé. Les années 1960 étant celles de la conquête spatiale, nous imaginions alors des sorties scolaires sur Mars. Dans les années 1970, le plastique était tendance. Aussi pensions-nous qu'à l'avenir, nos maisons seraient en plastique. Nous surestimons systématiquement la nouveauté. » Pour Rolf Dobelli, cette « néomanie » est une fausse piste caractéristique, qu'il vaut mieux laisser à autrui. Et les « cygnes noirs » du mathématicien et philosophe Nassim Nicholas Taleb, ces événements hautement improbables que nul ne peut prévoir et qui laissent une empreinte dans l'univers en donnant un tour nouveau au cours de l'histoire, ces cygnes noirs nous surprendront encore, immanquablement (nous et l'automobile).

Par ailleurs, l'automobile peut faire confiance, les yeux fermés, à l'extra-terrestre Alf, héros hirsute de série télévisée qui décrète : « Ce qui ne peut être réparé n'est pas cassé. »

3

MAGAZIN

—

MAGAZIN.

Magazin bedeutet: Die Freude am Auto verbunden mit der Leidenschaft fürs Zeitungmachen. Strukturen aufbrechen und das Thema Automagazin einmal gemeinsam weiterdenken, kreativ und zeitgemäß. Mutige Perspektivenwechsel, ein frecher dramaturgischer Mix. Unmittelbar, authentisch, intensiv. Immer wieder neu - und hoffentlich immer wieder anregend.

MAGAZINE.

Oh, yeah-we have a magazine too. It's the combined product of our passion for cars and our passion of magazine publishing. We believe in a creative and contemporary team approach to break down old encrusted structures within the auto magazine business and to take it in new directions, manifested by our bold changes in perspectives and our own audacious mix of dramaturgical aspects. Call it direct, authentic, intense. We always come up with new—and hopefully exciting—ideas.

MAGAZINE.

Pour nous, le magazine c'est : le plaisir de l'automobile associé à la passion du journalisme. Oser la rupture et repenser, ensemble, le concept de magazine automobile, avec créativité et dans l'air du temps. Changements d'angles inattendus sur fond de dramaturgie audacieuse. Immédiateté, authenticité, intensité. De la nouveauté, toujours - et espérons-le, une source d'inspiration, toujours et encore.

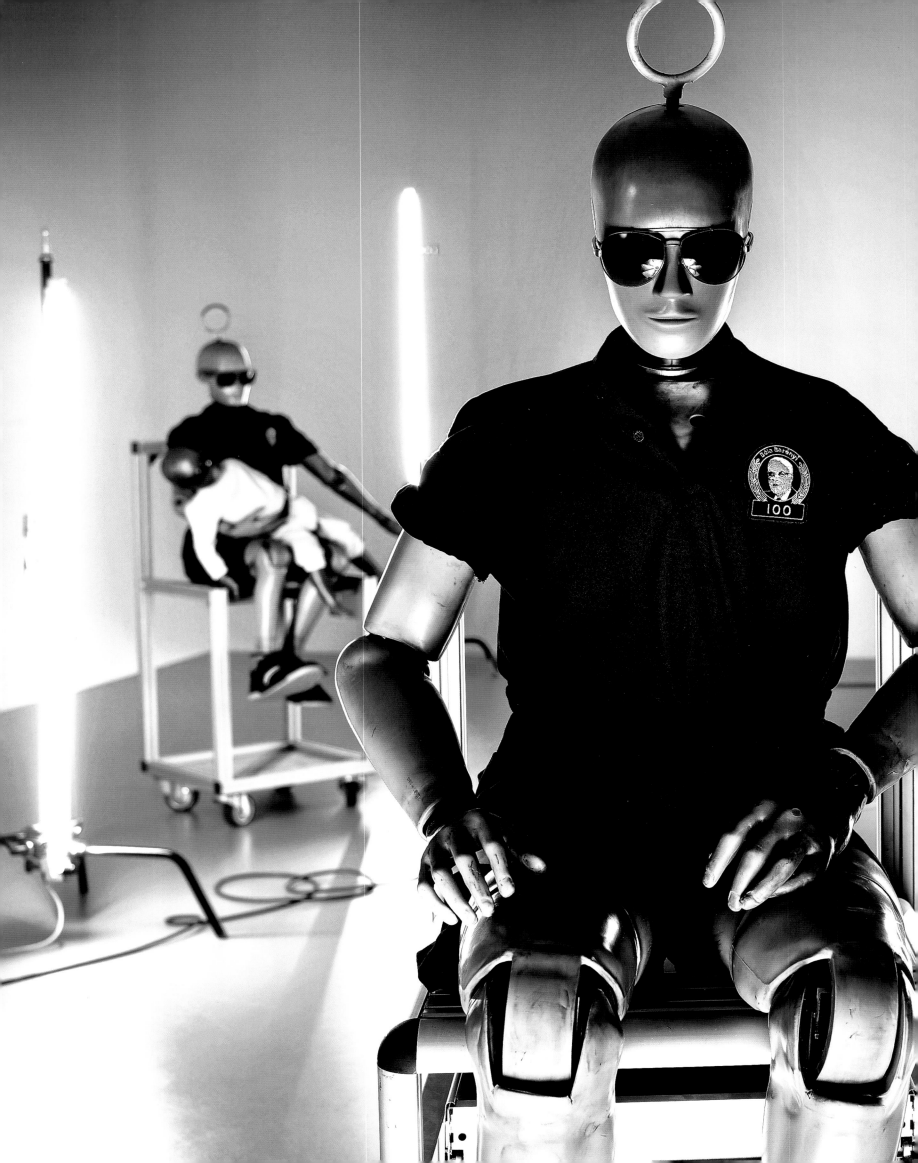

DIE DEN KOPF HINHALTEN —
Der Job eines Anthropomorphic Test
Devices ist es, den Kopf hinzuhalten.
Für die Fahrzeuginsassensicherheit.
Dass dabei nur Auffahrunfälle simu-
liert und die UV-Strahlung völlig außer
Acht gelassen wurde, empfanden wir
als großes Versäumnis – und haben mal
ein paar Sonnenbrillen gecrashtestet.

STICKING THEIR NECK OUT —
The job of an anthropomorphic test
device (ATD) basically boils down to
this: to stick its neck out. It's all about
motor vehicle passenger safety. Now,
we know all about the importance
of simulating collision impacts, but
what about that other risk factor,
you know, UV radiation? Well, we felt
it was high time to crash-test some
sunglasses.

CEUX QUI PRÊTENT LEURS TÊTES —
Mission de ces dispositifs anthropo-
morphes d'essai : prêter leurs têtes,
pour la sécurité des passagers. Le fait
que l'on ne simule que des collisions
par l'arrière et que l'on néglige totale-
ment les rayonnements UV nous a
paru un gros oubli – aussi avons-nous
soumis plusieurs paires de lunettes
au crash-test.

#01

RAMP
JETZT NEHMEN
WIR DIE SACHE
MAL SELBST IN DIE
HAND (LET'S GO!)

STORY Zur Sonne, Freunde

PHOTOGRAPHER Frank Kayser

CRASH TEST DUMMIES by Mercedes-Benz

MAGAZIN ——— A PASSION FOR CARS

ÜBERFLIEGER — Der ramp-super-supersuper-Test mit 1 155 PS in Berlin. Da sind freie Straße willkommen. Schön, dass hier in Berlin so flughafengroßzügig an uns gedacht wurde. Kolumnist Wladimir Kaminer gefiel bei nasser Straße der Nissan besser. Wegen des Allrads.

HIGHFLYERS — Get ready for the ramp super-super-super test packing 1,155 hp in Berlin. The hardest part was finding open roads. Thank God for the Berlin Airport, which was very generous in providing us with plenty of open roads. Our columnist Wladi-mir Kaminer liked the Nissan better on wet roads. That's because it came with four-wheel drive.

LES SURDOUÉES — Le test ultime pour ramp avec 1 155 chevaux à Berlin. Les rues dégagées sont les bienvenues : une chance que l'on ait pensé à nous, avec des voies comme des pistes d'aéroport. Le chroniqueur Wladimir Kaminer a préféré la Nissan sur chaussée humide. Pour ses quatre roues motrices.

RAMP
ALL YOU
CAN WISH

STORY Die Raketenkapsel und das Trojanische Pferd

PHOTOGRAPHER David Breun

CARS Ferrari 458 Speciale & Nissan GT-R

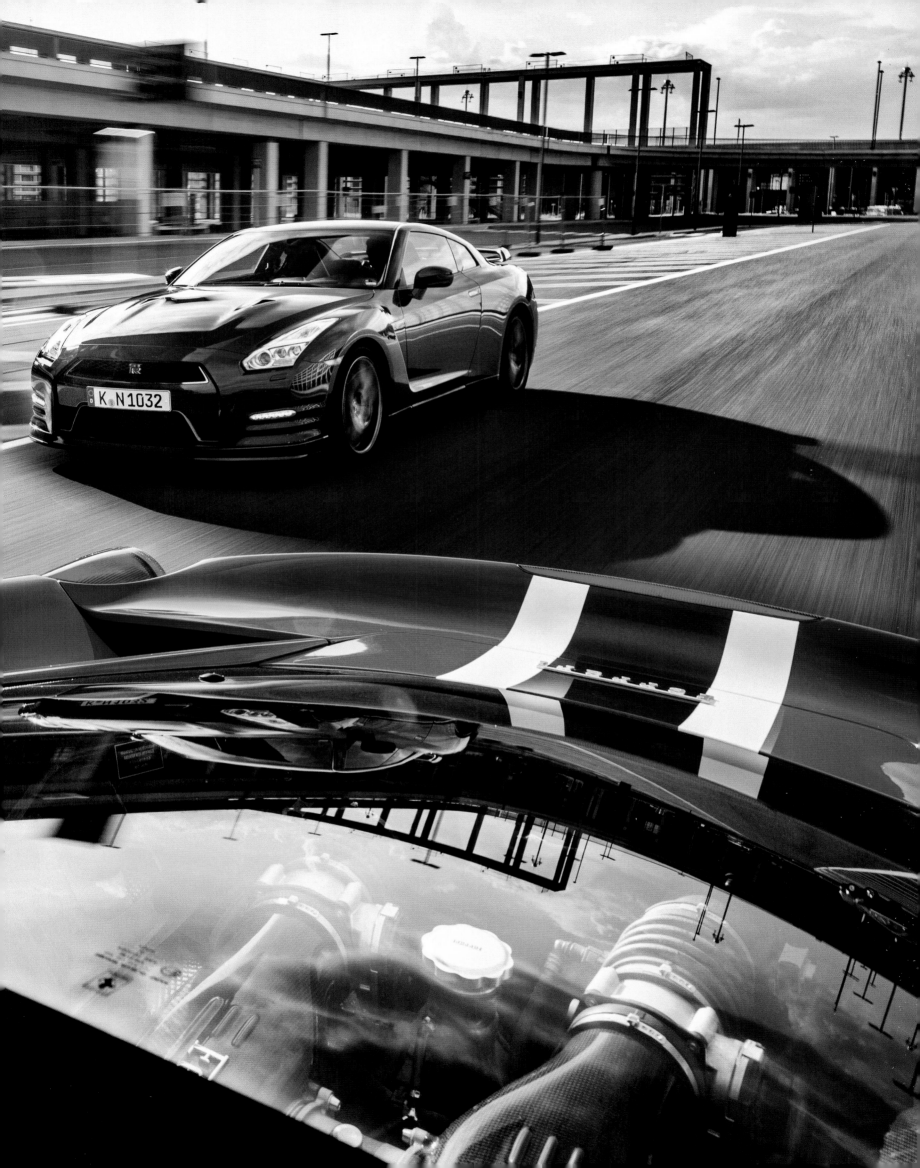

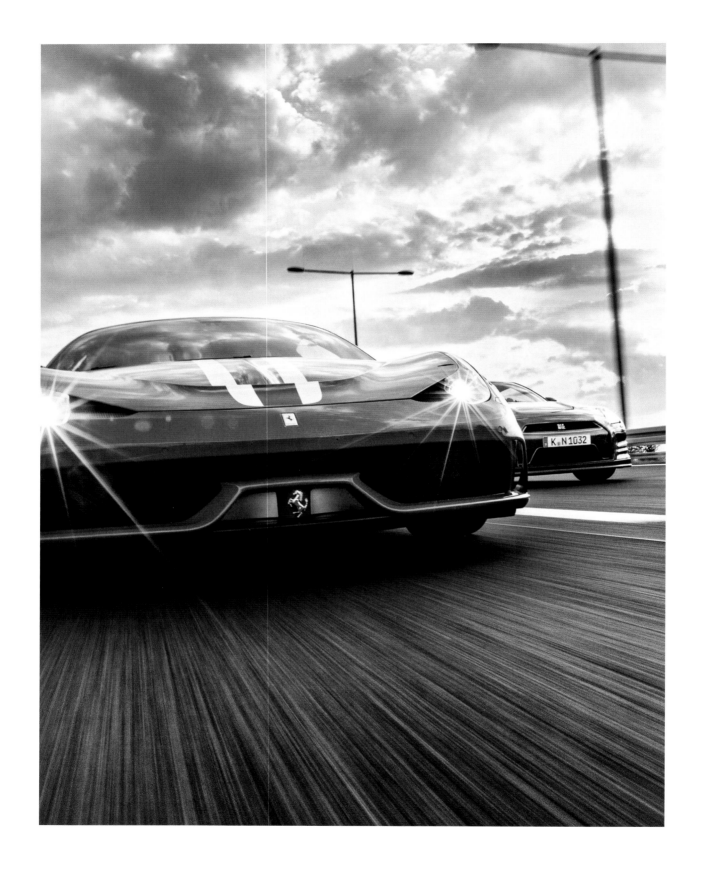

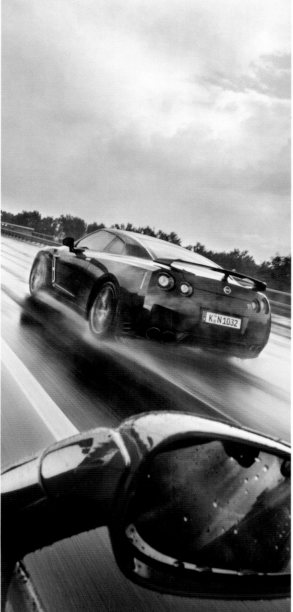
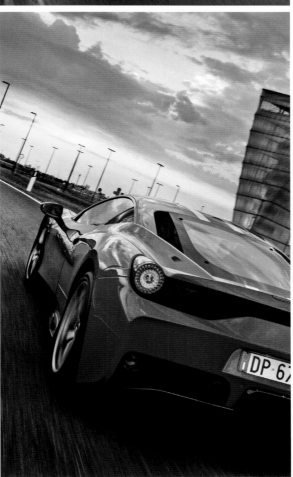

DAS BLITZDINGSSHOOTING —
Der neue Mercedes-AMG GT, angelegt
als „Porsche-Killer". Das interessiert
nicht nur die ganze Welt, sondern
auch gleich das ganze Autouniversum.
Die „Men in Black" waren dann auch
beim exklusiven Vorabshooting sofort
dabei. Die außerirdischen Kollegen
brachten dann die Freunde von
FLAVOR3D ins Bild.

SHOOTING THE BLITZ THING —
We're talking the new Mercedes-AMG
GT, a designated 'Porsche-Killer.'
Not only is this a matter of global
interest, it affects the entire auto-
motive universe. Needless to say,
we wasted no time sending our own
"Men in Black" for an exclusive
preview shooting. Of course, our
"MIB" couldn't resist taking some
of their friends of FLAVOR3D along
for the ride.

SHOOTING AU NEUROLASER —
La nouvelle Mercedes-AMG GT,
destinée à être une « Porsche-Killer ».
Le sujet passionne non seulement
la terre entière, mais aussi tout l'uni-
vers de l'automobile. Nos collègues
extraterrestres les « Men in Black »
étaient très vite sur place lors du
repérage. Et ils ont invité les amis
de FLAVOR3D sur les photos.

 #27

RAMP
YOU'LL NEVER
DRIVE ALONE

STORY GT – Der Superirdische / **PRODUCTION** FLAVOR3D

PHOTOGRAPHER Steffen Jahn / **CAR** Mercedes-AMG GT

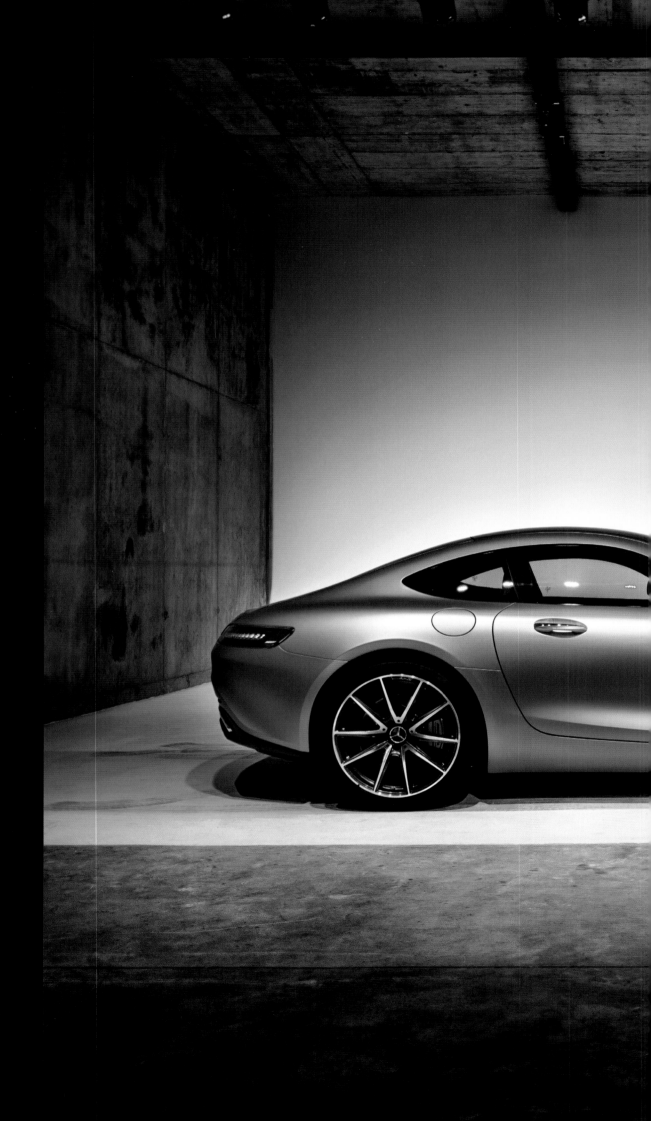

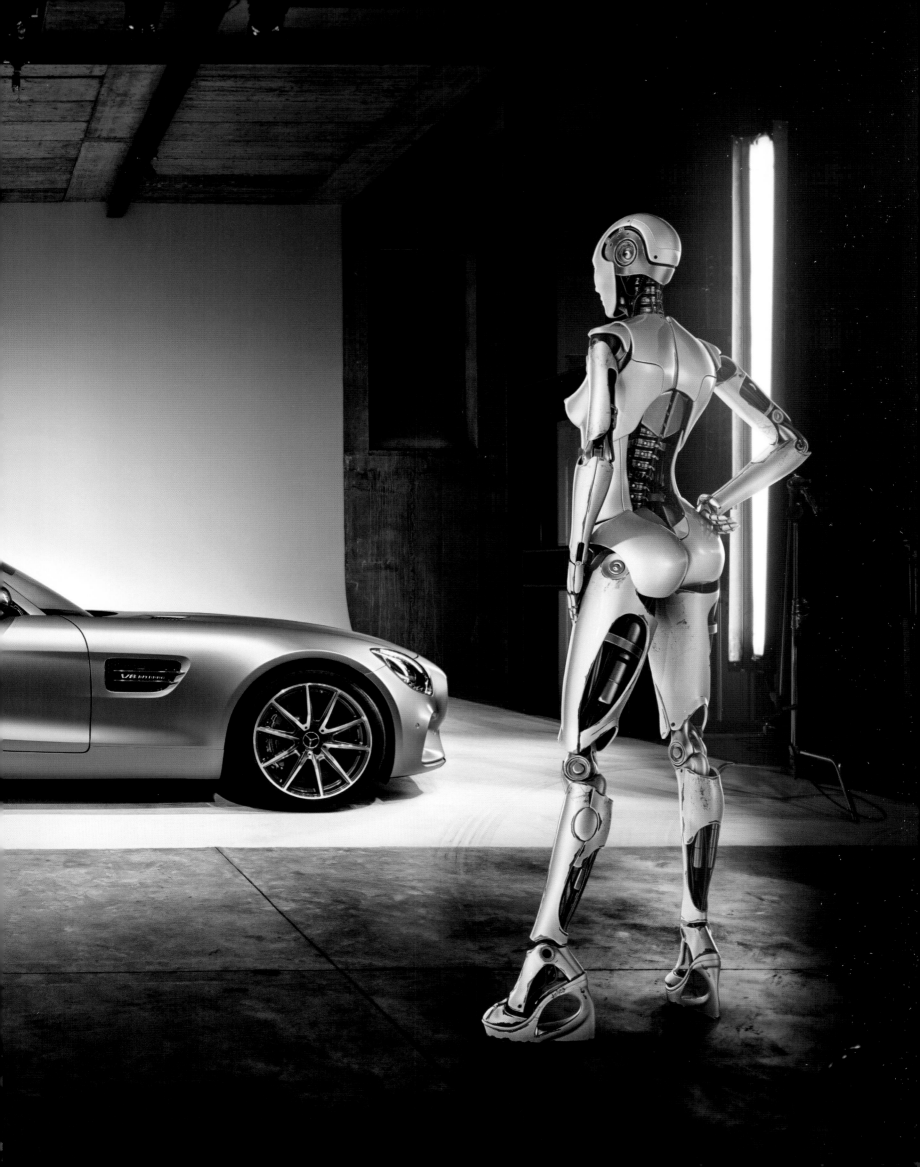

STUDENTENPARTY — Mit einem Lamborghini Huracán zur Uni. Für die Professoren hatten wir dann noch einen Range Rover LWB in der luxuriösen Autobiography Black Edition dabei. Streit gab es keinen. Der Fotograf nahm den Range, der Redakteur blieb beim Lamborghini.

COLLEGE BLOCK PARTY — We went to college in a Lamborghini Huracán. To acknowledge professors too, we decided to bring along a Range Rover LWB in its luxurious Autobiography Black Edition. No need to argue. While our photographer took the Range Rover, our editor humbly settled for the Lambo.

SOIRÉE ÉTUDIANTE — Cap sur l'université en Lamborghini Huracán. Pour les professeurs, nous avions prévu un Range Rover LWB dans la luxueuse édition Autobiography Black. Il n'y a pas eu de dispute. Le photographe a choisi le Range, le rédacteur la Lamborghini.

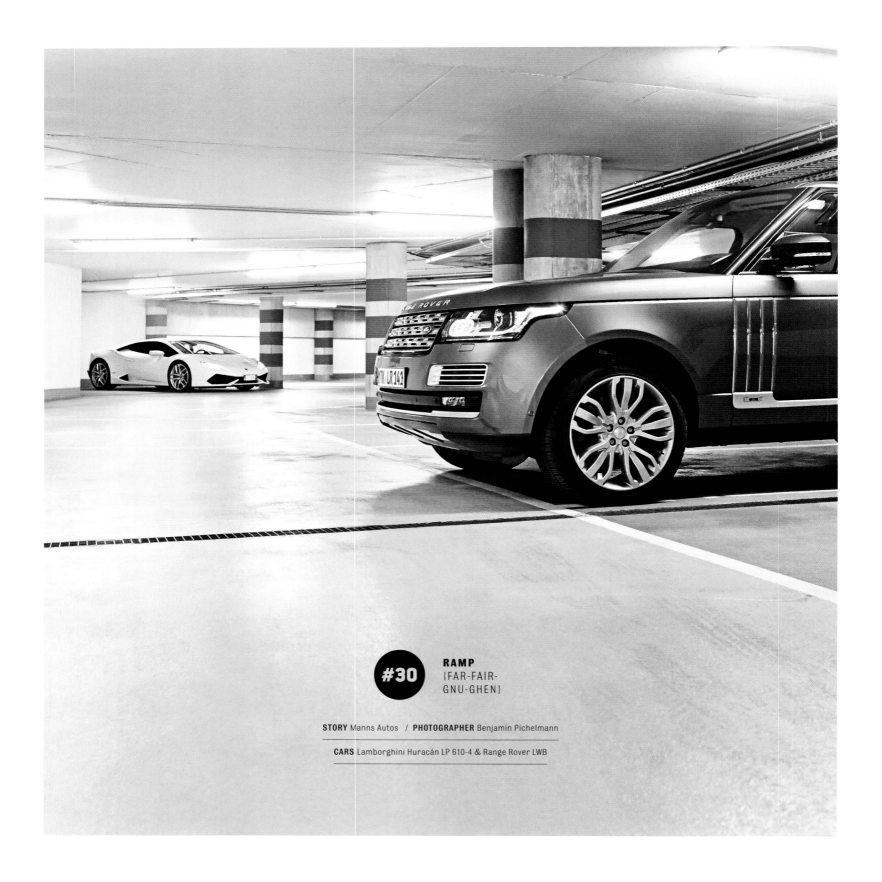

#30 **RAMP**
{FAR-FAIR-GNU-GHEN}

STORY Manns Autos / **PHOTOGRAPHER** Benjamin Pichelmann

CARS Lamborghini Huracán LP 610-4 & Range Rover LWB

ADRENALIN — Mehr Adrenalin gab es selten bei einem ramp-Shooting. All das, was auf dem Bild zu sehen ist, ist auch tatsächlich so passiert. Der Helikopter schwebte bis zu drei Meter über dem Boden und Simon Böer (zugegeben er war angegurtet) hielt unser Model Joana an der Hand. Ungesichert.

ADRENALINE — Rarely have we had a ramp photo shoot that produced more adrenalin than this one. Everything you see in the shoot really happened, just like you see it. The chopper was hovering three meters (almost 10 feet) from the ground, with Simon Böer (OK, he was strapped in) holding Joana, our model, by her hand. Unsecured.

ADRÉNALINE — Rarement il y a eu plus d'adrénaline lors d'un shooting pour le magazine ramp. Tout ce qu'on voit sur cette photo s'est réellement passé ainsi. L'hélicoptère planait jusqu'à trois mètres au-dessus du sol et Simon Böer (certes, il était attaché) tenait par la main notre modèle Joana. Sans protection.

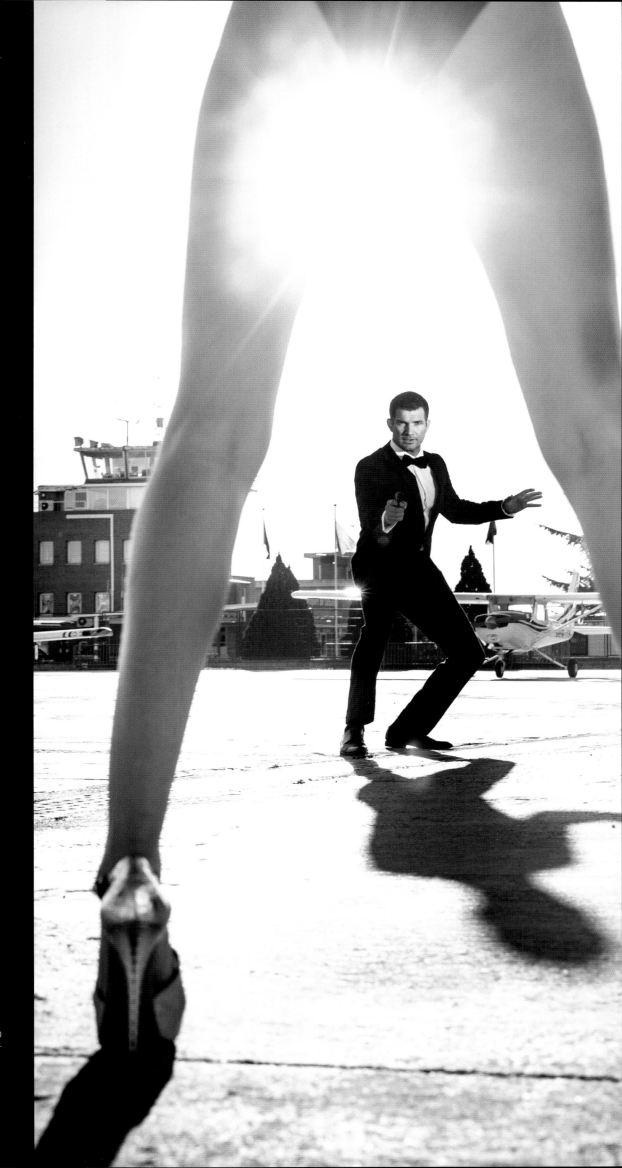

 #08

RAMPSTYLE
MACH'S GUT UND DANKE FÜR DEN FISCH

STORY Ein Quantum Zukunft
PHOTOGRAPHER Daniel Woeller / **CAR** SEAT Leon CUPRA 280

DREI FÜR EINEN VIERER —
Eine Stadt, ein Auto, drei Fotografen,
vier Blickwinkel: Schließlich war mit
Bernd Haase auch noch unser Redak-
teur dabei. Klingt nach Multikulti
und Chaos, brachte tatsächlich aber
für Fotograf Nils Hendrik Müller
sein Foto des Jahres 2014.

**THREE'S THE MAGIC NUMBER FOR
THE FOUR SERIES —** One town, one
car, three photographers, four angles:
Let's not forget our editor Bernd
Haase, who was part in making this
thing a success. For some, it may be
little more than a bunch of multicul-
tural chaos. For photographer Nils
Hendrik Müller, it was his most
significant picture of the year 2014.

TRIO POUR UN 4/4 — Une ville,
une automobile, trois photographes,
quatre angles de vue : outre Bernd
Haase, notre rédacteur était de la
partie. Dans cette atmosphère multi-
culturelle et chaotique, le photogra-
phe Nils Hendrik Müller a pu réaliser
la photo de l'année en 2014.

#27 **RAMP**
YOU'LL NEVER
DRIVE ALONE

STORY Das Bilbao-Experiment

PHOTOGRAPHERS Götz Göppert, Nils Hendrik Müller &

Sjoerd ten Kate / **CAR** BMW 4-Series Gran Coupé

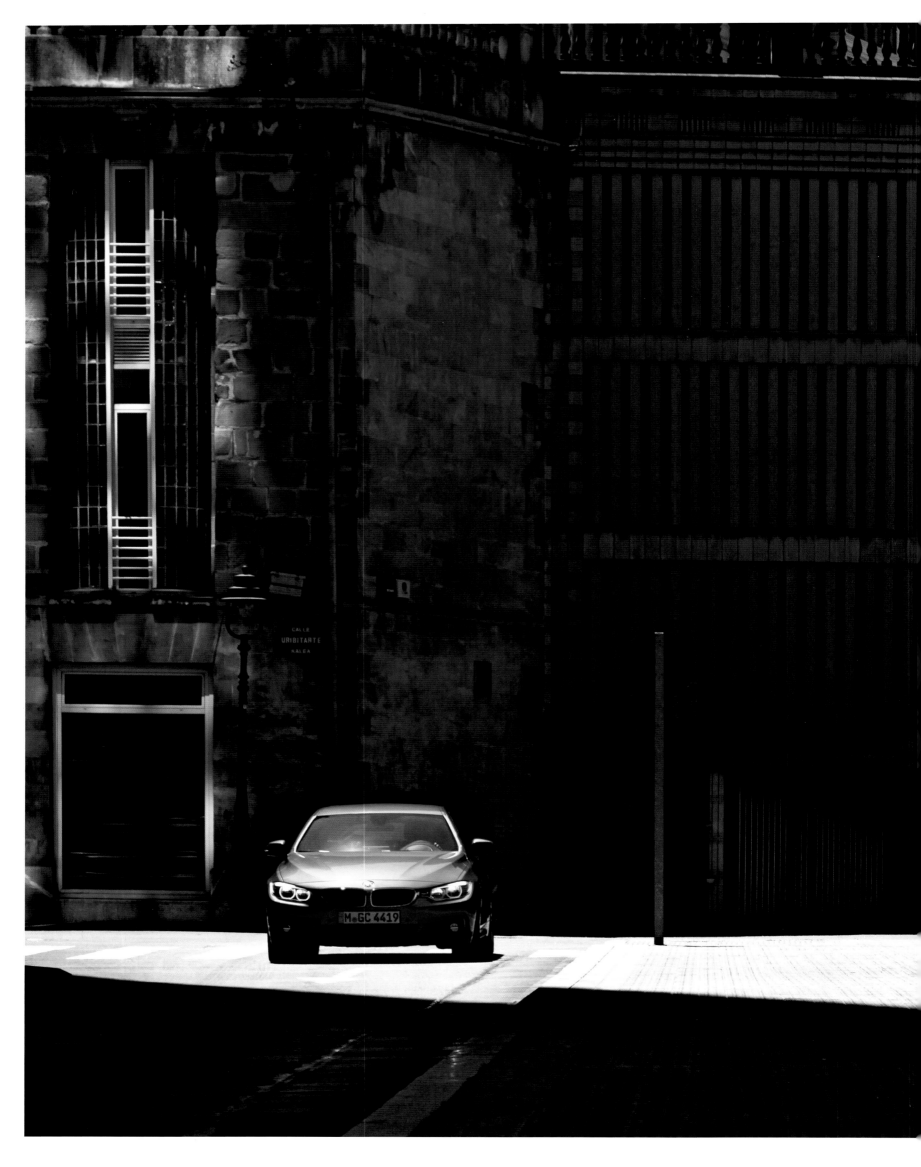

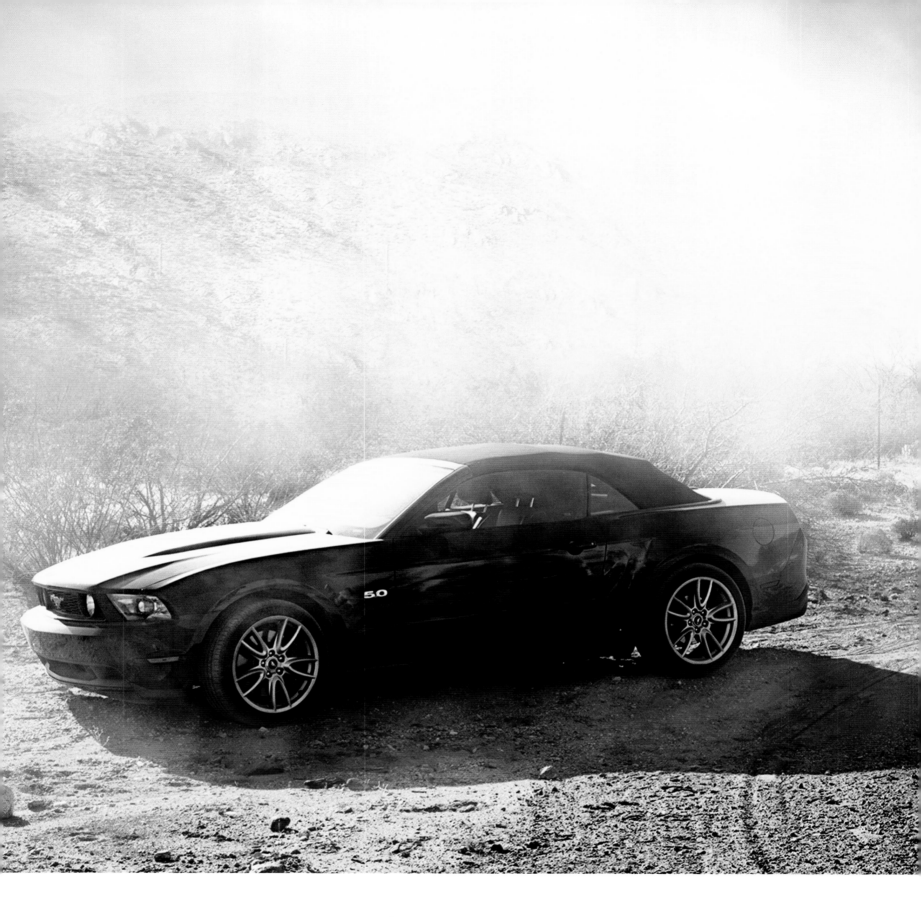

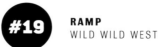 **RAMP**
WILD WILD WEST

STORY Sein oder nicht sein. / **PHOTOGRAPHER** Jan Friese

CAR Ford Mustang GT V8 Cabriolet

DAS COWBOYCOLLEGE — Cowboy wird man nicht automatisch mit einem Hut auf dem Kopf. Regel Nummer eins auf dem College der etwas anderen Art: Cowboysein ist eine Einstellung. Was bleibt ist die Frage: Darf man nun in ein Mustang GT Cabrio steigen und den Pferdesattel gegen Sportsitze tauschen? Ja, denn nicht jedes Gesetz ist gesetzt.

COWBOY COLLEGE — Being a cowboy isn't just all about wearing a Stetson. Rule Number One at Not-Just-Any-Ol' College: Being a cowboy is a state of mind. Which raises the question: Is it OK to slide behind the wheel of a Mustang GT Convertible and to trade the horse saddle for a pair of sports seats? Sure, why not? After all, not every rule is laid down.

LE COLLÈGE POUR COWBOYS — Ce n'est pas le chapeau qui fait le cowboy. Règle numéro un dans ce collège d'un type particulier : être cowboy, c'est un état d'esprit. Une question reste posée : peut-on prendre le volant d'un cabriolet Mustang GT et délaisser sa selle pour des sièges de sport ? Oui, car ici aucune règle sans exception.

DRECK LASS NACH — Als der 911er für's Gelände war er angekündigt, der neue Porsche Macan. Mussten wir überprüfen. Mitten in Marokko. Es staubte gar herrlich, nur dreckig werden wollte der Porsche nicht so recht. Die Lösung: das Atlasgebirge. Dort gibt es Schlammlöcher. Knie-tief. Das Ergebnis stellten wir dann vor dem La Mamounia Hotel in Marrakesch ab. Modern Art.

HITTING THE DIRT — Promoted as an off-road 911, there it was, the new Porsche Macan. To test their claim, we took it into the middle of Morocco, where we churned up tons of dust everywhere except on the Porsche. So we went to the Atlas Mountains, where we drove the Macan through pools of mud, some of them knee-deep, before parking it in front of the La Mamounia Hotel in Marrakesh. Talk about modern art.

LA POUSSIÈRE VAINCUE — La nouvelle Porsche Macan était annoncée comme la 911 tout-terrain. Nous avons voulu le vérifier au cœur du Maroc. Partout, de la poussière. Mais notre Porsche refusait de se salir. La solution : le massif de l'Atlas. Des flaques de boue à loisir, jusqu'aux genoux. Nous avons exposé le résultat devant l'hôtel La Mamounia à Marrakech : de l'art moderne.

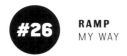

RAMP
MY WAY

STORY Off-Road-Runner / **PHOTOGRAPHER** Roman Kuhn

CAR Porsche Macan Turbo

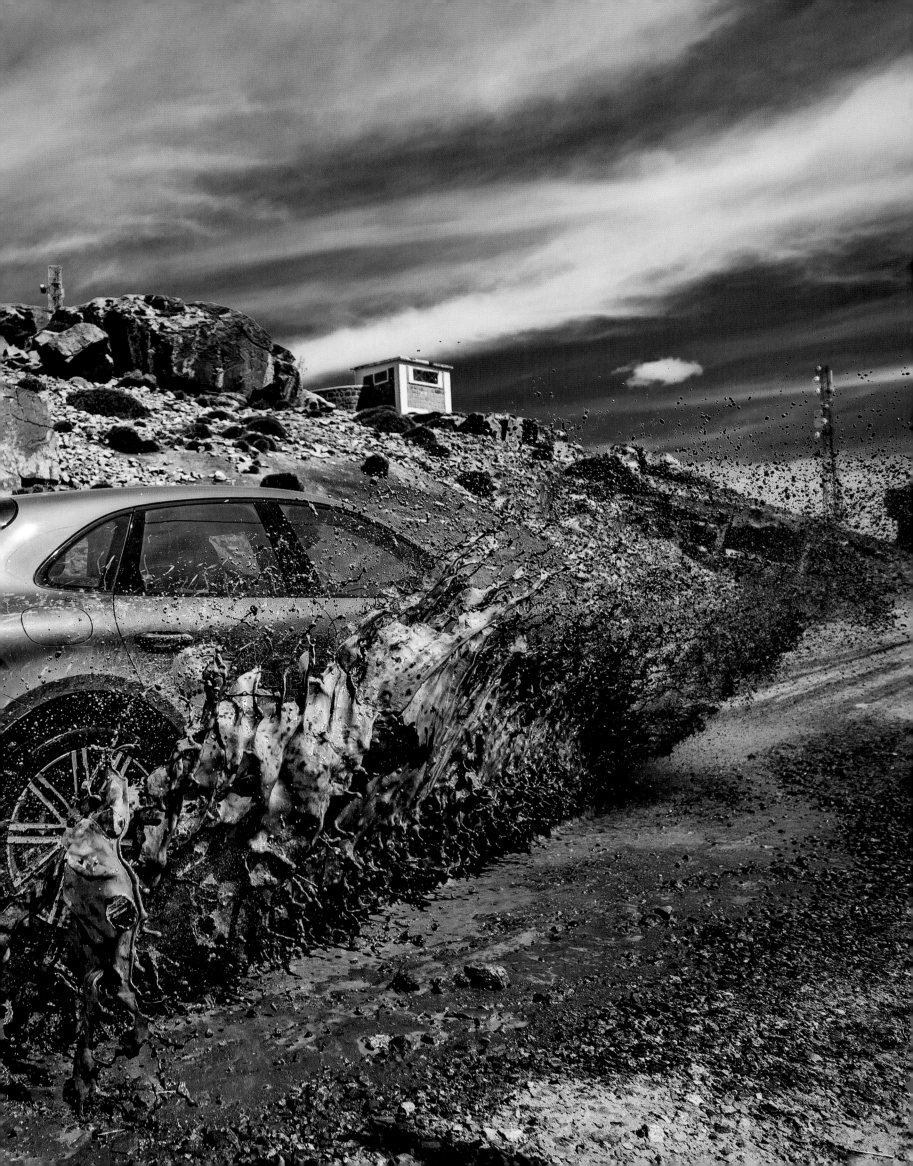

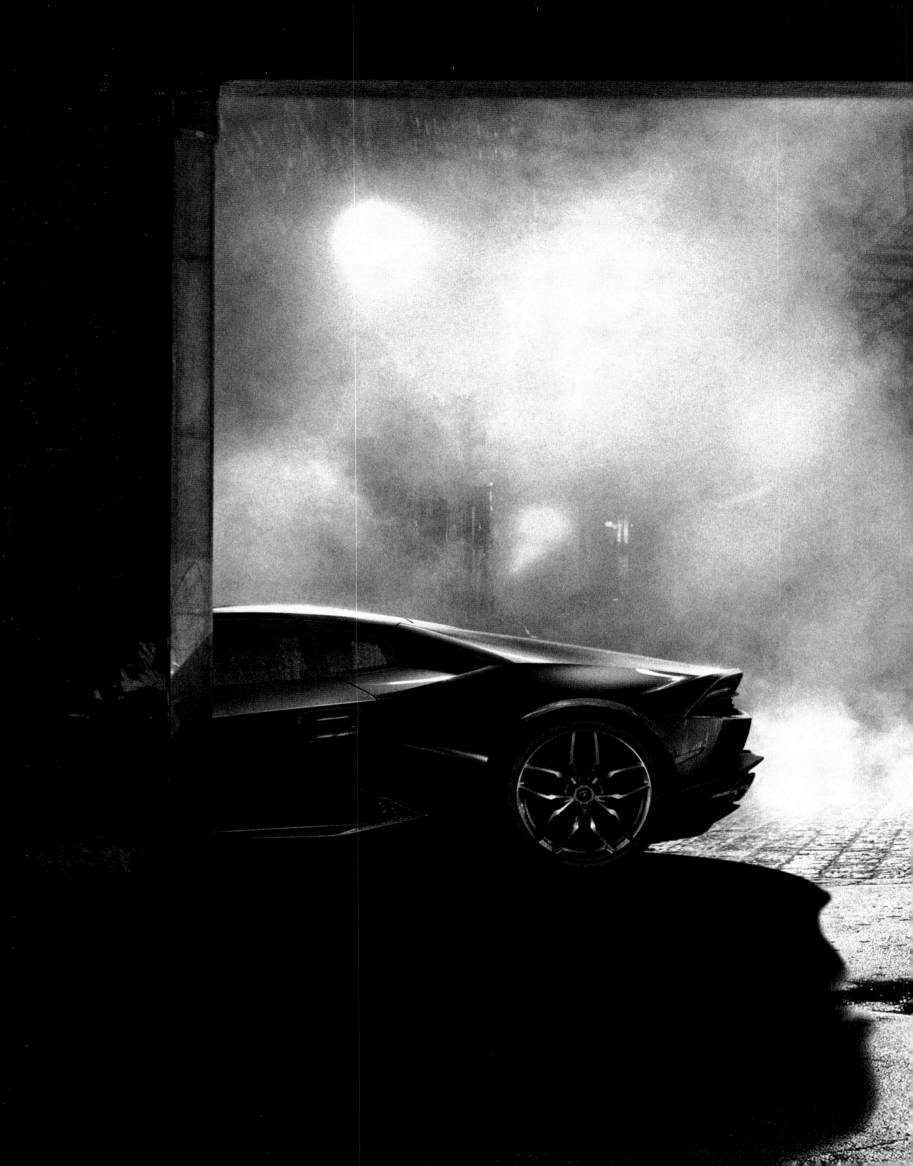

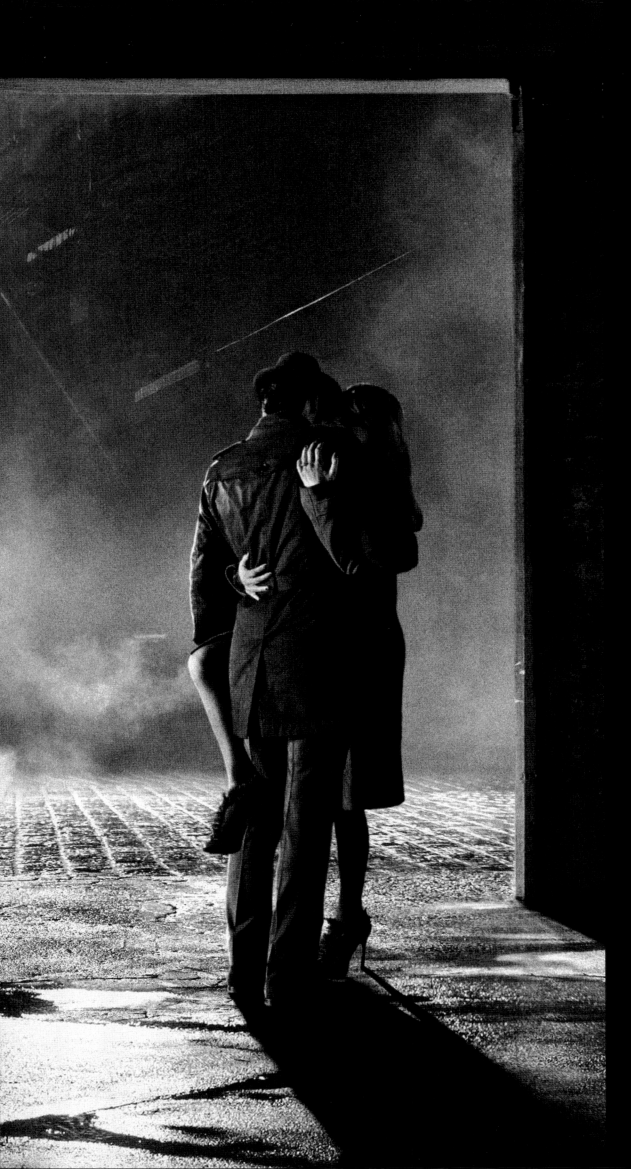

SCHAU MAL AUF DIE BILDER, BABY! — Ein klassischer Film noir. Es gibt ihn, es gibt sie und es gibt ein böses Auto. Tatsächlich aber gab es am Set nur ihn und sie, fein in Szene gesetzt von Fotograf Leopold Fiala. Der Lamborghini kam dann erst am Computer dank der Fertigkeiten von FLAVOR3D hinzu.

LOOKIT THOSE PICTURES, BABY! — It's a classic film noir. The storyline includes some guy, a gal, and one bad ride. The actual set, however, included only the guy and the gal, nicely arranged and shot by photographer Leopold Fiala. The Lamborghini was subsequently added by way of Photoshop and the technology of FLAVOR3D.

REGARDE LES PHOTOS, CHÉRIE ! — Un classique du film noir : elle, lui et une auto maléfique. En fait, sur le plateau, il n'y avait qu'elle et lui, magnifiquement mis en scène par le photographe Leopold Fiala. La Lamborghini est venue s'ajouter après coup seulement, par retouche informatique, grâce au talent de FLAVOR3D.

 #25 **RAMP**
MODERN TIMES

STORY Die Spur des Stiers

PHOTOGRAPHER Leopold Fiala / **CONCEPT &**

REALIZATION FLAVOR3D (Creative Veit Gross)

CAR Lamborghini Huracán LP 610-4

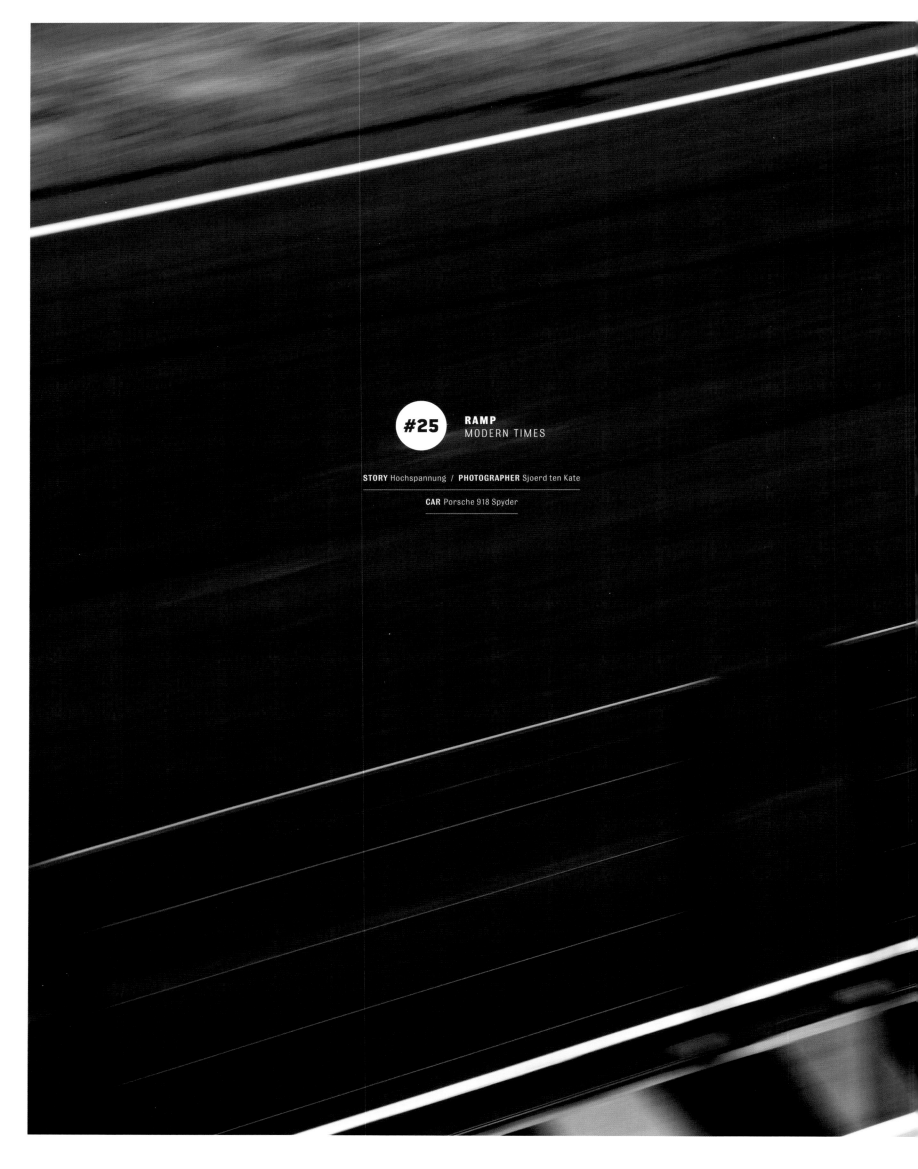

#25 **RAMP**
MODERN TIMES

STORY Hochspannung / **PHOTOGRAPHER** Sjoerd ten Kate

CAR Porsche 918 Spyder

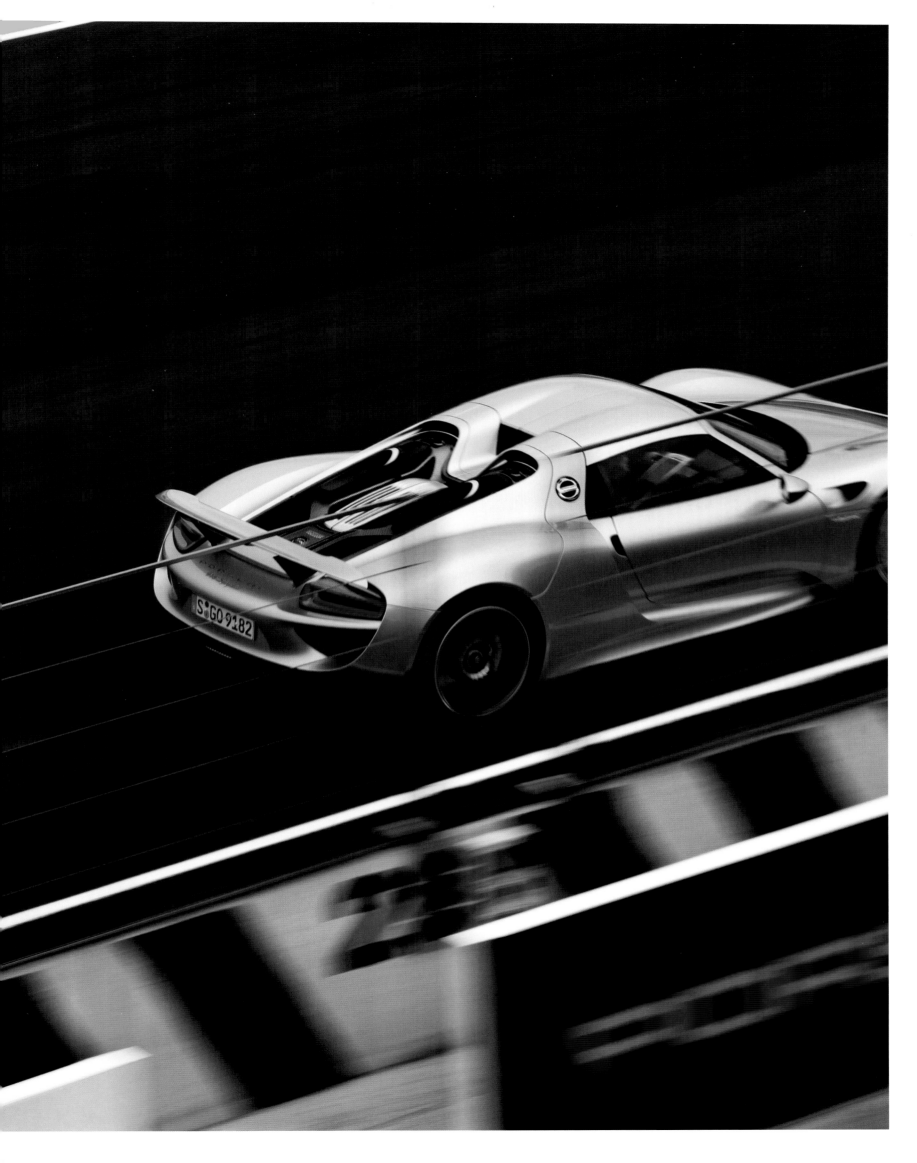

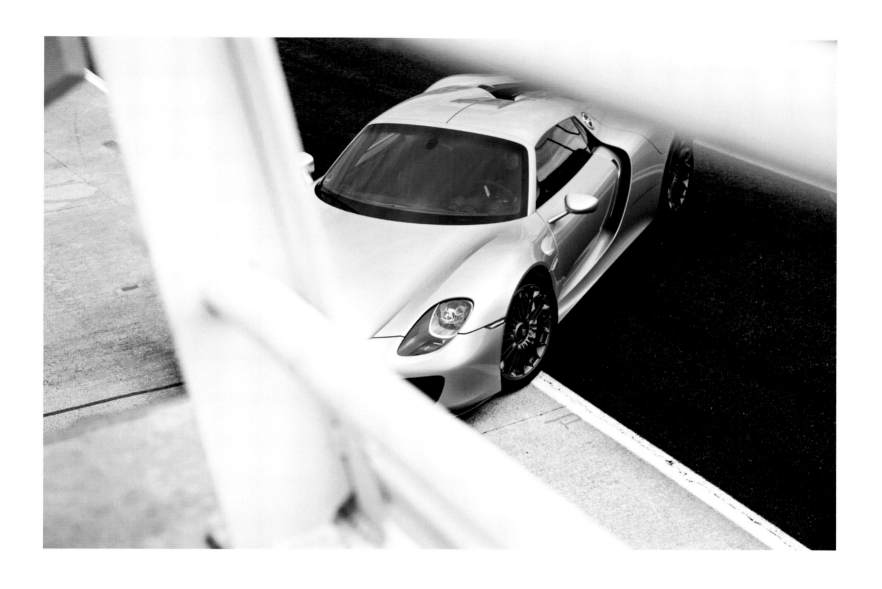

KREATIVE SCHNITTTECHNIK — Darf man das? Haben wir uns gefragt, als die Bilder des neuen Porsche 918 Spyder bei uns auf dem Tisch lagen. Um den Speed darzustellen, dachten wir uns, wir könnten das Auto im Layout ja mehrfach anschneiden. Am Ende war es wie so oft: Wir haben es dann einfach gemacht. Unkonventionell – aber kam gut an.

CREATIVE CUTS — "Is this thing even legal?" was what came to our minds when we saw the pix of the new Porsche 918 Spyder on our desks. Wanting to suggest a sense of speed, we figured the best way to do it might be to apply some special multiple cutting technique to the car in the layout. Instead, we just did what we do best: Keep it simple but unconventional—and everybody loved it!

MONTAGE CRÉATIF — A-t-on le droit de faire une chose pareille ? C'est ce que nous nous sommes demandé en recevant les photos de la nouvelle Porsche 918 Spyder. Pour matérialiser la vitesse, nous avons eu envie de pratiquer plusieurs entailles sur la photo, en réalisant la maquette. Au final, ça s'est passé comme souvent. Nous avons osé, tout simplement. Atypique – mais assez réussi.

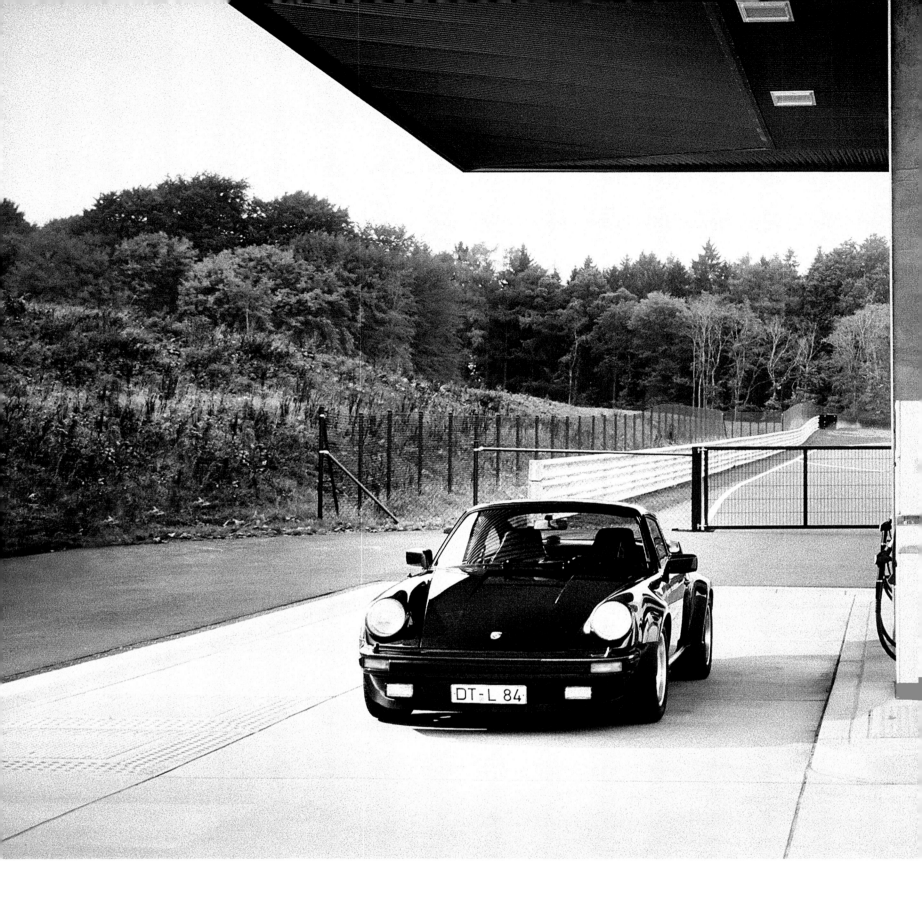

#24

RAMP
THE STARS (ARE
OUT TONIGHT)

STORY Kampf der Generationen / **PHOTOGRAPHER** Benjamin Pichelmann

CARS Porsche Turbo S (991) & Porsche Turbo (930)

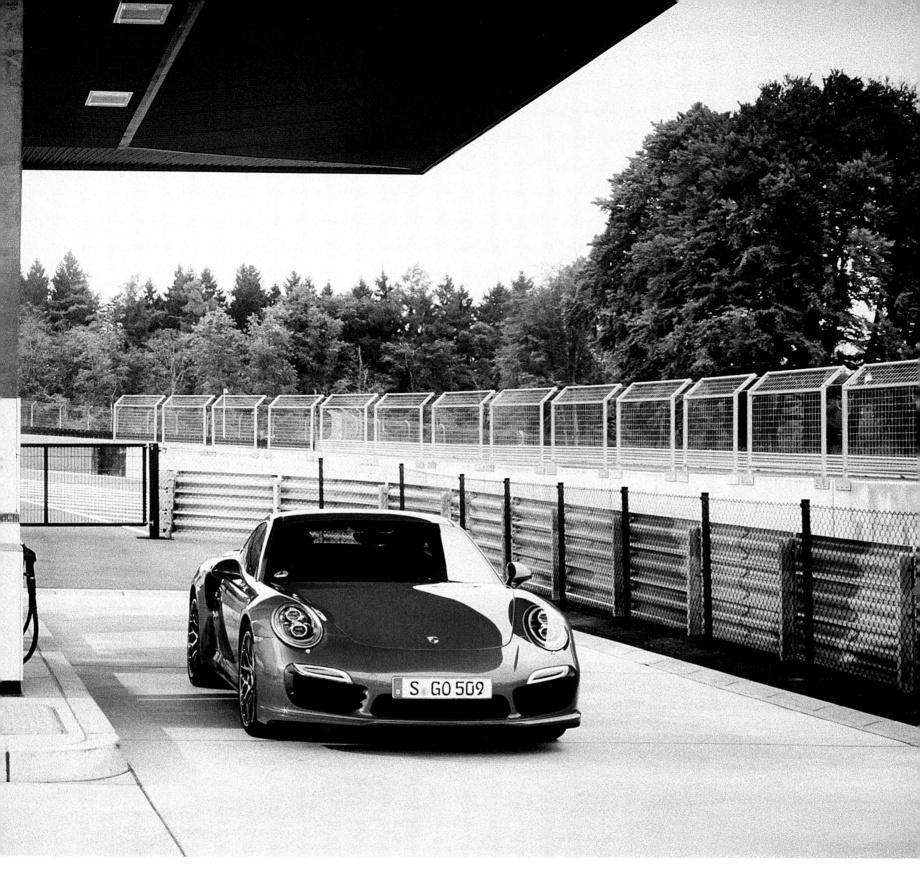

DIE TURBOS, KENNY UND SEIN KAUTABAK — Kenny Bräck, Rennfahrer und Indianapolis-Gewinner aus Schweden, nimmt sich am Bilster Berg den aktuellen 911 Turbo S und den legendären 930 Turbo aus dem Jahr 1978 vor. Trotz Regens. Dass er ein Auto auch bei glitschig-nasser Strecke im Grenzbereich beherrscht, gehört schließlich zu seinem Markenzeichen. Genau wie eine Dose Kautabak.

TWO TURBOS, KENNY, AND HIS DIP — Kenny Bräck, racecar driver and Indianapolis champion from Sweden, went to Germany to take the current Porsche 911 Turbo S and the legendary 1978 Porsche 930 Turbo for a spin on Bilster Berg. The rain didn't bother him. Pushing any car to its limits even on wet, slippery roads without ever losing control is one of his trademarks, after all. Just like his can of dip.

LES TURBOS, KENNY ET SON TABAC À CHIQUER — Kenny Bräck, pilote suédois vainqueur à Indianapolis, teste l'actuelle 911 Turbo S et la légendaire 930 Turbo de 1978 sur le circuit de Bilster Berg. Malgré la pluie. Maîtriser un bolide sur une piste détrempée et glissante, c'est sa marque de fabrique – tout comme ses prises de tabac à chiquer.

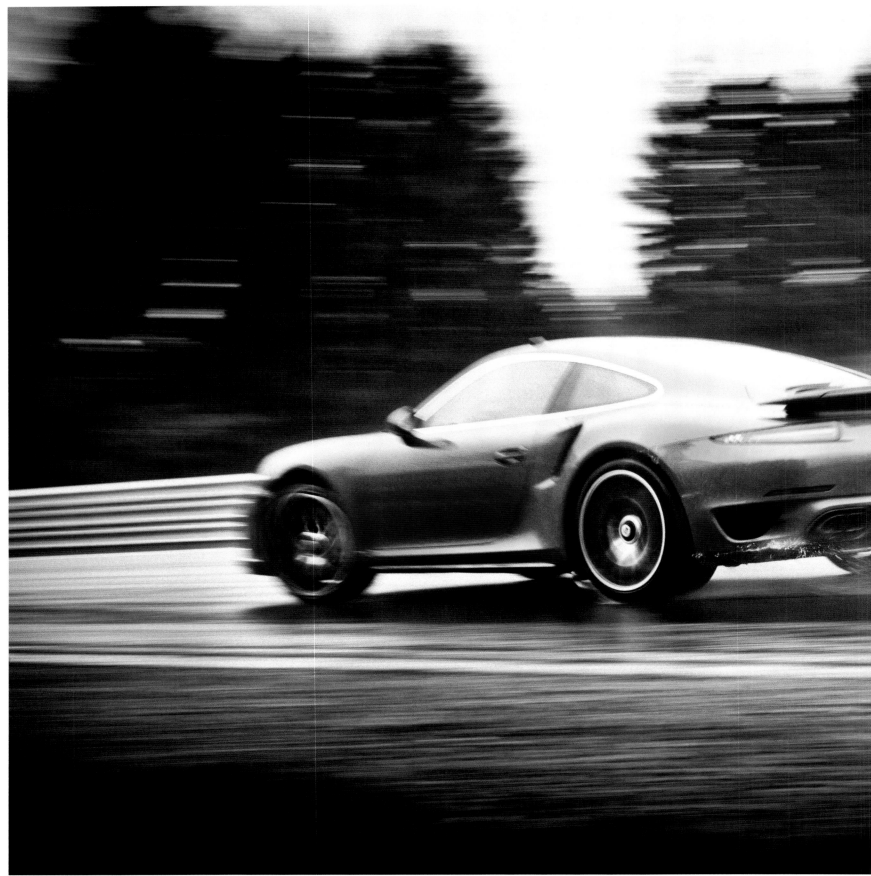

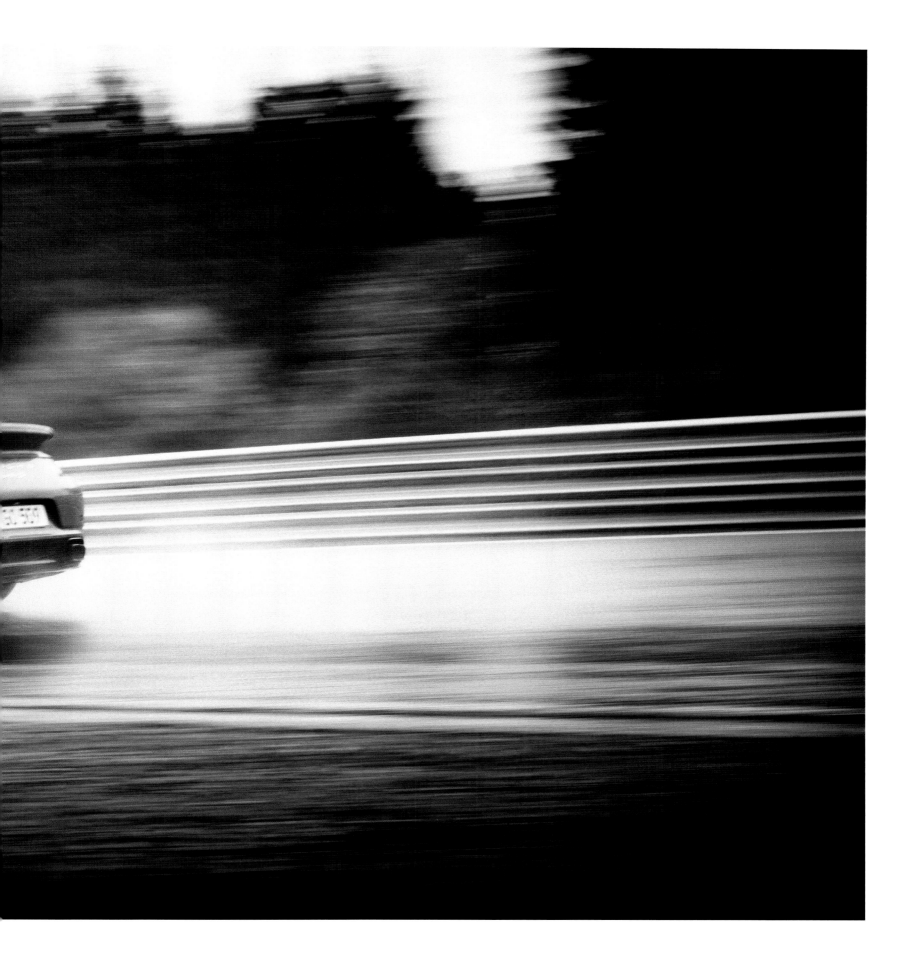

„Für eine schnelle Runde". Mit diesen Worten klebt Kenny Bräck seine Dose Kautabak auf das Dach des roten Turbo S. Und das so gut, dass die Dose nur mit viel Mühe wieder entfernt werden kann. Das Dach des Porsche hat es schadlos überstanden. Fast zumindest.

"Let's go for a quick spin." Having said that, Kenny Bräck attaches his can of dip to the roof of the red Turbo S. We would find out later on how surprisingly hard it was to remove. The roof of the Porsche sustained no damage...we *think*.

« C'est parti pour un petit chrono ! » : sur ces mots, Kenny Bräck colle sa blague à tabac sur le toit de sa Turbo S rouge. Il la fixe si bien qu'il sera difficile de l'enlever. Le toit de la Porsche en sortira indemne... ou presque !

0 mph

10.5°C

0 20 40 60 80 100 120 140 160 18
km/h

 #02 **RAMP**
IN DER HITZE
DER NACHT

STORY Spione wie wir / **PHOTOGRAPHER** Steffen Jahn

CAR Mercedes-Benz CL

NACHTSICHTSACHE — Ein Fotoshooting hat für gewöhnlich ein paar konstante Eckdaten: Setting, Fotograf, Objekt. Dann macht der Fotograf Bilder, und im Idealfall sind alle glücklich. Im Fall des Mercedes-Benz CL dachten wir: Muss das so sein? Die Antwort fiel uns dann beim Blick auf die Nachtsichtkamera des Mercedes ein. Das Ergebnis: erhellend.

NIGHT VISION — Any photo shoot usually involves some invariable basic data, such as information about the setting, photographer, and the object. The photographer then takes his or her pictures, and if all goes well, everybody's happy. In the case of the Mercedes-Benz CL, we couldn't help but wonder: Does it have to be like that? Driving back, we found the answer when we happened to see the night vision camera of the Mercedes. The result: illuminating.

QUESTION DE VISION DE NUIT — Dans un shooting, on retrouve généralement les mêmes ingrédients fondamentaux : un décor, un photographe et un sujet. Puis le photographe prend des photos et, quand tout va bien, tout le monde est content. Avec la Mercedes-Benz CL, nous nous sommes demandé : les choses doivent-elles impérativement se passer ainsi ? La réponse nous est apparue en regardant l'assistant de vision de nuit de la Mercedes. Résultat : l'illumination.

IMMER WEITER — Mit dem Mercedes zum Mars, um ein paar Österreicher zu treffen. Die perfekten Zutaten für eines der besten ramp-Bilder überhaupt. Bleibt die Frage: Was ist schwieriger? Ein paar Österreicher zum Mars zu schicken, oder einen Mercedes in 36 Stunden von Stuttgart nach Marrakesch zu bringen? Letzteres haben wir schon mal geschafft.

PUSHING THE LIMITS EVEN FURTHER — Riding a Mercedes to Mars to meet a couple of Austrians? Heck, yeah! It's got all the perfect ingredients for one of the best ramp photo shoots ever. The question remains: Which is the more difficult task? Sending a couple of Austrians to Mars, or driving a Mercedes from Stuttgart to Marrakech in the space of 36 hours? We already succeeded in doing the latter.

TOUJOURS PLUS LOIN — En route pour Mars à bord d'une Mercedes, à la rencontre de quelques Autrichiens. Les ingrédients parfaits pour l'une des meilleures photos ramp. Reste une question : qu'est-ce qui est plus difficile, envoyer quelques Autrichiens sur Mars ou transporter une Mercedes de Stuttgart jusqu'à Marrakech en 36 heures ? Le deuxième défi, nous l'avons déjà relevé.

#22 **RAMP**
SOME LIKE IT HOT

STORY Reise zum Mars bzw. von einem anderen Stern

PHOTOGRAPHER Benjamin Pichelmann

CAR Mercedes G500

ZEITREISE — Wenn Kenny Bräck und Tom Kristensen ramp oder rampstyle lesen, dann sind wir zufrieden - und vermutlich in Goodwood. Wir waren dort auf Spurensuche. Im Fokus: besondere Autos. Und haben das Shelby American Daytona Cobra Coupe gefunden. Neben den Rennfahrern auf den Campingstühlen.

TIME TRAVEL — Anytime we see Kenny Bräck and Tom Kristensen reading either ramp or rampstyle, you'll find us in a state of joy—and likely in Goodwood. Last time we went there on a quest. The object of our quest was special rides. That's when we found the Shelby American Daytona Cobra Coupe. It happened to be right next to the two race car drivers in their camping chairs.

VOYAGE DANS LE TEMPS — Si Kenny Bräck et Tom Kristensen lisent ramp ou rampstyle, nous sommes heureux - et probablement à Goodwood. Nous y sommes allés pour mener l'enquête. Notre cible : les autos d'exception. Nous sommes tombés sur la Shelby American Daytona Cobra Coupé. Près des pilotes, installés sur des chaises de camping.

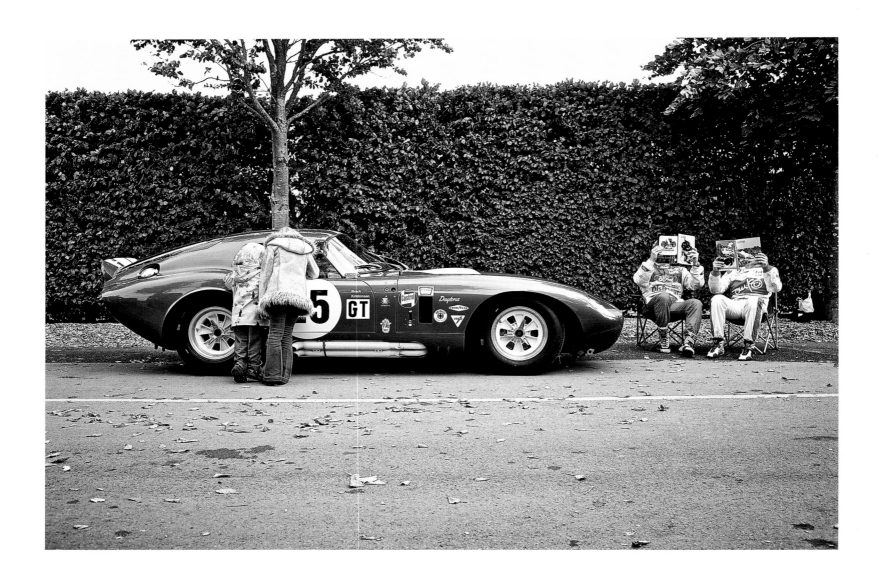

#16

RAMP
DLDUUDGR*
*DAS LEBEN, DAS UNIVERSUM
UND DER GANZE REST

STORY Das Universum in der Nussschale / **PHOTOGRAPHER** David Breun

CAR Shelby American Daytona Cobra Coupe

WEIL ER ES KANN! — Warum schenkt der Designchef des durchweg vernünftigen VW-Konzerns Lamborghini zum 50. Geburtstag ein so polarisierendes Unikat wie den Egoista? Weil er es kann. Und wer 608 PS aus einem V10-Mittelmotor generiert, der versetzt beim Shooting auch das denkmalgeschützte VW-Heizkraftwerk in Hochspannung.

BECAUSE HE CAN! — Why would the head of design of the otherwise sagacious and down-to-earth VW Group honor the 50th anniversary of Lamborghini by approving a polarizing model such as the Egoista? Because he can. Generating 608 hp from its mid-engine V10, the Egoista turns up the heat during its photo shoot at Volkswagen's landmark home power plant.

PARCE QU'IL EN A LES MOYENS ! — Pourquoi le responsable du design du groupe Volkswagen, d'habitude si raisonnable, offre-t-il à Lamborghini pour ses 50 ans un modèle unique qui divise autant que l'Egoista ? Parce qu'il en a les moyens. Et ce bolide qui tire 608 chevaux d'un V10 central électrise tout sur son passage lors du shooting, même la centrale de cogénération historique du site de Volkswagen.

 #26 **RAMP**
MY WAY

STORY Der Evoluzzer. Wir müssen nur wollen.

PHOTOGRAPHER Nils Hendrik Müller

CAR Lamborghini Egoista

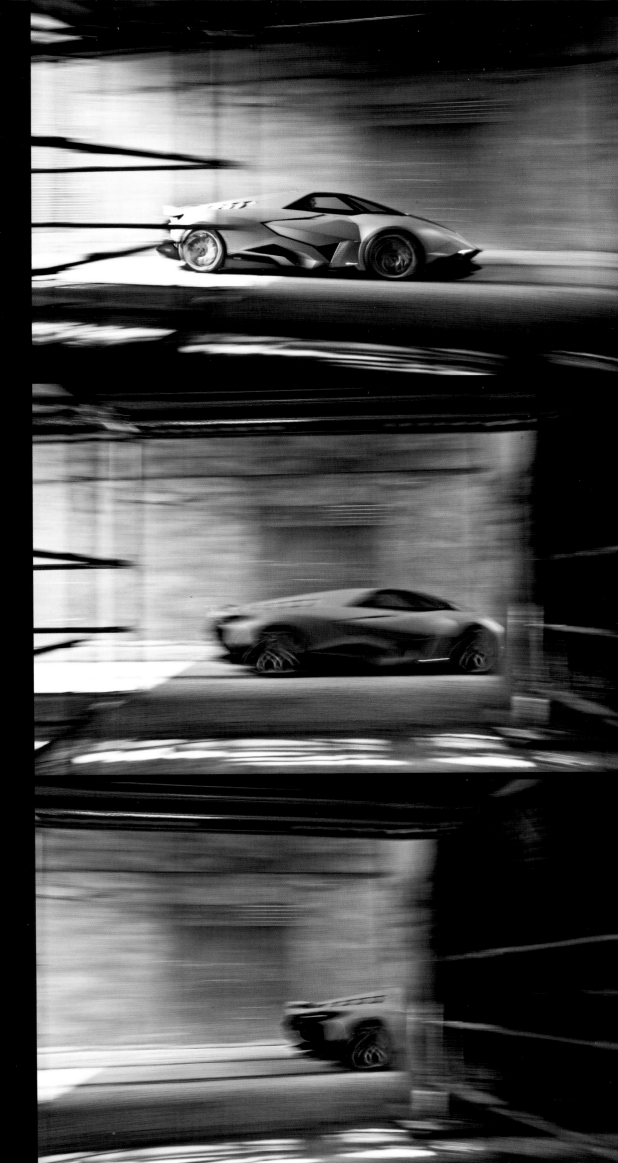

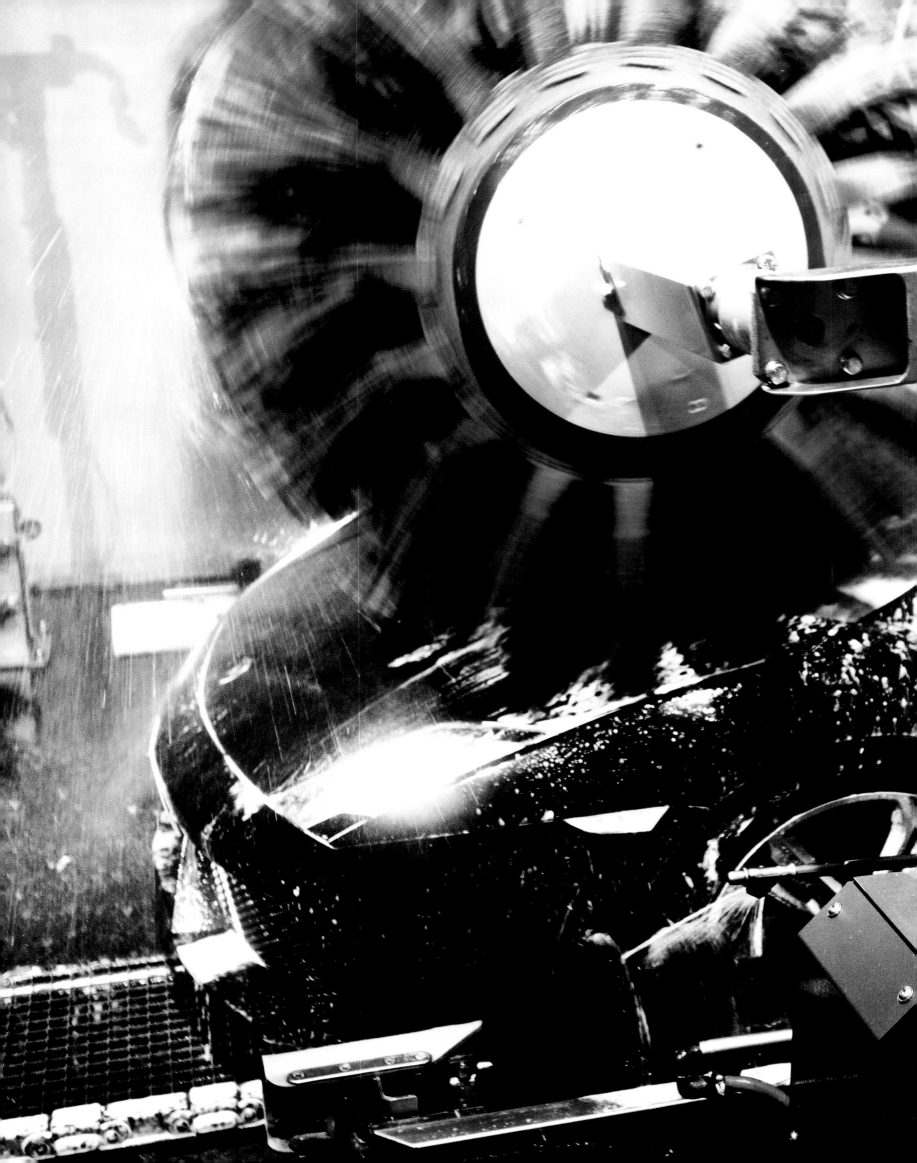

**WER A SAGT, MUSS AUCH NACH B
FAHREN ...** — Dass so ein Lambo
ganz prima für einen Belastungstes
in Sachen Maximalbeschleunigung
taugt, wussten wir. Wenn ramp-
Kolumnist Philipp Tingler den Zehn
zylinder anwirft, wird der Gallardo
ganz fix zum ultimativen Beziehung
test. Fragt sich nur: Wo ist eigentlich
dieser Punkt B, zu dem alle hinwoller

FROM POINT A TO POINT B... —
It's hard to beat a Lambo when it
comes acceleration testing. We all
knew that for sure. As ramp columnis
Philipp Tingler fired up the Gallardo'
V10, we also knew our feel for the ca
would be put to the ultimate test in n
time flat. The only thing we didn't
know for sure was Point B.

QUI DIT A, DOIT FONCER VERS B ... -
Que cette Lamborghini convienne
parfaitement aux essais d'accéléra-
tion extrêmes, nous nous en doution
Lorsque Philipp Tingler, chroniqueur
pour ramp, démarre la dix cylindres,
la Gallardo et son conducteur passen
par les affres d'une histoire passion-
nelle. Une question reste posée : mais
où est donc ce point B, que tout le
monde veut atteindre ?

 #07 **RAMP**
LET'S GET OUT
OF HERE!

STORY Paar mit Stier / **PHOTOGRAPHERS** outtofocu

David Breun & Martin Grega / **CAR** Lamborghini

Gallardo LP 560-4

MAGAZIN ——— A PASSION FOR CA

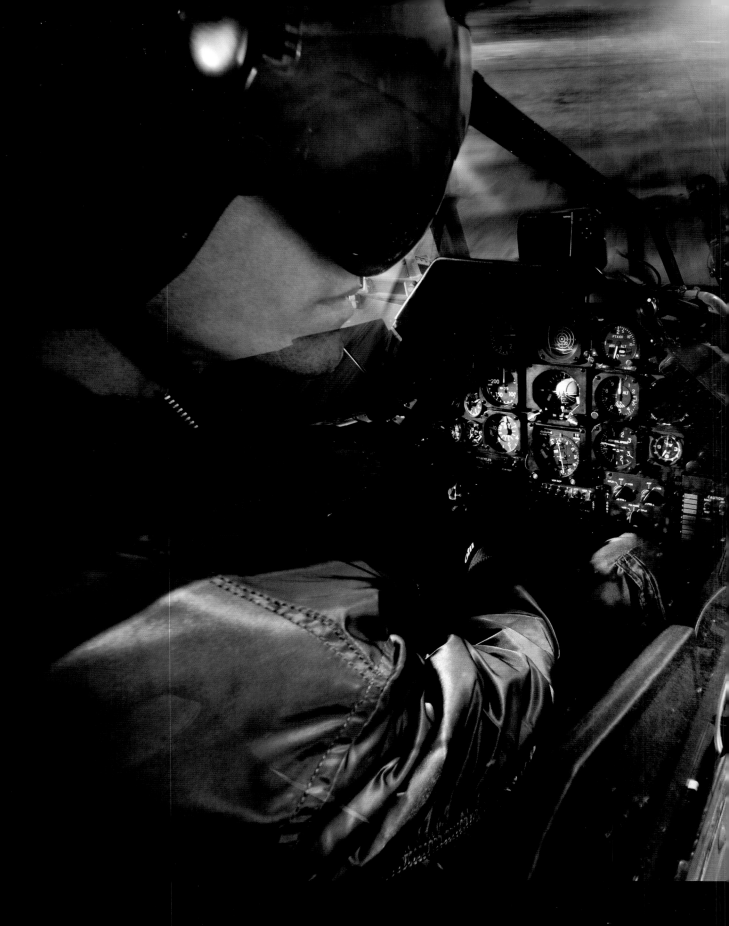

RAMP
ES LEBE DER
SPORT!

STORY Catch Me! / **PHOTOGRAPHER** Frank Kayser

CAR Audi R8 5.2 FSI Quattro V10

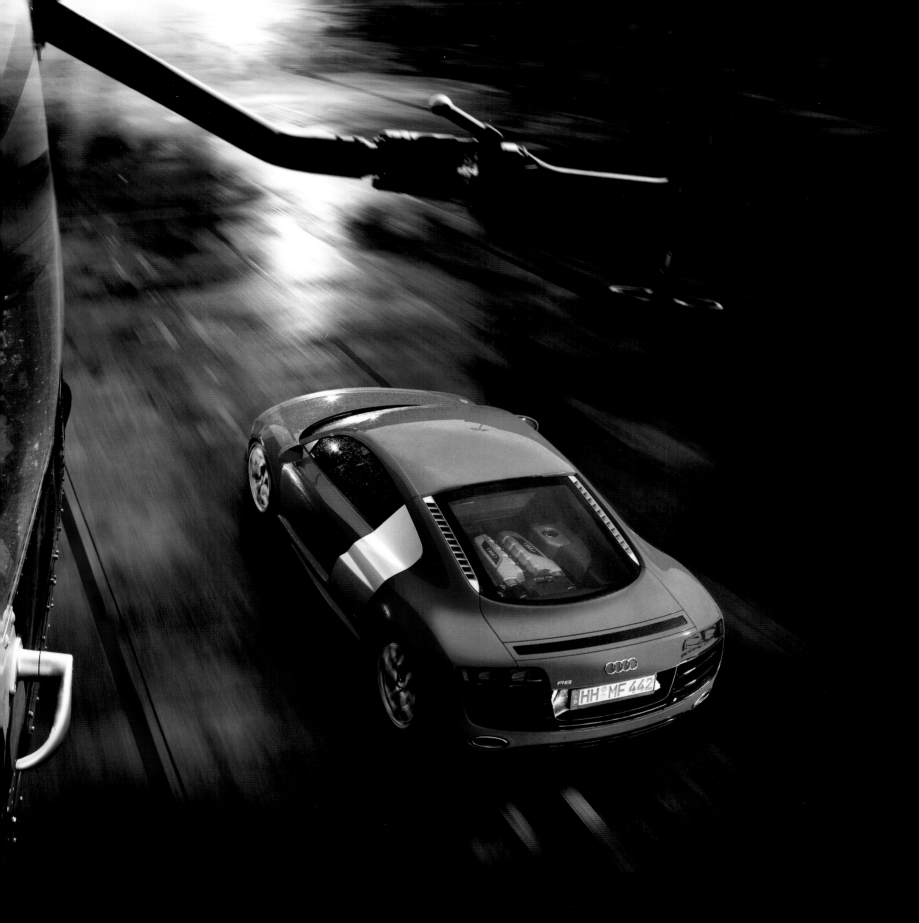

YES, WE CAN! — Wenn Audi einen Super-sportwagen der Extreme wie den R8 baut, dann ist es nur recht, dass der Rockstar unter den Autofotografen eine extrem schnelle Actionstory ins Bild setzt. In den Nebenrollen: eine Lady in Black und ein Kampfhubschrauber. Erübrigt sich die Frage, wer hier wen fangen kann, oder?

YES, WE CAN! — When you have Audi building an extreme super sports car like the R8, it's more than befitting for the rock star among car photographers to produce an extremely fast action story on video. Supporting roles included a lady in black as well as a combat helicopter. We don't have to tell you which one can do all the capturing...

YES, WE CAN! — Quand Audi présente une sportive de prestige exceptionnelle comme la R8, le scénario d'action ultrarapide conçu par la rock-star des photographes automobiles vient à point nommé. Dans les rôles secondaires : une femme en noir et un hélicoptère de combat. Inutile de se demander qui attrapera qui, n'est-ce pas ?

#03 **RAMP**
HELDEN

STORY Last Action Hero / **PHOTOGRAPHERS** outtofocus – David Breun & Martin Grega

CAR Porsche 911 Carrera GT3

ALARMSTUFE WEISS — Weiß steht für das Gute und Vollkommene. Aber auch für den Ursprung und puristische Klarheit. Kombiniert mit den 415 PS dieses Carrera GT3 ist klar: Eine neue Bildsprache muss her. Wenn dann noch Dynamik ins Spiel kommt, steht fest, dass die Farbe hier ganz und gar nicht für Unschuld steht.

CODE WHITE — You know how white stands for goodness and perfection, right? Inception and serene innocence, right? Well, when it comes to the 415 horses in this Carrera GT3, it's time to change the picture. The color notwithstanding, once you taste the performance of this bad boy, any thought of serene innocence goes right out the window.

NIVEAU D'ALARME BLANC — Le blanc est le symbole du bien et de la perfection, mais on l'associe aussi à l'authenticité et aux lignes épurées. Lorsqu'il côtoie les 415 chevaux de cette Carrera GT3, une chose saute aux yeux : le code visuel doit évoluer. Ajoutez à cela des lignes aérodynamiques et il est clair que le blanc n'est vraiment plus symbole de l'innocence.

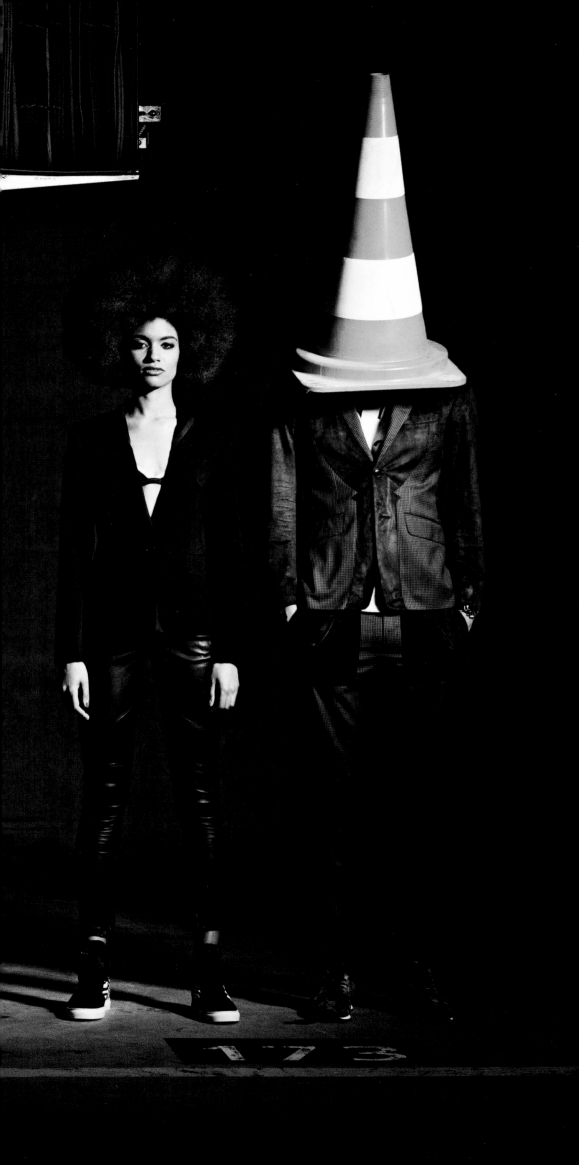

THE ZÜRICH JOB — Der Film „The Italian Job" diente als Inspiration. Zweifel an der WM-Tauglichkeit von Jogis Jungs waren die Motivation. Also haben wir uns den WM-Pokal gesichert, vorsichtshalber kurz vor der Fußball-WM 2014. Stilsicher mit einem Mini Cooper D. Im Sommer wurden wir von Schweinsteiger, Lahm und Co eines Besseren belehrt. Gott sei Dank handelte es sich bei unserer Trophäe nur um eine Attrappe.

—————

THE ZURICH JOB — What inspired us was the movie "The Italian Job." What motivated us was our doubt in the German national soccer team's ability to qualify for FIFA. Given our humble nature, we decided to just take the FIFA Cup ourselves, preferably right before the 2014 FIFA season, using a Mini Cooper D as our getaway. You know, something classy. Well, that summer, Schweinsteiger, Lahm, et al. proved us wrong. Thank God, we only took the fake.

—————

BRAQUAGE À LA ZURICHOISE — Cette scène est inspirée du film « Braquage à l'italienne ». Nous doutions des capacités de la Mannschaft à décrocher la coupe du Monde de foot 2014. Alors par précaution, nous l'avons raflée peu avant la compétition, avec élégance, dans une Mini Cooper D. Puis cet été, la bande à Joachim Löw, avec Schweinsteiger et Lahm, a montré que nous les avions sous-estimés. Dieu merci, notre trophée était factice.

 RAMP
MY WAY

STORY Wir holen uns das Ding

PHOTOGRAPHER Bernd Kammerer / **CAR** Mini Cooper

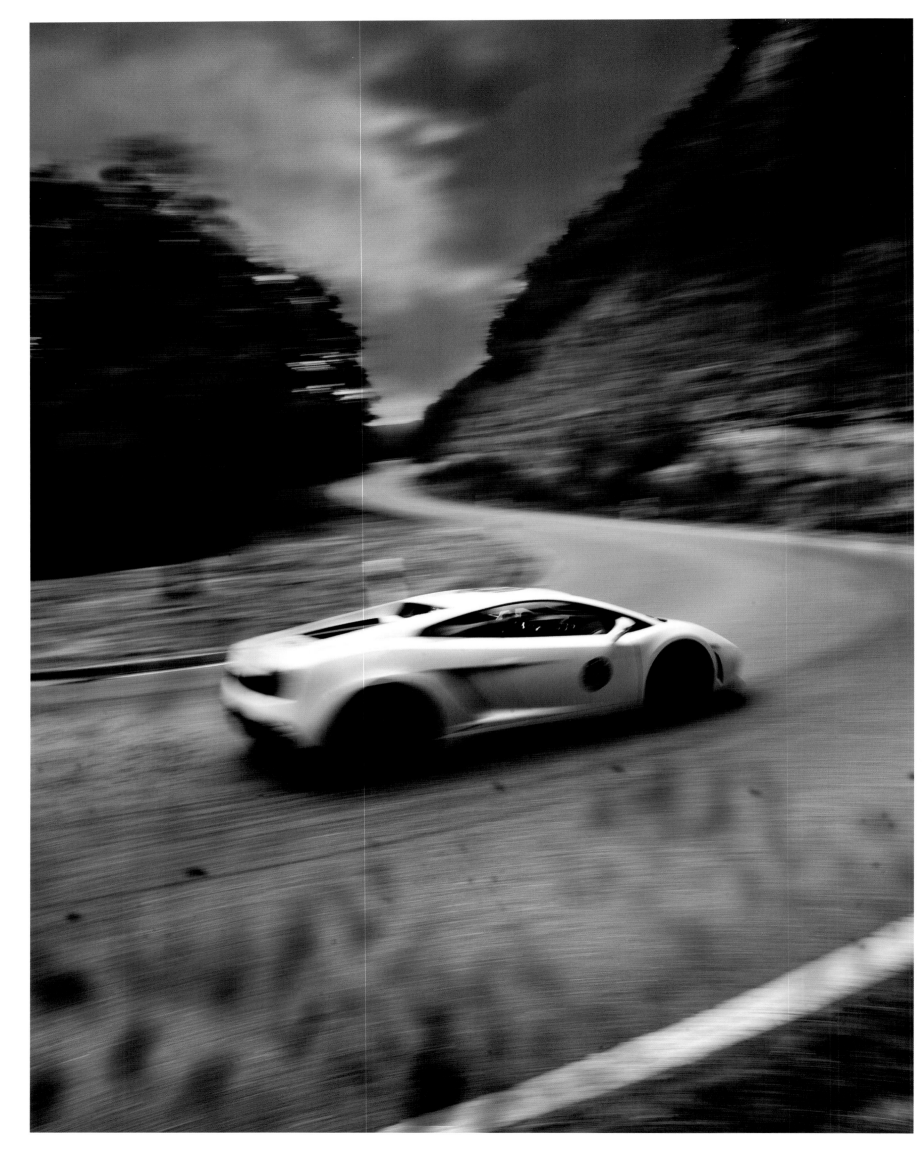

LAMBO-MISSION — Die Meldung: Mars-500. Astronauten trainieren 520 Tage im Isolationscontainer für die Mars-Mission. Fanden wir irgendwie langweilig. Viel spannender sind da doch drei Tage im Lamborghini. Stilecht natürlich mit esa-Branding.

LAMBO MISSION — Ever hear of the Mars-500? It's a bunch of astronauts spending 520 days inside an insulation container as part of their training for the mission to Mars. Doesn't sound like a whole lotta fun, if you ask us. We'd just as soon spend three days in a Lamborghini, esa style, of course.

MISSION LAMBO — L'info : Mars-500. Des astronautes qui s'entraînent 520 jours en chambre d'isolement pour la seconde mission vers Mars. Nous, on a trouvé ça ennuyeux. Trois jours en Lamborghini, c'est bien plus exaltant. Avec classe bien sûr, en combinaison de l'ESA.

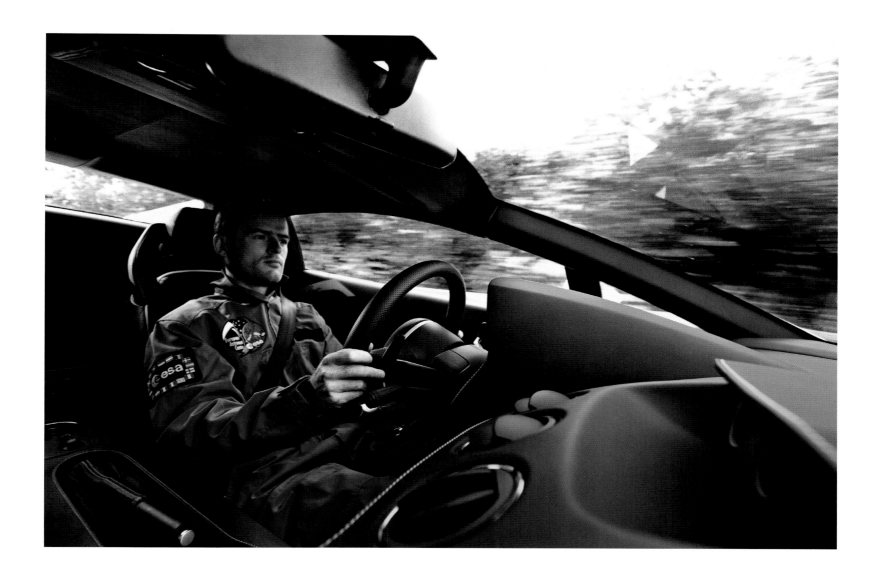

 RAMP
NACH DEM AUTO?

STORY Macht's gut und danke für den Lambo!

PHOTOGRAPHER Steffen Jahn / **CAR** Lamborghini Gallardo

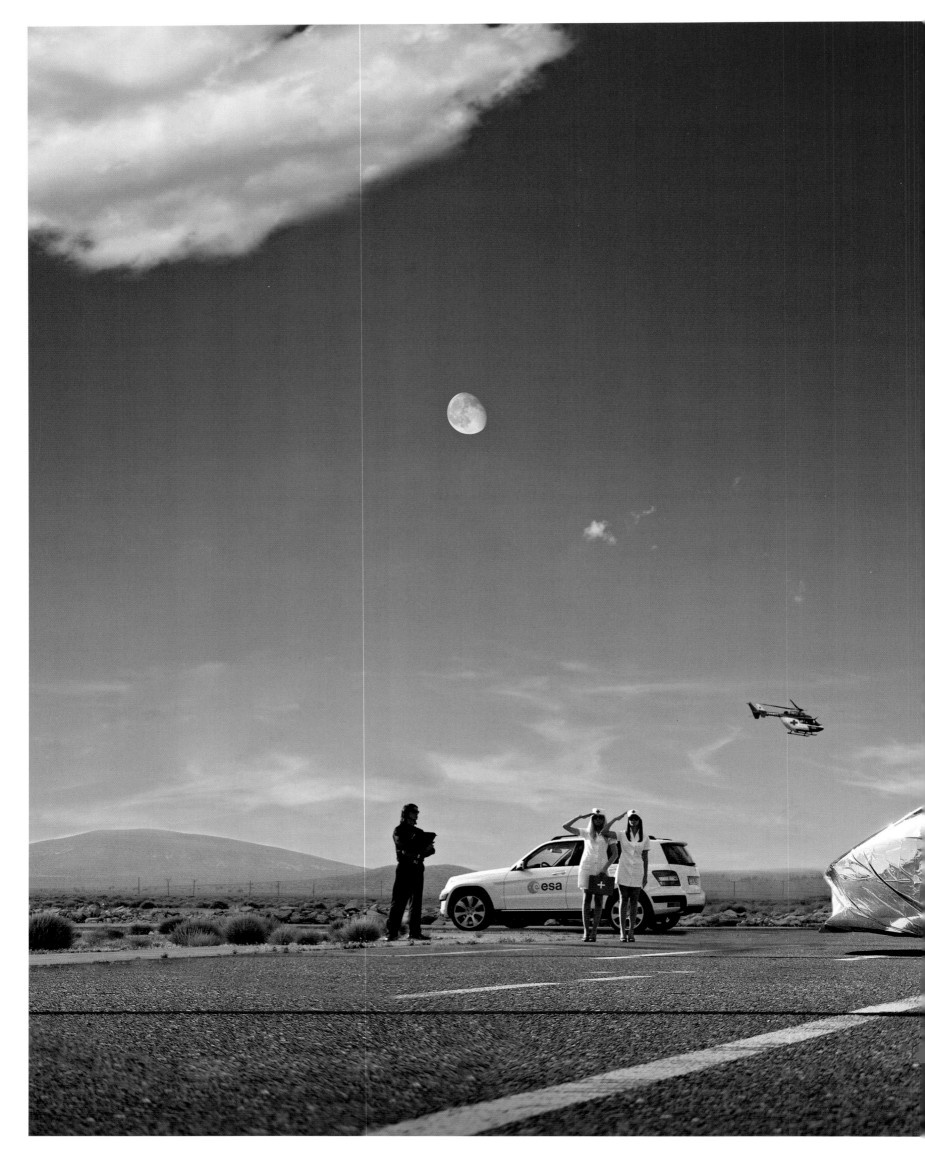

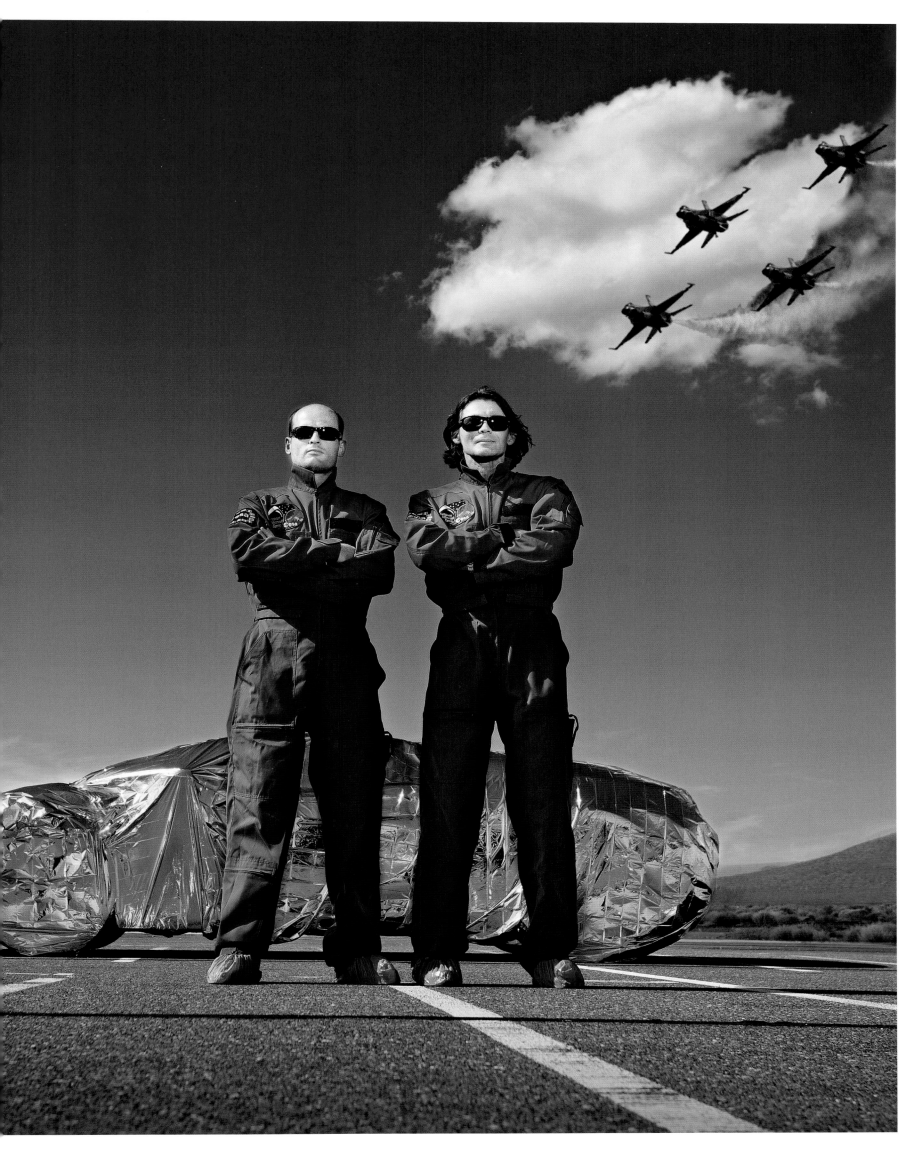

CON

DURCH DIESE AUGEN SIEHT RAMP DIE AUTOWELT – UND DARÜBER HINAUS.

THE PEOPLE WITH EYES TRAINED ON THE AUTO WORLD FOR RAMP—AND BEYOND.

C'EST À TRAVERS LEURS YEUX QUE RAMP VOIT LE MONDE DE L'AUTOMOBILE - ET AU-DELÀ.

ALASTAIR BOLS

ESSEX, UNITED KINGDOM

www.alastairbols.com

AMY SHORE

LEICESTER, UNITED KINGDOM

www.amyshorephotography.com

ANDREAS RIEDMANN

VIENNA, AUSTRIA

www.hochform.at

ANDY FOX

MUNICH, GERMANY

www.andy-fox.com

ANNA-LISA LANGE

STUTTGART, GERMANY

www.lange-photography.de

BENJAMIN PICHELMANN

HAMBURG, GERMANY

www.benjaminpichelmann.de

BENJAMIN TAFEL

BERLIN, GERMANY

www.benjamin-tafel.de

BERND KAMMERER

STUTTGART, GERMANY

www.berndkammerer.de

BYRON MOLLINEDO

LONDON, UNITED KINGDOM

www.byronmollinedo.com

DANIEL WOELLER

FRANKFURT, GERMANY

www.woellerphoto.tumblr.com

DAVID BREUN

BERLIN, GERMANY

www.breungrega.com

DENIZ SAYLAN

STUTTGART, GERMANY

www.denizsaylan.com

FRANK KAYSER

EICHENZELL, GERMANY

www.kayser-photography.com

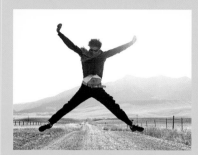

GÖTZ GÖPPERT

PARIS, FRANCE

www.gotzgoppert.com

HELMUT WERB

LOS ANGELES, USA

www.helmutwerb.com

HENRIK PURIENNE

CAPE TOWN, SOUTH AFRICA

www.purienne.com

IGOR PANITZ

FILDERSTADT, GERMANY

www.igorpanitz.com

JAN FRIESE

BERLIN, GERMANY

www.janfriese.com

JAN STEINHILBER

HAMBURG, GERMANY

www.steinhilber.biz

JASON LEE PARRY

LOS ANGELES, USA

www.jasonleeparry.com

JIM KRANTZ

TUGBOAT, NEW YORK CITY, USA

www.jimkrantz.com

JUSTIN LEIGHTON

SPARSHOLT, UNITED KINGDOM

www.justinleighton.com

KAI-UWE GRUNDLACH

HAMBURG, GERMANY

www.studiogundlach.de

LAURENT NIVALLE

PARIS, FRANCE

www.laurentnivalle.fr

LEOPOLD FIALA

MUNICH, GERMANY

www.leopoldfiala.com

MARCUS PHILIPP SAUER

MUNICH, GERMANY

www.marcussauer.com

MARKUS ALTMANN

BERLIN, GERMANY

www.markus-altmann.de

MARKUS MEUTHEN

DUSSELDORF, GERMANY

www.meuthen-photography.com

MARTIN GREGA

BERLIN, GERMANY

www.breungrega.com

MICHAEL HANDELMANN

BERLIN, GERMANY

www.michaelhandelmann.de

NILS HENDRIK MÜLLER

BRAUNSCHWEIG, GERMANY

www.nilshendrikmueller.com

RICHARD THOMPSON

LOS ANGELES, USA

www.rvt3.net

ROBERT ROITHER

MUNICH, GERMANY

ROMAN KUHN

MALLORCA, SPAIN

www.romankuhn.eu

BUT

SCOTT TOEPFER

VENTURA, USA

www.sgtoepfer.com

SJOERD TEN KATEN

AMSTERDAM, NETHERLANDS

www.sjoerdtenkate.com

STEFFEN JAHN

STUTTGART, GERMANY

www.steffenjahn.com

THILO ROTHACKER

STUTTGART, GERMANY

www.thilo-rothacker.com

TIM ADLER

BERLIN, GERMANY

www.timadler.de

TINE ACKE

HAMBURG, GERMANY

www.tineacke.de

TODD COLE

LOS ANGELES, USA

www.toddcolephoto.com

YONA HECKL

HAMBURG, GERMANY

www.yonaheckl.de

RAMP // STYLE // CLASSICS // SPECIAL

RAMP #01

JETZT NEHMEN WIR DIE SACHE MAL
SELBT IN DIE HAND (LET'S GO!)

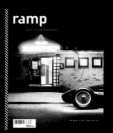

RAMP #02

IN DER HITZE DER NACHT

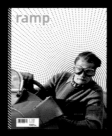

RAMP #03

HELDEN

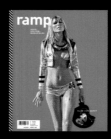

RAMP #04

NACH DEM AUTO?

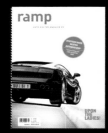

RAMP #05

UPON THE LADIES!

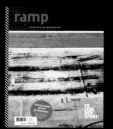

RAMP #06

ES LEBE DER SPORT

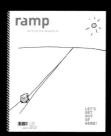

RAMP #07

LET'S GET OUT OF HERE!

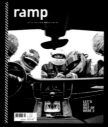

RAMP #08

LET'S GET OUT OF HERE 2

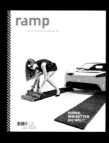

RAMP #09

HURRA, WIR RETTEN DIE WELT!

RAMP #10

SEX, DRUGS & ROCK'N'ROLL

RAMP #10

SEX, DRUGS & ROCK'N'ROLL

RAMP #11

FAMILY AFFAIRS

RAMP #12

FOREVER YOUNG

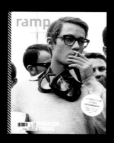

RAMP #12

FOREVER YOUNG

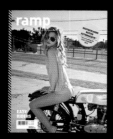

RAMP #13

EASY RIDERS

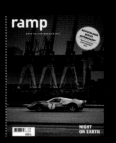

RAMP #14

NIGHT ON EARTH

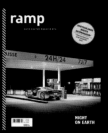

RAMP #14

NIGHT ON EARTH

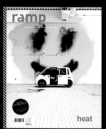

RAMP #15

HEAT

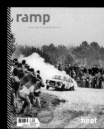

RAMP #15

HEAT

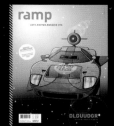

RAMP #16

DLDUUDGR* (DAS LEBEN, DAS UNIVERSUM UND DER GANZE REST)

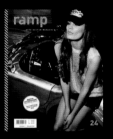

RAMP #17

24

RAMP #17

24

RAMP #18

ENDLICH 18!

RAMP #19

WILD WILD WEST

RAMP #20

HUNGRY HEARTS

RAMP #21

ZURÜCK IN DIE ZUKUNFT

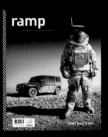

RAMP #22

SOME LIKE IT HOT

RAMP #23

ENDSTATION SEHNSUCHT

RAMP #24

THE STARS (ARE OUT TONIGHT)

RAMP #25

MODERN TIMES

RAMP #26

MY WAY

RAMP #27

YOU'LL NEVER DRIVE ALONE

RAMP #28

ALL YOU CAN WISH

RAMP #29

DIE GROSSE FREIHEIT

RAMP #30

FAR-FAIR-GNU-GHEN

RAMPSTYLE #01

PLUG AND PLAY

RAMPSTYLE #01

PLUG AND PLAY

RAMPSTYLE #02

QUICK AND DIRTY

RAMPSTYLE #02

QUICK AND DIRTY

RAMPSTYLE #02

QUICK AND DIRTY

RAMPSTYLE #03

ONE AND ONLY

RAMPSTYLE #04

COME AS YOU ARE

RAMPSTYLE #05

BAD BOYS

RAMPSTYLE #06

DUSK TILL DAWN

RAMPSTYLE #07

SMOOTH OPERATORS

RAMPSTYLE #08

MACH'S GUT UND
DANKE FÜR DEN FISCH

RAMPSTYLE #09

EASY PEASY LEMON SQUEEZY

RAMPSTYLE #10

KÜHL WIE EINE GURKE

RAMPCLASSICS #01

LIEBLING, ICH WERDE JÜNGER

RAMPCLASSICS #02

FLASH BAM POW

RAMPCLASSICS #03

GO LIKE HELL

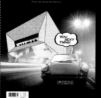

RAMPCLASSICS #04

PORSCHE MUSEUM SPECIAL

YOU SEXY THING!

RAMPCLASSICS #04

PORSCHE MUSEUM SPECIAL

YOU SEXY THING!

RAMPSPECIAL

MERCEDES-BENZ E-KLASSE

WELCOME HOME!

RAMPSPECIAL

DUNLOP #1

125 JAHRE DUNLOP

RAMPSPECIAL

DUNLOP #2

AMG DRIVING ACADEMY

RAMPSPECIAL

SEAT LEON

ONE WAY OR THE OTHER

RAMPSPECIAL

SEAT LEON

FREERIDE

RAMPSPECIAL

SEAT IBIZA

COMING HOME

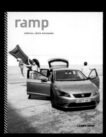

RAMPSPECIAL

IBIZA RELOADED

LADIES DRIVE

RAMPSPECIAL

SEAT CUPRA

IT'S UP TO YOU

RAMPSPECIAL

SEAT CUP RACER

GOODBYE GRAVITY!

RAMPSPECIAL

AMG DUCATI

WILD THINGS

RAMPSPECIAL

AMG DUCATI

WILD THINGS #2

RAMPSPECIAL

MASERATI

NEW WORLD

RAMPSPECIAL

MASERATI

NEW WORLD

RAMPSPECIAL

MASERATI GHIBLI

VIVA LA MASERATI

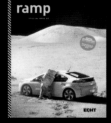

RAMPSPECIAL

OPEL #1

ECHT

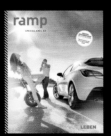

RAMPSPECIAL

OPEL #2

LEBEN

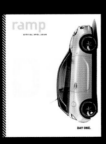

RAMPSPECIAL

OPEL ADAM

DAY ONE.

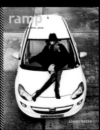

RAMPSPECIAL

OPEL ADAM

ADAMS ROCKS

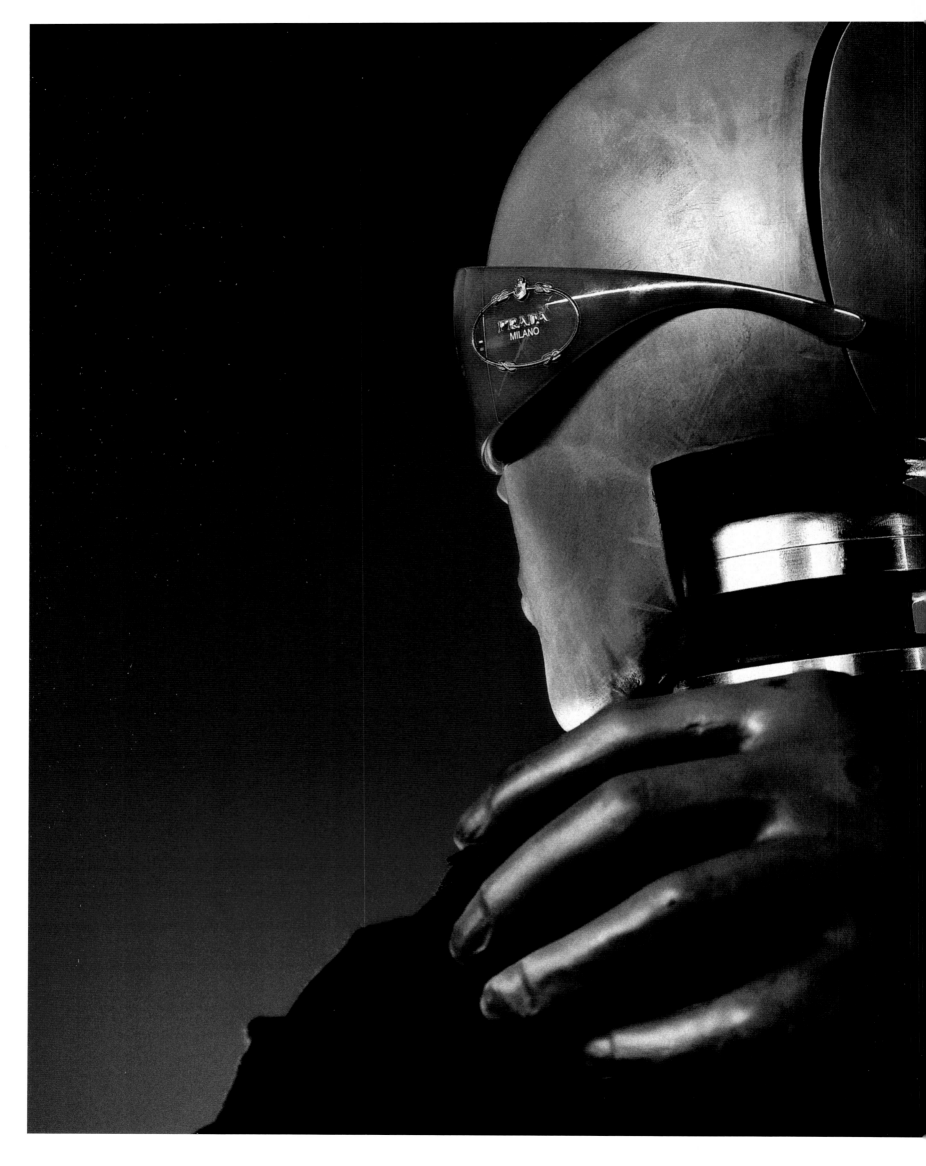

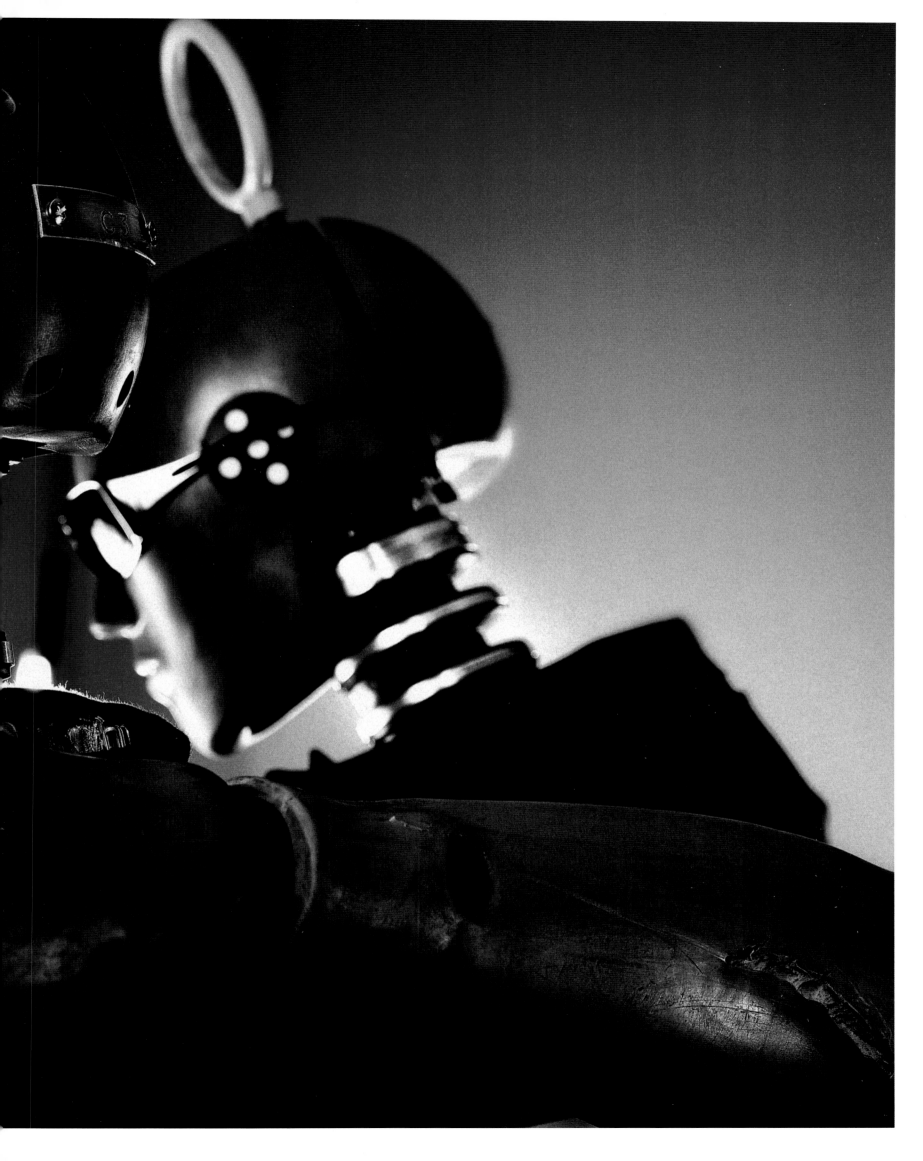

IMPRINT

© 2015 teNeues Media GmbH + Co. KG, Kempen

© 2015 Red Indians Publishing GmbH + Co. KG, Reutlingen

CONCEPT & IDEA
Michael Köckritz

DESIGN CONCEPT & ART DIRECTION
Michael Köckritz & STAN STUDIOS, Stuttgart

INTRODUCTION
Michael Köckritz, Ulf Poschardt

EDITORIAL STAFF
Alexander Morath, Bernd Haase, Christina Rahmes, Matthias Mederer, Simon Burks

LAYOUT
STAN STUDIOS, Stuttgart

PHOTO EDITOR
Antonietta Procopio

EDITORIAL MANAGEMENT TENEUES
Regine Freyberg, teNeues Media GmbH + Co. KG

TRANSLATION
Conan Kirkpatrick, Artes Translations (English), Claude Checconi (French)

PROOFREADING
Susanne Schleußer, derschönstesatz (German), Dr. Suzanne Kirkbright, Artes Translations (English), Tina Calogirou (French)

PRODUCTION
Alwine Krebber, teNeues Media GmbH + Co. KG

PREPRESS
STAN STUDIOS, Stuttgart

COLOR PROOFING
David Burghardt

PUBLISHED BY
TENEUES PUBLISHING GROUP
teNeues Media GmbH + Co. KG
Am Selder 37, 47906 Kempen, Germany
Phone: +49 (0)2152 916 0
Fax: +49 (0)2152 916 111
e-mail: books@teneues.com

Press department: Andrea Rehn
Phone: +49 (0)2152 916 202
e-mail: arehn@teneues.com

teNeues Publishing Company
7 West 18th Street, New York, NY 10011, USA
Phone: +1 212 627 9090
Fax: +1 212 627 9511

teNeues Publishing UK Ltd.
12 Ferndene Road, London SE24 0AQ, UK
Phone: +44 (0)20 3542 8997

teNeues France S.A.R.L.
39, rue des Billets, 18250 Henrichemont, France
Phone: +33 (0)2 48 26 93 48
Fax: +33 (0)1 70 72 34 82

www.teneues.com

ISBN: 978-3-8327-3301-8
Library of Congress Control Number: 2015940195
Printed in the Czech Republic

Bibliographic information published by the Deutsche Nationalbibliothek. The Deutsche Nationalbibliothek lists this publication in the Deutsche Nationalbibliografie; detailed bibliographic data are available in the Internet at http://dnb.d-nb.de.